THE METROPOLITAN MUSEUM OF ART

Europe in the Middle Ages

THE METROPOLITAN

INTRODUCTION

BY

Charles T. Little

AND

Timothy B. Husband

CURATORS
DEPARTMENT OF MEDIEVAL ART
AND THE CLOISTERS

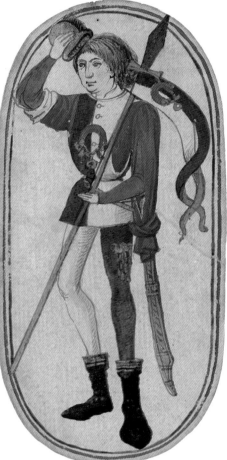

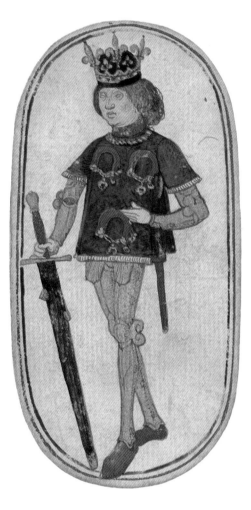

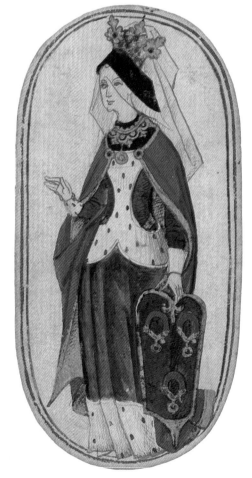

MUSEUM OF ART
Europe in the Middle Ages

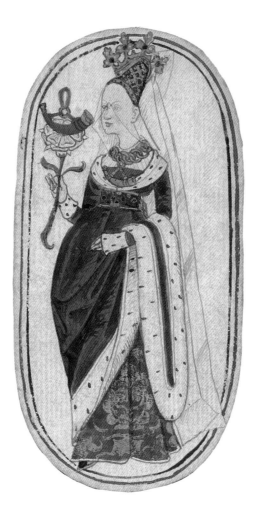

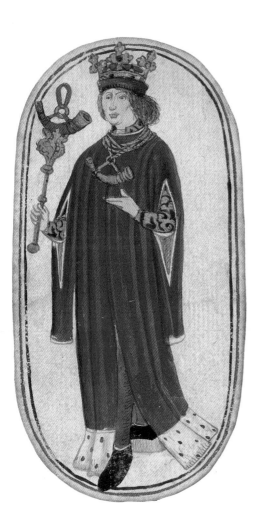

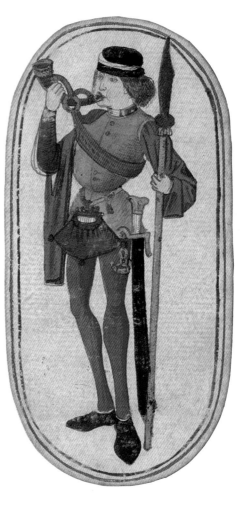

THE METROPOLITAN MUSEUM OF ART, NEW YORK

PUBLISHED BY

THE METROPOLITAN MUSEUM OF ART
New York

PUBLISHER

Bradford D. Kelleher

EDITOR IN CHIEF

John P. O'Neill

EXECUTIVE EDITOR

Mark D. Greenberg

EDITORIAL STAFF

Sarah C. McPhee

Josephine Novak

Lucy A. O'Brien

Robert McD. Parker

Michael A. Wolohojian

DESIGNER

Mary Ann Joulwan

———

Commentaries written by Mary B. Shepard, museum educator, Department of Medieval Art and The Cloisters, The Metropolitan Museum of Art.

Photography commissioned from Schecter Lee, assisted by Lesley Heathcote: Plates 1, 2, 4, 5, 13, 19–22, 26, 27, 28–30, 40, 43, 49, 54, 55, 61, 62, 64, 67, 70, 71, 78, 88, 96, 98, 99, 100, 101, 104, 105, 111, 112, 118, 132, 133, 142. The photograph for Plate 75 by Malcolm Varon. All other photographs by The Photograph Studio, The Metropolitan Museum of Art.

Maps and time chart designed by Wilhelmina Reyinga-Amrhein.

TITLE PAGE

Playing Cards (6 from a set of 52)
South Lowlands (Burgundian territories), ca. 1475
Pasteboard with pen and ink, tempera, and applied gold and silver, each about 5⅞ x 2⅝ in. (13.8 x 7.1 cm.)
The Cloisters Collection, 1983 (1983.515.11–13, 37–39)

THIS PAGE

Jean, Duc de Berry, at Prayer (f. 91r) (detail) from *The Belles Heures de Jean, Duc de Berry*, ca. 1410
Pol, Janequin, and Herman de Limbourg
French, act ca. 1400–1416
Tempera and gold leaf on parchment; 9⅜ x 6⅝ in.
(23.8 x 16.8 cm.)
The Cloisters Collection, 1954 (54.1.1)

Pages 132–133: Text

Library of Congress Cataloging-in-Publication Data

Metropolitan Museum of Art (New York, N.Y.)
 Europe in the Middle Ages.

 1. Art, Medieval—Themes, motives—Catalogs. 2. Christian art and symbolism—Medieval, 500–1500—Themes, motives—Catalogs. 3. Art—New York (N.Y.)—Catalogs.
4. Metropolitan Museum of Art (New York, N.Y.)—Catalogs.
I. Little, Charles T. II. Husband, Timothy.
III. Title.
N5963.N4M44 1987 709′.02′07401471 86-23477
ISBN 0-87099-447-6 ISBN 0-87099-448-4 (pbk.)

Printed in Japan by Dai Nippon Printing Co., Ltd.
Composition by U.S. Lithograph, typographers, New York.

This series was conceived and originated jointly by The Metropolitan Museum of Art and Fukutake Publishing Co., Ltd. DNP (America) assisted in coordinating this project.

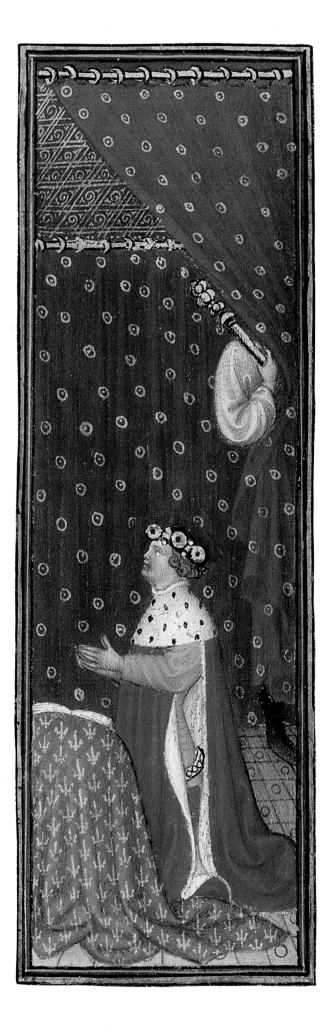

This volume, devoted to the arts of the medieval world, is the third publication in a series of twelve volumes that, collectively, represent the scope of the Metropolitan Museum's holdings while selectively presenting the very finest objects from each of its curatorial departments.

This ambitious publication program was conceived as a way of presenting the collections of The Metropolitan Museum of Art to the widest possible audience. More detailed than a museum guide, broader in scope than the Museum's scholarly publications, this series presents paintings, drawings, prints, and photographs; sculpture, furniture, and decorative arts; costumes, arms, and armor— all integrated in such a way as to offer a unified and coherent view of the periods and cultures represented by the Museum's collections. The objects that have been selected for inclusion in the series constitute a small portion of the Metropolitan's holdings, but they admirably represent the range and excellence of the various curatorial departments. The texts relate each of the objects to the cultural milieu and period from which it derives and incorporate the fruits of recent scholarship. The accompanying photographs, in many instances specially commissioned for this series, offer a splendid and detailed tour of the Museum.

We are particularly grateful to the late Mr. Tetsuhiko Fukutake, who, while president of Fukutake Publishing Company, Ltd., Japan, encouraged and supported this project. His dedication to the publication of this series has contributed greatly to its success.

The Department of Medieval Art and The Cloisters, established in 1933, oversees collections housed in the Museum's main building and in The Cloisters in upper Manhattan. The gift of J. Pierpont Morgan in 1917 forms the core of a collection in the main building of over four thousand pieces, which has been augmented by the gifts of such generous donors as George Blumenthal, Ruth and Leopold Blumka, Mrs. Joseph Brummer, Ella Brummer, Ernest Brummer, Mr. and Mrs. Maxime L. Hermanos, Alastair B. Martin, Mrs. Harriet Barnes Pratt, Frederic Pratt, George D. Pratt, Norbert Schimmel, Georges and Edna Seligmann, and Irwin Untermyer. The Robert Lehman Collection contains many important medieval works of art, two of which are reproduced in this volume. In addition, funds established by Isaac D. Fletcher, Frederick C. Hewitt, and Jacob S. Rogers, among others, have permitted the Museum to continue to add to its medieval collections.

The Cloisters, located in Fort Tyron Park, a magnificent setting overlooking the Hudson River, incorporates architectural elements from four medieval cloisters, Saint-Michel-de-Cuxa, Saint-Guilhem-le-Désert, Trie-en-Bigorre, and Froville, as well as from many monastic foundations in the Comminges region of southwestern France, including the Cistercian abbey at Bonnefont-en-Comminges. In 1925 John D. Rockefeller, Jr. helped acquire the collection of medieval sculpture assembled by George Grey Barnard. Mr. Rockefeller then also provided the grounds and building for The Cloisters, contributed many important pieces from his own collection, and established an endowment for further acquisitions. The Cloisters opened in 1938.

We are grateful to the staff of the Department of Medieval Art and The Cloisters for their help in preparing this volume, and especially to Timothy B. Husband and Charles T. Little, curators, who prepared the introductions; to Mary B. Shepard, museum educator, who wrote the commentaries; and to William D. Wixom, Michel David-Weill Chairman of the department, who, along with his colleagues, reviewed the selections, the design, and the texts.

Philippe de Montebello
Director

EUROPE IN THE MIDDLE AGES

PART ONE

LATE ANTIQUE TO HIGH GOTHIC

Between Antiquity and the Middle Ages:
Mediterranean Art from the 3rd to the 7th century

The Christian art that emerged from the Greco-Roman world is one of the most important legacies of the West. According to writers of the Italian Renaissance such as Lorenzo Ghiberti and Giorgio Vasari, the end of the Classical world corresponded with the reign of Constantine the Great (306–337). Clearly, the Edict of Milan, which in 313 formally recognized Christianity as a lawful religion, was a critical turning point. From then until the outbreak of iconoclasm in Byzantium (726–843), Christian religious imagery came into its own. The transition from Classical to Christian art was not abrupt, since for several hundred years both cultures coexisted and competed with each other. Recognizable Christian themes did not begin to appear until the third century. Because Christianity descended from Judaism, the proscription against images dictated by the second commandment impeded the development of a pictorial language appropriate to the new religion. In addition, Christians resisted images at first because of the potential association with pagan religious practices in which the veneration of images was central. Gradually, the power of the image became important to the promotion of Christianity and to conveying its message.

The first known Christian art comes from tombs and catacombs. Within a funerary setting emerge themes of faith, deliverance, salvation, and the eternal joy of Paradise. The Good Shepherd was one of the most popular subjects adopted from pagan art (where it had been a symbol of philanthropy) to become an allegory of faith as expressed in the Gospel of John (Chapter 10). The idea of deliverance and redemption through divine intervention is symbolically presented in the earliest example, from around 300, of the Last Judgment in Christian art, a sarcophagus lid (Plate 10) on which a youthful Christ-Shepherd is depicted accepting the sheep and rejecting the goats. Even though the subject matter is purely Christian, the style is Roman, complete with extensive drill work and palmette acroteria. The figure type has become increasingly abstract, however, and the action is pressed onto a single plane. Equally

evocative of this fusing of Classical form with biblical subject matter is the sepulchral relief of Jonah swallowed and cast up by the sea monster (Plate 9). Depictions of the miracles of salvation such as this proliferated during the fourth century as allegories of Christ's own death and resurrection.

In the fourth century, the centrality of Christ manifested itself in new themes such as the *Traditio Legis*, where Christ the Lawgiver gives the law to Saint Peter and at the same time emphasizes the importance of Saint Paul. Though initially developed as an apse theme, and probably first used in Old Saint Peter's in Rome, it quickly spread to other churches and funerary monuments (see Plate 11). The composition, portraying Christ as ruler, emphasizes the ceremonial character of the imperial court in Heaven. The relief is imbued with a Classical humanism that looks both to the past and to imperial art for stylistic elements that would inject Christian imagery with a new spirit. Although carved in Rome during the reign of Theodosius I (379–395), it was produced under a strong Eastern influence.

Since the reign of Constantine, Byzantium had increasingly become the center of the empire while barbarian threats gradually disrupted the political and cultural fabric of the West. The splendor and fame of Constantinople, the new capital in the East, began with Constantine, and although many of its celebrated monuments were begun by him—the first Hagia Sophia and the Church of the Apostles—few were completed before his death, and only the Hippodrome survives. The artistic wealth of the capital was often achieved at the expense of the provinces, allowing Saint Jerome to proclaim that "Constantinople was dedicated by denuding almost all other cities." Official art of the New Rome, as Constantine called his city, is best seen in imperial portraiture, which aggrandized and commemorated the authority of the emperor. The marble portrait (Plate 8) of his younger son, Constans (ca. 323–350), with calm, outward-gazing countenance, conveys a softer and more naturalistic style that transforms the severe and rigid portrayal of individuals in earlier generations.

Clearly, Constantinople was destined to transmit the Classical heritage to the Middle Ages. By the sixth century, it became

the nucleus of a brilliant civilization. The emperor Justinian (r. 527–565) and his powerful and intelligent wife, Theodora, unified the empire, halted barbarian threats, and gained new territories. Justinian inaugurated a dazzling building campaign of churches, public buildings, city walls, and aqueducts, not only in the capital, but throughout the empire. Following the destruction of the first Hagia Sophia in the riots of 532, a new, daring architectural wonder was erected in just five years. Its extraordinary and ethereal vastness was produced by a series of domes and semidomes on pendentives that permitted the largest interior space until modern times. Indeed, the enormous central dome, "dematerialized" by forty windows pierced around the rim, led one contemporary to proclaim with wonder that "it seems not to be founded on solid masonry, but to be suspended from Heaven." Appropriate to this dome of heaven, gold mosaics glistened throughout, adding to its splendor and helping to "dematerialize" it. Worthy of both the imperial and heavenly court, architecture and its adornment combined to provide a profoundly spiritual experience for the worshiper.

The aesthetic aims of this Golden Age of Byzantium transcended all art forms and can be witnessed in portraits, ivories, and jewelry. Ivory carvings are among the most sumptuous objects to survive and were highly prized throughout the Middle Ages. The elegant simplicity of the Diptych of Justinian (Plate 15), made for his appointment as consul in 521, is indicative of the quality of Constantinopolitan workmanship. The most celebrated ivory of the period is the episcopal chair of Bishop Maximian of Ravenna, carved with an abundance of organic motifs, figural compositions, and narrative subjects over every available surface; its style radically departs from the Classical sophistication of the diptych to become ornamental and more abstract in its conception of space and decoration. Likewise, the serene elegance and introspective gaze of the portrait of a lady of rank (Plate 16), which originally formed part of a funerary memorial, synthesizes several stylistic tendencies of the Justinianic age: It clearly is classically retrospective in its type and form, but its clarity of volumes, polish, and surface simplicity are injected with a new physical and spiritual unity.

The eastern Mediterranean, long subject to the Greek tradition and the standardizing influence of Rome, witnessed the impact of Constantinople and acquired a more independent "subantique" character in its art. The Transfiguration mosaic in the apse at the church of Saint Catherine on Mount Sinai (ca. 560–65) is thought to be a literal transplantation of the court style to a geographically distant place. Its strictly symmetrical composition appears more as a pure symbol and visionary image than as a factual narrative of a biblical event. A more schematic and more abstract orientation unequivocably became the basis for figurative representations. A pyxis, from Syria or Palestine, with the three Maries at the Holy Sepulcher, illustrates this changing tendency (Plate 32). It also shows in miniature an abbreviated representation of an altar, symbolically identified with the tomb of Christ.

Implements for the celebration of the Mass—gold and silver chalices, patens, ewers—essentially continue Roman forms of construction and design but are adapted to new functions. The so-called Antioch Chalice (Plate 17) from the early sixth century, composed of a silver-gilt openwork cage over a silver liner, teems with quotations from the Classical tradition; inhabited vine scrolls with apostles portrayed as ancient philosophers frame the figure of Christ, who is depicted as both teacher and resurrected Lord. This magnificent vessel, the most elaborate to survive, is a typical example of Syrian art and reflects the standards and quality established in Constantinople. At the same time, there were widely contrasting modes of representation throughout the Mediterranean. Startling differences emerge between the ivories showing Saints Peter and Paul from South Gaul and the same subject on a silver bookcover from Syria (Plate 18). The cubic reduction and schematization of the figures on the ivories amounts to a resistance to, if not a rejection of, Classical models. The elimination of naturalistic forms, therefore, places a greater emphasis on the figure as an image or sign.

The most distinctive local art of the Mediterranean developed in Egypt, where a particular form of Christianity, known as Coptic, evolved. Essentially decorative in character, with a delight in foliate and geometric patterns (see Plate 2), Coptic art ultimately formed one of the bases for Islamic art. When narrative or iconic themes are represented, such as in the Ascension ivory (Plate 3), all spatial qualities are suppressed, intensifying the abstraction of the surface, and strict frontality and symmetry rule the composition. The great quantity of textiles that survive from Coptic Egypt also show the tendency toward two-dimensional shapes, emphatically set off from one another by solid, bold colors (see Plate 1). Increasingly, decorative designs subordinate the figurative forms. Thus, even within the Byzantine Empire, the coexistence of different regional styles, some more abstract, some more Classical, reflected the varied conditions of each area.

Hellenism continued to be the key regenerating force through the sixth and seventh centuries, and it is no more eloquently expressed than in the nine silver plates embossed with episodes of the life of David (Plates 28, 29, 30). Were it not for their control stamps, which date them to the reign of Emperor Heraclius (r. 610–641), their date would be uncertain. The astonishing technical precision of these solid silver plates, worked and chased totally from the front, extols the living tradition of Late Antique and Early Byzantine silver work for the court. They glorify and presumably continue rather than revive a tradition of academic classicism seen in earlier silver for the Byzantine court, here invested with ceremonial presentation and dramatic narrative. Conceived as a display set with the monumental plate of David and Goliath in the center, they are masterpieces of Old Testament narrative, with the explicit objective of revealing the emperor Heraclius as the New David. Imperial Byzantine art intentionally emulated styles of another age for political purposes and often merged religious and profane subjects for similar objectives. Probably commissioned to commemorate his victory over the Persian general Razatis in 627, the series of narrative plates utilizes a pictorial model, probably an illustrated manuscript of a royal psalter that was then adapted to the circular fields of the plates. Because of the rarity of early medieval biblical illumination, the plates are important documents for studying the interconnection of narrative cycles in different mediums, and their impact can be seen in Byzantine art several centuries later.

Although Heraclius was triumphant over the Persians, the Byzantine Empire was entering a time of instability. In 568 the Lombard invasion of Italy left only Ravenna and the southern region in Greek hands. More importantly, the rise of Islam permanently transformed the civilization of the eastern Mediterranean, North Africa, and even Spain. Another crisis of momentous significance to the art of the period was the violent dispute over the permissibility of images that erupted in 726 and led to the wholesale destruction of all representations by the "icon smashers," as they were called. During iconoclasm, which lasted until 843, images were officially banned. Thus, in its wake, early Byzantine images of Christ, the Virgin, and the saints were destroyed, and much of the lavish decoration of the

churches obliterated. A possible rare exception is the early enameled reliquary of the True Cross (Plate 31), made not in the capital, but on the fringes of the Byzantine Empire or possibly in Italy, where toleration of images might have continued. Although technically proficient and rare, it is stylistically impoverished and offers a dramatic contrast to the David Plates, which show that, from the artistic point of view, the eighth and ninth centuries were ones of stagnation. Simultaneously, the northern European communities, especially the Frankish kingdom, began to emerge artistically at this critical stage, during which a truly medieval art was to be formed.

Art of the Barbarian Tribes

The barbarian invasions of the Classical world permanently transformed it and marked the beginnings of the rise of the Western civilizations of Europe. So named because they spoke no Greek and were outside Hellenistic culture, the barbarians consisted of a number of Germanic and Eastern tribes who migrated, devastated, and eventually settled in western Europe. Their tribal organization and nomadic character—hunting rather than farming—meant they existed without a written history or literature. Although they engaged in a variety of crafts —woodworking, weaving, and potting—it is their metalwork that has survived. Their way of life required that they carry their wealth with them as objects of personal attire, ornamentation, weapons, and occasionally as household articles. This portable wealth, usually in the form of jewelry, also became a sign of rank and position within their military society. These symbols of power, used to decorate men and horses, also had a magical and apotropaic function and accordingly were placed with the owner in the tomb.

Living on the fringes of civilization, barbarians were not an integral part of the Classical world. When the Roman Empire extended its borders, it encountered numerous indigenous tribes, which it conquered or assimilated. The Celts were the principal indigenous adversary of Rome in Gaul and were the object of Julius Caesar's military campaign in 57 B.C., which he chronicled in *The Gallic Wars*. Torcs worn by the Celts were more than articles of adornment, they were also emblematic badges of chiefs and heroes and thus became prized trophies of battle. The gold torcs from the hoard of Frasnes-les-Busissenal, Hainaut, Belgium (Plate 4), dated to the first century B.C. by the coins found with them, rank as the most magnificent existing examples. Possibly buried at the time of the invasion of the Roman legions, the large torc is embossed with animal and linear scroll designs that are mutations of Eastern motifs deriving from Scythian and Sarmatian forms. Likewise, the slanting planes of the curvilinear patterns illustrate the technique of "chip carving," so called because the faceting of the design is akin to woodcarving, which was to become so popular in the fourth and fifth centuries. This method of Celtic goldsmithing on the torc essentially transforms the natural vocabulary and volumetric appearance of Classical forms into geometric abstraction.

Some four hundred years later, the zenith of this chip-carving technique is brilliantly illustrated in the lance mounts from the Vermand Treasure (Plate 12). Discovered in 1885 in a Gallo-Roman cemetery in northern France, the ornamented mounts are among the richest military garnitures of the period, datable by coins to the second half of the fourth century. Such resplendent arms were for a person of high rank, either a Roman or a barbarian in the Roman service. Almost totally barbarian in style, the decoration on the mount abstractly condenses designs in an intricate way, utilizing chip carving and

niello for rather flashy results. This geometric transformation of Classical designs probably took place under the influence of the curvilinear art of the Celts.

According to a Byzantine chronicler, "a totally unknown and strange people came to Constantinople in 565, who were called the Avars." Living between the lands of the Germanic tribes and the frontiers of the Byzantine Empire, the Avars, who originally came from central Asia, became legendary hoarders of gold and silver, acquired mostly through tribute paid by Byzantium. Their mastery of cast-metal technology is evident in the gold belt fittings from a celebrated hoard at Vrap in Albania (Plate 26). Such lavish belt mounts in bronze, silver, or gold functioned both as badges of rank within the Avar society and as emblems of a particular clan. The repertory of motifs utilizing griffins, stags, and chip-carved vine scrolls point strongly to the influence of Scythian traditions. Because part of the treasure included Byzantine silver and gold, such as the cup with city personifications (Plate 27), it may have ended up in the hands of the Avars as a result of the Byzantine campaigns against them around 600. The variety of gold objects in the Vrap hoard indicates that the workshop functioned as a royal treasury, transforming Byzantine tribute (coins, cups, vessels, etc.) into useful and portable wealth.

The fifth century was marked by increasing violence and the acceleration of local tribal migration, primarily initiated by pressure from the Huns in Mongolia, who displaced the Goths in the Danube basin. Under the ruthless leadership of Attila, they tormented much of western Europe from 444 until his death in 453, resulting in a massive shift of the nomadic tribes: The Visigoths moved into Italy and Spain, the Vandals into Spain and North Africa, the Langobards into northern Italy, the Franks into present-day France and adjacent areas, and the Anglo-Saxons into Britain. Two principal styles dominate the artistic forms of the migrating peoples: the polychrome style, associated with the Goths, Vandals, and Huns, and the animal style, with its abstract overall patterns, which originated in Scandinavia and northern Germany. The bow fibula (Plate 19) and the great square-headed brooch succinctly characterize these tendencies (Plate 21): The first relies on the sparkling chromatic contrasts of gold set with red garnets and gold filigree wire to produce a sumptuous effect, while on the second, animal and bird head motifs, which frame fields of chip-carved, abstract serpentine forms, ultimately create the basis of the Celtic-Christian art of the British Isles.

The Franks, who established the only lasting political power in Roman Gaul, ultimately founded the Carolingian Empire. During the reign of Clovis I (r. 481–511), the founder of the Frankish Merovingian dynasty, the Franks converted to Christianity. This produced an allegiance that became the prevailing military force in Europe, and one which made Clovis "champion of the kingdom of Christ," as the pope called him. The goldsmith work as seen in their jewelry reflects both the polychrome and animal styles of the Germanic tribes. The bird-shaped fibulae (Plate 20), executed in cloisonné with garnets and mica, are among the most frequent types, probably deriving from Hunnish forms that embodied a solar symbolism but that also had a Christian significance. These delightful motifs also materialize in Merovingian manuscript illumination, often ingeniously transformed into letters of the alphabet, such as in a scene in the Sacramentary of Gelasius of about 750. The geometric ordering of natural forms, combined with an exquisite sensibility of color and intricacy of patterning, was so purely aesthetic in purpose that it was limited as a form of Christian expression. The art of the Mediterranean world would, of ne-

cessity, be needed to put this northern genius into the service of the Christian church.

Carolingian and Ottonian Art

With the coronation of Charlemagne as "King of the Franks and Lombards" in 774, and as "Emperor of the Romans" in 800, more of Europe was politically unified than it had been since the end of the Roman Empire. Reforms of both ecclesiastical and political administrations laid the foundation for a cultural revival begun and personally promoted by Charlemagne. The royal court and the imperial monasteries were the main vehicles for this "renaissance" in which the visual arts were the greatest achievement. The essential qualities of barbaric art —abstract, nonnarrative, geometric—were inappropriate for symbolizing the revival of the western Roman Empire.

Since Classical culture and art had been almost totally eclipsed in the intervening centuries, Charlemagne initiated reforms in art, literature, and script by bringing scholars to court who could teach and promote the new religion. Its center was in Aachen (Aix-la-Chapelle), which was conceived of as the new Rome, and an ambitious plan of building was launched, supervised, according to one poet, by Charlemagne himself. A scriptorium was set up for the production of the written word: liturgical and divine service books; writings of the Church Fathers; works of history, grammar, poetry, and law. In each case, authoritative versions were sent throughout the empire as exemplars, many with lavish illuminations. A new minuscule script was developed, which became the basis of the modern Roman alphabet. Precious ivories were carved to decorate the most important gospel books. Bronze casting on a large scale provided resplendent doors, railings, and fittings for the new palace church, which was modeled on the great Justinianic church of Saint Vitale in Ravenna. In fact, marble columns and capitals were brought from Ravenna and Rome to be incorporated into the structure. Indeed, the popes described Charlemagne as "the new Constantine."

The catalyst for this renaissance required both an energetic emperor and the financial means to accomplish it. Through tribute payment, conquest, and the capture of loot, wealth accumulated. In 795, gold and silver plundered from the Avars filled fifteen wagons that were carried off to Aachen. Propelled by this wealth, the arts flourished.

Not only were the arts important as a means of enhancing the image of the court, but they could also be transformed into a powerful instrument of education. Classical art of the Mediterranean provided the impetus for the new court style, and it quickly permeated and transformed the artistic tradition of the Migration Period. For the pictorial arts, the presentation of the three-dimensional world became paramount, but a passion for texture, pattern, and linear effects sets the Carolingian artist apart from his Late Antique predecessors. One of the most splendid examples of this new orientation toward and adaptation of earlier models is the *Saint John the Evangelist* ivory (Plate 33). Because monumental sculpture was almost completely suppressed from the eighth to the tenth centuries, ivory carving became the principal means for sculptural expression. The great ivory reliefs intended to adorn the lavishly decorated gospel books and psalters often depended on known Late Antique models. Carolingian carvers tried to interpret what they saw with a fresh eye, and they did it so well that some Late Antique ivories have been mistaken for works of the ninth century.

Rooted in realism, the imagery, especially narrative pictorial cycles, could be used for teaching. By around 600 Pope Gregory the Great already saw pictures as important instruments in the conversion of barbarian Gaul: "Those who are ignorant of letters might gather knowledge of history from pictures, but the people might by no means sin through the adoration of a pictorial representation." Church interiors were adorned with scenes from the Old and New Testament as well as lives of saints to be exemplars for learning, conversion, and achieving a pious life. The great illuminated Bibles of Tours, of the mid-ninth century; the inspired illusionism of the Utrecht Psalter, of around 830; and the manuscripts produced for Charlemagne's successors, Louis the Pious (r. 814–840) and Charles the Bald (r. 840–877) are the prime remaining examples of painting, since virtually all the monumental painted cycles are lost. Glimpses of this narrative competence are seen in ivory carvings of the second half of the ninth century (see Plates 34, 36), which display many cross-references to the paintings. For the first time, book illumination, ivory carving, and metalworking were being practiced together in the same workshop. Throughout the Carolingian period, there existed a certain resistance to the dominant Classical tendency, which often surfaced on the same object. For example, we see this in the *Way to Emmaus* ivory (Plate 36), which is enclosed in two borders, one a Classical acanthus border, the other a zone filled with abstract ornament and birds, thus combining Classical and anti-classical tendencies in a fresh and independent way.

The disintegration of the Carolingian Empire rapidly followed the death of Charles the Bald. For nearly a century, the Vikings had been making isolated raids on the coast of England and northern Europe. After 877, they became more prevalent, and the political structure of Carolingian rule was broken into five independent and warring kingdoms. This situation, combined with Arab depredation in the south and the terror of the Magyars in the east, all but eliminated any artistic achievement. Yet the rise of the Saxon dynasty under Otto the Great (r. 936–973) and his victory over the Magyars in 955 inaugurated a christianization of central Europe under an imperial monarchy that clearly was modeled on the emperorship of his Carolingian predecessors: Like Charlemagne, Otto was crowned in Rome, and he established a new Rome in Magdeburg, where a new church, also using Roman columns and capitals, was built in order to bring the East into the Western cultural and ecclesiastical orbit. In fact, the emperor himself is depicted on one ivory offering a model of his new imperial church at Magdeburg to Christ for blessing (Plate 37). Major ecclesiastical centers such as Cologne, Hildesheim, and Reichenau became the principal promoters of the arts.

The most important contribution of Ottonian art to new imagery was the introduction of pictorial narrative cycles of the life of Christ, which carried a basic missionary message of salvation. Comprehensive cycles of the New Testament, based partly on Early Christian models and also on contemporary Middle Byzantine manuscripts, were incorporated into gospel book illustrations, wall paintings, and even ivory situlae, or water buckets (see Plate 39). The impact of Byzantine art on the West through traveling artists and importation of Eastern ivories, luxury objects, and textiles is best explained by the marriage of Otto II (r. 972–983) to a Byzantine princess, Theophano, who certainly provided the catalyst for the merging of Eastern and Western traditions. One feature of Ottonian art, however, is specifically Western: the emergence of large-scale sculpture. Often functioning as monumental reliquary containers, crucifixes and cult images proliferated. The rigorous abstraction and expressive realism of the celebrated crucifix given by Archbishop Gero (r. 969–976) to the Cologne cathedral began a tradition that still can be detected one hundred fifty years later

in the altar corpus, probably from the vicinity of Salzburg (Plate 58). The international influence of Ottonian art, radiating to Spain, Italy, France, and England marked one of the most productive periods in Germany.

Anglo-Saxon England of the tenth and eleventh centuries was charged by a cultural and religious revival that displayed remarkable inventiveness and technical virtuosity in the visual arts. The firm, monumental quality of Germanic art contrasts with the exuberance and dramatic expressionism of miniatures and ivories produced in such centers as Winchester. The *Christ in Majesty* ivory (Plate 46) reveals a nervous linear energy that conceals the underlying mass. Essentially, its stylistic character is adopted from manuscript illumination, which is especially evident in the acanthus leaf and animal ornament on the back.

Byzantium (843–1204): A Second Golden Age

Iconoclasm contributed not only to a permanent separation of the Eastern and Western churches, but also to a shift in artistic leadership to the Carolingian world. Yet the reinstitution of icon worship in 843 under the long-lasting Macedonian dynasty inaugurated a major campaign to redecorate the churches and palaces of Constantinople, producing an astonishing revival of manuscript illumination, enameling, and ivory carving.In 867 the patriarch Photios had new mosaics placed throughout Hagia Sophia, including the celebrated new monumental icon of the Mother of God (still visible in the apse). The most venerated and influential icon in Constantinople was the standing Virgin and Child called the Hodegetria. This legendary image, thought to be painted by Saint Luke himself, was brought to the capital from Jerusalem in the fifth century, and although lost in the sack of Constantinople in 1453, a number of copies in ivory survive. The slender ivory Virgin (Plate 40) from the second half of the tenth century, which was cut from a larger icon panel, strikes a balance between Classical form and a more dematerialized concept in which the child seems to be suspended before the mother. This new hieratic style, which suppresses emotion, aims at a greater solemnity and devotional character, and the sharp, angular lines of the garments begin to resist the laws of nature: The concept of the figure becomes more important than its reality.

In Middle Byzantine art, there is always an internal affinity with Classical works. This intrusion of the Classical mode into the Christian during this period finds a high point in the Joshua Roll (in the Vatican Library) and some ivory plaques copied from it. As a unique surviving example of a late Classical type of picture book, the Joshua Roll is essentially a horizontal triumphal frieze of military activity. The continuous strip narrative of the Old Testament Book of Joshua is not so much a reversion to the ancient form, as it is a direct copy of a much older work. Shifting from violent battle scenes to ceremonial groupings, the roll seems to be a courtly product celebrating a narrative of war and triumph in religious guise. Ivory caskets with selected episodes from the Book of Joshua (Plate 43) indicate that they and the roll were intended for the secular sphere. Framed with rosettes and masked medallions, the scenes correspond closely but not exactly to the Joshua Roll. The style is a hybridization of plastic and illusionistic elements. Such complete caskets were destined for a rich and luxury-loving clientele.

Most Byzantine ivories, however, depicted religious subjects, and the most popular form was the triptych, which was used as a portable icon for private devotion. Some of these ivories so closely parallel manuscript illumination in their composition and style that they are called "painterly." The central plaque of a triptych depicting a crucifixion (Plate 41) with the exceptional feature of the cross stabbing Hades, the ruler of the underworld, transforms a narrative picture into a devotional icon. By isolating each component of the representation with a pierced baldachin setting, the Renaissance character of the ivory emerges: A Classical river god becomes Hades, and the *contrapposto* of John demonstrates the infiltration of ancient types. But they are infused with a ceremonial and emblematic quality that is peculiar to the art of tenth- and eleventh-century Constantinople.

Dignity and solemnity permeate not only the art of ivory carving, but are also manifest qualities of Byzantine manuscript and wall paintings, mosaics, and goldsmith work. The gold cloisonné enamel medallions of saints from an icon of the archangel Gabriel (Plate 42) conform to these tendencies. Probably made in Georgia for the monastery of Djumati, around 1100, they reflect the prevailing taste for lavish and elaborate surface effects and brilliant color. The refined aesthetic sensibility and superb craftsmanship of Byzantine enameling were widely recognized. In the West, such enamels were highly prized. When Abbot Desiderius of Monte Cassino refurbished his church in the mid-eleventh century, he commissioned from Byzantium an enameled and gemmed altar frontal. The single most spectacular Byzantine enamelwork to survive is the Pala d'Oro in the Basilica of San Marco in Venice, which was also ordered from Constantinople. This, plus the dazzling spoils of Constantinople, which were plundered by the Venetians during the sack of 1204, and the mosaics of San Marco, which essentially copy Eastern models, transformed Venice into the most important repository of Byzantine art in the West. Through Venice, Sicily, and other centers, Byzantine art had a profound effect on the art of the Latin West. European medieval artists were repeatedly seeking inspiration from the living tradition of Classical art, and Byzantium provided the catalyst, shaping and propagating ideas and images.

Romanesque Europe

The beginning and end of the Romanesque period as a whole or within any particular country are not strictly linked to historical events or rulers. Although it was originally coined as an architectural term in the nineteenth century to designate heavy and massive buildings with rounded arches that echoed Roman forms, "Romanesque" has now become an artistic concept with many different dimensions. Many of its salient characteristics are already present in Ottonian art—monumentality of form with geometrically reduced surfaces—and its identification with architecture is due to the great explosion of building activity throughout Europe in the late eleventh and twelfth centuries. Concurrently, the decoration of these churches generated new categories of sculpture: portal entrances with increasingly prominent themes depicted on door jambs, trumeaus, tympana, archivolts, and capitals carved with narrative subjects within the churches and the cloisters.

Clearly, the Church became the principal patron of the arts, and it was the unifying factor in the creation of the international character of the Romanesque period. The elaboration of the decorative forms certainly pleased the contemporary eye and was reported enthusiastically by chroniclers. For example, Abbot Wiricus of Saint Trond, near Liège, Belgium, reportedly said of his church:

> So much did the industrious architect devote to the decoration of the monastery that everyone in our land agrees that it surpasses the most magnificent palaces by its varied workmanship. By the beauty of the work he gave immortality to the author of the enterprise.

Ironically, the name of the architect is excluded. However, this is symptomatic of the role of the medieval artist: His talents, being a special gift of God, should be addressed to—and enhance—the glory of the Church, without expectation of material rewards. For this reason, medieval art is largely anonymous, although many craftsmen, both lay and monastic, are known, and they were surprisingly versatile. The most gifted innovator of English Romanesque art in the second quarter of the twelfth century was Master Hugo, who worked at the abbey of Bury Saint Edmunds and was responsible for the bronze doors of the church, a bell, and a magnificent illuminated Bible (now in Cambridge). According to a contemporary account, the Bible was "incomparably painted by the hand of Master Hugo, who since he did not find calf hide in our region suitable to him, bought parchment from Scotland." Finally, it is known he also "incomparably carved a cross in the choir with Mary and John." The masterful ivory cross (Plate 48) has been associated with the art of Hugo or his direct influence. No single work of the Romanesque period better telescopes and reflects medieval theology in visual form.

The fact that anonymity usually prevailed in the Middle Ages does not mean that pride of achievement was totally suppressed. A number of Romanesque works are signed and documented, especially in Italy. The cathedral of Modena, begun in 1099, was designed by the architect Lanfranco. But it is the principal sculptor Wiligelmo whose self-esteem is proudly inscribed on a relief panel on the facade: "Among sculptors, your work shines forth, Wiligelmo. How greatly you are worthy of honors." His reliefs on the facade depicting the Creation story, depending in part for their format and style on imitation of the Late Antique, certainly confirm this praise and demonstrate that pious anonymity was often circumvented. In France one of the most celebrated masters of Romanesque sculpture was Giselbertus, who might have trained at the great Benedictine abbey of Cluny in Burgundy. Around 1125, he began the decoration of the church of Saint Lazarus at Autun, where he carved capitals throughout the church, the gigantic tympanum of the west door, and the other principal entrance, the north transept door. The latter no longer exists, except for fragments such as the celebrated Eve from the lintel, and a censing angel from the archivolts (Plate 50). His proud inscription at the feet of the Christ of the Last Judgment on the west door tympanum, which says *Giselbertus me fecit*, was more than an expression of proud authorship. It was a wish for recognition by posterity. Thus, by the Romanesque period, the craftsman had begun to regard himself as an artist.

The resurgence of monumental sculpture and architecture in the late eleventh and twelfth centuries was linked to rapid economic expansion and the growth of the population. Monasteries, cathedrals, and smaller churches proliferated throughout Europe. Perhaps the most enduring expression of the international character of the Romanesque was the pilgrimage church. Motivated by piety or penance, pilgrimages had been made since Early Christian times to the Holy Land and to Rome. By the eleventh century, Santiago de Compostela had become especially significant, with the tomb of Saint James, the "Moor-Slayer," as the principal attraction. Four routes, one starting in Paris, another in Vézelay, a third from Le Puy, and a fourth from Arles, joined across the Pyrenees at Roncesvalles and proceeded through Burgos and Léon to Santiago. Churches along these roads evolved a cruciform ground plan with radiating apsidal chapels that allowed the throngs of the faithful to circulate around the building and past the shrines and reliquaries displayed on the altars. Making the choir more accessible to the laity was a new departure. Saint Martin at Tours, built between 1003 and 1014, and Saint Martial at Limoges, built after 1063, initiated the designs that would distinguish a magnificent series of pilgrimage road churches: the great church of Abbot Hugh at Cluny, begun 1088, at Saint Sernin, Toulouse, and the cathedral of Santiago begun in 1078. A *Pilgrim's Guide*, the precursor of today's Michelin guides, written about 1030, describes these routes. It lists prominent sites, notes sacred relics, gives information about where pilgrims could lodge, and characterizes the people in each locale. The exchange of ideas and travel were of central importance for Romanesque architecture and sculpture. The most conspicuous innovations of this period were doorways decorated with sculptural programs of great richness (see Plate 62), and the historiated capital. On the portals, on the aisles of the church, and in the cloisters, carved capitals with scenes from the Scriptures take on the function of wall paintings in earlier churches. The same may be said for the decorated portals, which presented theophanic images that were previously the focus of apsidal paintings (see Plates 54, 55). The powerful and dramatic vision of the Last Judgment at Sainte-Foy, in Conques, and at Saint Lazarus, in Autun, became practical images for the faithful pilgrims: Through the interceding action of the local saint, before these threatening subjects of eternal judgment, salvation could be gained.

If pilgrimages were one of the most visible manifestations of the era, it was in part due to the rapid expansion of monasticism and the creation of several new orders. The rule of an order dictated its way of life and worship. The ordered life of the monastery is harmoniously revealed in its art and architecture because the ideal monastery was supposed to emulate the Kingdom of Heaven. Central to the physical framework of the *vita communis*, or community life, are the cloister and the chapter house (see Plates 53, 60). The decoration of these areas was often one of exceptional richness, especially those of the Cluniac order, such as the cloister at Moissac. It contains images of the apostles on the piers, and the patron Abbot Durand de Bretons (1048–1072) and an entire encyclopedia of scenes from the Old and New Testaments on the capitals. The monks lived in a space permeated with art, and therefore it is not surprising that the lavishness and excessiveness of the Cluniac houses shocked the austere cistercian Saint Bernard of Clairveaux, whose incisive *Apologia ad Guillelmun* denounced such affluence while extolling this art for its fundamental religious significance:

> In the cloister under the eyes of the brethren who read there, what profit is there in those ridiculous monsters, in that marvelous and deformed beauty, in that beautiful deformity . . . in short, so many and so marvelous are the varieties of shapes on every hand, that we are more tempted to read in the marble than in our own books, and to spend the whole day wondering at these things rather than in meditating the law of God.

The imaginative capitals of the Cuxa Cloister (Plate 60) bring this passage to life and summarize an essential feature of the Romanesque: a tension between the meaningful and the ornamental beauty of style, between the world of illusion and abstraction, and between factual reality and rationalized religious fervor.

The decoration furnishing the Romanesque church extended also to the precious objects for the celebration of the liturgy. Resplendent altars, ambos, books for the Mass, reliquaries, and chalices all aimed at a comprehensive sensual experience in order to achieve total spiritual concentration. These "ornaments" of the church required superb craftsmanship and are often of great beauty. During the eleventh and twelfth centuries,

several geographical centers of metalworking existed: Limoges, the Meuse valley, the Lower Rhineland, and Saxony. Fortunately, there survives a treatise, *De Diversis artibus* (On the Various Arts), by Theophilus, a monk and a priest, who wrote in the early twelfth century about the techniques for painting, glasswork, goldsmith work, and bronze casting. Giving special emphasis to metalworking, his text provides a wealth of information about the workshop, tools, metals and their properties, casting procedures, repoussé, gilding, enameling, and niello.

One of the most distinctive centers to use these techniques was the Meuse valley, with Liège as the main center. Three extraordinary artists dominated Mosan art during the twelfth century: Reiner Huy (known for his masterful baptismal font at Liège), Godefroid de Claire, and Nicholas of Verdun. Godefroid perfected the technique of champlevé enamel. Such exquisite enamels as the reliquary triptych of the True Cross (Plate 67) and the Pentecost plaque (Plate 66) are eloquent expressions of soft classicizing forms combined with inventive iconographic programs that reflect the essence of Mosan art.

Romanesque art, whether it is the monumental sculpture of the churches, manuscript illumination, or the sumptuary arts, is a synthesis of the preceding epochs, striving for orderly systematization of ideas and images. Simultaneously, the Romanesque style evolved common recognizable features that justly made it international. The Church, pilgrimages, and the Crusades all equally contributed to its international character. Although in some areas the Romanesque survived into the thirteenth century, its increasing exposure to classicizing forms (mainly as a result of Byzantine influences) led to its eclipse and to the rise of the Gothic.

Gothic Art to 1270

Between 1140 and 1270 a new style emerged in France that dominated the artistic landscape of northern Europe for nearly four hundred years. It is not coincidental that the concept of the Gothic is closely identified with the age of the cathedrals, for during this period rose the cathedrals of Chartres, Paris, Amiens, Bourges, and Reims. The principal catalyst for the miraculous rise of these structures was the rebirth of the cities where new political, commercial, and ecclesiastical wealth was concentrated. Paris, which was previously of little cultural and artistic significance, emerged as the center of power, prestige, and artistic creativity. Of pivotal significance to the genesis of Gothic art was the rebuilding of the Royal Abbey of Saint-Denis under the patronage and inspiration of one of the most important figures in medieval French history, Abbot Suger, who ruled the abbey from 1122 to 1151. Though he was not of noble birth, his friendship with King Louis VII (r. 1137-1180) gave him political authority, and he ruled as regent of France during the king's participation in the Second Crusade in 1146.

Abbot Suger embellished his abbey church with a monumental facade with twin towers, triple portals, and the first rose window that was an integral part of the design. Ceremoniously dedicated in 1140, this triumphal entrance, with innovative column statues of Old and New Testament kings and queens flanking each of the portals, emphasizes the royal aspect of the church. These column figures became a hallmark of Early Gothic portals, and the figure from the Saint-Denis cloister (Plate 64) is a superb example of this first generation of the Gothic style. Just four years later, the new choir was also consecrated, presenting a new spaciousness and linearity of form that became the standard for future construction. Suger eloquently described his achievements and the reason for creating such a splendid setting for the liturgy. His aim—based in part on the writings of Pseudo-Dionysus the Areopagite—was to express visually the idea that God is manifest in light. Both the architectural space and the manipulation of the dazzling radiance of the stained-glass windows illuminated the new church physically and spiritually. To Suger, the luminosity of the church was paramount: "And bright is the noble edifice that is pervaded by the new light." In glorifying his church, he simultaneously memorialized the Carolingian dynasty and established Saint Denis as the principal saint of France.

The immediate influence of the Royal Abbey of Saint-Denis, particularly its humanizing program of sculptural decoration on the facade and its stained glass, can be seen at Chartres. In the first generation of Gothic cathedrals, sculpture takes on the new role of portraying central elements of Christian cycles of images across the facade. Old Testament kings and queens in the door jambs physically and iconographically support the themes depicted in the tympana and archivolts, of Christ, the Virgin, and the Second Coming. Parisian sculptors at Notre Dame produced other variants of Chartrain subjects. The Saint Anne portal—the earliest of the three portals on the facade—copies some elements of Chartres and combines apocalyptic themes and elements from the life of Saint Anne and other scenes. The head of King David (Plate 63), from the statue columns, reveals the transitional character of Early Gothic sculpture. It combines the linear and decorative qualities of the Romanesque with a sense of the worldly presence and organic sensibility of the new age. Extended sculptural programs were a new vehicle of monumental decoration and didactic purpose, and stained glass, too, became a means for illuminating the Heavenly Jerusalem on earth. The graphic precision and jewel-like brilliance of the window from Troyes (Plate 65) offer a glimpse of one of the most masterful paintings of the later twelfth century. Exact in conception, it glows like a monumental miniature painting. In fact, the correspondence to manuscript illumination is so close that the glass may well have been executed by a glazier trained as an illuminator or possibly an enamel worker. The Troyes window also exemplifies a classicizing tendency that pervades all the arts from the second half of the twelfth century until well into the thirteenth, as is handsomely seen in the Reliquary Triptych of the True Cross (Plate 67) and the precious gilt-bronze clasp with an allegorical scene (Plate 76).

The emulation of antique forms in the figurative arts is one of the most intriguing aspects of the Gothic period. Antiquity inspired the arts in different ways. Henry of Blois, bishop of Winchester, actually bought antique statues while in Rome and had them shipped home. Another late twelfth-century English traveler in Rome, "Magister Gregorius," glowingly admired a statue of Venus that to him seemed "rather a living creature than a statue . . . because of its striking beauty and sort of magic attraction." Such fascination for the antique occasionally became the basis for imitation in the figurative arts: The famous Visitation Group on the facade of Reims cathedral (ca. 1230) is most remarkable in its propensity for abundant clinging drapery, clearly evoking statuary of Roman women. Such antique models must have been available in Reims itself, a city rich in Gallo-Roman ruins. Artistically, the purpose of this imitation was to achieve more coherent means of representation, utilizing the forms instead of the content of antique images. The crisp foliate Corinthian capitals with imitations of antique masks on the abaci from the cloister of Saint-Guilhem-le-Désert (Plate 73) reveal a transformation of antique prototypes, but they are more linear and therefore more essentially medieval. Again, the availability of Roman monuments in Provence had

a direct effect not only on the sculpture of Saint-Guilhem-le-Désert, but also on the facade decoration of Saint-Gilles-du-Gard and Saint-Trophime at Arles.

The greatest master of this "Classical revival" was the goldsmith Nicholas of Verdun, whose enameled ambo from Klosterneuburg (1181) and monumental shrine for the Three Kings in Cologne, made at the end of the twelfth century, display a remarkable style that had an astonishing impact. His art decisively breaks with the past, portraying humanity with a vitality and plasticity that are totally new. The precise sources of his style are enigmatic, but clearly Byzantium and perhaps Late Antique works provided the strongest impulses. His pioneering works reveal a new capacity to dominate the human figure with majestic presence. The clinging, calligraphic drapery and interest in movement give life to form in his figures. Both physically and psychologically, Nicholas of Verdun's art paved the way for interpreting figures in terms of organic movement as in the Reims Visitation Group. The head of a King (Plate 78) of around 1230, likewise captures this new understanding of presenting nature infused with a Classical temperament. Most importantly, the Classical element in Gothic art had a profoundly humanizing effect on the imagery.

The reign of King Louis IX (r. 1226–1270), who was canonized in 1279, epitomizes High Gothic art in France. By then, *opus francigenium*, as its architecture was called by the German chronicler Burckhart of Halle, embraced the whole of western Europe. The most astonishing structure of the age is Saint Louis's exquisite Sainte-Chapelle, dedicated in 1248 and built to house the relics of Christ's Passion, purchased from Emperor Baldwin II of Byzantium in 1239. Conceived as a monumental reliquary, the church is a cage of translucent screens of stained glass and tracery that give it a jewellike quality. The twelve apostles, each standing before a pier, combined with an elaborate iconographic program of stained glass that glorifies the relics, symbolically acknowledges the presence of Christ.

Sainte-Chapelle and the major cathedrals used sculptural decoration and stained-glass windows as vehicles for more elaborate encyclopedic programs. Illustrating the history of mankind from the Incarnation to the Apocalypse became widespread. On smaller churches, subjects on portals were telescoped and focused on a single theme, as on the Burgundian doorway from Moutiers-St.-John (Plate 81). The apocryphal theme of the heavenly Coronation of the Virgin that dominates the tympanum is essentially an invention of the Gothic era, and one of the leading programmatic ideas also seen in such miniature forms as an ivory diptych (Plate 83). It is the glorification and veneration of the Virgin that dominated so much of the visual imagery of the thirteenth century. Promotion of the cult of the Virgin by Bernard of Clairvaux, and especially by the Dominicans, led to an extraordinary proliferation of representations of the Virgin and Child. The hieratic image of the Virgin as the Throne of Wisdom in the twelfth century (Plate 52) was quickly transformed into majestic yet more human portrayals as both Mother and Queen of Heaven. Formally and symbolically, she adopts many new aspects: Regal in stance, producing an eloquent *contrapposto*, the Virgin now radiates with a smile and enlivened rapport with the Christ child (Plate 88). This new humanization and animation was a result not only of the pious literature celebrating the Virgin, but also of the possible adaptation of Byzantine subjects where she is depicted as the Mother of God (Nikopoia). The Virgin from the choir screen at Strasbourg cathedral, erected before 1261 (Plate 89) epitomizes the lofty majesty of the Queen of Heaven and is a key monument of the courtly style of sculpture. Her drapery, no longer the clinging damp-fold style of the early thirteenth century, now cascades in sharply breaking heavy folds, and her face is that of an idealized Gothic princess. Created under the influence of the court in Paris and the style of the apostles of Sainte-Chapelle, the Strasbourg Virgin shows acceptance of the trends set in the capital and their diffusion throughout Europe.

Charles T. Little

PART TWO

THE LATE GOTHIC

With the death of Saint Louis in 1270, the last preponderantly feudal kingship ended. The increased consolidation of secular monarchies in the hands of strong and longevous rulers led to centralized authority that spawned growing ranks of ministers and professional bureaucrats while directly threatening the hereditary interests of the nobility. Demographic shifts from country to town gave rise to an urban middle class that became the natural ally of monarchs. Kings were obliged, in return, to yield a measure of power. Furthermore, the Church's age-old claim that all matters, temporal as well as spiritual, were ultimately subject to papal authority, was successfully challenged by Louis's grandson, Philippe IV. Feudalism as a viable system was ending; society was drifting toward secularism.

Gothic cathedrals—soaring, visionary structures that combined all arts in a harmonic unity—dominated the High Middle Ages. The construction of these testaments to the supremacy of God's rule on earth required the marshaling of resources on a national level. In a society that was no longer predominantly feudal or ecclesiastical, construction on this scale ceased to be feasible. Although the construction of the cathedral at Reims continued until 1299, the age of great cathedrals had come to an end.

Architecture remained, nonetheless, the primary form of artistic expression throughout the thirteenth century, and its aesthetic tenets influenced all other arts for most of the fourteenth. The "Rayonnant" style, named for the radiating spokes of its great rose windows, achieved its most refined and coherent statement in structures linked with Saint Louis and the Court Style, such as Sainte-Chapelle. The scale and monumentality of the High Gothic were diminished. The triforium was eliminated, allowing the windows to reach the vaults; structural ele-

ments such as flying buttresses were reduced, and walls were penetrated with vast fenestrations. Refinement of detail superceded monumentality, giving these diaphonous structures the appearance of delicate cages of glass. In part because it was embraced by the Cistercian order, the Rayonnant style, in varying regional forms and permutations, spread throughout Europe by the end of the century.

Monumental stone sculpture, long conditioned by the rational linearity of classic Gothic design, began to disengage itself from its traditional architectural framework, rendering it a more independent and three-dimensional art form. The classicizing tendencies of High Gothic sculpture gave way to a more intimate, if stylized, aesthetic; the regal monumentality of the mid-century yielded to greater warmth and humanity. The Virgin, for example, no longer portrayed as the Queen of Heaven, was now depicted as a mortal in courtly dress. Delicately mannered poses and smiling masklike faces (see Plate 87), first introduced in the famed Reims angel (ca. 1260–70) persisted for several more decades.

Stained glass, still the dominant painterly art, was necessarily constrained by its architectural framework; yet, new concepts in design were introduced to serve changing architectural forms. Windows of large-scale figures and narrative medallions executed in saturated, radiant hues were replaced with transparent clear glass or *grisaille* windows painted with trace lines of delicate strapwork or foliate interlace ornament (see Plate 106); in band windows, spans of *grisaille* were broken by colored, figural panels placed in the central zones. These clear windows admitted greater amounts of light to illuminate the miraculously attentuated, weightless structures. Manuscript painting, while not physically constrained by architecture, paid tribute to it on the formal level. Scenes were set in oval or quatrefoil medallions borrowed from Rayonnant stained-glass windows, or placed in architectural frameworks set against tessellated or floral-strewn backgrounds. Like stained glass, manuscript illumination was still perceived as a narrative and two-dimensional art.

By the turn of the fourteenth century, Europe was more than ever before in ferment. Permanent climatic change—colder and wetter—drastically altered living conditions and changed patterns of cultivation. Successive crop failures led to the Great Famine of 1315–17, in which as much as ten percent of the population starved. Hard conditions led to recurrent unrest and occasional open conflict, such as the Flemish peasant rebellion in 1322. Depopulation and demographic shifts brought about a redistribution of wealth resulting in new centers of intellectual and artistic activity. Trade increased enormously: Bypassing the turmoil in French territories, the Venetians, in 1317, sent a fleet to England and the Netherlands, establishing a trading link that would yield great economic and cultural fruits for more than a century. The Hanseatic League codified its trade regulations, and by 1360 there were some fifty-two member cities in northern Europe. Urban patriciates in Bruges and other new commercial centers flourished. Standard coinage became the common means of financial transaction, and the foundations of modern banking were laid. Skilled laborers became a distinct economic class as industries expanded. The middle class, whose views tended to be more liberal and democratic, brought a new climate to patronage; yet, there was an eager emulation of the luxurious tastes of the upper classes. The continuing political decline of the Church encouraged secularism. The foundations of an outmoded social, political, and economic order had crumbled; the necessity to build anew brought an apparent sense of rejuvenation and modernity to the early fourteenth century.

For in this tumultuous environment, artistic and intellectual achievement advanced with astonishing inventiveness and expressiveness. Around 1300, the second part of Jean de Meung's *Roman de la Rose* was completed; Froissart chronicled the royal house of France, keeping alive the fictions of chivalry. Popular texts, such as the *Golden Legend* of Jacobus de Voragine, were translated into numerous vernaculars. In England, Chaucer wrote the *Canterbury Tales*; Ockham opened up new philosophical vistas. Wycliffe and the Lollards broached questions of Church reform. Dunstable and other proponents of the *ars nova* movement, which eschewed didacticism in favor of a worldly delight in profuse ornamentation, brought musical composition to new heights. Dante began his sublime *Divina Commedia* in about 1307 and started a trend in the use of the vernacular. Boccaccio's *Decameron* was published in 1353. Petrarch's enthusiasm for the classics was beginning to have its effect in Rome, Florence, and Avignon.

Architecture was characterized by regionalism. Around 1300, the Perpendicular style, emphasizing verticality through strongly rectilinear tracery patterns, was something of an English court style. Characteristic emphasis on the particular is seen in the continual development of decorative elements. Fan vaults—lacy, concentric webs, which disguise the underlying structural supports—first appear in the choir of Gloucester cathedral (1351–77). In Germany, the *Sondergotik* found its most typical form in the *Hallenkirche*. Interiors gained expansive, fluid unity through the equal height of the nave and aisles and through the unbroken runs of piers and bundle columns fanning out at the ceiling into veritable canopies. An international flavor characterized the work of the famed Parler family of sculptors and architects, whose French taste is evident in the cathedral of Saint Vitus at Prague, built by Peter Parler between 1353 and 1374. The influence of the Parlers can be seen in numerous building programs throughout Germany, such as the choir of Saint Sebald at Nuremberg (1361–72). The Italian Early Gothic facade, assembled in a screenlike fashion from relatively simple elements, such as that at Orvieto (begun ca. 1310), was more rational and ordered. French influence was more pronounced at the end of the century; surfaces became elaborate networks of ornament that disguised the relatively simple skeletal structures. This is particularly true in the case of the cathedral at Milan, which, in spite of its grandeur, is a somewhat mechanical blending of northern and southern aesthetics.

Pictorial art in the north—manuscript illumination, that is—struggled against its fundamental respect for architectural form and the essentially additive nature of narrative tradition in which each figure and form is a separate element in the fabric of the whole. Jean Pucelle, working in Paris but familiar with Italian painting, abandoned two-dimensional architectural frameworks in favor of architectural stages that suggest depth and volume (see Plate 105). Figures began to interrelate with heightened animation. Vignettes of the real and imaginary inhabit the margins, commingling sacred and profane imagery, while giving greater continuity to page composition. Perhaps influenced by stained glass, *grisaille* was used for the first time, establishing a tradition that continued through the Middle Ages. In the burgeoning artistic centers in the north of France, Flanders, and Hainaut, manuscript illuminators, such as André Beauneveu, experimented with form, color, and space, creating a statuesque calm and clear, cool-toned linearity. Jean de Bandol was among the first to employ the historical illustration, depicting a contemporary event. In the Boucicaut Hours, numerous figures, interacting in dramatic action, are placed in open landscapes with distance and space suggested by the

multiplanar compositions. In spite of these tentative experiments, revolutionary advances in painting, at least in the north, would have to wait for the turn of the fifteenth century.

The pictorial arts in Italy—mural and panel painting—developed at a quicker pace. The Sienese painter Duccio broke with a long tradition of Byzantine influence, transforming stiff angularity into a softer, more delicate and volumetric style. With Giotto's frescoes at the Arena Chapel (1305–06), Padua, the picture plane was conceived as a unified whole. The weighty figures inhabit an expanded space defined by planar relationships and unified by light and color, while the suggested depth binds the figures and landscape. The result is a revolutionary, if not entirely coherent, concept of the picture plane. Although Simone Martini had less interest in spatial clarity, often retaining archaic gold grounds, he created, through observation of form and incident, unprecedented dramatic intensity and delicately lyrical expression. Ambrogio Lorenzetti's frescoes of Good and Bad Government in the Palazzo Pubblico (1338–40), Siena, combine planar depth with sculptural volumes to create landscape and architectural portraits in commanding, panoramic space. Through traveling artists, Italian influence spread to the north: In Paris, at the palace of the exiled popes in Avignon, at the courts of the duke of Burgundy in Dijon, the duke of Berry in Bourges, and the Holy Roman Emperor in Prague, painters continued to experiment with spatial continuum, depth, and the corporeal volume of figures.

By the early 1300s, monumental sculpture in France had been freed from its traditional architectonic framework; jamb figures became essentially free-standing rather than supportive, while tympanum, voussoir, and dado figures were carved in such high relief that they appear to float off their supportive surfaces. The figure style was characterized by a gentler *contrapposto*, by reduced volumetric forms, and by more elegant, attenuated lines. A deflated quality, reducing corporeal form to elegant abstractions and thus denying the reality of underlying anatomy —something of a reaction against High Gothic realism—persisted until the end of the fourteenth century. Freestanding and relief sculpture was adopted, in small scale, by artists in other mediums. Paris became a center of ivory carving, producing both secular and religious objects, from small, multi-scened devotional diptychs to caskets with scenes of romances. The silver gilt Madonna and Child reliquary, presented to the abbey of Saint-Denis by Jeanne d'Evreux in 1339, is a masterpiece of the goldsmith's art. In Germany, the spread of the French style is evident in such monuments as the portal of the Lorenzkircke, Nuremberg (1330–40) and the tympanum at Schwäbisch Gmünd (1340). At the same time in Germany, a rather exaggerated style emerged, associated with devotional imagery in which emotional content superceded physical reality (see Plate 111).

The fast pace of artistic achievement during the first half of the fourteenth century was halted by the onslaught of the Black Death in 1348. The devastating effects of this plague, which reduced the European population by a third, cannot be overstated. Combined with the outbreak of the Hundred Years War in 1337, after a period of relative stability, the mid-century saw a complete turn of circumstance, which typified the contrasts of the age. An inquiring fascination with the natural world was suddenly countered by an obsession with death; objects with *vanitas* and *memento mori* themes, as well as images and texts pertaining to death, the dying, and the dead, proliferated. Complacency was supplanted by uncertainty. In the face of political strife and warfare, outmoded, chivalric fictions enjoyed renewed popularity; scenes of romances and courtly love abound in manuscript illuminations, ivory carvings, and tapestries. Recur-

rent economic recession brought on extremes of poverty and wealth: While famine caused widespread starvation, the dukes of Burgundy established a court of exaggerated pomp and extravagance. Lavish objects of every description were produced in unprecedented quantities to satisfy the luxurious tastes of both the nobility and the wealthy middle class. The philosophical tenor of the age was, likewise, dominated by contrasting doctrines. On one hand, mysticism rooted in the teachings of Saint Thomas Aquinas and his Neoplatonist followers expounded the divine nature of the soul and effectively substituted religious authority with religious experience. On the other hand, William of Okham expounded the *via moderna*, a doctrine that, reinforcing secularization, insisted on the separation of the sacred and the profane. The world could thus be studied from a purely experiential vantage point, encouraging scientific inquiry and investigation.

These polarities profoundly influenced artistic expression in the latter half of the fourteenth century. Mysticism gave particular emphasis to devotional imagery: the pietà (see Plate 111), the Man of Sorrows, private shrines and altars, and *Andachtsbilder* or personal devotional images. Christ's wounds, the Virgin's sorrows, and the saints' sufferings were represented with exaggerated realism to inspire contemplative piety. Nominalism, which encouraged the examination of the world outside of any preconceived framework, led to a replacement of abstract or conceptualized images by others that more accurately reflected the real, observable world. This empirical tenor radically changed pictorial expression, bringing new life to portrait, landscape, and genre painting. In sculpture, there was a new interest in realism of weight and volume that harked back a century. Perhaps the clearest examples of this trend are the figures of the Moses Well at the Chartreuse of Champmol in Dijon (1395–1406) carved by Claus Sluter, a Netherlander working for the duke of Burgundy. These large-scale figures, of corporeal amplitude, are draped in soft, extravagant folds; most striking is the reality and accurate rendering of detail, both in the textures of costume and flesh and in the individuality of expression. This interest in the tangible and the specific, the individuality of form, whether in inanimate detail or monumental human form, distinguishes late-fourteenth-century realism from its High Gothic prototype. Northern influence in Italy is particularly evident during this period; the apostles atop the choir screen at Saint Mark's in Venice (1394) reveal the same, if less emphatic, interest in weight, volume, and realistic observation.

Around 1400, a brief artistic unity, the International Style, swept Europe. Northern and Italian influences commingle, producing a style characterized by slender, elongated, elegant figures draped in soft, flowing, curvilinear folds, which hint at the anatomical forms and impart a mystical lyricism to the human image. Though predominantly a painterly style, sculptural parallels occur, notably in the so-called Beautiful Madonna style that flourished in Middle Europe. In Italy, Gentile da Fabriano and Giovanni dei Grassi were leading exponents of the style. In the north, this soft, pictorial quality was accompanied by a greater illusion of depth of space, which, forsaking the architectural frame, imparts a panorama of life in the wonder of its natural surroundings. This lyrical, naturalized setting, emphasizing the realism of the particular, was introduced in Avignon by Simone Martini and other Sienese painters in the employ of the exiled papal court, and it quickly appeared in Franco-Netherlandish painting. The Limbourg brothers visually explored the natural world with renewed observation, clarity of light, and unprecedented illusion of space

(see Plate 124). While this uniformity of style can, in part, be explained by the internationalism of commerce and patronage, the communality of vision upon recovering from the traumas of the century must have played a role as well.

In the course of the fifteenth century, Europe changed from an agricultural, feudal, and ecclesiastical society to an urban, national, and secular one. The economic fabric had become essentially mercantile, depending increasingly toward the end of the century on far-flung trade linked to overseas empires. Banking, manufacturing, and commerce established the middle class as the backbone of society for the first time since the Roman Empire. As a new plutocracy, the middle class emulated the nobility, married into it, and eventually melded with it. Hereditary monarchies, particularly in France, England, and Spain but less in Germany and Italy, achieved unprecedented strength, exerting supreme authority over political events, directing state religion in the wake of the Reformation, and controlling state economy. Even the most powerful dukedoms were eventually subsumed by monarchies; Burgundy, the most splendid of all, was incorporated, through marriage and warfare, into the Habsburg domains by the end of the century. Nationalism was reinforced by the universal use of the vernacular. The invention of the printing press around the middle of the century effected the spread of thought and knowledge on an unprecedented scale; mass circulation of the printed word became a potent force that, for example, transformed Martin Luther's theological convictions into the reality of the Reformation. The university system made education more widely accessible, engendering professional careers in law, business, medicine, and government administration; at the same time, science and philosophy advanced for the first time since antiquity. The Council of Basel in 1417 concluded the Great Schism and left the papacy enjoying something of an Indian summer; in the second decade of the sixteenth century, however, the Reformation ended the unity of Christianity with Rome at its center.

In the opening decades of the fifteenth century, Gothic realism, anticipated by Claus Sluter, went through something of a second revolution. If the fourteenth century can be said to have been dominated by sculpture and the three-dimensional arts, the fifteenth century was one in which the two-dimensional art of painting flourished. In the Netherlands, there was a radically new effort to master the depiction of the visible world. Beginning with Robert Campin and Jan van Eyck, the picture plane was conceived as a window through which the viewer could look to a world beyond, endowed with an illusion of infinite space, unlimited depth, and continuity. Pigments in an oil medium were ideally suited to the Netherlandish masters, as they could be worked in either heavy, opaque or in thin, transparent layers or glazes, creating a luminosity and simulation of true surface qualities, further enhanced by subtle gradations of color and plays of light.

The transition from the synthesized ideal to the illusion of the real is seen in the shift from the courtly settings found in the paintings of the International style to modest, urban, middle-class interiors such as that seen in Campin's *Annunciation* triptych (Plate 127). These settings are not, however, as simple as they may appear; every detail is infused with hidden meaning beyond the apparent, creating multilayered complexes of disguised symbolism. Jan van Eyck's *Ghent Altarpiece* of 1434 demonstrates the degrees of complexity to which subject and composition were elevated. Rogier van der Weyden approached his subjects with greater spareness in scope and detail but imbued them with a higher level of spirituality. At the same time, portraits moved from being psychologically neutral to being more deeply personal reflections. Hugo van der Goes created

scenes of atmospheric spaciousness and in the *Portinari Nativity* contrasted the spiritual calm of the Virgin with the dramatic intensity of the shepherds. Outside the Netherlands, parallel efforts to reflect the visible world with greater intensity and realism are evident; Conrad Witz of Basel, in the background of his *Miraculous Draft of Fish* of 1444, painted a recognizable landscape portrait of his native Alpine land. Jean Fouquet, in his self-portrait, elevated the portrait to an independent art form.

Sculpture moved from the exterior to the interior of churches in the form of large tabernacles, screens, altars, and other types of church furniture. Particularly in Germany, sculpture took the form of large-scale, carved and painted altarpieces. These elaborate architectural shrines of gilded wood, housing central, usually polychromed sculptural ensembles, flanked by folding, painted panels or low relief wings, were veritable theaters of Christian belief and frequently incorporated complex iconographical programs—in effect, the counterparts of High Gothic sculptural portal programs. The production of these altarpieces required large workshops of specialized crafts and a division of labor; carvers, painters, gilders, carpenters, and ironworkers labored under the supervision of a master who insured the quality and stylistic unity of the finished product. Hans Multscher, with a workshop in Ulm, active between 1427 and 1467, was the first medieval sculptor whose work and entrepreneurial career can be traced over a span of time. In general, sculpture, greatly influenced by painting, moved from an elegant and ethereal to a more empathetic, human vision of religious figures. But individual style was the hallmark of Late Gothic sculpture; Michael Erhart, Jörg Syrlin the Elder, Tilman Riemenschneider (see Plate 139), Michael Pacher, Jörg Ratgreb, Bernt Notke, Veit Stoss (see Plate 140), Adam Kraft, and Peter Vischer were all outstanding masters whose careers and production, spanning the Late Gothic and early northern Renaissance periods, can be traced in considerable detail.

More than ever before, the decorative arts flourished in the fifteenth and early sixteenth centuries. Tapestries—the mural paintings of the north—were woven in large workshops in Paris, Arras, Tournai, and Brussels (see Plates 122, 145). Silver- and goldsmiths wrought ecclesiastical objects—reliquaries, monstrances, processional crosses, and other liturgical objects—as well as secular objects—caskets, jewelry, drinking vessels, and plates—often enhanced with engraved decoration, gems, rock crystal, and enamel (see Plates 129, 135, 141). Objects of every description, from the simplest, most utilitarian to the most lavish, were produced in every conceivable material: glass, textile, ceramic, base metals, fruitwoods, ivory. Increased demand largely from a wealthy middle class, modified guild regulations, improved working methods and technology, stricter quality control to protect markets, and competition all contributed to increased quality and variety of production.

The high level of artistic inventiveness that characterized the decorative arts at the end of the Middle Ages, however, can be attributed to the increased involvement of major artists in broader circles of creativity. Through the rapid development of the print in the fifteenth century—whether woodcuts as single sheets, book illustrations, or more refined and richly textured intaglio prints struck from engraved metal plates—pictorial imagery of the outstanding artists of the day became universally accessible. But the direct activity of these artists in design brought a higher level of artistic achievement to all the arts. Albrecht Dürer, for example, consistently lent his creative genius to the designing of minor objects such as stained glass, jewelry, wallpaper, and drinking vessels. Through the dissemi-

nation of such designs, leading artistic personalities exerted an immediate influence on both the quality and the variety of workshop production. Small-scale domestic glass now shared the same designer as a major church-glazing program; a single-sheet devotional woodcut tacked to the wall of a modest home could be by the same artist who had painted a monumental polyptych.

Although generally eclipsed by other arts, northern architecture in the fifteenth century continues to evolve new decorative formulas. In France, the Flamboyant style, so-called because of the flamelike curves and reversed curves of the tracery patterns, dominated. The earliest, and relatively sober examples, appeared in the late fourteenth century, such as at Auxerre (1392–1401), but the style continued, with ever greater elaboration, into the sixteenth century. At Rouen, the facade (additions from 1386 to 1514) became an exuberant layering of tracery, arcades, and gables pierced with flaming vertical elements; at La Trinité, Vendome (ca. 1500), a more sober but dazzling effect was achieved by contrasting the myriad, darting patterns of the portal, gables, and windows with the austere, undecorated ashlar walls. England saw the continued elaboration of the fan vault. The complicated, weblike patterns became increasingly flattened, emphasizing horizontality; yet, the careful use of ribs united the walls, windows, and vaults with remarkable cohesion. In the later pendant fan vault, the ribs disappear above a suspended, openwork vaulting system; the most striking example of this architectural tour de force is seen in the chapel of Henry VII, in Westminster (1503–19). Virtuoso effects of ornamental detail are, likewise, characteristic of German architecture. The decorative nature of Late Gothic architecture was suited to secular buildings; whether domestic or civic, elaborate structures were erected as testaments to the elevated status of a wealthy, urban middle class. When Renaissance influence infiltrated the north in the early sixteenth century, architects saw little need to rethink the form and structure of their buildings; decorative elements of Renaissance motifs simply replaced the Gothic, continuing a system of additive overlay that had characterized architecture for more than a century.

Around 1400, the Florentine chronicler, Filippo Villani, first explicitly categorized artists in the liberal rather than the mechanical arts. This elevated view of the artist, a humanistic recognition of individual artistic expression, heralds the end of the Middle Ages in Italy. In 1425, only two years after Gentile da Fabriano's *Adoration*—a monument of the International style—Masaccio produced the Trinity fresco at Santa Maria Novella. Taking the volumes and corporeal weight introduced by Giotto, he created large-scale figures of severe but sculpted volumes; conceived as clothed nudes in *contrapposto* inspired by Classical models, they are placed in a dramatically recessive space defined by a single vanishing point. In sculpture, Nanni di Banco's four saints at Or San Michele blend, for the first time, the unity of the Classical form with the spiritual content of the subject, no longer separated as in Gothic classicism. At the same time, Brunelleschi's San Lorenzo (1421–69) and Pazzi Chapel (1430–33) revolutionized architecture. Artistic expression governed by rational, scientific principles based on humanistic interpretations of Classical thinking marks the end of the Gothic and the inception of the Renaissance in Italy.

In the north, the lingering indifference to the Italian Renaissance began to fade around 1500. Dürer's travels to Italy greatly reinforced his scientific and ordered approach to art and encouraged his attempt to structure a disciplined framework in which students could train and elevate both the public's perception of artists and the artists' perceptions of themselves. Notwithstanding Dürer's humanistic inclinations, he remained essentially a medieval man; of all artists in the north, Dürer was perhaps the only one to successfully marry medieval tradition with Renaissance aesthetic. Growing humanistic consciousness around the turn of the sixteenth century brought a heightened sense of individual artistic expression, but the underlying principles of this expression remained medieval. Gothicism survived in the north, in spite of Italianate inroads, until the Baroque style emerged as an international movement in the later part of the century.

Art is a continuum; styles have no strict chronological beginnings and ends. Artistic movements bracketed by dates are convenient inventions of scholars attempting to establish synoptic and comprehensible order out of a bewildering array of political events, social changes, spiritual beliefs, and everyday realities that, at once, influence and condition human thought and creativity. A brief introduction to the art of the Middle Ages down to the dawn of the modern world requires a broad brushstroke following prominent guideposts of events and ideas; it is necessarily a highly subjective exercise, which seeks to characterize late medieval artistic achievement and creative context.

Timothy B. Husband

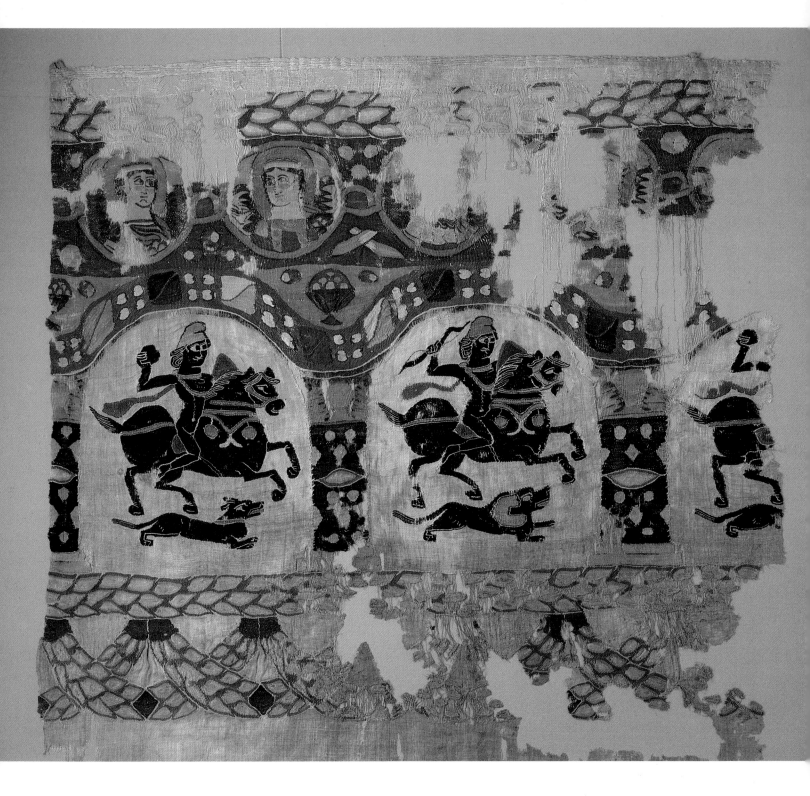

Coptic Art

The art of Coptic, or Christian, Egypt had its roots in both the local artistic traditions of ancient Egypt and in the classicizing styles practiced in the Mediterranean basin. As it developed from the third century toward its maturity in the late fifth to late seventh centuries, prior to the Arab invasion, Coptic art became increasingly abstract, favoring a two-dimensional treatment of the pictorial surface.

The fragment of a wall hanging (Plate 1), woven in various colors of wool over linen cross-threads, demonstrates the early Coptic retention of Late Antique imagery interspersed with abstract patterning. The hunters on horseback are of two types: One type brandishes a bow in a raised hand and is accompanied by a running dog; the other, followed by a lion, wields a rocklike weapon. Rhythmically arranged, the hunters are an integral part of a vivacious design that avoids monotony by ordering the repeated images in a staggered sequence.

The limestone column capital (Plate 2), which comes

from the monastery of Saint Jeremias at Saqquara, shows an even greater sense of allover design repetition. Barely raised from the background, the downward-pointing, seven-pronged leaves cover the capital's entire surface in an even arrangement. This abstraction and formalization is characteristic of figural compositions as well.

As in the wall hanging and column capital, the figures in the carved ivory of the Ascension of Christ (Plate 3) form an allover pattern, completely covering the fragmented elephant-tusk surface. Only the angels' bodies are depicted in profile; their faces and the other figures are all positioned frontally. The Virgin, in the lower register, raises her hands in prayer, while the apostles gesture to the books they hold in their arms.

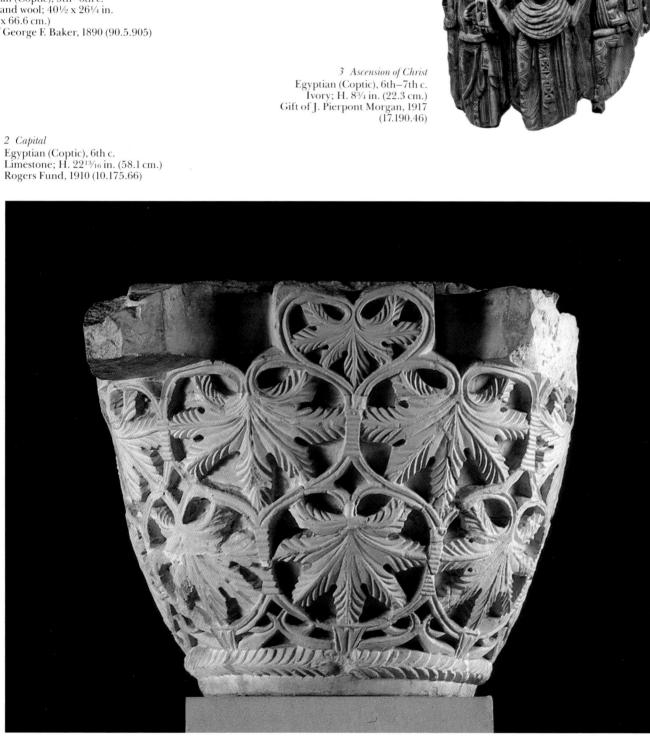

1 Hanging with Hunters on Horseback
Egyptian (Coptic), 5th–6th c.
Linen and wool; 40½ x 26¼ in.
(102.8 x 66.6 cm.)
Gift of George F. Baker, 1890 (90.5.905)

3 Ascension of Christ
Egyptian (Coptic), 6th–7th c.
Ivory; H. 8¾ in. (22.3 cm.)
Gift of J. Pierpont Morgan, 1917
(17.190.46)

2 Capital
Egyptian (Coptic), 6th c.
Limestone; H. 22¹³⁄₁₆ in. (58.1 cm.)
Rogers Fund, 1910 (10.175.66)

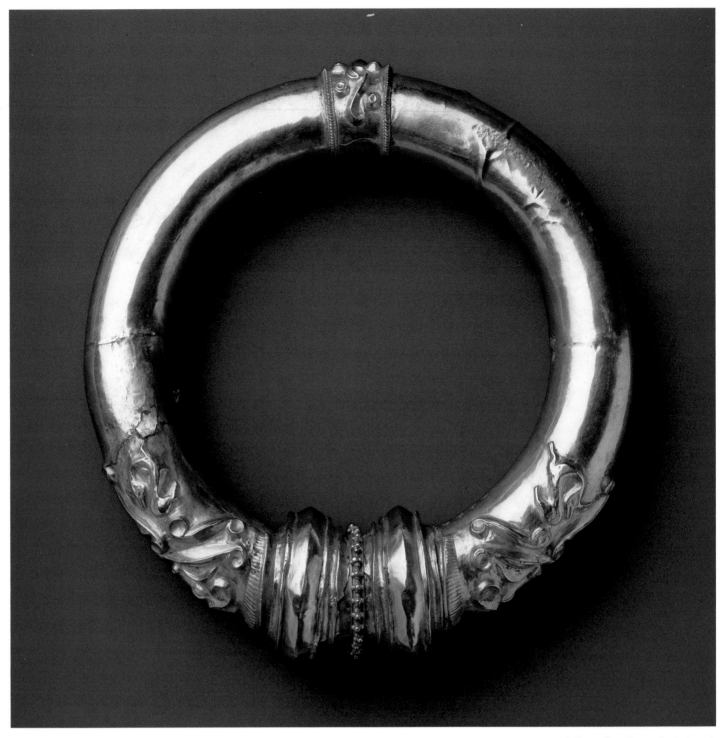

4 *Torque from Frasnes-les-Buissenal,*
Hainaut, Belgium
Northern Gaul, 1st c. B.C.
Gold with iron, beeswax, and
resin-filled core; D. 7⅞ in. (20 cm.)
Anonymous Loan (L.53.43.1)

GOLD TORQUE AND COINS

In the Old English saga *Beowulf,* the hero of the title is described as being honored with

> ornate gold...presented in trophy: two arm-wreaths,
> with robes and rings also, and the richest collar
> I have ever heard of in all the world.

Such collars, or torques, were worn by chiefs and warriors of the barbarian tribes of northern Europe, signifying—as in the case of Beowulf—their bravery and rank. This extraordinary torque was made by placing a thin gold sheet over an iron ring covered with beeswax and resin. It could

be opened, so as to be placed around the wearer's neck, by pulling apart the two halves at the center. The decoration combines scroll patterns with smooth, sharply angled surface areas. The design culminates in a sumptuously worked area comprising spiral, ribbon, and scroll motifs surrounding a highly stylized ram's head.

The coins are of the Nervii—reported by Julius Caesar to be the fiercest of warriors—and the Morini tribes, who lived in or near the Hainaut in southwestern Belgium. The hoard from which these coins came may have been buried in 57 B.C., at the time of Caesar's invasion.

5 Nine Coins from Frasnes-les-Buissenal,
Hainaut, Belgium
Celtic, 75–50 B.C.
Gold Anonymous Loan (L.53.43.3-11)

6 Portrait Medallion of Gennadios
Alexandrian, 250–300
Gold glass; D. 1⅝ in. (4.2 cm.)
Fletcher Fund, 1926 (26.258)

7 Medallion Portrait of a Woman and Boy
Alexandrian, early 4th c.
Gold glass; D. 1⅞ in. (4.8 cm.)
Gift of J. Pierpont Morgan, 1917 (17.190.109)

TWO ALEXANDRIAN PORTRAIT MEDALLIONS

Portraiture was largely the domain of the upper classes during the Early Christian period, since usually they alone were able to afford it. Portrayed in the Classical tradition of the second half of the third century, the handsome young man in Plate 6 is identified by the inscription as "Gennadios most accomplished in musical art." Gennadios's portrait has been attributed to Alexandria on the basis of the Greek dialect of its inscription. While the subjects of the portrait of a woman and boy in Plate 7 are not identified, this medallion is linked by style and manufacture to Alexandria as well. Later in date than the medallion of Gennadios, the representation of a woman and boy is slightly more formalized. Yet the portrayal of the child's vulnerable innocence is a tour de force of secular portraiture of the period. Such jewellike portraits were drawn on gold leaf, attached to the surface of a deep sapphire-blue glass roundel, and sealed with a clear glass overlay. Both are beveled at their rims for mounting, perhaps to be worn as pendants.

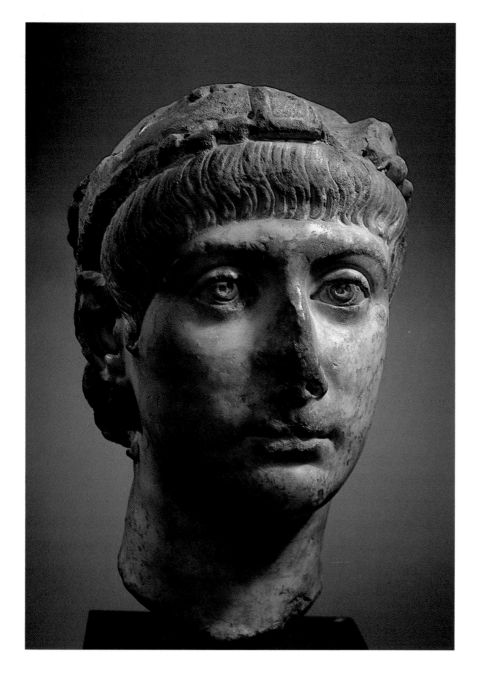

8 *Head of Constans*
Constantinople, ca. 337–340
Marble; H. 10¼ in. (26 cm.)
Rogers Fund, 1967 (67.107)

HEAD OF CONSTANS

As in the Roman Empire, imperial portraiture during the Early Christian period was used by the emperor to translate his authority into visual terms for all to see. To reflect the exalted status of its subjects, imperial portraits were made from the most precious materials: Silver, gold, ivory, and gems were used for small-scale objects, while marble, bronze, and porphyry were employed for larger sculpture. This marble portrait of Constans (r. 337–350), the youngest son of the first Christian emperor, Constantine (r. 306–337), was originally designed for insertion onto a full-length statue.

He is portrayed wearing the hairstyle and diadem crown popularized by his father in about 325. Characterized by the stiffly ceremonial pose and expressionless gaze typical of such portraits, the face of the young emperor is nevertheless softly modeled and tempered by the locks of hair that evenly ring his forehead. While some of these features are known from other portraits, Constans appears to have been portrayed here at a particularly young age, perhaps as he assumed the throne in 337, when he was, at most, seventeen years old.

RELIEF WITH THE STORY OF JONAH

Old Testament legends played an important role in the formation of Early Christian imagery. These narratives were often illustrated in episodes, arranged sequentially following the biblical text. This sculptural fragment shows two scenes from the story of Jonah: Jonah being cast to the sea monster, and then being disgorged from the monster's open mouth. The naked Jonah is shown lowered over the side of the ship, feet first, his legs already in the sea monster's waiting jaws. Nearby, he is cast up, emerging head first with his arms raised in prayer. Likening himself to Jonah, Christ was believed to have foretold his own death and resurrection: "For as Jonas was in the whale's belly three days and three nights: so shall the Son of man be in the heart of the earth three days and three nights" (Matthew 12:40). Thus, Jonah was seen as a symbol for the salvation of all men: "He . . . who after three days brought forth Jonah living and unharmed from the belly of the whale . . . shall not lack power to raise us also" (Apostolic Constitution, Book V).

9 Relief with the Story of Jonah
Early Christian (Asia Minor), 300–325
Marble; 19½ x 23 x 12½ in.
(49.5 x 58.4 x 31.8 cm.)
Gift of John Todd Edgar, 1877 (77.7)

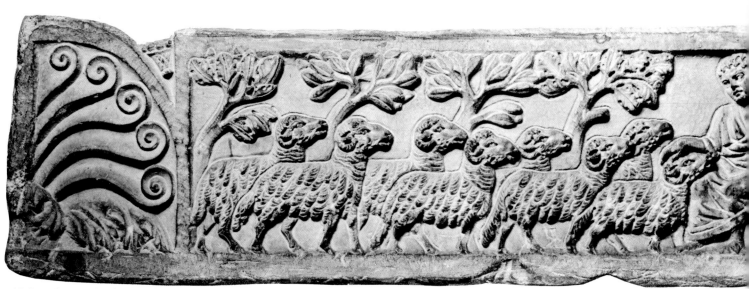

10 *Sarcophagus Lid with Last Judgment (Separation of the Sheep from the Goats)*
Late Roman (Rome), late 3rd–early 4th c.
Marble; 16 x 93½ x 2¾ in. (40.6 x 237.5 x 7 cm.)
Rogers Fund, 1924 (24.240)

SARCOPHAGUS LID AND SEPULCHRAL RELIEF

The imagery of Early Christian sarcophagi often pertains to the attainment of eternal life. The parable of the separation of the sheep from the goats (Matthew 25:31–46), depicted on the relief in Plate 10, signifies the Last Judgment and is the earliest surviving such representation in Christian art. Dressed as a teacher-philosopher, the softly modeled figure of Christ is shown seated in the center in the pose of a shepherd. He places his right hand tenderly on the head of the first of eight sheep, which approach him from his right. On the left, he repulses five goats with a raised

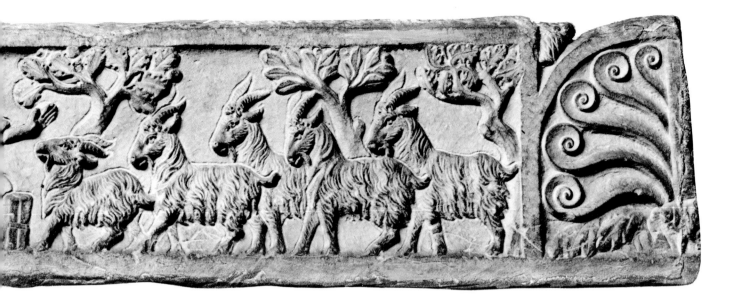

hand. The assembled flock, according to the parable, represents men of "all nations," whom Christ will divide "into two groups, as a shepherd separates the sheep from the goats, and he will place the sheep on his right and the goats on his left." Those on the left "will go away to eternal punishment, but the righteous will enter eternal life."

The sepulchral relief illustrating the *Traditio Legis* (Christ giving the law to Peter) similarly deals with the theme of salvation but emphasizes the role of the Church in its attainment. Carved in high relief, it shows Christ in the central right niche (his face is missing) raising his right hand in proclamation while unfurling the scroll of the law toward Peter. Paul stands on Christ's right. Above the subtly modeled, well-rounded figures of the apostles is an intricately carved arbor supporting abundant clumps of ripe grapes. The grapes not only act as a decorative motif, but perhaps serve, too, as an allusion to the Eucharist, and thus to the hope of redemption through the sacrament of the Christian Church—represented by the apostles and based upon the authority of Christ himself.

11 Sepulchral Relief with Traditio Legis
Early Christian, late 4th c.
Marble; 19⅛ x 52½ x 5¾ in.
(48.6 x 133.4 x 14.6 cm.)
Gift of Mrs. Joseph Brummer and Ernest
Brummer in memory of Joseph Brummer,
1948 (48.76.2)

25

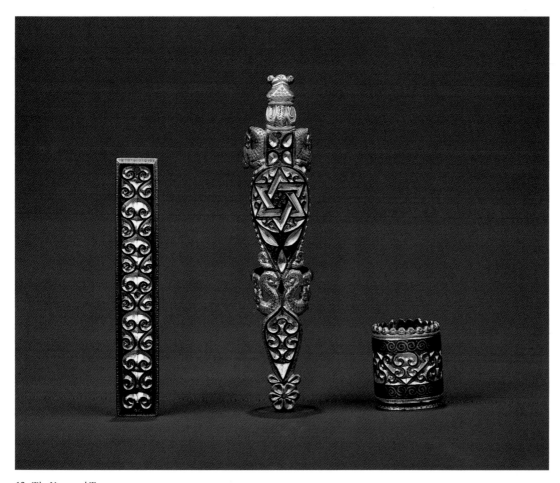

12 The Vermand Treasure
Provincial Roman, 350–400
Silver gilt and niello; *left:* L. 3¾ in. (9.5 cm.);
center: L. 4⅞ in. (12.4 cm.);
right: H. 1⅜ in. (3.5 cm.), D. ⅞ in. (2.2 cm.)
Gift of J. Pierpont Morgan, 1917 (17.190.143-145)

THE VERMAND TREASURE

A group of richly decorated silver mounts was among the objects unearthed from a military tomb in Vermand, near the city of Saint-Quentin in northern France. The tomb must have been that of a chieftain of high rank, perhaps a Roman military officer or a barbarian in Roman service. Three of the pieces are illustrated here: a ring and two plaques for a spear shaft. They are decorated with vines and floral arabesques, cicadas, and fantastic animals.

These patterns belong to the repertory of Late Antique art, but the technique with which they were achieved was a new method developed in the frontier regions along the Rhine and Danube rivers. Used chiefly for the decoration of military trappings, it is called chip-carving because the patterns, although not actually carved, are made up of wedge-shaped troughs like those left by the chips cut in woodcarving. The contrasts in the design are made more vivid by the use of niello—a black sulphur alloy set into the incised gilded silver. The Vermand find is the most distinguished example of chip-carving to have survived.

13 Tyche of Constantinople
Early Byzantine, 4th–5th c.
Bronze; H. 10 in. (25.4 cm.)
Fletcher Fund, 1947 (47.100.40)

Two Early Christian Bronzes

Both of these Early Christian bronzes are cast in the form of women who symbolize the power and authority of the Byzantine Empire. Imperial busts, usually of empresses, became the most popular form in the Byzantine era. The unidentified empress in Plate 14 is elaborately coiffed and crowned with a richly jeweled diadem from which hang strands of pearls. Her aristocratic bearing is enhanced by her four-tiered gem-and-pearl-studded necklace, the scroll grasped in her left hand, and the gesture of blessing she makes with her right hand. The bust could be suspended by its hook and moved along the balance—or steelyard—to establish the weight of the commodity hung from the opposite side.

The representation of imperial power is also exhibited in the hollow-cast Tyche—or female personification of a city—in Plate 13. Seated on a simple throne and crowned with the city's walls, she holds a horn of plenty in her right hand and once grasped a staff in her left, attributes that identify her as the personification of the city of Constantinople and its prosperity. She was created sometime after the city's founding and dedication by the emperor Constantine in 330. Representations of Tyches have their roots in antiquity and continued to be popular through the Early Christian era. This continuity is evinced in the Tyche's dress and pose, which had changed little since the creation of the type in the sixth century B.C.

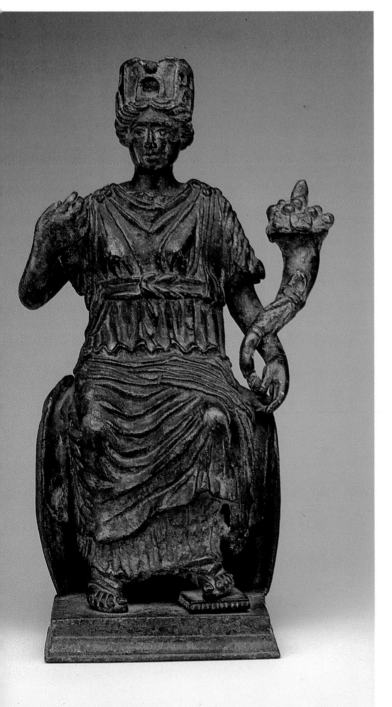

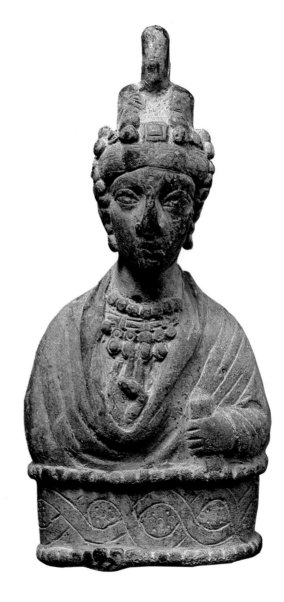

14 Steelyard Weight in the Form of a Bust of a Byzantine Empress
Early Byzantine, 400–450
Weight: copper alloy; hook: brass;
9⅛ x 4¼ in. (23.5 x 11 cm.), 5.04 lb. (2.29 kg., or 7 Byzantine litrae)
Purchase, Rogers Fund, Bequest of Theodore M. Davis, by exchange and Gifts of George Blumenthal, J. Pierpont Morgan, Mrs. Lucy W. Drexel and Mrs. Robert J. Levy, by exchange, 1980 (1980.416a,b)

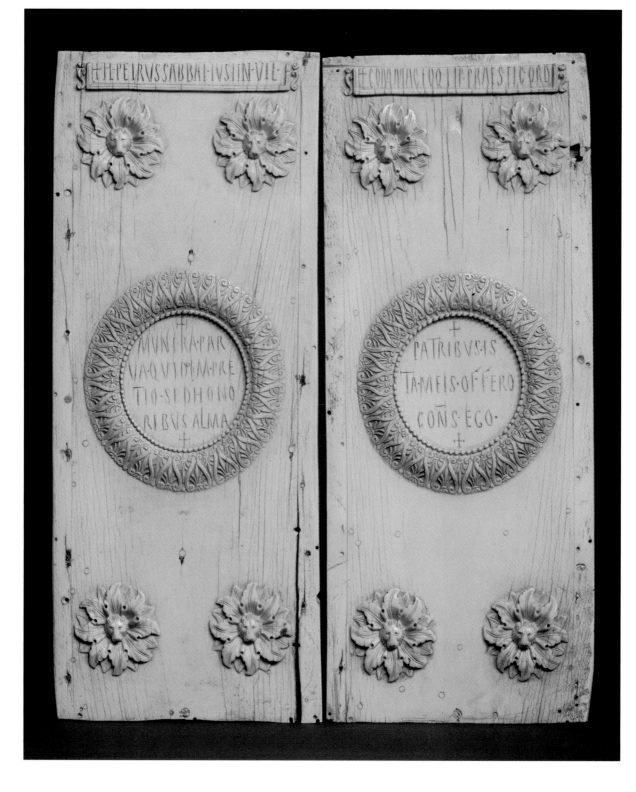

DIPTYCH OF THE CONSUL JUSTINIAN

Justinian was appointed consul for the East in 521, six years before he became emperor, and he had this diptych made for presentation to members of the Senate to celebrate his consulship. Such ivory diptychs were a popular form of self-aggrandizement in the early Byzantine Empire. This simply carved, refined example announces Justinian's appointment at the top of each wing, while a running inscription addressed to the senators is bordered by an elaborate beaded and palmette raised molding in the center of each wing. At the four corners of each leaf, lions' heads emerge from the

center of lush acanthus leaves. The soft, tactile quality of the acanthus stands in marked contrast to the abstract decorative medallions.

In comparison with other consular diptychs, this example is relatively plain, since it was given to members of the Senate, rather than to higher government officials who would have received more elaborately carved examples. The fact that three such diptychs presented by Justinian survive is certainly due to the subsequent political importance of the man whose consulship they proclaim.

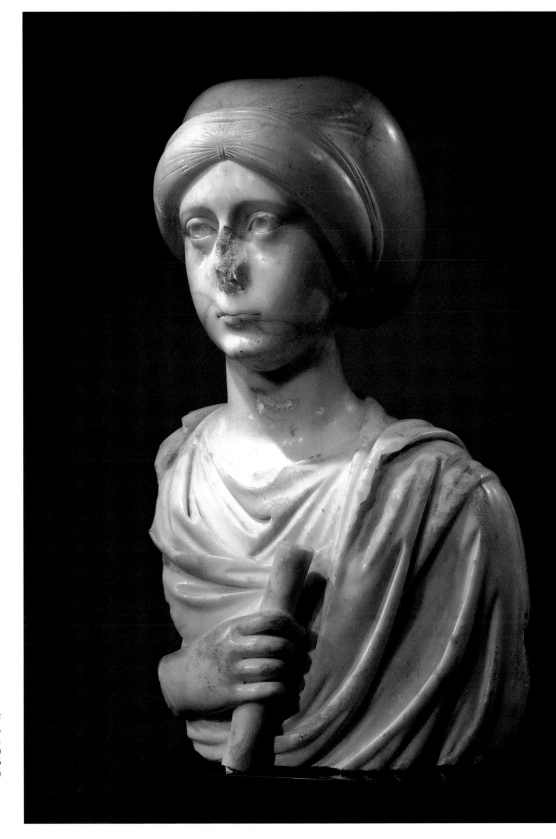

16 Bust of a Lady of Rank
Early Byzantine (Constantinople),
late 5th or early 6th c.
Marble; H. 20⅞ in. (53 cm.)
The Cloisters Collection, 1966
(66.25)

BUST OF A LADY OF RANK

This superb marble bust, made in the Byzantine capital of Constantinople, portrays a woman of rank. It was probably once part of a double portrait of a husband and wife, a type often found in funerary art of the period. This would account for the cutting off of the lady's right shoulder and arm, as well as for the slight turn of her head to the right. More than just a memorial, this bust captures some of the lady's gentle spirit: A modest and virtuous spouse, she wears her hair tightly coiffed and covered by a thin scarf, or snood, in the style popular during the fifth and sixth centuries; as a cultivated woman, she carries a scroll, indicating her high social status.

The sensitive carving of the lady's eyes, mouth, and chin, and the delicate modeling of her face, endow the portrait with a feeling of naturalism, despite the subject's aristocratic bearing and fixed gaze.

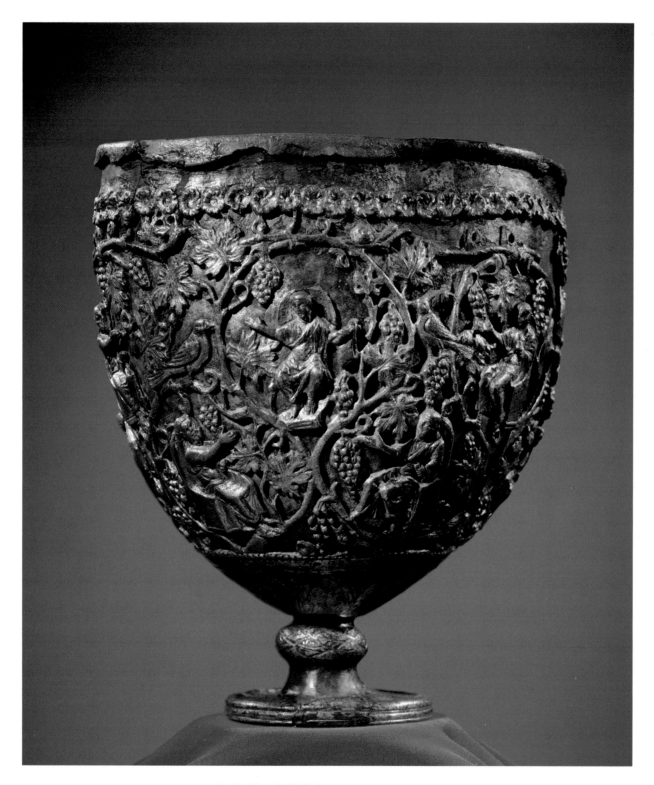

17 The "Antioch Chalice"
Early Byzantine (Syria? [Kaper Koraon]), 6th c.
Silver, silver gilt; H. 7½ in. (19.1 cm.)
The Cloisters Collection, 1950 (50.4)

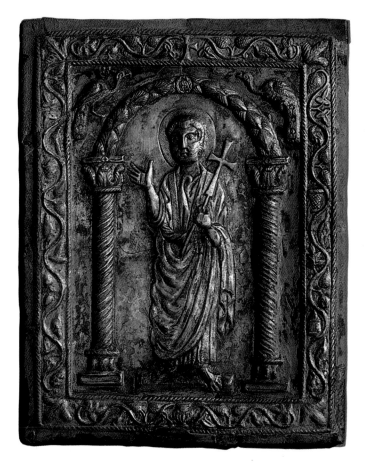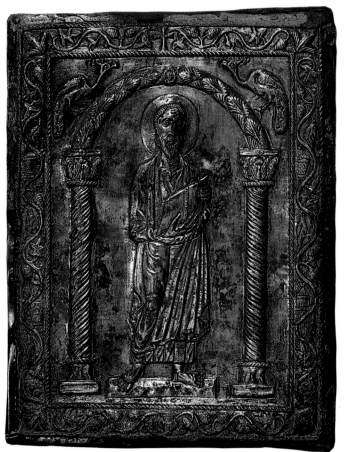

18 Silver Plaques with Saints Peter and Paul
Early Christian (?) (Syria?), 550–600
Silver with traces of gilding; 10¾ x 8½ in.
(27.3 x 21.6 cm.)
and 10⅝ x 8½ in. (27 x 21.6 cm.)
Fletcher Fund, 1960 (50.5.1,2)

EARLY CHRISTIAN SILVER

Donations of precious silver objects played an important role in the economic ascendancy of the Church during the Early Christian period. These gifts were sometimes solicited by Church officials, but they were also given out of the donor's desire to secure salvation or offer thanks for favorable blessings from God. These three sumptuous works formed part of a great cache of liturgical objects discovered in the early twentieth century.

The so-called "Antioch Chalice" (Plate 17) has inspired controversy almost since its discovery. Traditionally thought to have been used as a chalice, it has been recently suggested that it served as an oil lamp. Regardless of its original function, however, it remains one of the most beautiful works of art dating from this period. Formed in the late Roman manner from a simple inner bowl overlaid with elaborate figural openwork, the piece's rich—albeit enigmatic—imagery shows Christ seated with a lamb standing under his right arm. Under him an eagle, with wings spread, stands on a basket of fruit. On the other side, Christ again appears enthroned, holding a scroll. The lower section of the bowl depicts seated figures who acclaim Christ, perhaps in reference to his declaration, "I am the Light." A luxuriant growth of vines completes the composition.

Rather than being worked from the front, as was the "Antioch Chalice," the plaques representing Saints Peter and Paul were made by hammering the figures out from the back, a technique called repoussé. The saints, considered the founders of the Christian Church, are set beneath arches with peacocks perched in the spandrels. Each plaque is framed by a ropelike vine border. At the center of the top border is a cross. The stiff and bold presentation of Peter and Paul is softened somewhat by the gently falling drapery folds of their tunics and mantles. The plaques might have been used as book covers—perhaps for editions of the saints' epistles. However, they could also have been part of a friezelike series of plaques on a piece of liturgical furniture, possibly flanking a central image of the cross or Christ to represent the foundation of the Church.

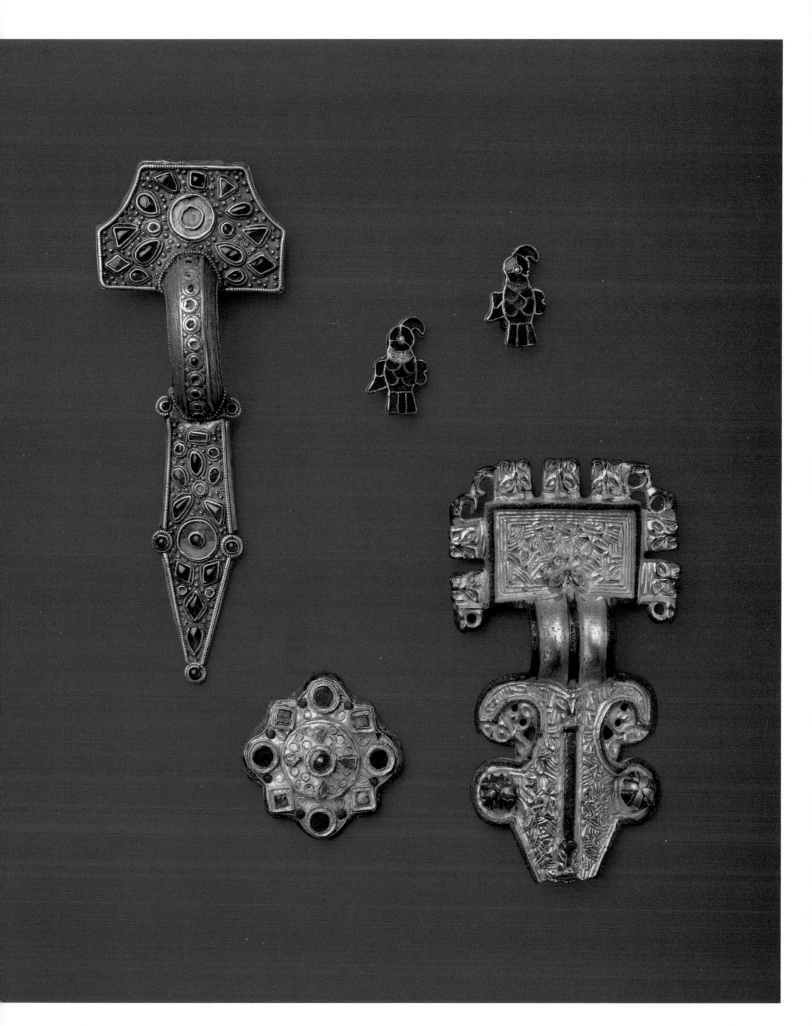

19 Bow Fibula
Gepidic, 5th c.
Gold leaf over silver core with almandine,
mother-of-pearl, or enamel; L. 6¾ in. (17.1 cm.)
Fletcher Fund, 1947 (47.100.19)

20 Pair of Bird Fibulae
Frankish, 500–550
Bronze gilt, red glass, pearls;
each H. 1½ in. (3.8 cm.)
Gift of J. Pierpont Morgan, 1917 (17.190.164,165)

21 Great Square-Headed Brooch
Anglo-Saxon, 6th–7th c.
Gilt bronze and niello; L. 5⁵⁄₁₆ in. (13.5 cm.)
Purchase, Rogers Fund and Alastair B. Martin,
Levy Hermanos Foundation, Inc. and
J. William Middendorf II Gifts, 1985 (1985.209)

22 Quatrefoil Fibula
Frankish, 7th–8th c.
Gold, bronze, and glass; D. 2³⁄₁₆ in. (5.5 cm.)
Gift of J. Pierpont Morgan, 1917 (17.191.134)

FIBULAE

This grouping of fibulae, or clasps, demonstrates the variety of designs, patterns, and materials with which these pins were made in the West during the period following the Early Christian era. Known today from excavations of burial sites, the surviving works of art produced during this time of great upheaval—objects such as fibulae—are mostly small in size but of great artistic impact. Fibulae were usually worn at the shoulder, often in pairs, to secure a mantle or other piece of clothing, as demonstrated by the small rosette-shaped fibulae that fasten the peplos of the bronze Tyche (Plate 13).

The specific filigree patterns, interlace designs, and glass-paste coloring or cut-stone embellishment are generally distinctive of a fibula's origin. The head and foot plates joined by an arched bow in the fibula on the left, the earliest of the group, are characteristic of a type discovered mainly in Hungary and southern Russia. Similarly, the decoration of the great square-headed brooch, at the bottom right, with its entire surface covered with detailed incised interlace interspersed with abstracted animal masks, is characteristic of Anglo-Saxon ornament. The Frankish quatrefoil disk fibula, next to the brooch, was made of bronze covered with a sheet of gold or silver and decorated with filigree and precious stones or colored glass in raised settings. Much different in its decoration are the two small eagle-shaped fibulae above, each consisting of small cells filled with red glass paste, neck collars made of mica, and small pearls that form the eyes. While the bow, disk, and animal-shaped fibulae are found primarily in the graves of women, the great square-headed brooch might have been worn by an important person of either sex. The geometric decoration and accomplished metalworking technique exhibited in these fibulae were an important legacy of the nonclassical tradition to the formulation of Carolingian and later medieval art.

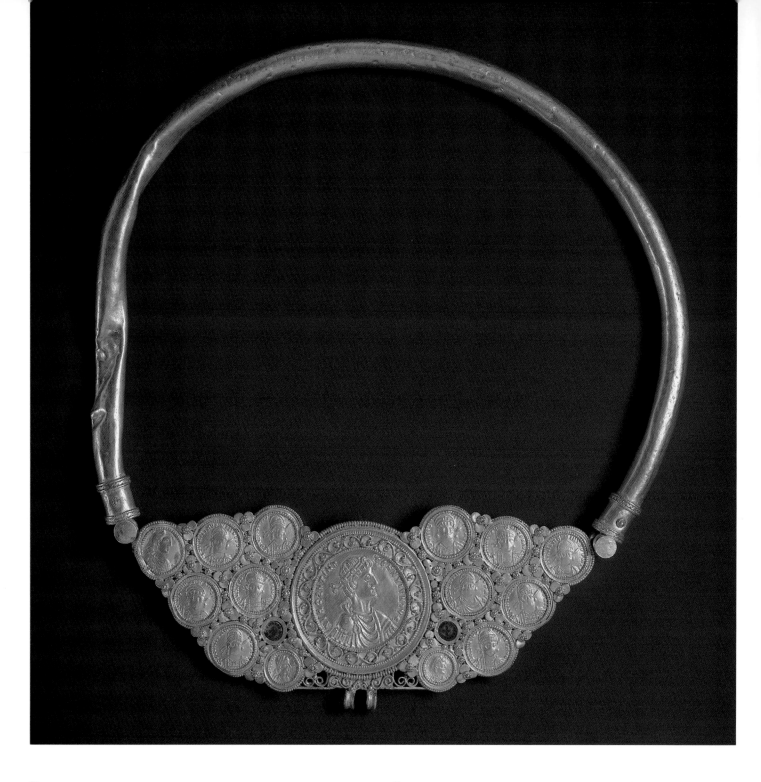

PECTORAL

Neck rings, such as this imposing gold example, are cited in early sources as playing a role both in the glorification of military heroes and in coronation ceremonies. This pectoral necklace is composed of a plain, hollow neck ring attached to a frame set with a large central medallion flanked by coins and two small decorative disks. Although it was found in Egypt, the pectoral is believed to have been made in Constantinople, since a personification of that city is depicted on the reverse of the central medallion. The front of the medallion and the smaller coins depict Byzantine emperors. The two ribbed rings at the pectoral's lower edge once held a large medallion of the emperor Theodosius I. This imperial imagery suggests that the pectoral is composed of a collection of military trophies that once belonged to a distinguished general or member of the imperial court.

BRACELET

Judging by its luxurious decoration, this bracelet, made in Constantinople in the early seventh century, was intended for a woman of great wealth. It was found, however, in Egypt, where other pieces of jewelry from Constantinople, such as the pectoral in Plate 23, were also discovered. Strings of pearls alternating with gold beads frame sapphires and emerald-green plasmas (a variety of quartz) on the bracelet's wide gold band. The sapphire of the central mount is set in a circle of pearls. The high quality of the craftsmanship extends even to the inside, where the back of the mount is overlaid with an openwork vine pattern and the middle of the band is formed by a series of bow-shaped pieces. Bracelets such as this were decorated with gems particularly favored by the aristocracy and are similar to depictions of jewelry worn by the imperial court in contemporary mosaics.

23 Pectoral with Late Roman Coins
Early Byzantine (Constantinople?), mid-6th c.
Gold and niello; H. including neck ring
9⅜ in. (23.8 cm.)
Gift of J. Pierpont Morgan, 1917 (17.190.1664)

25 Ewer with the Adoration of the Magi
Early Byzantine (Constantinople), 6th c.
Silver and silver gilt; H. 12⅜ in. (31.5 cm.), D. 3¹⁵⁄₁₆ in. (10 cm.)
Purchase, Rogers Fund and Schimmel Foundation Inc.
Gift, 1984 (1984.196)

EWER WITH THE ADORATION OF THE MAGI

This slender silver ewer is decorated with a series of acanthus borders and ivy and grapevines. In the center, the Three Kings, following the star of Bethlehem and escorted by an angel, bring gifts to honor the Christ Child, shown seated on his mother's lap and accompanied in the rear by Joseph. The figures stride vigorously around the circumference of the ewer, turning and gesturing to each other in animated conversation. Their flowing garments emphasize the action. The decoration, still bearing traces of gilding, is worked in repoussé. The shape of ewers such as this, as well as the decorative acanthus and ivy pattern, are the legacy of Late Roman silver. This example might have served as a container for the water that was mixed with wine during the celebration of the Eucharist.

24 Bracelet
Early Byzantine (Constantinople), 6th–early 7th c.
Gold, pearls, sapphires, emerald plasma;
D. 3¼ in. (8.3 cm.)
Gift of J. Pierpont Morgan, 1917 (17.190.1671)

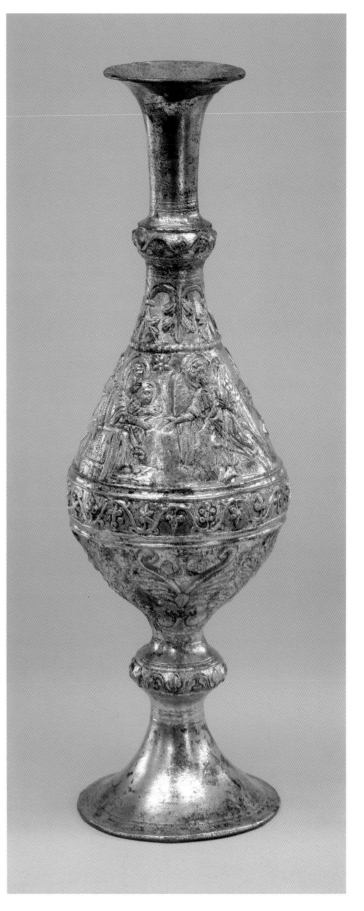

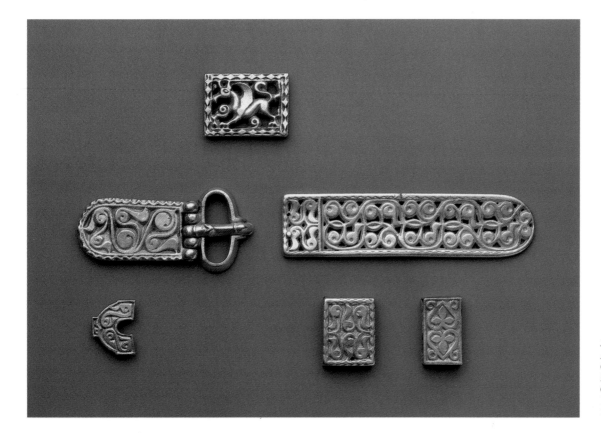

26 Gold Mounts
Avaric, 8th–9th c.
Gold; L. of largest mount
5 in. (12.7 cm.)
Gift of J. Pierpont Morgan,
1917 (17.190.1673, 1678,
1683, 1686, 1697, 1698)

THE ALBANIAN TREASURE

These splendid cups and gold mounts were found together in a treasure cache in the vicinity of a Roman road near Durazzo, Albania. The chalice, at the left, is sumptuously decorated with four female figures worked in repoussé and identified by Greek inscriptions as Rome, Alexandria, Constantinople, and Cyprus. Like the bronze Tyche of Constantinople (Plate 13), they are dressed in Classical garb, hold staffs, and wear crowns modeled after city walls. Unlike the Tyche, however, these figures cannot represent cities, since the island of Cyprus is among them. Instead, they may be personifications of ecclesiastical provinces. After the Council of Ephesus in 431, the Metropolitan See of Cyprus dissolved its ties with the See of Antioch and declared itself to be independent. Thus the inclusion of Cyprus suggests manufacture on the island after the Council of Ephesus but before the Arab invasion of 647.

The irregular engraved lines that characterize this cup's decoration are exhibited to a much lesser extent on the footed cup decorated with a repeated allover decoration of fish scales in relief. The plain drinking bowl, with a side handle for suspension, probably belonged to a tribe of horsemen, possibly the Avars. The gold mounts would have served on several different belts. The buckle and protector plate are the pieces through which the leather strap would be secured. Like the fibulae in Plate 20, these pieces are decorated with swirling, foliate forms and engaging animal motifs typical of personal adornment in the nonclassical tradition. It is possible that these widely diverse pieces were brought together because of the Byzantine campaigns against the Balkan Slavs and Avars in the last decade of the sixth century.

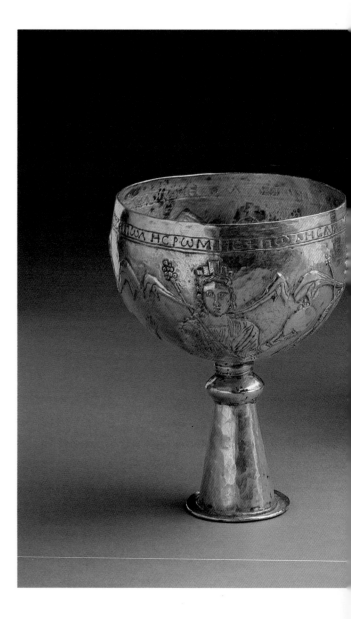

DAVID PLATES FROM CYPRUS *(Pages 38–39)*

Produced during the reign of the emperor Heraclius (r. 610–641), these three silver plates are part of a set of nine illustrating scenes from the Old Testament life of King David. They were discovered in 1902 in northern Cyprus, sealed in a wall niche with a horde of jewelry and gold. The largest and most important plate (Plate 28) combines several episodes related to David's slaying of the Philistine warrior Goliath (1 Samuel 17:40–54). At the top, Goliath curses David in the Valley of Elah, where David took the stones for his sling. (The valley is symbolized by the river god between the two figures.) In the center, Goliath lunges at David, who prepares to cast the shot that will stun his adversary. At the bottom, David beheads the fallen Goliath. The remaining plates illustrate ceremonial events, such as Saul arming David (Plate 29), or other heroic adventures, such as David slaying the lion that set upon his flock (1 Samuel 17:34–39)

(Plate 30). The artist's adaptation of Classical representations of Herakles slaying the Nemean lion for his portrayal of David is indicative of a conscious effort to evoke the Hellenistic styles of antiquity.

The relief decoration made these plates unsuitable for practical use, either domestic or liturgical, and the set must have been intended for ceremonial display. It is possible that the emperor Heraclius commissioned the plates to commemorate his victory over the Persian general Razatis in 627; the emperor's triumph evokes comparison to that of the Old Testament monarch. Each plate is made from a solid piece of silver and is intricately chased by hand. Despite the difficulty of this task, the artist has endowed the images with an extraordinary sense of movement and volume and with a wealth of decorative detail, making them among the most spectacular pieces of Byzantine art to survive.

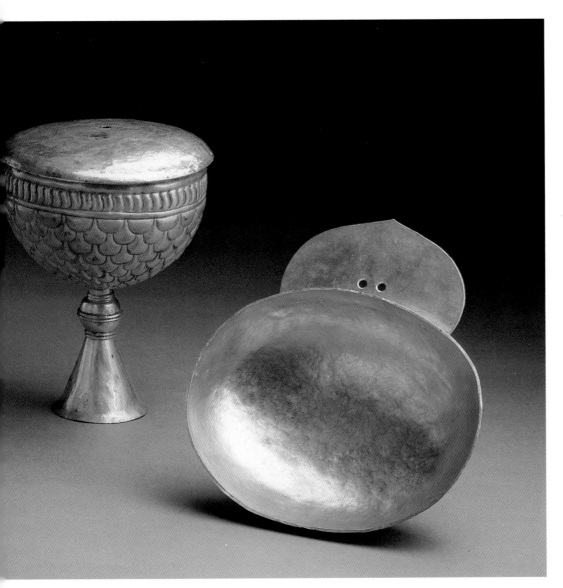

27 Chalices and Drinking Bowl

Chalice (left):
Byzantine (probably Cyprus), 600–650
Chalice with Cover (center):
Avaric or Byzantine, 7th–9th c.
Both chalices: Gold; H. 6⅝ in. (16.8 cm.), D. 4¹³⁄₁₆ in. (12.2 cm.)
Gift of J. Pierpont Morgan, 1917 (17.190.1710, 17.190.1711ab)

Drinking Bowl (right):
Avaric, 8th–9th c.
Gold; H. 7 in. (17.8 cm.), D. 6⁷⁄₁₆ (16.4 cm.)
Gift of J. Pierpont Morgan, 1917 (17.190.1708)

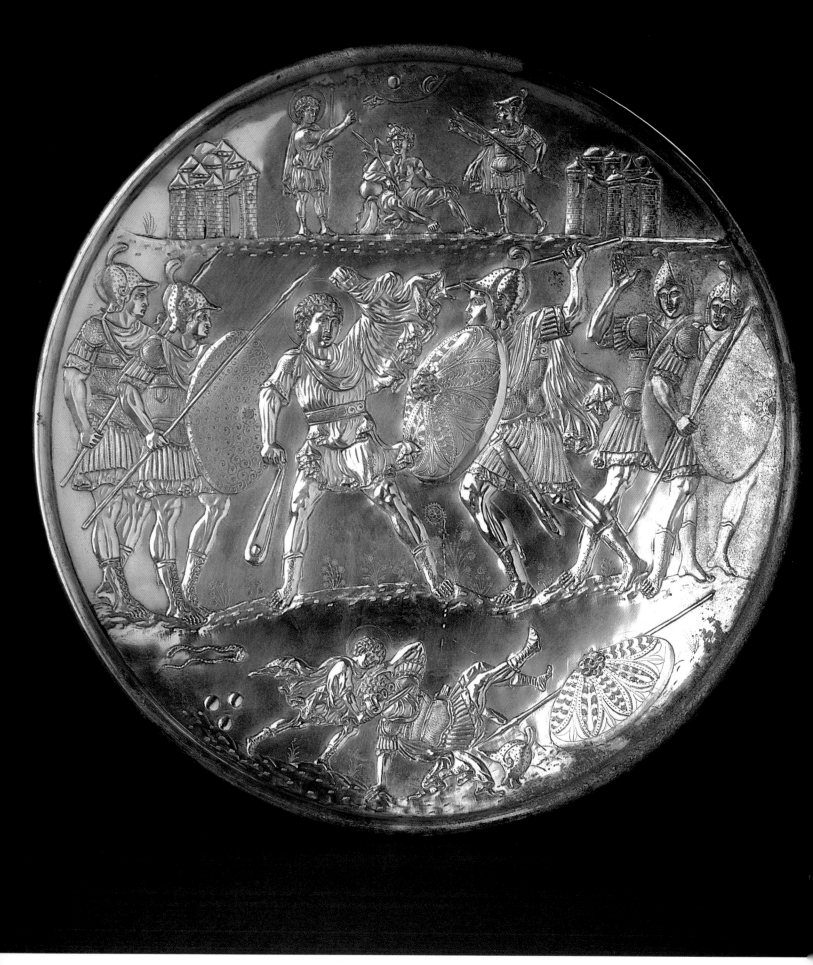

28 David and Goliath
Early Byzantine (Constantinople), 628–630
Silver; D. 19½ in. (49.4 cm.)
Gift of J. Pierpont Morgan,
1917 (17.190.396)

Page 37: text

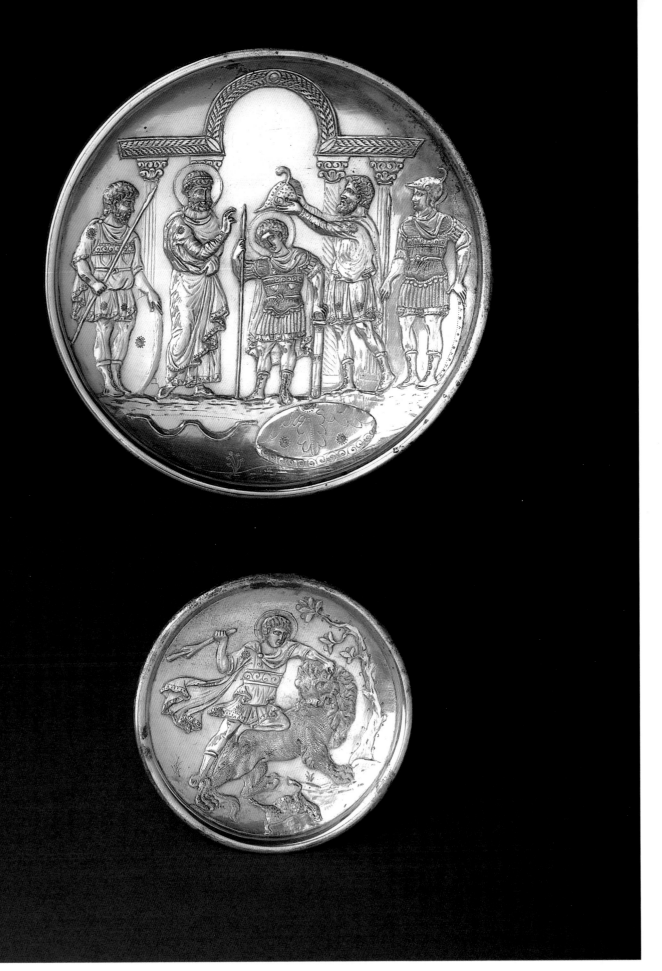

29 *Saul Arms David*
Early Byzantine (Constantinople), 628–630
Silver; D. 10½ in. (26.7 cm.)
Gift of J. Pierpont Morgan,
1917 (17.190.399)

Page 37: text

30 *David Battles the Lion*
Early Byzantine (Constantinople), 628–630
Silver; D. 5½ in. (14 cm.)
Gift of J. Pierpont Morgan,
1917 (17.190.394)

Page 37: text

31 Reliquary of the True Cross
Byzantine (Constantinople), early 9th c.
Silver gilt, cloisonné enamel, niello;
4 x 2⅞ in. (10.2 x 7.35 cm.)
Gift of J. Pierpont Morgan, 1917
(17.190.715)

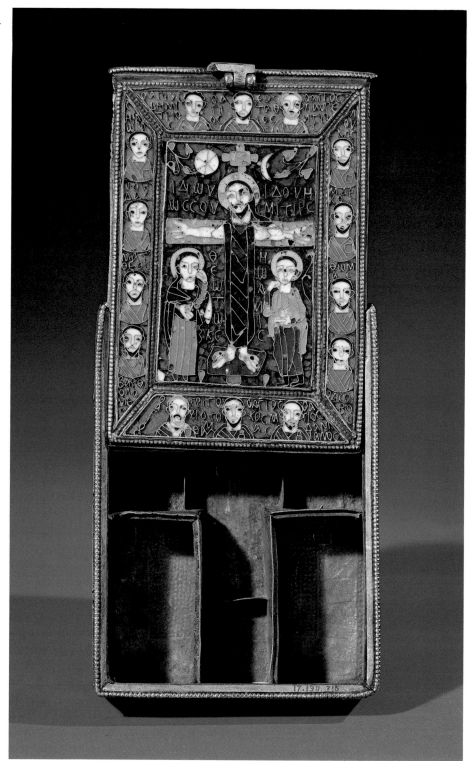

RELIQUARY OF THE TRUE CROSS

More than eleven hundred reliquaries of the True Cross are known, found today in church treasuries and museums or recorded in surviving texts. Relics of the cross were quickly and widely distributed after the legendary discovery in the fourth century of the True Cross by Saint Helena, mother of the emperor Constantine. Throughout the medieval period, such relics were housed in precious containers where they could be venerated by the faithful. This finely made small box is one of the earliest examples of such a reliquary. The sliding lid, decorated with a Crucifixion scene and busts of saints, depicts four episodes from the life of Christ on its underside. The lid draws back to reveal five interior compartments for relics laid out in the shape of a cross. In the

Crucifixion, Christ, flanked by the mourning figures of the Virgin and Saint John, is shown alive on the cross, wearing a long tunic popular in Eastern depictions of this scene. The clarity and richness of color are characteristics of enamel paste—a combination of glass, sand, and soda or ashes heated together to form a clear flux to which metallic oxide was then added for color.

A precious reliquary such as this was probably kept in at least one other container, for it was often the custom to house a relic in a series of interfitting boxes, the smallest of which contained the actual relic and was made of the most precious material. Pope Innocent IV (r .1243–52) is said to have owned this reliquary.

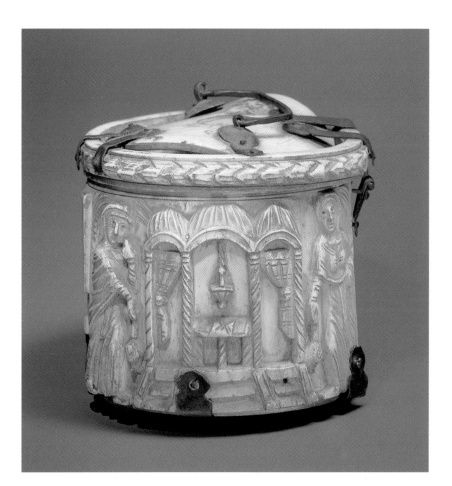

32 Pyxis with the Holy Women at the Tomb of Christ
Early Byzantine (Syria-Palestine?), 6th c.
Ivory; H. 4 in. (10.2 cm.), D. 5 in. (12.7 cm.)
Gift of J. Pierpont Morgan, 1917 (17.190.57)

IVORY PYXIS

Adapted from a vessel popularly used by the ancient Greeks and Romans, the small circular pyxis was employed in the Early Christian church as a container for the reserve of Eucharistic bread to be preserved or taken to ill communicants, or for use at home. The circumference of this fine ivory pyxis—one of only three surviving examples illustrating scenes from Christ's Passion—is decorated with the scene of the three holy women visiting the tomb of Christ. In this view, two Marys, carrying censers, approach not a tomb but an altar. By substituting an altar for the actual tomb, the artist made visible the Early Christian association of the

Holy Sepulcher with the main altar of a church. The development of this imagery coincides with the emerging belief in the performance of the liturgy as a reenactment of the Crucifixion and Resurrection and in the Eucharist as the actual blood and body of the crucified Christ. Thus this scene was an appropriate choice for a pyxis. The liturgical symbolism of the scene is effectively conveyed on this circular surface through an arcade that links the three women with the church containing the altar. Their starkly frontal or profile gestures similarly focus attention on the altar and emphasize the sanctity of the event.

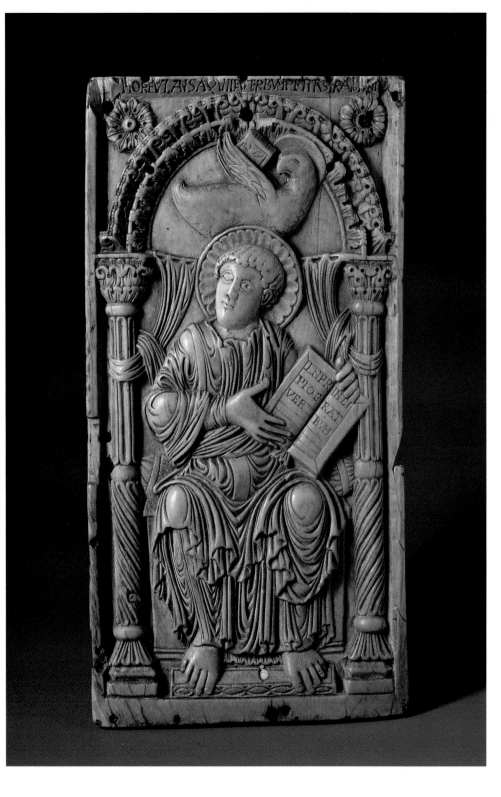

33 Plaque with Seated Saint John the Evangelist
Carolingian (court school), early 9th c.
Ivory; 7½ x 3⅝ in. (18.3 x 9.5 cm.)
The Cloisters Collection, 1977 (1977.421)

CAROLINGIAN IVORY CARVING

Charlemagne, sole king of the Franks from 771, was crowned Holy Roman Emperor by the pope in 800. The cultural revival he instigated sought to reassert the grandeur of the era of the first Christian emperors. The arts played an important role in this renaissance, and artists were encouraged to look to Classical prototypes for inspiration. Ivory carving particularly flourished under this artistic resurgence. The plaque representing Saint John the Evangelist (Plate 33) was probably made in Charlemagne's court school. The saint, accompanied by his symbol, the eagle, is shown on a simple seat with a rolled cushion, displaying the opening text of his gospel: "In the beginning was the word." The inscription along the top edge is from the writings of the Early Christian poet Sedulius and translates as, "Calling out like an eagle, the word of John reaches the heavens." While inscribed in a later hand, this probably replaces an earlier original. The deep layering of John's tunic folds constitutes a lively interpretation of Classical drapery, as does the architectural setting in which the saint is placed.

The Crucifixion reproduced in Plate 34 was probably produced in Metz, an artistic center that flourished during the middle to the third quarter of the ninth century under

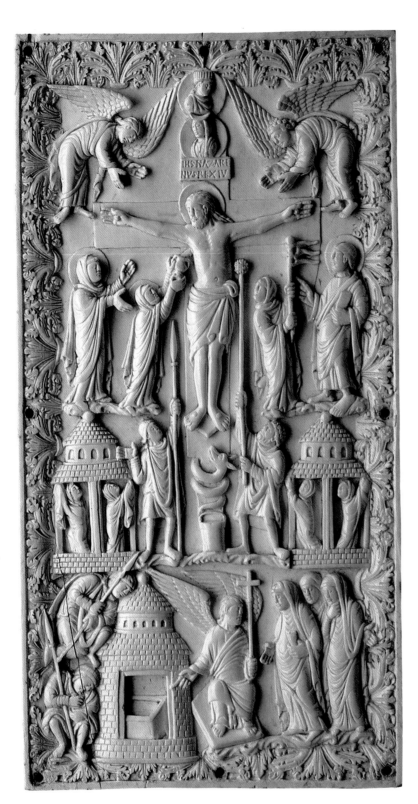

34 Crucifixion
Carolingian (Metz), ca. 870
Ivory; 9⅜ x 4²⁷⁄₃₂ in. (23.8 x 12.3 cm.)
The Cloisters Collection, 1974 (1974.266)

Lothair II, Charlemagne's great-grandson. It shows a multitude of figures in a stately style all delineated by simple linear draperies and, with the exception of Christ, rendered in bold profile. Christ stands erect on the cross, his eyes open in victory over the dog-eared serpent (representing Death and Evil) wound around the base of the cross. Between the Virgin and Saint John the Evangelist, Ecclesia, symbolizing the Church, catches the blood streaming from Christ's side. Synagogue, wielding a banner, turns away from this hope of redemption, while Stephaton grasps the sponge soaked in vinegar and Longinus, the spear with which Christ's

side was pierced. The two tombs signify the hill of Golgotha. In the lower register the Three Holy Women visit Christ's tomb. An angel points to the empty sarcophagus: "He is not here; he has been raised again, as he said he would be" (Matthew 28:6). The plaque's subject matter, size, and format indicate that this ivory probably served as the front cover of a sacramentary or Gospel book. This context, as well as the expression of the power of Saint John the Evangelist's Gospel in his ivory portrait, exemplify both Charlemagne's emphasis on learning and the importance he placed on the adornment of the books of Christian knowledge.

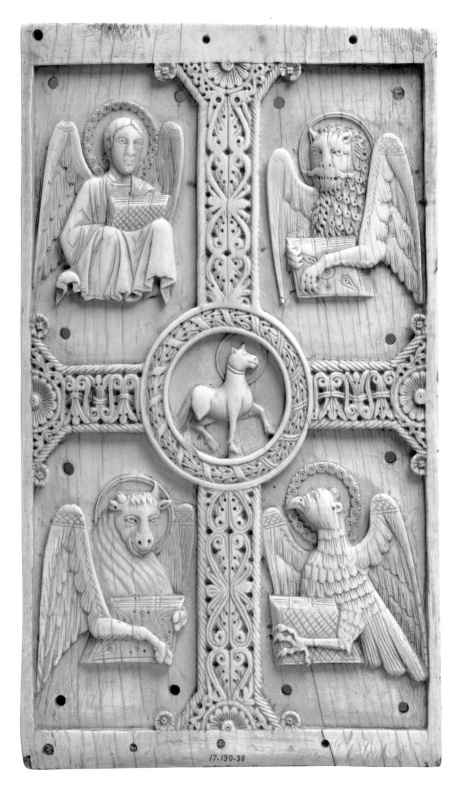

35 Plaque with Agnus Dei on a Cross between Emblems of the Four Evangelists
German or north Italian, probably 9th c.
Ivory; 9¼ x 5⅜ in. (23.5 x 13.7 cm.)
Gift of J. Pierpont Morgan, 1917 (17.190.38)

IVORY BOOKCOVER

The production of sumptuously bound manuscripts was prompted not only by the rarity and value of books in the Middle Ages but also by the importance of the written word in the Christian faith. This Carolingian ivory plaque was once set into a metal or ivory frame to serve as the front cover of such a binding. The representation of the symbols of the four evangelists—Matthew (the winged man), Mark (the winged lion), Luke (the winged ox), and John (the winged eagle)—suggests that the manuscript was a Gospel book.

These figures surround the Lamb of God (Agnus Dei) at the center of the cross, following Saint John's vision related in the Book of Revelation (4:6-7): "In the center, round the throne itself, were four living creatures, covered with eyes, in front and behind. The first creature was like a lion, the second like an ox, the third had a human face, and the fourth was like an eagle in flight." Framed by the arms of the cross, which is placed at the center, each evangelist's symbol prominently displays his Gospel.

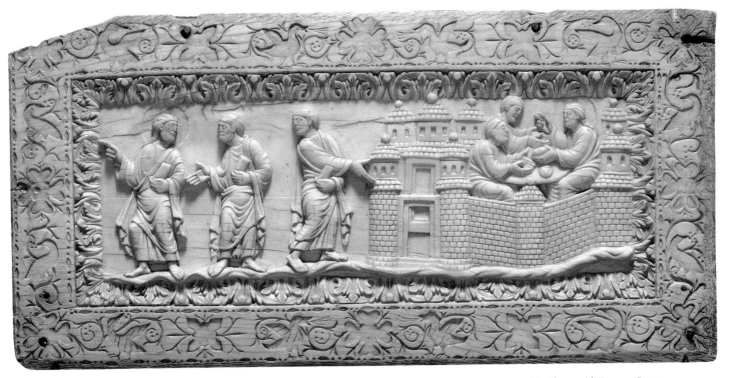

36 Plaque with Emmaus Scenes
Carolingian (Metz), ca. 860–880
Ivory; 4¹⁷⁄₃₂ x 9¼ in. (11.5 x 23.5 cm.)
The Cloisters Collection, 1974 (1974.266)

Two Early Medieval Ivories

The development from the Carolingian emphasis on softly flowing drapery and on spatial modeling inspired by Classical antiquity toward an emphasis on two-dimensional pattern in the late ninth and tenth centuries is evident in these two ivory plaques. The interplay of the figures, the sense of rounded bodies beneath the draperies, and the richness of detail make the ivory in Plate 36 a fine example of Carolingian art. Its rectangular shape suggests it was once a panel of a casket. At the left, Christ appears to two of his disciples on the road to Emmaus after his Resurrection; at the right, the Supper at Emmaus is shown. The representation of Emmaus —the carefully constructed gate, walls, and towers—is a remarkable early achievement in suggesting three-dimensional space.

The artists who worked under the patronage of the Ottonian rulers in the tenth century inherited the Carolingian narrative tradition while effecting a notable development in style. The dedication plaque carved for Magdeburg Cathedral in the time of Otto I (r. 962–973) (Plate 37) exemplifies a movement toward short, blocky figures without the lively animation that characterized Carolingian carving styles. The emperor Otto I is shown presenting Christ a model for the cathedral church of Saint Mauritius, which he founded. The archangel Gabriel and Saint Peter are among those supporting his donation. The surface patterning formed by the figures' draperies and strict profiles is heightened by the checkerboard background. Originally this openwork checkered ground would have been backed with gold. This work is one of nineteen surviving plaques from a larger series. It was perhaps originally intended to decorate an ambo (pulpit) or chancel door of the cathedral.

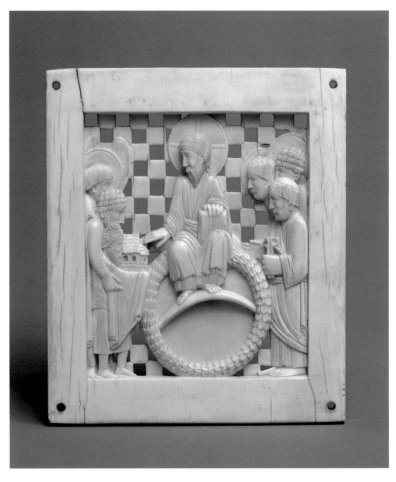

37 Christ Enthroned with Saints and Emperor Otto I
Ottonian, 962–973
Ivory; 5 x 4½ in. (12.7 x 11.4 cm.)
Gift of George Blumenthal, 1941 (41.100.157)

VIKING SWORD

The Viking warrior's love for fine and beautiful weapons extends beyond recorded history into the realm of legend. The most important weapon was the sword, of which the mythical Norse smith, Wayland, taught by the elves, forged heroic examples of phenomenal sharpness. This sword dates from the time when Norsemen invaded the coast of France and sailed up her rivers. It is reported to have been excavated from the canal at Orleans. The blade is straight, broad, and double-edged, with a shallow groove running nearly to its tip. Popularly used in Europe from Early Christian times to the eleventh century, this type of sword blade was constructed of alternating twin strips of iron and steel welded together. The bars were then twisted spirally and fused into one. Lavish attention was also paid to the decoration of the sword's handle. In this case, the hilt and pommel are adorned with a pattern of alternating strips of silver- and copper-covered iron. Such a powerful and richly embellished weapon embodied the strength and power of the Norse warrior.

38 Sword
Viking, 10th c.
Iron, copper, and silver;
L: 37¾ in. (95.9 cm.)
Rogers Fund, 1955 (55.46.1)

39 Situla
Germany (Rhineland?), 10th c.
Ivory; 8½ x 5⅛ in. (21.6 x 13.4 cm.)
Gift of J. Pierpont Morgan, 1917
(17.190.45)

HOLY-WATER BUCKET

One of only three in existence, this ivory holy-water bucket, or situla, invokes the ancient tradition of using water for purification. While such buckets sometimes had secular associations, this example would have been used in a sacred context. The water was drawn by means of a whisk, or aspergillum, and was sprinkled over the congregation and altar before Communion, usually upon the singing from Psalm 51, verse 7: "Thou shalt sprinkle me with hyssop and I shall be cleansed." Once owned by the parish church of Saints Peter and Paul in Cranenburg, Germany, this bucket's unbroken width reveals that the ivory is a cross section of a large elephant tusk. Its walls are divided into two lateral registers filled with panels bearing scenes from Christ's Infancy, Passion, and Resurrection—fitting subjects for a container filled with redemptive holy water. This view illustrates the Scourging of Christ on the upper left next to the Crucifixion on the right. The Baptism of Christ with attendant angels is portrayed in the lower compartments. The carving is marked by small, vibrant figures whose succinct, direct gestures convey the impact of the drama.

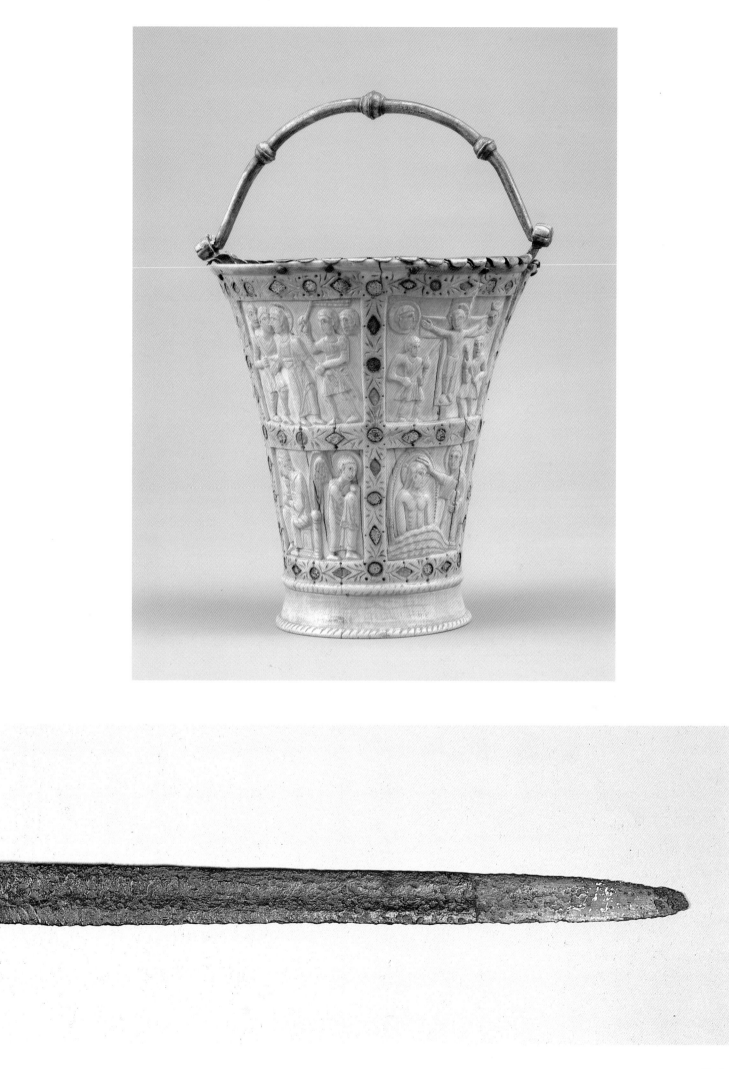

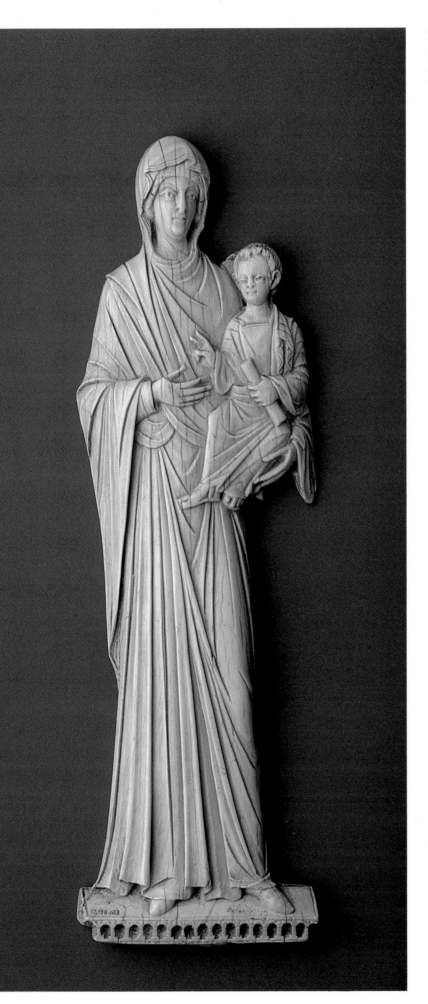

BYZANTINE VIRGIN AND CHILD

This exquisite ivory Virgin stands on an arcaded footstool, turning slightly to her left, and gesturing with her right hand to the Christ Child, whom she cradles in her left arm. Known in Byzantium as the *Theotokos Hodegetria*, this type of image was widely copied from a portrait believed to have been painted from life by Saint Luke and therefore a true representation of the Mother of God. It hung in a monastery dedicated to the Virgin in Constantinople, on the site of a fifth-century shrine with a miraculous spring to which the blind were led to be healed, hence the name *Hodegetria*—she who leads or guides the way. In this case, the Mother of God presents her son, the fulfillment of God's law (signified by the scroll), as the vehicle through which man's salvation can be attained. The formal portrayal of the infant Christ as a miniature man, dressed in the manner of a Roman magistrate and holding a scroll with one hand while blessing the viewer with the other, would influence twelfth-century Western representations of the Virgin and Child (see Plates 49, 52, 55). Barely a half-inch thick, this exceptionally slender and elongated statue was probably at some time cut away from a larger plaque.

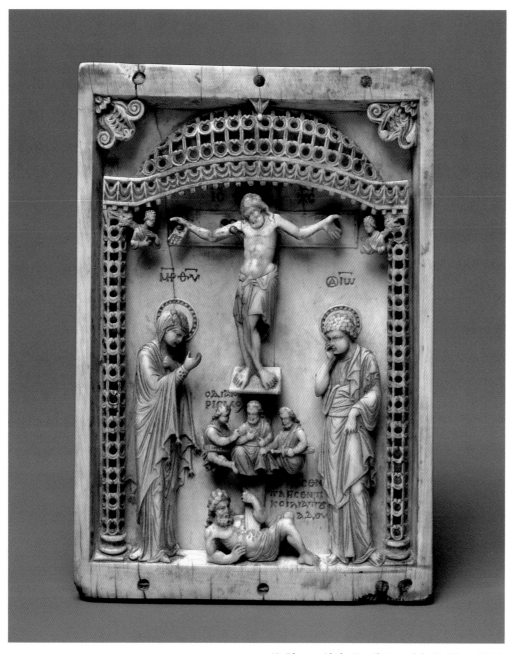

PLAQUE WITH THE CRUCIFIXION AND THE STABBING OF HADES

Like the Carolingian ivory representation of the Crucifixion (Plate 34), this Byzantine depiction emphasizes Christ's victory over death. Yet here both the imagery and style differ considerably from the earlier example. Christ's body is shown limply attached to the cross, his arms bent at the elbows, his legs turned, pushing his hip slightly outward. His head falls forward against his left shoulder. The Virgin and Saint John the Baptist mourn his passing, while underneath the foot support, the three soldiers divide Christ's seamless garment.

Although these figures are frequently portrayed as witnesses to Christ's sacrifice for mankind, the presence of the bearded reclining man stabbed by the cross is unique among surviving Byzantine representations of the Crucifixion. Like a defeated and subdued warrior, this figure personifies Hades, ruler of the underworld. In this case, the cross signifies both the weapon with which Christ's Crucifixion wins man's salvation and the victory standard. The impact of this message is brilliantly conveyed through the simplicity of the composition, which is marked by large areas of uncarved ivory underneath the architectural canopy. The resulting shallow space creates a dramatic stage for the figures, whose elongated bodies are articulated by the finely chiseled folds of their classically inspired drapery.

42 Nine Medallions of Saints
Byzantine (Constantinople?),
late 11th–early 12th c.
Cloisonné enamel on gold;
each D. 3¼ in. (8.25 cm.)
Gift of J. Pierpont Morgan, 1917
(17.190.670–678)

43 Plaques with Scenes from the Story of Joshua
Byzantine (Constantinople), second half of 10th c.
Ivory; *top* 3¾ x 7½ in. (9.5 x 19.1 cm.);
bottom 3¾ x 5⅝ in. (9.5 x 14.3 cm.)
Gift of J. Pierpont Morgan, 1917 (17.190.135, 136)

NINE MEDALLIONS OF SAINTS

The veneration of religious pictures in the Byzantine Empire led to the creation of a type of image called an icon. These representations usually comprised a single frontal portrait of a saint, which was thought to make visible his or her efficacious power. In the Byzantine church, icons, like crosses, were set up on stands as well as carried in procession on feast days. These nine enameled medallions once decorated the frame of a silver icon of the archangel Gabriel (now destroyed) from the monastery of Djumati in the republic of Georgia. Produced in the enameling technique known as cloisonné, each saint is portrayed resplendent against an unadorned gold background. In the highly technical and time-consuming process of cloisonné enameling, thin strips of metal are bent to form the desired outline and are soldered to the metal surface. Each of the resulting cells (cloisons) is layered with one color of enamel paste, and the whole is fired and then gradually cooled. The delicate renderings of the individualized figures make these works among the finest medallions produced in the Byzantine Empire during the late eleventh and early twelfth centuries.

PLAQUES WITH SCENES FROM THE STORY OF JOSHUA

The prosperity and cultural renaissance of the Byzantine Empire during the tenth and eleventh centuries spurred a renewed interest in ivory carving. These plaques, carved with the Old Testament story of the reconquest of the Holy Land by Joshua and the Israelites, once formed the sides of an ivory casket. On the top, Joshua leads the Israelites in ambushing the army led by the king of Ai (Joshua 8:10–23); below, he condemns the king of Jerusalem (Joshua 10:26). Each plaque is framed by a border of medallions containing bust portraits in profile and rosettes. The story of Joshua was popularly represented at this time. All these works, including the example reproduced here, utilize classicizing motifs in the depiction of the story. The friezelike compositions, including biblical inscriptions and Classical drapery styles, evoke the triumphs of the Early Christian emperors. Joshua may have been seen at this time as a prototype for the current attempts at a Byzantine reconquest of Palestine from the Arabs. Such images would have served to commemorate Byzantine victories over the infidels and signified the desire to restore the Holy Land to Christian rule.

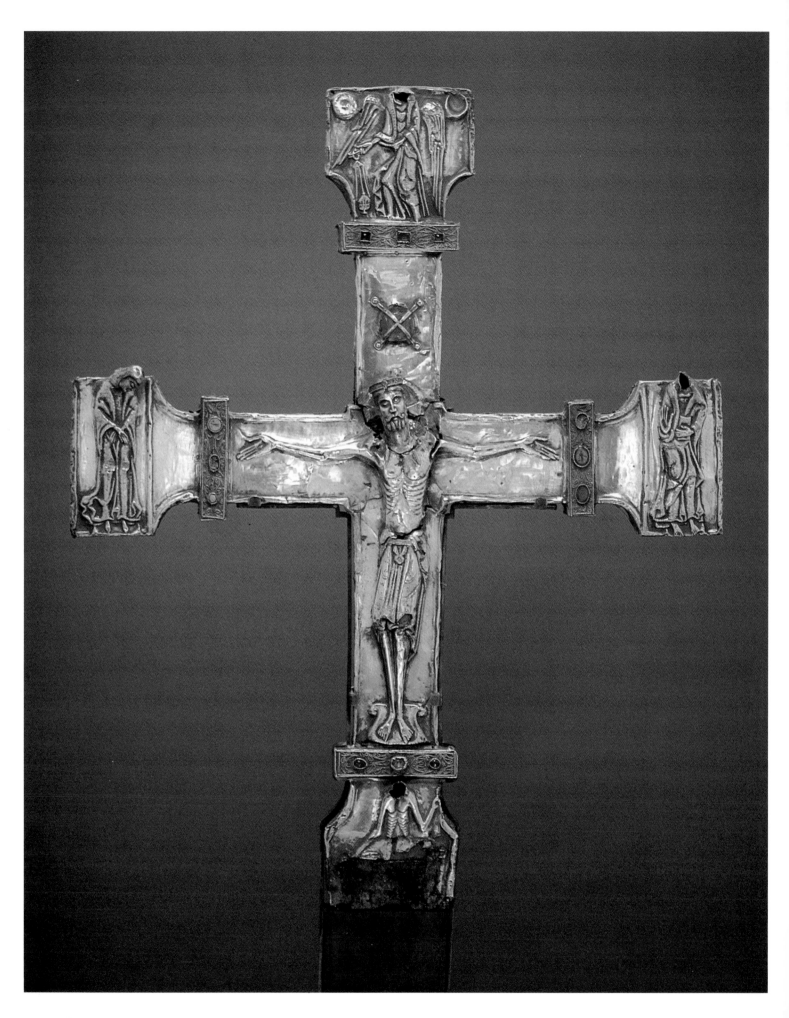

CRUCIFIX

The figure of Christ flanking the Virgin and Saint John dominates the front of this Spanish crucifix from the church of San Salvador de Fuentes in the province of Oviedo. Above the large crystal that once held a relic, an angel is shown swinging a censer. At the bottom, Adam rises from his grave—traditionally believed to be the hill of Golgotha where Christ was crucified. Supported by a wooden core, the figural decoration is formed from silver worked in such high relief that all heads but Christ's and the Virgin's have broken off. The reverse illustrates the Lamb of God surrounded by the symbols of the four evangelists. It also bears a Latin inscription, which translates, "Sanccia Guidisalvi made me in honor of Saint Salvador." While Sanccia may have been the female donor, contemporary records do refer to women artists working at this time in Spain. The arresting spirit of this cross proclaims salvation from the sin of Adam through the sacrifice of Christ, who is shown crowned and victorious over death, a juxtaposition that boldly portrays the scriptural passage: "For as in Adam all die, even so in Christ shall all be made alive" (I Corinthians 15:22).

44 Crucifix
Spanish (Asturias, Church of San Salvador de Fuentes), ca. 1150–75
Silver, silver gilt, and niello repoussé over a wooden core, with antique intaglios, precious, semiprecious, and glass stones; 23¼ x 19 in.
(59.1 x 48.3 cm.)
Gift of J. Pierpont Morgan, 1917 (17.190.1406)

PLAQUE WITH THE JOURNEY TO EMMAUS AND THE *NOLI ME TANGERE*

Two appearances of the risen Christ—to two disciples and to Mary Magdalene—are represented on this ivory plaque. Christ's encounter with two disciples on the road from Jerusalem to Emmaus is depicted at the top. According to the Gospel of Luke, the disciples, "their faces full of gloom," lamented Christ's Crucifixion to a stranger they met on the road. Knowing that he was not recognized, Christ explained that it was preordained that the Messiah must suffer to redeem mankind (Luke 24:13–27). Unlike the Carolingian representation of this scene (Plate 34), the figures here are not placed in an illusionistic setting, but are portrayed against a neutral background. Shown equipped with appropriate traveling gear—staff, water gourd, and purse—the travelers' spirited discussion is emphasized by their lively stride.

In the lower register, Christ appears to Mary Magdalene, who, according to the Gospel of John, stood weeping outside Jesus' empty tomb. Seeing Christ and thinking he was the gardener, she said, "If it is you, sir, who removed him, tell me where you have laid him, and I will take him away." Jesus said, "Mary!" She turned to him and said, "Rabbuni!" [Hebrew for "My Master"]. Jesus said, *Noli me tangere* [Do not touch me] for I have not as yet ascended to the Father" (John 20:11–17). The drama of both these narratives is effectively conveyed through the vigorous, elongated bodies, gesturing heads, and large hands. The swirling drapery with pearled borders similarly emphasizes the action. The plaque was part of a larger composition representing scenes from the life of Christ, yet its context remains unknown.

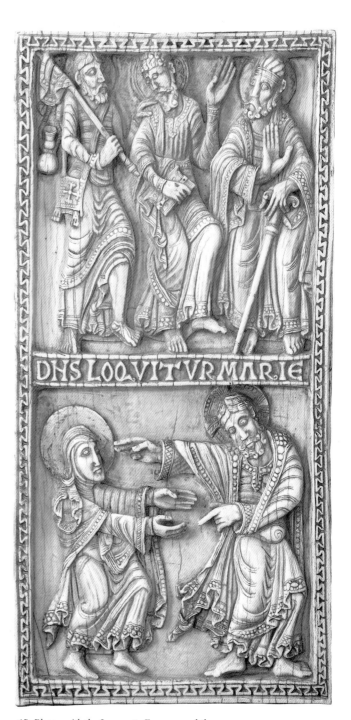

45 Plaque with the Journey to Emmaus and the
Noli Me Tangere
North Spanish (León), ca. 1115–20
Ivory; 10⅝ x 5¼ in. (27 x 13.2 cm.)
Gift of J. Pierpont Morgan, 1917 (17.190.47)

CHRIST IN MAJESTY

This ivory fragment might have come from a pectoral cross, which would have hung from the neck of a prominent Church official. One face depicts Christ Enthroned with the Lamb of God; the other bears two evangelist symbols. This piece dates from the period when a shortage of elephant tusks from Africa and India impelled the use of walrus ivory by northern European artists. While it lacks the fine grain and almost pure white color of elephant ivory, walrus ivory has a mellow golden hue that with years of handling can acquire a rich, glowing patina.

The copper-gilt foil behind Christ augments the rich tone of this piece. Christ's rigid posture—emphasized by the compact rendering of his robe in overlapping, flat planar folds—as well as his alert oval eyes (once inlaid with glass beads), drooping mustache, and segmented beard are all stylistic traits found in contemporary English and northern French manuscript illumination. This international flavor is not unusual in art of this period: Manuscripts were often exchanged between monasteries, where they influenced artistic production, and itinerant artists frequently traveled between England and the Continent, bringing with them different stylistic approaches.

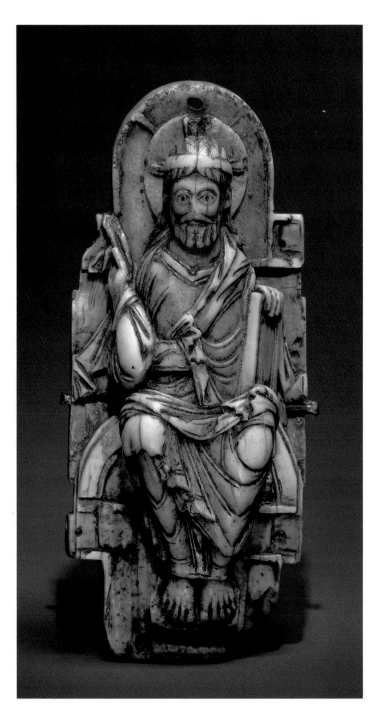

46 Christ in Majesty
Anglo-Saxon, 1000–1050
Walrus ivory; 5⅞ x 2⁷⁄₁₆ in.
(14.9 x 6.2 cm.)
Gift of J. Pierpont Morgan,
1917 (17.190.217)

PORTION OF A CROSIER SHAFT

This luxuriously carved shaft probably formed the upper portion of a bishop's crosier. These pastoral staffs adapted their form from that of shepherds' crooks, since Christ—and therefore his bishops—characterized themselves as shepherds of the Christian flock. The use of a material as precious as ivory indicates this crosier's origins in a wealthy bishopric. The shaft is divided into four bands depicting the celestial and terrestrial realms—the two central bands contain rejoicing angels who mediate between the earthly scene below and the heavenly visions above. The lower band illustrates the installation of a bishop—a most appropriate subject for a crosier. At the top, images of the Virgin and Child and of Christ are shown enthroned within honorific almond-shaped frames called mandorlas. Christ's mandorla teems with the tiny figures of the elders of the Apocalypse, who, according to the Book of Revelation (4:4–10), surrounded "the One who sits on the throne" on "twenty-four other thrones" dressed in "[robes of] white and wearing crowns of gold." The refined, animated style of this crosier shaft—densely populated with lively figures clothed in flowing, often windswept drapery—is a tour de force of Romanesque ivory carving.

47 Portion of a Crosier Shaft
North Spanish, late 12th c.
Ivory; H. 11¼ in.
(28.6 cm.), D. 1⅜ in. (3.5 cm.)
The Cloisters Collection, 1981 (1981.1)

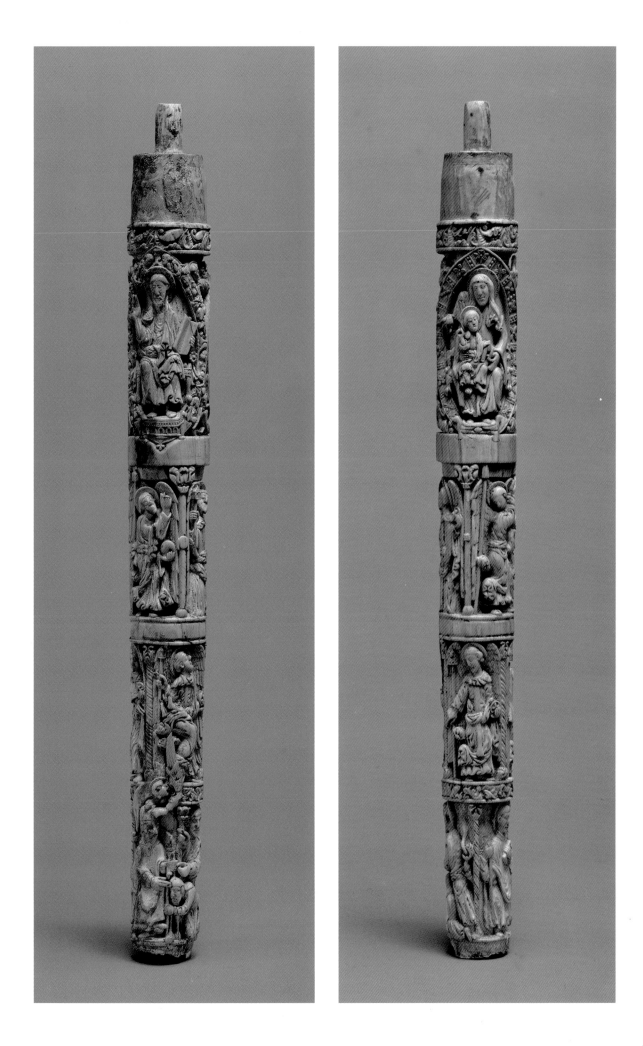

THE CLOISTERS CROSS

48 The Cloisters Cross
English (Bury Saint Edmunds?),
mid-12th c.
Walrus ivory; 22⅝ x 14¼ in. (57.5 x 36.2 cm.)
The Cloisters Collection, 1963 (63.12)

Opposite: back view

This mid-twelfth-century cross, which is carved on both sides, is assembled from five pieces of walrus ivory. Probably intended as an altar cross, its complex imagery centers on the promise of salvation through Christ's sacrifice. The front shows the cross as the Tree of Life, with holes still visible where the hands and feet of the missing body of Christ were originally attached. In the center medallion, Moses is shown raising the brazen serpent, an Old Testament event widely thought to prefigure, or foretell, the Crucifixion. In the square ends of the arms are represented: the Resurrection and the Three Marys at the Tomb in the left end, the Deposition and the Lamentation in the right end, and the Ascension at the top end of the cross. Just below the Ascension, Pontius Pilate and the high priest Caiaphas argue about the title on the cross. At the foot of the cross, Adam and Eve rise from the grave, grasping the tree in recognition of Christ's sacrifice to redeem mankind from their sin.

The back of the cross is carved with eighteen prophets, all holding scrolls inscribed with Old Testament quotations,

56

which were interpreted from the time of the Gospel writers onward as prophecies of the events related to the Passion of Christ. The three terminals on the back show symbols of the evangelists Mark, Luke, and John; the now-missing symbol for Matthew was originally at the base. The center medallion shows the Lamb of God pierced by the spear of the figure of Synagogue, with Saint John weeping. An angel holds a text from the Apocalypse that refers to the slain Lamb of God. The inscriptions, highlighted in green paint and running down the front and sides of the cross, also emphasize the prefiguration of the events of the New Testament by those in the Old—a theme of increasing interest during the twelfth century. The more than one hundred small figures are carved in extraordinarily high relief, their animated movements and gestures enlivened by clinging draperies. The sophistication of style and theological imagery suggests that the cross, among the finest in Romanesque art, was produced at the Abbey of Bury Saint Edmunds in eastern England, a thriving monastic center in the twelfth century.

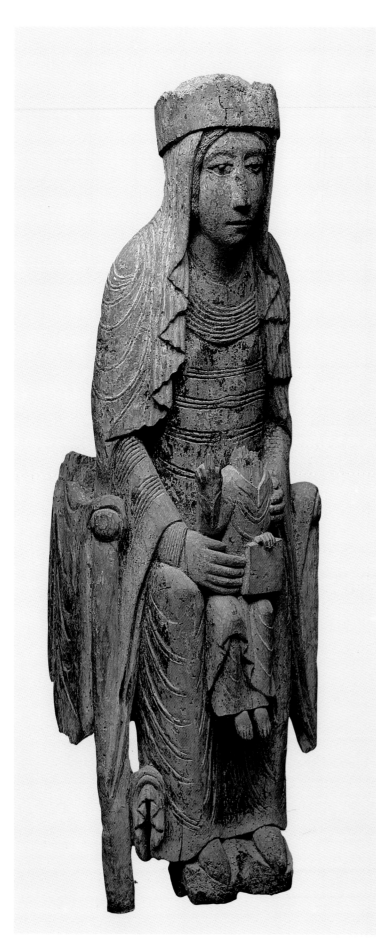

49 Enthroned Virgin and Child
French (Burgundy, Autun?), 1130–1150
Birch and polychromy; H. 40½ in. (102.9 cm.)
The Cloisters Collection, 1947 (47.101.15)

THREE ROMANESQUE SCULPTURES

The great ecclesiastical building programs of Romanesque France stimulated a new emphasis on architectural decoration. Itinerant artists often transported the styles employed at one site to new buildings, influencing not only exterior sculptural decoration, but three-dimensional works intended for veneration inside the church as well. These three works exemplify this diffusion of style. The relief of a half-length figure (Plate 51) probably comes from the west portal sculpture of the powerful abbey church at Cluny in Burgundy. In its original state, it probably looked much like the angel from the Cathedral of Saint-Lazare (Plate 50), carved in extraordinarily high relief against a stone voussoir, one of a series of wedge-shaped stones from which an arch is assembled. The sculptors trained at Cluny probably traveled to Autun, where the cathedral was begun in about 1120 as a shrine for the relics of Lazarus, whom Christ raised from the dead. The angel from Autun, thought to have come from the side doorway (demolished in 1766)—which depicted the Raising of Lazarus and the Temptation of Adam and Eve—may have once held a censer like those on the doorway from Moutiers-Saint-Jean (Plate 81). Its execution is almost a drawing in stone: The elongated proportions; the thin drapery, fluttering at the hem, with folds indicated by fine calligraphic lines; the beaded borders; and the feathered wings make the angel appear to be in flight. This energy and animation is characteristic of the sculptural program at Autun, with which the name Gislebertus is associated. The inscription *Gislebertus Hoc Fecit* appears in the center of the Last Judgment scene on the western portal and is believed to be the signature of the artist responsible for the church's sculptural decoration. The prominent position of the signature suggests not only Gislebertus's pride in his artistry but also his contemporaries' recognition of his preeminence among sculptors.

The Enthroned Virgin (Plate 49) also demonstrates the influence of Gislebertus's style. She is carved with the same attenuated form, the same linear quality, the same treatment of thin drapery with folds indicated by parallel ridges set close together, the same upward swirl of the garments at the hem as if blown by a sudden gust of wind. Her heavy-lidded eyes (one of which still retains an inset piece of lapis lazuli), straight mouth, and softly modeled oval face with tiny chin are similarly characteristic of Gislebertus's style. Originally completely polychromed, the statue was carved from a single block of birch—only the Christ Child's head (now missing) was attached with a dowel. Her slightly turning pose and human, compassionate expression lend this Virgin a softness absent in the frontal rigidity of the sculpture of the same type from the Auvergne (Plate 52).

50 *Angel*
French (Autun, Cathedral of Saint-Lazare),
ca. 1135
Limestone; 23 x 16½ in. (58.4 x 41.9 cm.)
The Cloisters Collection, 1947 (47.101.6)

51 *Fragment of an Angel*
French (Cluny), 12th c.
Limestone; H. 13¾ in. (34.9 cm.)
The Cloisters Collection, 1947
(47.101.16)

O V E R L E A F :

ENTHRONED VIRGIN AND CHILD (*Page 60*)

Like the Spanish fresco painting (Plate 55) and the French wooden sculpture from Autun (Plate 49), both of which represent the Enthroned Virgin and Child, this majestic sculpture portrays the Virgin as the Mother of God, the Throne of Divine Wisdom. Accordingly, one of the child's hands would have originally held a scroll or rested upon a book (as in the Autun Virgin and Child), symbolizing the imparting of knowledge through the Word of God. Christ's humanity and divinity are thus both revealed: As a child he sits upon his mother's lap, while as God he reveals the path to salvation. The abstract, conceptual basis of this piece is effectively expressed by the figures' rigidly frontal poses and stern, expressionless faces. The crisply chiseled drapery folds create a rich, calligraphic surface pattern that reinforces this hieratic function. Some original paint survives, and recent studies have revealed a small cavity behind the Virgin's shoulder that once would have held a relic. This type of sculpture inspired intense popular devotion. Not only would it have been venerated while displayed upon an altar, but it would also have been carried in processions and used to represent Mary and the Christ Child in liturgical dramas, such as in performances retelling the story of the Three Wise Men. Thus the image maintains an iconic function, making visible the divine character of Mother and Son.

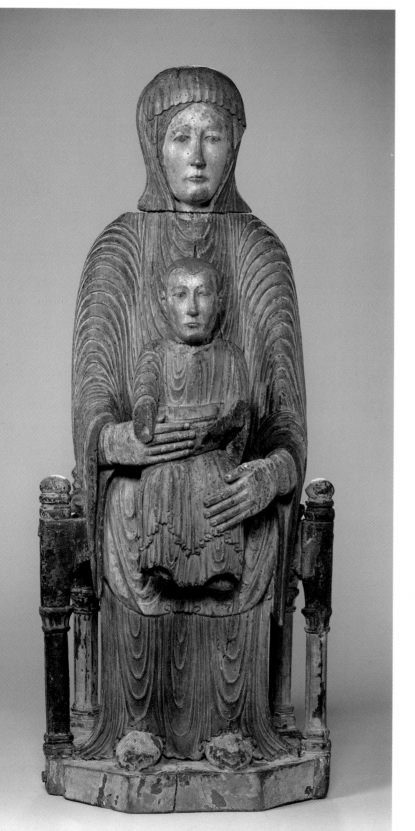

CHAPTER HOUSE FROM NOTRE-DAME-DE-PONTAUT

"Whenever any important business has to be done in the monastery, let the abbot call together the whole community and state the matter to be acted upon." So Saint Benedict began Chapter Three of his *Rule for Monasteries.* The chapter house was devised to facilitate such meetings. Usually located off the cloister, chapter houses, such as this example, were generally rectangular in shape and furnished with stone-hewn benches encircling the room.

53 Chapter House
French
(Abbey of Notre-Dame-de-Pontaut), 12th c.
Limestone and brick; interior: 42 x ca. 33 ft.
(12.8 x 10.06 m.)
The Cloisters Collection, 1935 (35.50.; 35.51)

The abbot sat on a separate, often raised, seat. The room was illuminated by windows on the rear wall, as well as by the arcades at the entrance. This view of the Pontaut Chapter House shows the entrance from the cloister. Originally the interior walls were plastered and perhaps painted. (Some color can still be seen on the ribs of the vaults.) The decorations of the capitals and abacus blocks are imaginatively varied and include the rosette, palmette, and basketweave patterns as well as carvings representing pinecones.

Like many other church buildings, the abbey of Pontaut suffered from changing political fortunes and neglect: It was partially destroyed in 1569 during the Protestant Reformation and was abandoned by 1791 in the aftermath of the French Revolution. By the nineteenth century, the chapter house was being used as a stable, and it fell into a dilapidated condition until its purchase in the early 1930s.

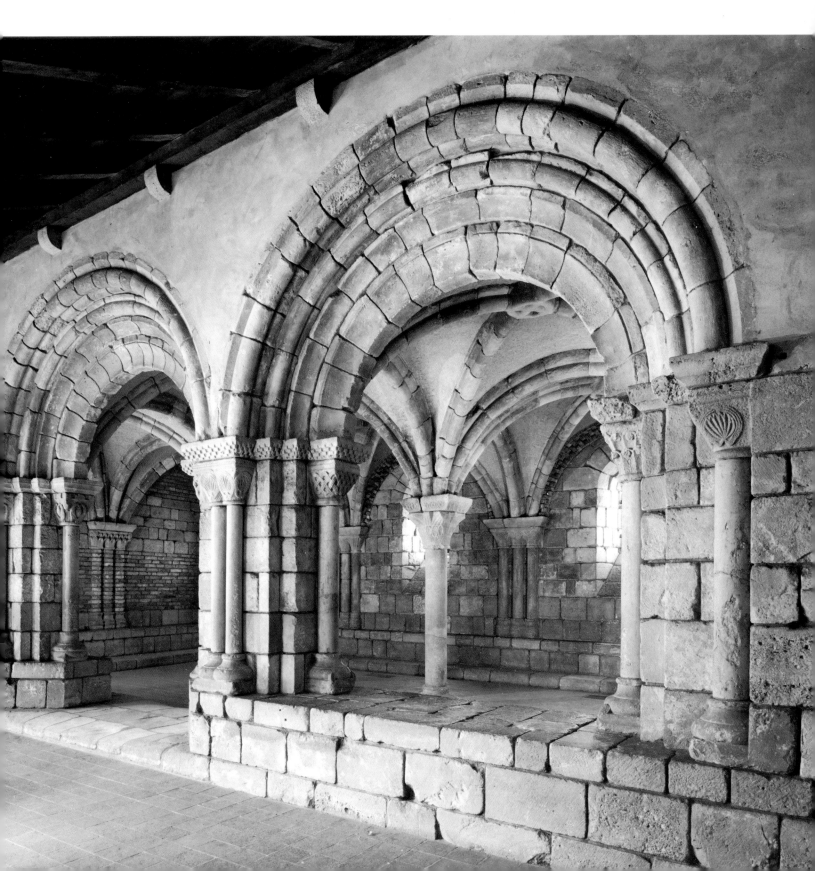

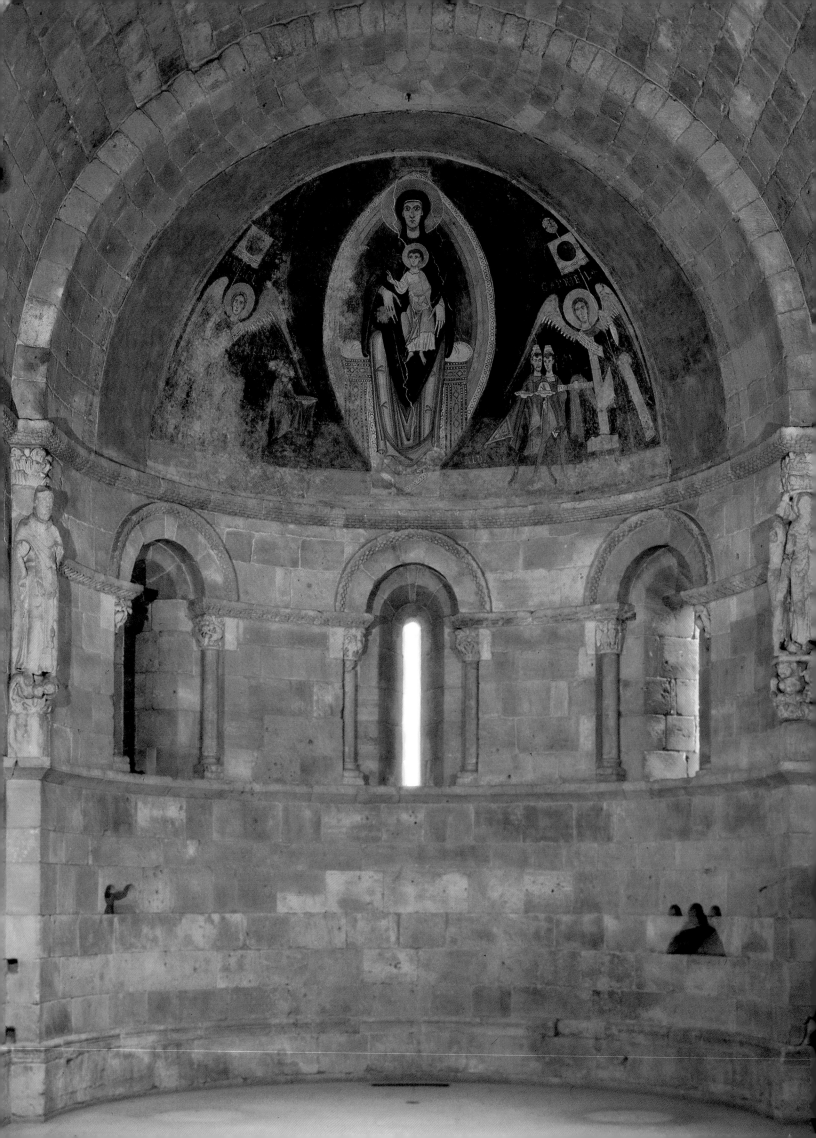

ARCHITECTURE

54 Apse
Spanish (Fuentidueña, Segovia, church of San Martín), 1175–1200
Limestone; H. to top of barrel vault: 29 ft. 8½ in. (9.05 m.)
W. interior max. 22 ft. ½ in. (6.72 m.)
Exchange loan from the Government of Spain, 1958 (L.58.86)

FRESCO

55 Enthroned Virgin and Child with Saints Michael, Gabriel, and the Three Magi
Spanish (Catalonia, Church of San Juan de Tredós), 12th c.
Fresco; H. at center 10½ ft. (3.06 m.)
The Cloisters Collection, 1950 (50.180a-c)

Right: detail

SPANISH APSE AND FRESCO

The apse, or rounded end of a church that usually faced east, was the building's most sacred space. Because it contained the altar, this was the site where the Mass was performed. The majestic apse in Plate 54 comes from the church of San Martín in the Spanish village of Fuentidueña, about seventy-five miles north of Madrid. Constructed of some three thousand massive blocks of golden limestone, the apse is composed of a graceful arch and semicircular barrel vault surmounted by a half dome. This architectural system is ultimately of Roman origin, and by virtue of this derivation, the style it exemplifies is now referred to as the Romanesque. The small, unglazed windows and the fortresslike walls contribute to the feeling of austerity and strength that is typical of Romanesque churches. Sculpted capitals illustrating biblical stories and fantastic animals, in combination with intricate bands of interlace and floral patterns that ring the circumference of the apse and the window arches, enliven the wall space in a lively counterpoint of light and shade. This sculptural decoration is joined by two long column statues—perhaps originally intended to flank a portal—representing the Annunciation and the church's titular saint, Martin of Tours.

The great expanse of wall space in churches of this period was often decorated with fresco paintings, such as the representation here of the Virgin and Child Enthroned in Majesty, originally in a smaller apse in the church of San Juan de Tredós in the Catalonian Pyrenees. Fresco, meaning "fresh," was produced by applying paint directly onto wet plaster. An extremely durable technique, fresco painting demanded a sure and nimble hand on the part of the artist: A misapplication of the brush doomed the painter to scraping off the marred plaster and starting anew. This fresco shows the Virgin as the Mother of God—severe, remote, and transcendent. As she and Christ are the most important figures, they are the largest. Second in this divine hierarchy are the archangels Michael and Gabriel, shown bearing imperial standards; the Three Wise Men, being mortal, are the smallest. Each magus is labeled and wears a small hat more Byzantine in feeling than the crowns traditionally seen in Western representations.

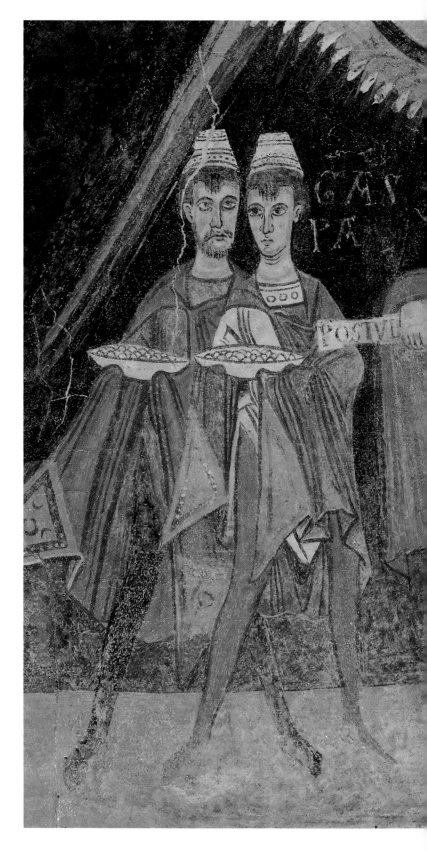

ENAMEL RELIQUARY CHASSE

This enameled chasse once belonged to the church at Champagnat, a village located outside the city of Limoges—a thriving center of enamel production during the Middle Ages. Champlevé enamel, such as that used here, is made by scooping out hollows in a copper plate and filling them with ground glass. The plate is fired in a kiln until this glass paste is liquefied, and then it is gradually cooled. The bright colors and durability of this medium made it extremely popular. The front of the chasse shows Christ enthroned between the Virgin Mary and Saint Martial—the first bishop of Limoges. The local belief in Saint Martial as a member of the company of apostles and witness to many of Christ's miracles accounts for his exceptional placement. On the reverse are shown the symbols of the four evangelists, each clasping his Gospel text. The richly ornamented effect, with its wide range of blues and greens, is elaborated by the extensively worked foliage in the center, springing, in the case of the lower panel, from fantastic beasts with human faces.

SPANISH CRUCIFIX

According to tradition, this crucifix hung in the convent of Santa Clara near Palencia in northern Spain. The figure of Christ, crowned as the King of Heaven, is made of white oak; the cross is made of pine. Parchment was placed over the wood in places, covering joints to provide a smooth surface on which to lay a thin coat of gesso. This chalky, plaster base prevented paint from seeping into the untreated grain of the wood and, in some places, was thickly applied and modeled to produce finer details than could be achieved by carving. Like the carving, the color scheme is simple and direct. Christ's hair and beard are black, his diadem is gold, studded with painted red and green jewels, and his loincloth, once blue, is bordered in gold. The cross itself, which retains most of its original paint, is dark green with a border that has been gilded and painted so as to appear gem studded. The dignity and spirituality of this work make it one of the finest surviving examples of this type of crucifix.

56 Chasse of Champagnat
French (Limoges), ca. 1150
Copper gilt and champlevé enamel;
4⅞ x 7⁷⁄₁₆ x 3⅜ in. (12.4 x 18.9 x 8.5 cm.)
Gift of J. Pierpont Morgan, 1917
(17.190.685–87, 695,710–11)

Below: back view

57 Crucifix
Spanish (Palencia, Convent of Santa Clara de
Astudillo), 1150–1200
Cross: red pine and polychromy; *Christ:* white oak
and polychromy; 8 ft. 6½ in. x 6 ft. 9¾ in.
(2.6 x 2.07 m.)
Samuel D. Lee Fund, 1935 (35.36 a,b)

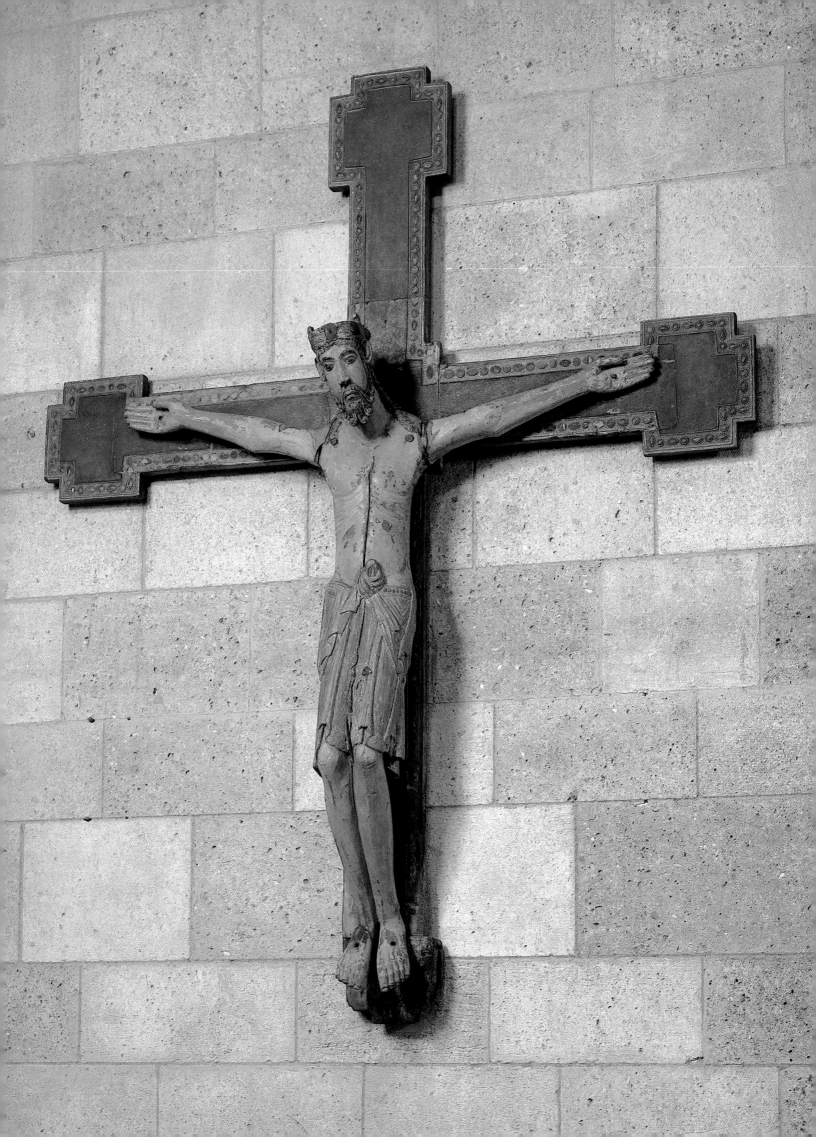

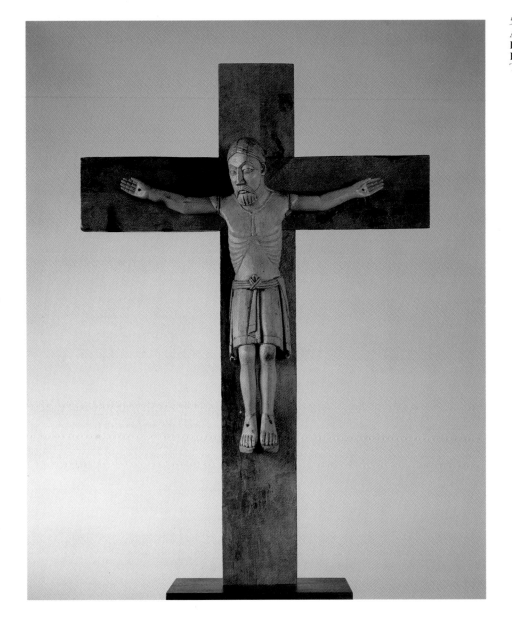

58 Christ on the Cross
Austrian (Tirol, Salzburg?), 1125–50
Lindenwood and fir with traces of polychromy;
H. cross (before restoration) 29¼ in. (74.3 cm.)
The Cloisters Collection, 1984 (1984.129)

59 Arch
French (Narbonne), 1140–75
Marble; 74 x 40 in. (188 x 101.6 cm.)
The Cloisters Collection, 1922 (22.58.1)

Opposite above: detail

CHRIST ON THE CROSS

Like the Spanish processional cross and large wooden crucifix in Plates 44 and 57, this Germanic Crucifixion emphasizes Christ's victory over death. His head slightly turned and his eyes open and alert, the figure was once crowned to represent Christ as the King of Salvation. Wearing a rigid, centrally knotted loincloth, he stands symmetrically positioned on the cross by means of a foot rest, or *suppedaneum*. The geometric, planar treatment of Christ's body and facial features is distinctly Germanic. Every element is reduced to its essential form, giving the work a heightened abstractness. The firm, bold carving style was further accented by paint, little of which survives on the figure. The cross, however, retains more of its original color. It was painted with alternating bands of azurite blue and vermilion red on the arms and shaft. Its back was painted with the same design in gray and black. Such representations of Christ as the Triumphant Redeemer stand in strong contrast to later depictions, which emphasize the suffering of Christ hanging from the cross.

MARBLE ARCH FROM NARBONNE

The collection of animals that decorates this twelfth-century arch functions like a stone counterpart to a bestiary. Such compilations presented an enchanting mixture of fact and fancy to which were added interpretations of natural phenomena that served as moral and religious lessons. Looking from left to right, the manticore, basilisk, harpy, griffin, centaur, and lion are among the animals represented. The manticore, with the face of a man, the body of a lion, and the tail of a scorpion, is a vicious creature with a lyrical, flutelike voice. The basilisk is so frightful it can kill merely by a look or hiss. The harpy, a birdlike creature with a human head, lures sailors to their doom with its beautiful voice. The griffin, with the body of a lion and the wings, head, and beak of an eagle, feasts upon men. The centaur, with the body of a horse and the arms and head of a man, is a creature of great intelligence, yet is ruled by animal passions. The lion is shown crowned as the king of beasts. Each animal is compactly designed to fill the space it occupies and expertly carved to form a richly patterned and harmonious whole.

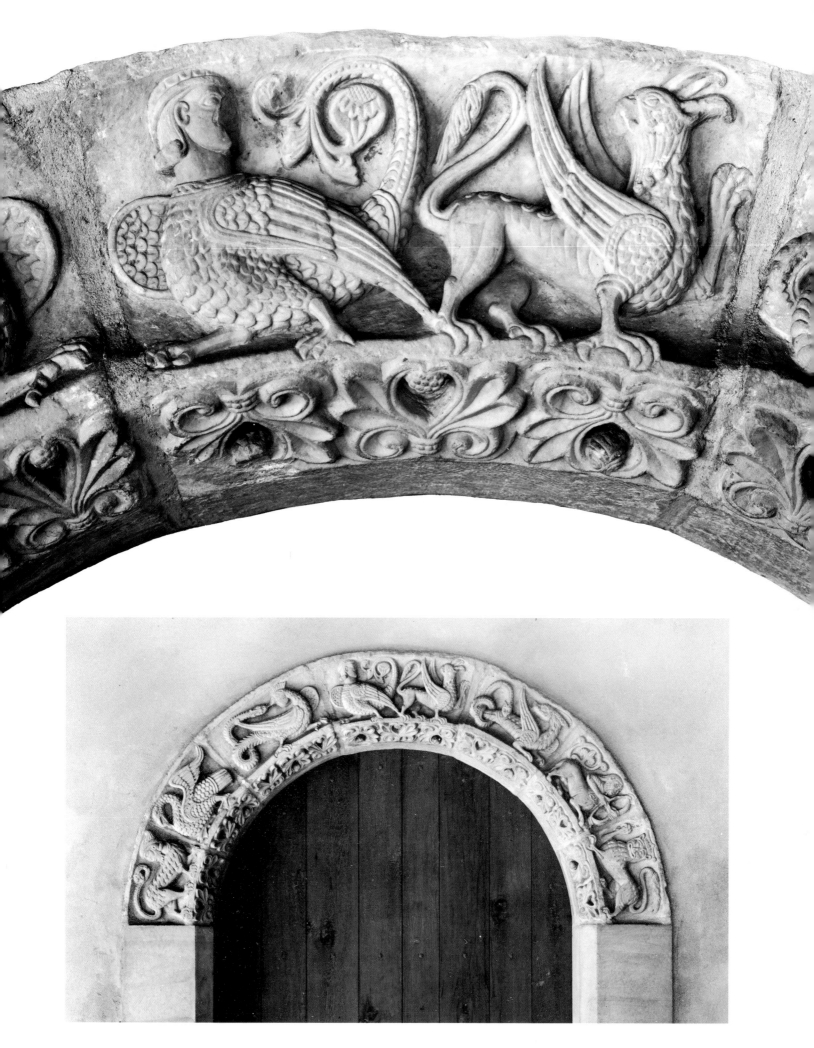

The Cuxa Cloister

The Benedictine monastery of Saint-Michel-de-Cuxa, located at the foot of Mount Canigou in the northeast Pyrenees, was founded in 878. In 1791, when France decreed the Civilian Constitution of the Clergy, Cuxa's monks departed; the monastery's stonework was subsequently dispersed. Nineteenth- and twentieth-century studies have determined that the monastery's cloister, built during the twelfth century, once measured some 156 by 128 feet, or approximately twice its current size at The Cloisters, much of whose architecture is modern.

The cloister was the heart of a monastery. By definition, it consists of a covered walkway surrounding a large open courtyard, with access to all other monastic buildings. Usually attached to the southern flank of the church, a cloister was at the same time passageway and processional walkway, a place for meditation and for reading aloud. At once serene and bustling, the cloister was also the site where the monks washed their clothes and themselves.

The warm beauty of the pink marble used at Cuxa harmonizes this cloister's many elements, such as the varied capital sculptures carved during different periods in its construction. Some of these are fashioned in the simplest of block forms, while others are intricately carved with scrolling leaves, pinecones, animals with two bodies and a common head (a special breed for the corners of capitals), lions devouring people or their own forelegs, or a mermaid holding her tail. While many of these motifs may derive from popular fables or depict the struggle between the forces of good and evil, the conveyance of meaning seems to have been less important for the Cuxa artists than the creation of powerful works capturing the energy and tension between the forms depicted.

60 The Cuxa Cloister
French (Roussillon, Monastery of int-Michel-de-Cuxa), ca. 1130–40
Marble
The Cloisters Collection, 1925
(25.120.398, 399, 452, 547–589, 591–607, 609–638, 640–666, 835–837, 872c,d, 948, 953, 954)

OVERLEAF:

Two Italian Church Portals *(Pages 70–71)*

The use of Late Roman architectural and sculptural elements and the adaptation of antique forms in these two church portals demonstrate the revival of interest in Late Antique and Early Christian art that marked the Romanesque period. The San Leonardo portal (Plate 62) is composed of side posts cut from an antique sarcophagus and recarved with Christian imagery. The Annunciation and the Visitation decorate the left jamb, while a full-length representation of the church's titular saint, Leonard (thought to have lived in the early sixth century), occupies the right. The patron saint of prisoners, Leonard is portrayed grasping a small shackled man, signifying his benevolence. The surmounting lintel illustrates Christ's entry into Jerusalem (Matthew 21:1–11). On the right, Christ rides an ass led by an apostle, as boys spread their cloaks before him or scramble into nearby trees to catch a glimpse of the event. The apostles who follow are miraculously joined by

Saint Leonard, dressed in clerical garb and bent over his staff. The effect of a continual frieze is indebted to the similar treatment on Early Christian sarcophagi (see Plates 10, 11), fragments of which were plentiful in the region.

The San Nicolò doorway is a composite of pieces of varying styles and dates, joined together during a later medieval renovation to form the main portal of an abbey church in southern Umbria. Antique fragments are reused at the portal's base, as well as in the lintel and arch. The two lions of different origins guarding the entrance are most likely older than the rest of the sculpture. While not as sophisticated as the lintel of the San Leonardo doorway, the carvings on the San Nicolò jambs and lintel were also inspired by Classical models: The acanthus-leaf motifs, inhabited foliage vines, and egg-and-dart moldings all have their origins in antiquity. While awkwardly joined, these disparate elements create a sense of lively decorative expression.

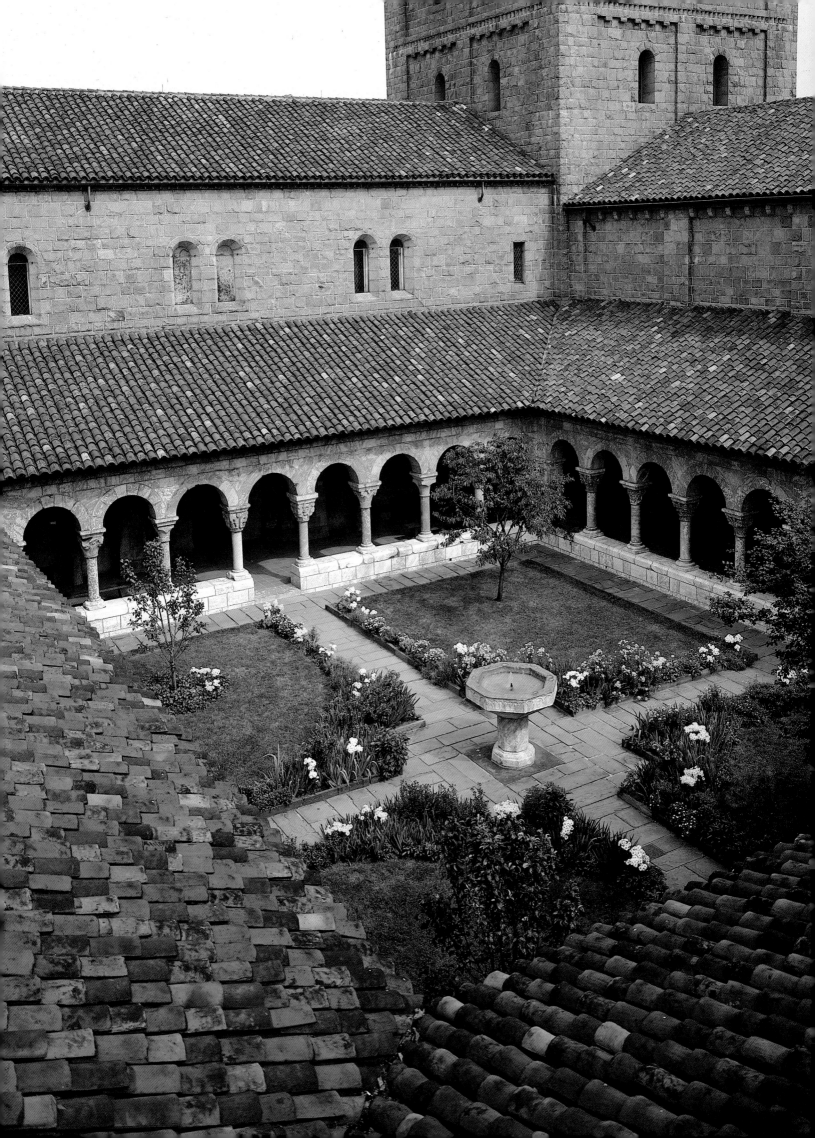

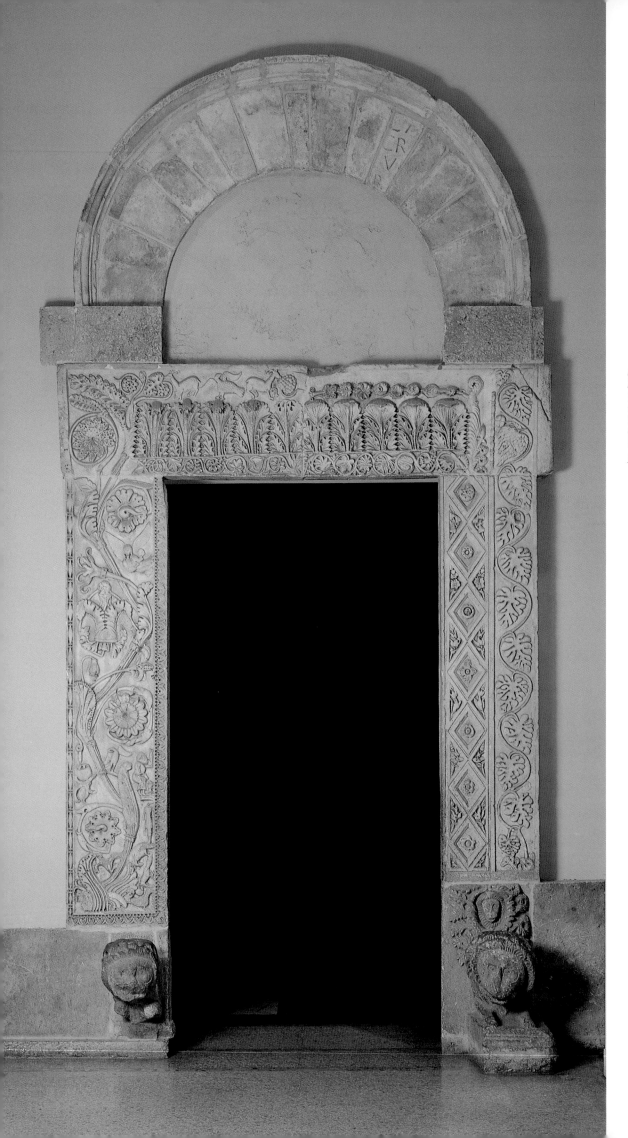

*61 Portal from the Church of
San Nicolò, Sangemini*
Italian (Umbria), 11th c., with later
reconstruction
Marble; 11 ft. 9 in. x 8 ft. 4 in.
(3.58 x 2.54 m.)
Fletcher Fund, 1947 (47.100.45 a–c)

Page 68: text

*62 Portal from the Church of
San Leonardo al Frigido*
Italian (Tuscany, Frigido,
near Massa Carrara), ca. 1175
Marble; 13 ft. 2 in. x 6 ft. 4 in.
(4.01 x 1.93 m.)
The Cloisters Collection, 1962
(62.189)

Page 68: text

Holy Water Font
(to the left of the portal)
Italian (Tuscany), late 12th c.
Marble; H. 9½ in. (24.1 cm.),
D. 15 in. (38.1 cm.)
The Cloisters Collection, 1964
(64.96)

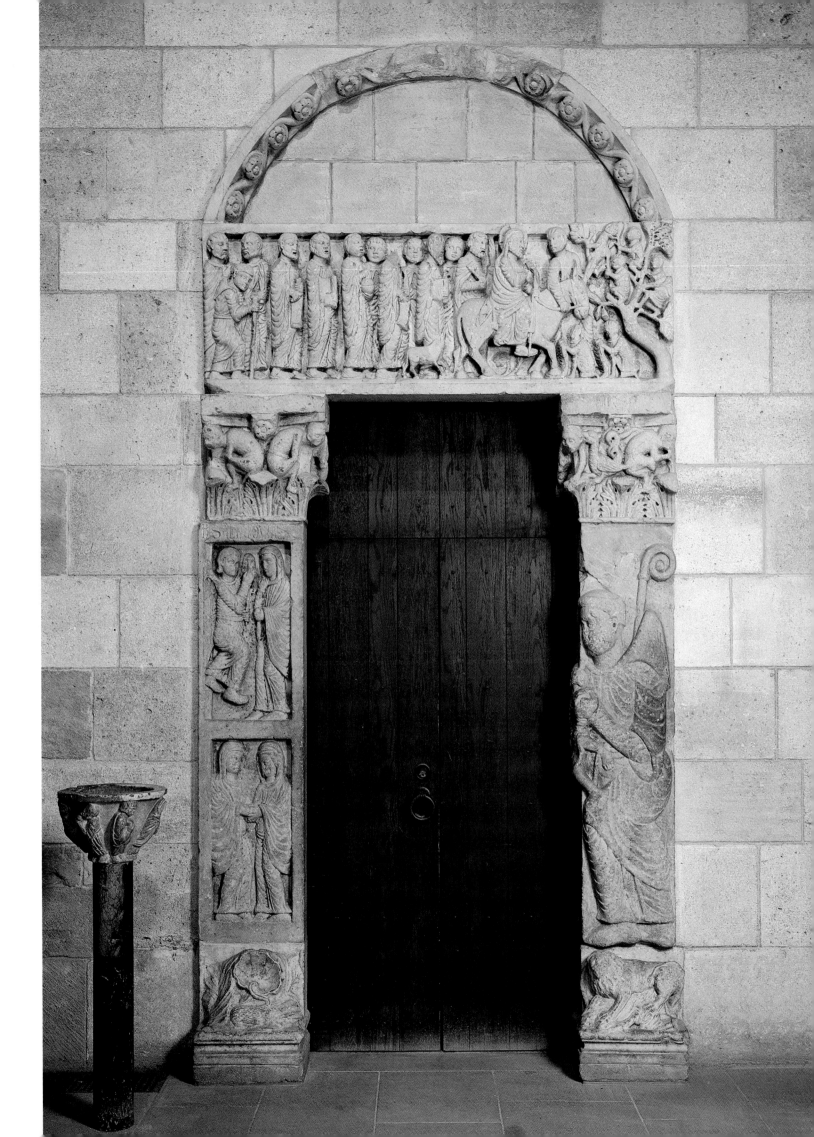

Two Early Gothic Sculptures

The portrayal of Christ's royal genealogy perhaps found its greatest expression in French architectural sculpture. Produced at the commencement of the great age of Gothic cathedrals, these two representations of Christ's biblical ancestors embody the forceful majesty evoked by such sculptural groups. The column statue of a king (Plate 64) was originally located in the cloister of the Royal Abbey of Saint-Denis, just outside Paris. The head of King David (Plate 63), a fragment from a similar full-length sculpture, was positioned in a group flanking the doorway of the right portal on the western facade of the Parisian cathedral of Notre Dame. Their original location and appearance are recorded in eighteenth-century drawings.

Dignified yet impassive, both figures exhibit a vertical rigidity due in part to the diagonal cut of the statues into the squared length of the original stone blocks. The sculptures were attached along their entire axis to a column, the arms and hands likewise subjugated to the initial shape of the block. This verticality is enhanced by the thin, pleated drapery folds of the Saint-Denis king's robes and the long, incised hair and beard seen on both kings. The original painted stone surfaces were enlivened by simulated jeweled decoration. For example, the collar and border of the Saint-Denis king's robe and the crowns of both statues would have been inset with stones to effect a brilliant appearance.

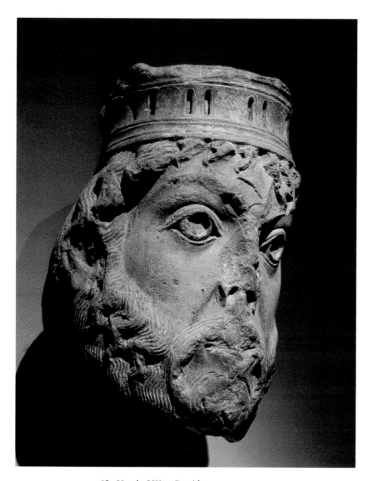

63 Head of King David
French (Paris, Cathedral
of Notre Dame), ca. 1150
Limestone; H. 11¼ in. (28.6 cm.)
Harris Brisbane Dick Fund, 1938
(38.180)

PANEL WITH CENSING ANGELS

Dating from the last quarter of the twelth century, this representation of censing angels surrounded by a luminous green background, once part of a window dedicated to the Dormition (death) of the Virgin, is one of the earliest examples of stained glass in the Museum's collection. Its meticulous painting style departs from that usually found in stained glass of the period. At least three coats of mat wash were added to the precise trace-lines to render and model the figures' faces and drapery. This practice of building form with successive coats of paint, as well as the graphic precision and use of a stylus for highlighting, is more characteristic of the work of an enamel worker or manuscript illuminator than of a glass painter. While the crisp, calligraphic handling of the figures remains rooted in the Romanesque aesthetic, a new spatial and corporeal awareness looks forward to glazing innovations of the thirteenth century.

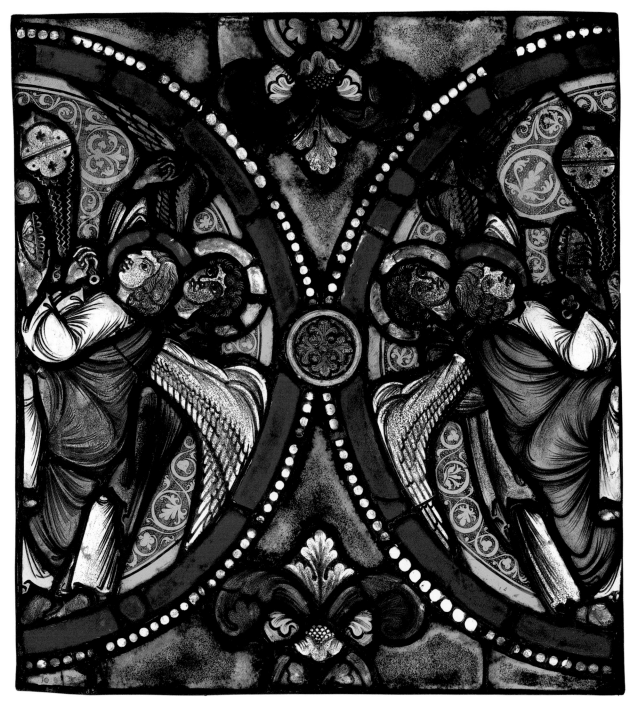

64 Column Figure of a Nimbed King
French (Ile-de-France,
Abbey of Saint-Denis), ca. 1150–60
Limestone; H. 45¼ in. (115 cm.)
Purchase, Joseph Pulitzer Bequest,
1920 (20.157)

65 Panel with Censing Angels
French (Troyes, Collegiate Church of
Saint-Étienne), ca. 1170–80
Pot-metal glass with vitreous paint;
18½ x 17⅜ in. (47 x 44 cm.)
Gift of Ella Brummer, in memory of her
husband, Ernest Brummer, 1977 (1977.346.1)

73

Plaque Showing the Pentecost

Traditionally renowned for their production of outstandingly beautiful works in champlevé enamel, artists of the Meuse valley (in modern-day France and Belgium) created this plaque illustrating the Pentecost. According to the Book of Acts 2:2–4, Christ's apostles had gathered together fifty days after Easter, when "suddenly there came a sound from Heaven as of a rushing mighty wind, and it filled all the house where they were sitting. And there appeared unto them cloven tongues like as of fire, and it sat upon each of them. And they were all filled with the Holy Ghost and began to speak with other tongues, as the Spirit gave them utterance." This depiction of that miraculous event shows the hand of God appearing to the disciples; Peter, holding keys to the Kingdom of Heaven, is seated in the center of the architectural setting, with only five other apostles beside him. (The other six are suggested by partially visible halos.) Each face is individually characterized—an unusual and forward-looking way of heightening the sacred drama. A rich and varied spectrum of colors—more than twelve hues appear—further enlivens the delicate, animated style of engraving. The play of light upon such colorful imagery gives the plaque the aura of a sparkling jewel. The crowning piece of a number of Mosan enamels in the Museum's collection, this work was part of an extensive series of plaques that once decorated a single large object, perhaps an altarpiece or pulpit.

66 *Plaque Showing the Pentecost*
Mosan, 1150–75
Champlevé enamel on copper gilt;
4½ x 4½ in. (11.4 x 11.4 cm.)
The Cloisters Collection, 1965 (65.105)

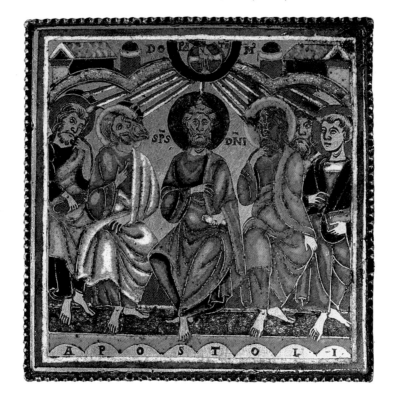

67 Reliquary Triptych of the True Cross
Mosan, ca. 1160
Champlevé enamel on copper gilt;
closed: 11½ x 6¾ in. (29.2 x 17.2 cm.)
Anonymous Loan (L. 1979.138.3)

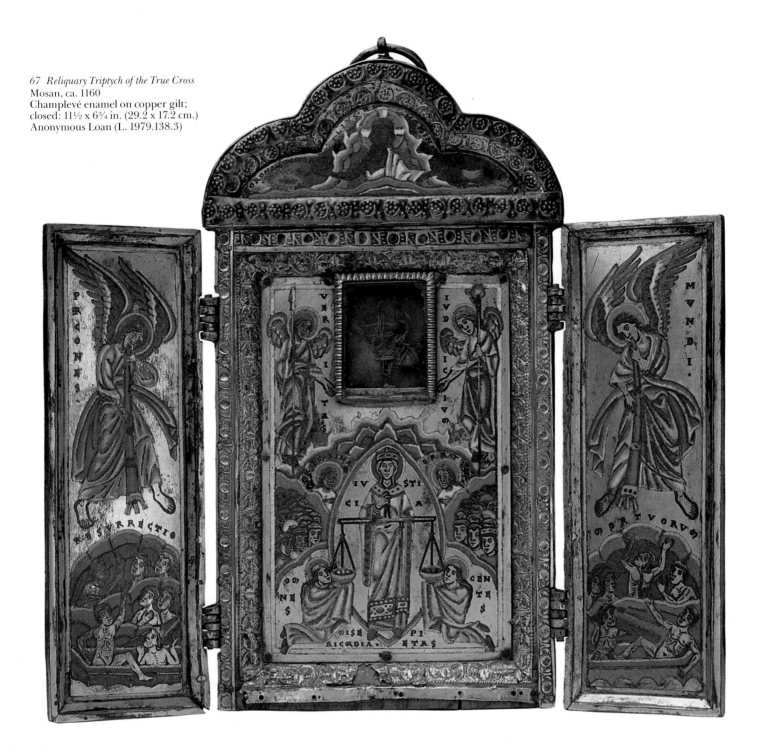

RELIQUARY TRIPTYCH OF THE TRUE CROSS

The continued proliferation of relics of the True Cross during the twelfth century inspired the creation of reliquaries of profound spirituality and extraordinary beauty. Unlike the Byzantine reliquary of the True Cross (Plate 31), this Mosan reliquary triptych is devotional in format, serving not only as a container for a fragment of the holy wood, but also as a metaphor of the Christian faith. The relic, originally seen through a piece of rock crystal rather than the glass currently installed, is the focal point of the composition. Angels representing Truth and Judgment support the relic window with one hand and hold instruments of Christ's Crucifixion in the other. The crowned figure of Justice stands below, holding her scales balanced with three weights in either pan. At her feet kneel Mercy and Piety. The two figures partially hidden by the clouds represent Almsgiving and Prayer. Below are gathered men of all nations, for whom divine justice was instituted. In the lunette at the top of the reliquary, Christ appears, not as judge but as the redeeming Savior, holding the crown of thorns and the cup of vinegar. On the wings, angels sound the trumpets of the Resurrection, the dead rise from their tombs, and the promise of the Second Coming is fulfilled.

The soft hues of blue, green, and yellow of the champlevé enamel contrast with the more vibrant tonality of the Pentecost plaque (Plate 66). This subtle play of color enhances the fluid figural representations—arranged with masterful symmetry—and emphasizes the relic and the sanctifying powers contained therein.

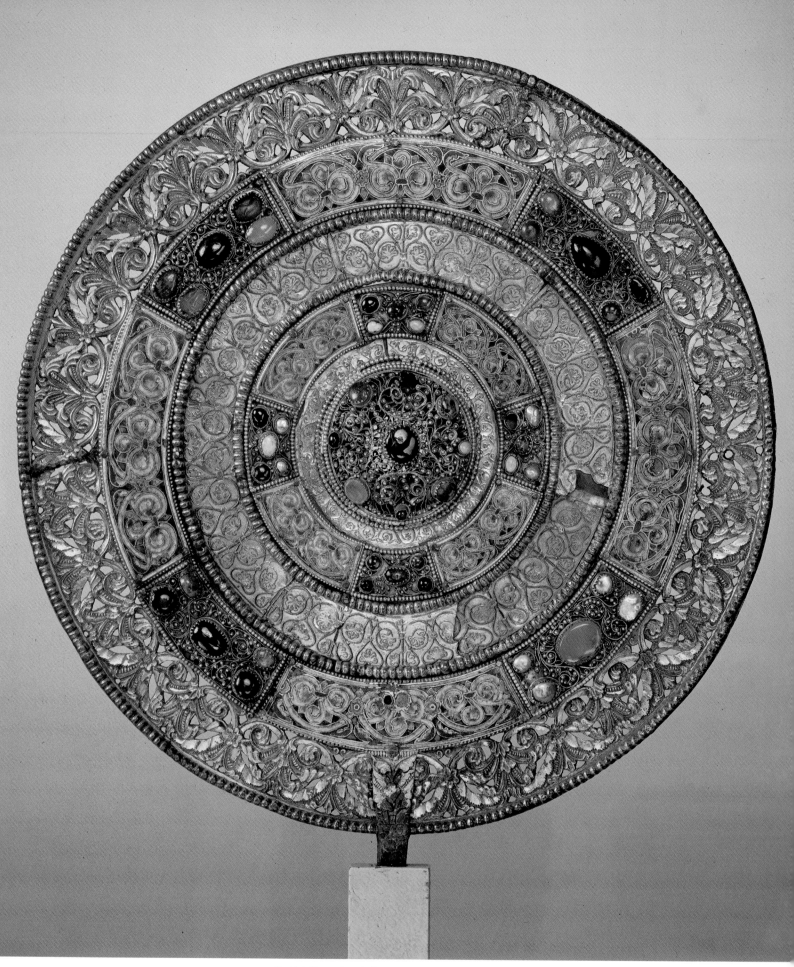

68 Flabellum (Liturgical Fan)
German (Rhineland, perhaps Cologne), ca. 1200
Gilt bronze, champlevé enamel, silver,
semiprecious stones, glass gems; D. 11½ in. (29.2 cm.)
The Cloisters Collection, 1947 (47.101.32)

LITURGICAL FAN

This flabellum, or liturgical fan—created for the practical function of keeping flies off the Eucharist—is a particularly fine example of its type. Originating during the Early Christian period, flabella were first constructed from parchment or feathers and were attached to long shafts to be held by the subdeacon behind the altar during the blessing of the bread and wine. Later, however, as their function became more purely ceremonial, more lavish materials were used in their construction. All that remains of this fan is its head, richly ornamented with concentric bands of silver gilt comprising jeweled and enameled friezes decorated with stylized acanthus-leaf scroll and palmette patterns. The hinged, central boss opens like a door to reveal a compartment that once held a relic.

69 Chalice, Paten, and Straw
German, ca. 1235
Silver, partly gilt, niello, gems; *chalice*: H. 8 in. (20.3 cm.);
paten: D. 8¾ in. (22.2 cm.); *straw*: L. 8½ in. (21.6 cm.)
The Cloisters Collection, 1917 (47.101.26–29)

CHALICE, PATEN, AND STRAW

This set of a chalice, paten, and straw was made for Saint Trudpert's monastery near Freiburg im Breisgau in Germany. These sacred objects, sumptuously ornamented with filigree patterns, gems, and engraved niello images and inscriptions were essential to the celebration of the Eucharist. An increasing reverence toward the Eucharist is reflected in the shape and design of these objects: Unlike earlier chalices, the shallow cup of this example holds only a small amount of wine—indicative of the prevailing practice of reserving communion for the priest. The paten, which held the bread, was designed to fit on top of the chalice, while the straw was used to prevent even a drop of wine from being spilled.

Christ, enthroned with his apostles, is illustrated within the arcades of the chalice's bowl. Below, scenes from the Old Testament on the foot prefigure the events in Christ's life depicted on the central knob. On the paten are juxtaposed the sacrificial offerings of Abel and Melchizedek as told in the Old Testament with those of Christ, shown holding the sacraments; also shown is Saint Trudpert, the monastery's patron saint, holding his palm of martyrdom. The inscriptions further emphasize the theme of salvation through Christ and the celebration of the Eucharist.

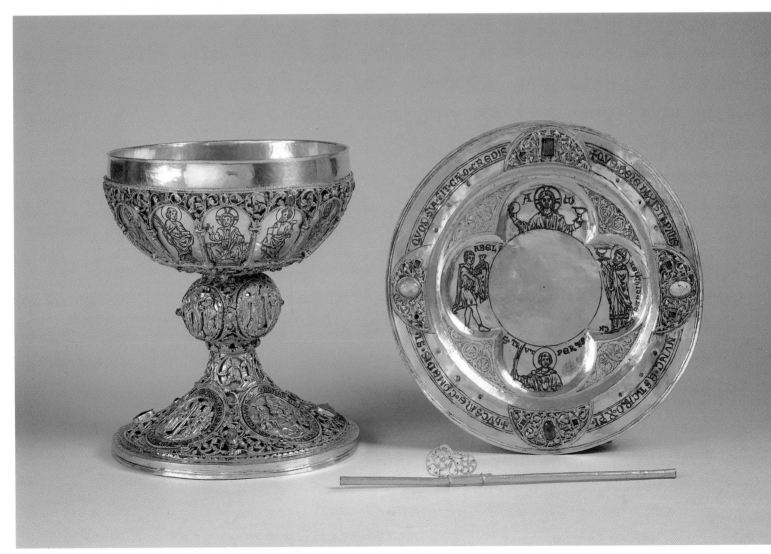

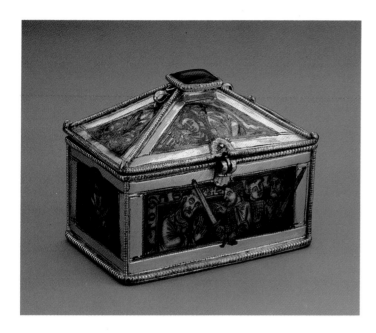

70 *Reliquary of Saint Thomas Becket*
English, ca. 1173–80
Silver gilt, niello, glass;
2¼ x 2¾ x 1¾ in. (5.7 x 7 x 4.4 cm.)
Gift of J. Pierpont Morgan, 1917
(17.190.520)

RELIQUARY OF SAINT THOMAS BECKET

In 1170 Thomas Becket was murdered by soldiers of King Henry II as Becket celebrated Mass in Canterbury Cathedral. This prompted the archbishop's canonization only three years later and a subsequent proliferation of his relics. A fragmented inscription and the compartmentalization of this tiny reliquary indicate its probable use as a container for phials of Saint Thomas's blood. Becket's martyrdom and burial are illustrated on the front and back plaques in niello. Superb craftsmanship is evident in the crisp drawing style, animating both the figures and surrounding floral ornament, as well as in the fine beaded ornament, the hinges, and the glistening red "ruby" (actually pink glass backed by red copper foil) crowning the lid.

BOWL OF A DRINKING CUP

Striding, muscular nudes and fantastic winged beasts entangled within leafy vines decorate this spectacular bowl of a drinking cup. Once believed to be part of a ciborium (a liturgical vessel used to contain the Host), its similarity to twelfth-century drinking cups indicates a probable secular use. Little secular metalwork from this time has survived; most was melted down for its precious materials or due to changes in taste. This remarkable survivor is now missing its foot and has sustained loss in one of the pairs of dragons but is otherwise in superb condition. Though small in size, the figure, entwined in stylized branches and struggling to escape from dragons, is monumental in effect, with all the vitality of the finest Romanesque art.

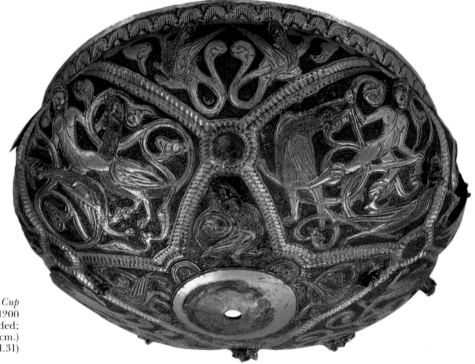

71 *Bowl of a Drinking Cup*
English or northern French, 1175–1200
Hammered silver, engraved, nielloed, and gilded;
H. 2¾ in. (8 cm.), D. at rim 6¾ in. (15.5 cm.)
The Cloisters Collection, 1947 (47.101.31)

Plaque with the Three Holy Women at the Tomb of Christ

This walrus-ivory relief illustrating the visit of the Three Holy Women to the Tomb of Christ was one in a series detailing the Life and Passion of Christ that might have once decorated a pulpit or other church furnishing. The relatively narrow walrus tusks necessitated the use of three pieces for the central composition, which is framed by decorative bands. Like the Early Christian pyxis (Plate 32), this plaque emphasizes the liturgical associations of this biblical event. The first holy woman carries a censer, and the architectural arcades, surmounted by domes and turrets with a hanging lamp, suggest the interior of a church. Yet the biblical narrative is also maintained. The stylized plants in the foreground are appropriate to an outdoor setting, and, as related in the Gospel of Matthew, the angel of the Lord is shown seated on the empty sarcophagus addressing the women: "I know you are looking for Jesus who was crucified. He is not here; he has been raised again, as he said he would be. Come and see the place where he was laid, and then go quickly and tell his disciples" (Matthew 28:6–7). The spiral patterns of the figures' drapery folds are outlined by sequences of tiny pricks, a hallmark of ivory carving in Cologne at this time. The masterly use of gently sloping orthogonal lines effectively contrasts with the strong verticals of the background architecture.

72 *Plaque with the Three Holy Women at the Tomb of Christ*
Rhenish (Cologne), ca. 1135
Walrus ivory; 8⅜ x 7¾ in. (21.3 x 19.7 cm.)
Gift of George Blumenthal, 1941 (41.100.201)

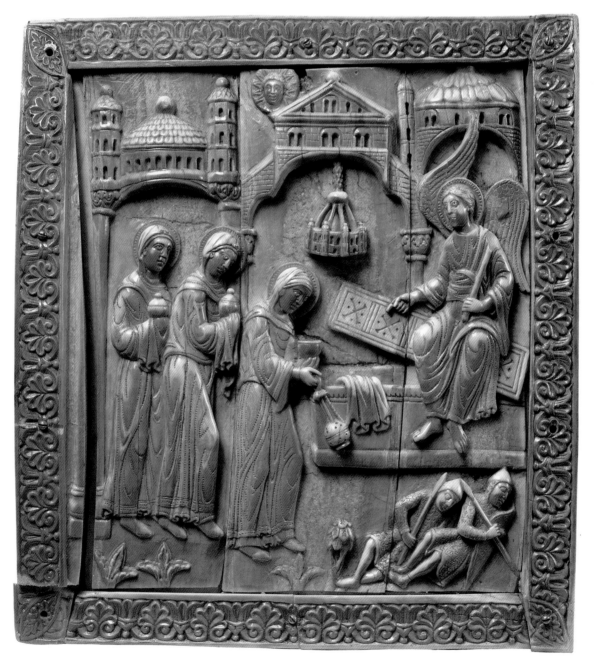

73 *The Cloister of Saint-Guilhem-le-Désert*
French (near Montpellier), before 1206
with 14th-c. additions; marble
The Cloisters Collection, 1925
(25.120.1-134)

THE CLOISTER OF SAINT-GUILHEM-LE-DESERT

Situated in a valley near Montpellier in southern France, the Benedictine abbey of Saint-Guilhem-le-Désert was founded in 804 by Guilhem (Guillaume) au Court-Nez, duke of Aquitaine and a member of Charlemagne's court. By the twelfth century, the abbey had been named in honor of its founder and had become an important site on one of the pilgrimage roads that ran through France to the holy shrine of Santiago de Compostela in Spain. With the steady visits of travelers en route to the shrine and the gifts they brought with them, a period of prosperity came to the monastery. By 1206 a new, two-story cloister had been built at Saint-Guilhem, incorporating the columns and pilasters from the upper gallery seen here. Most of these columns are medieval versions of the Classical Corinthian column, based on the spiny leaf of the acanthus. This floral ornamentation is treated in a variey of ways. Naturalistic acanthus, with clustered blossoms and precise detailing, is juxtaposed with decoration in low, flat relief, swirling vine forms, and even the conventionalized bark of palm trees. Among the most beautiful capitals are those embellished by drill holes, sometimes in an intricate honeycomb pattern. Like the adaptation of the acanthus-leaf decoration, this prolific use of the drill must have been inspired by the remains of Roman sculpture readily available in southern France at the time. The drilled dark areas contrast with the cream-colored limestone and give the foliage a crisp lacy look that is elegant and sophisticated.

Like other French monasteries, Saint-Guilhem suffered greatly in the religious wars following the Reformation and during the French Revolution, when it was sold to a stonemason. The damages were so severe that there is now no way of determining the original dimensions of the cloister or the number and sequence of its columns. Those collected here served in the nineteenth century as grape-arbor supports and ornaments in the garden of a justice of the peace in nearby Aniane.

80

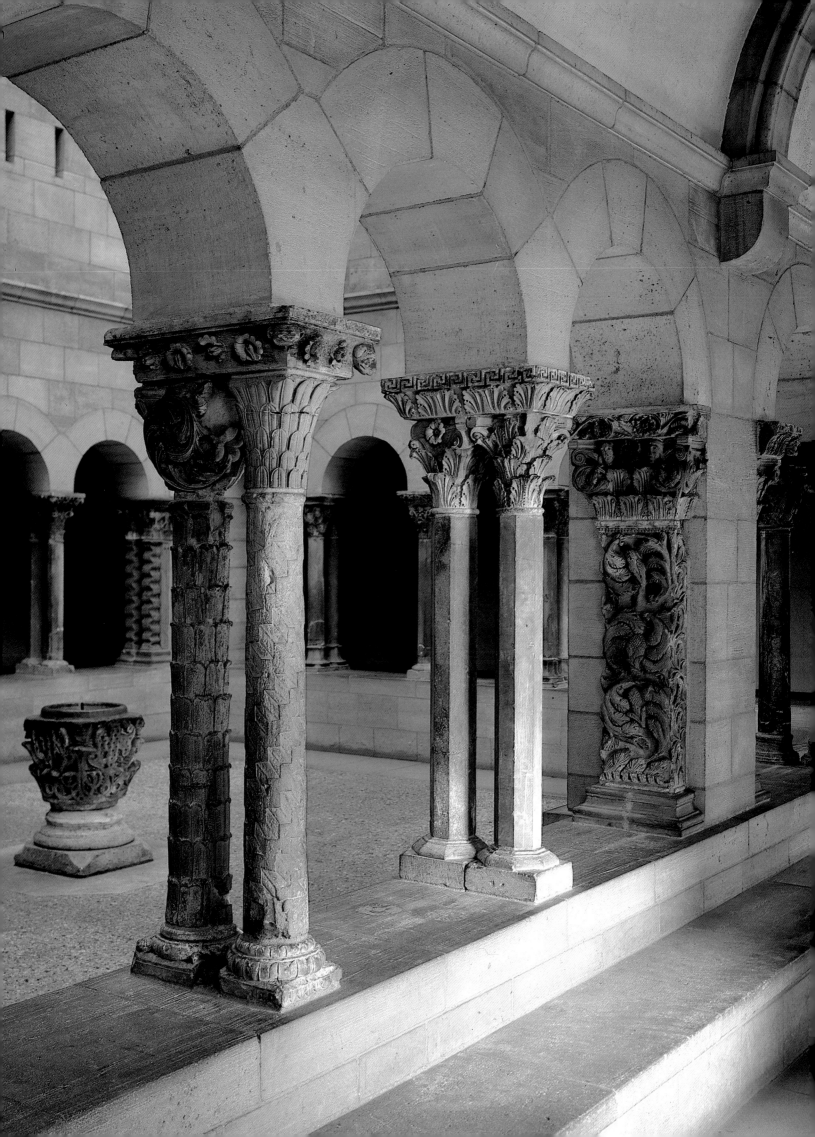

SCENES FROM THE LIFE OF SAINT NICHOLAS

These panels, attributed on stylistic grounds to the glazing program of Soissons cathedral, represent two episodes from the life of Saint Nicholas. Bishop of Myra in the fourth century, Nicholas became one of the most popular saints of the Christian calendar. By the twelfth and thirteenth centuries, he was especially revered in northern France, where in 1200 a chapel was dedicated in his name at the cathedral of Soissons. The scenes reproduced here relate the Legend of the Three Generals, in which Saint Nicholas secures the release of three innocent knights from an unjust imprisonment im-

posed by a corrupt magistrate. The panels were executed in rich, translucent hues of red, blue, yellow, and green. The figural style, marked by small, tubular drapery folds and long-nosed, heavy-jawed faces, ultimately derives from a tradition begun during the late twelfth century in the Meuse valley, where the reliquary triptych of the True Cross (Plate 67) originated. The arcaded setting and rectangular shape of the panels herald a new, more open approach to window design at a time when arrangements of clustered medallion shapes predominated.

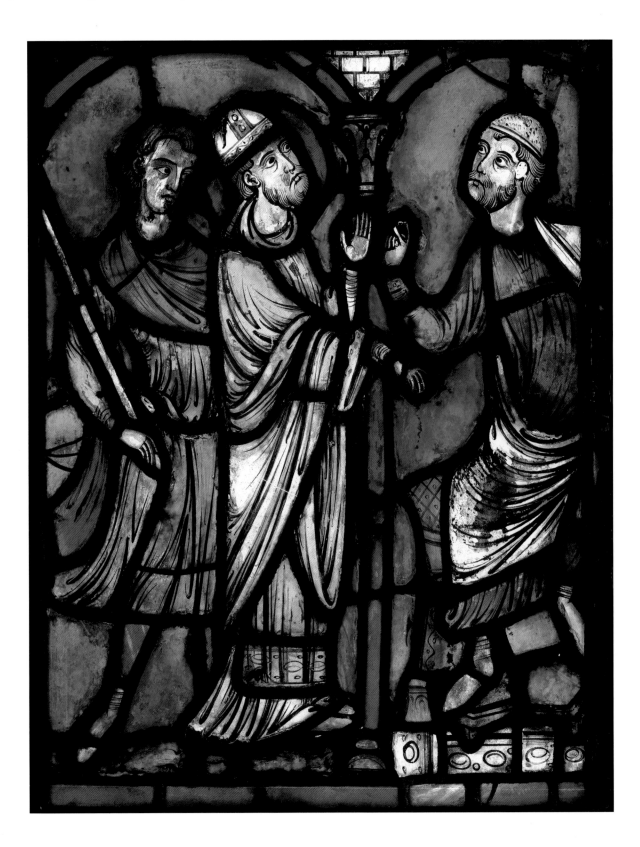

74 Scenes from the Life of Saint Nicholas
French (Soissons, Cathedral of Saint-Gervais
and Saint-Protais), 1205–10
Pot-metal glass with vitreous paint;
Opposite: 21⅜ x 16 in. (54.2 x 40.7 cm.)
Below: 21½ x 16¼ in. (54.6 x 41.3 cm.)
The Cloisters Collection, 1980 (1980.263.3,2)

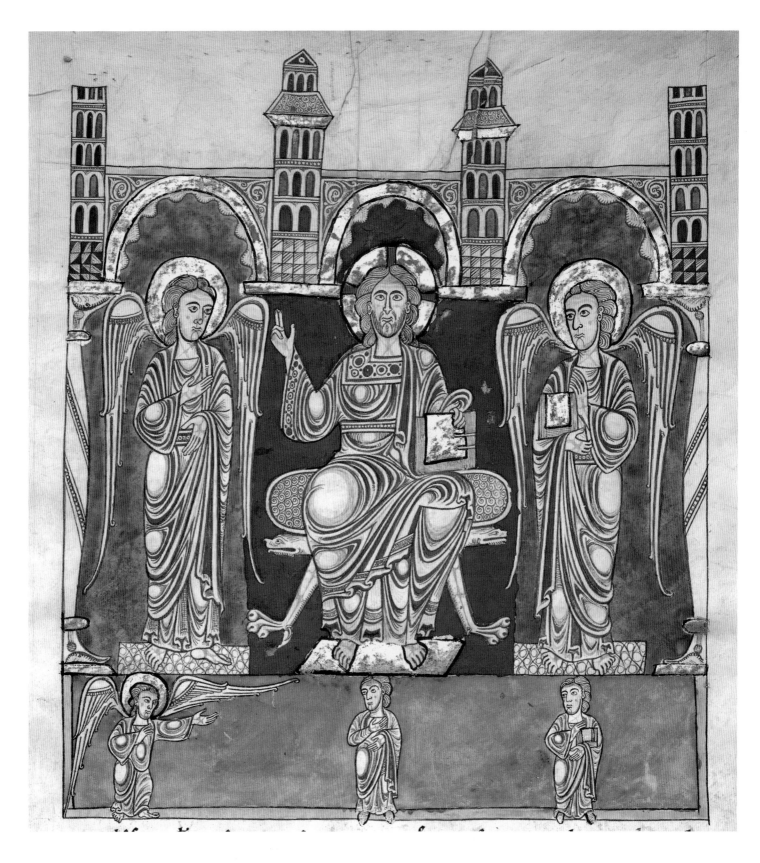

Manuscript Leaf from a Commentary on the Apocalypse by Beatus of Liébana

Around the year 776 an Asturian monk, Beatus of Liébana, compiled passages from the last book of the Bible, the Apocalypse, which he interpreted as Christian allegories. Illuminated manuscripts of his commentary became as important in Spain as gospel books and bibles were elsewhere in Europe. This leaf, one of fourteen in the Museum's collection, shows Christ in majesty and flanked by angels in the top register, while below the angel of God orders Saint John "to make known to his servants the things which must shortly come to pass" (Apocalypse 1:1–2). The bold blocks of color and dramatic use of gold leaf in this depiction contrast with the refined linear treatment of figures with their distinctive tear-drop-shaped drapery folds. In this folio leaf the painter's emphasis on the revelation of Christ allows the reader to share in Saint John's vision while also contemplating the accompanying scripture and commentary.

Bronze Clasp

The subject depicted in this magnificent clasp is difficult to establish. On the right portion of the buckle, a crowned male is shown with his feet resting on a lion; on the left is a veiled female resting her feet on a basilisk, a creature composed of a monkey's head and the body of a dragon. Each of the figures, who might represent biblical personages, is accompanied by a kneeling and a seated attendant. The inclusion of the basilisk and lion suggest Psalm 91:13: "Thou shalt tread upon the adder and the basilisk and trample under foot the lion and the dragon"—a passage traditionally interpreted as referring to the triumph of Christ and the Church. The entire group is arranged within a diminutive acanthus-vine framework. The symmetrical composition is enlivened not only by the intricate detail but also by the vigorously pulled drapery folds, revealing the figures' anatomical structure. Each small figure is thus endowed with great power and monumentality, qualities associated with the style pioneered by the late-twelfth-century Mosan goldsmith Nicholas of Verdun.

75 Christ in Majesty with Angels and (below) the Angel of God Directs Saint John to Write the Apocalypse (the Book of Revelation)
Spanish (Burgos, Monastery of San Pedro de Cardeña), ca. 1180
Tempera, gold, and ink on parchment; 17½ x 11¾ in. (44.5 x 30 cm.)
Purchase, The Cloisters Collection, Rogers and Harris Brisbane Dick Funds, and Joseph Pulitzer Bequest, 1991 (1991.232.3r)

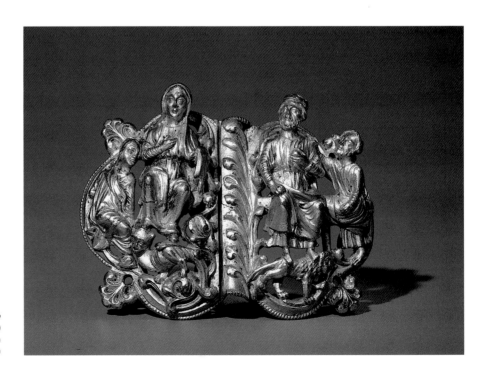

76 Clasp
Mosan, ca. 1210
Gilt bronze; 2 x 3 in. (5 x 7.5 cm.)
The Cloisters Collection, 1947 (47.10.48)

LIMOGES RELIQUARY CHASSE

The rectangular, boxlike shape of the medieval chasse is an adaptation of the sarcophagus shape, ultimately deriving from the Early Christian tradition of honoring saints at their burial sites. The word chasse is derived from the Latin *capsa* (coffin), and it has come to refer to an enclosed shrine with a pyramid-shaped roof. Such reliquaries were often placed on altars, where the devout could venerate the relic held inside. In keeping with twelfth-century tradition, this chasse, which once served as a portable container for the relics of revered saints, is decorated with gables and finials to echo the shape of a church. In the view shown here, the Crucifixion is represented flanked by images of the sun and moon, with rows of the apostles standing beneath a series of arcades. The richness of this decoration is enhanced by the background scroll-like patterns called *vermiculé*. Literally adopted from a Latin term suggestive of worm shapes or movement, these twisting, incised lines provide a foil for the figures, whose massive feet and hands stand in stark contrast to their tiny heads.

77 Reliquary Chasse
French (Limoges), ca. 1180–90
Champlevé enamel on copper gilt with *vermiculé* pattern; 10⁵⁄₁₆ x 11⁷⁄₈ x 4⁹⁄₁₆ in. (26.2 x 30.2 x 11.6 cm.)
Gift of J. Pierpont Morgan, 1917 (17.190.514)

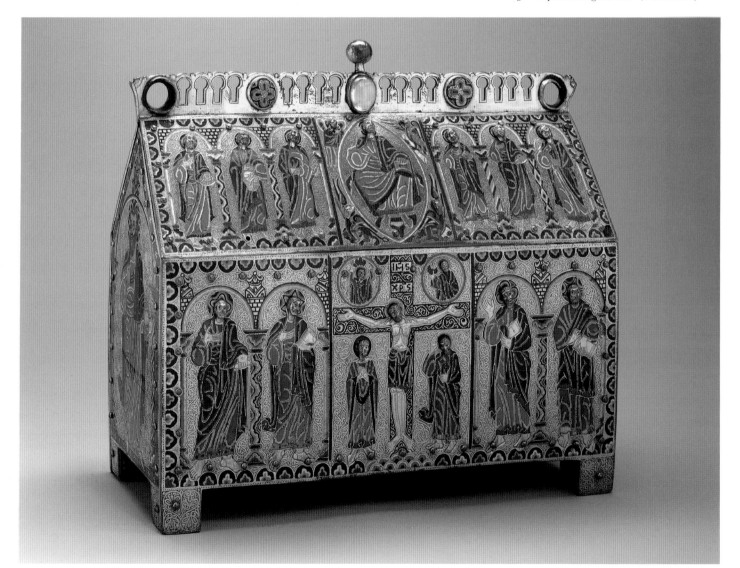

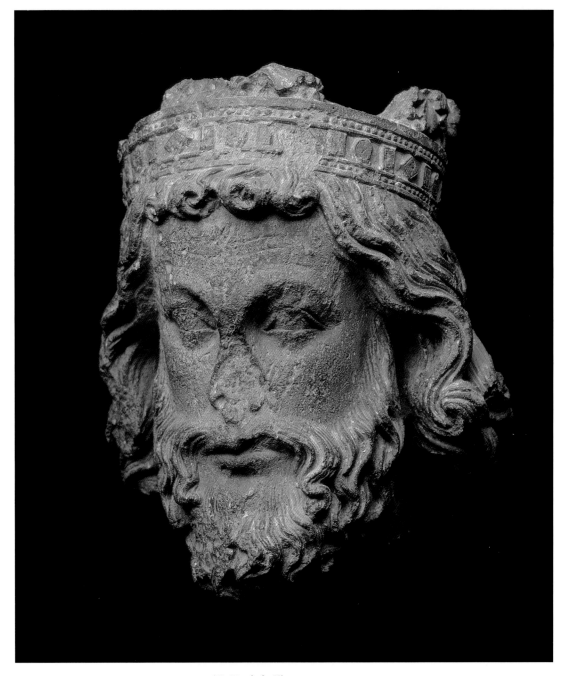

78 Head of a King
French (Ile-de-France), ca. 1225
Limestone; H. 13½ in. (34.3 cm.)
Fletcher Fund, 1947 (47.100.55)

HEAD OF A KING

The aristocratic style of this stone head is Parisian in spirit, though the type of limestone from which it is carved precludes its attribution to Paris itself. Like the jamb statue of a king from the twelfth-century cloister at the royal abbey of Saint-Denis outside Paris (Plate 64) and the two kings installed on the doorway from the Burgundian abbey of Moutiers-Saint-Jean (Plate 81), this fragment from a full-length statue was originally set within an architectural context. The tactile rendering of the king's head boldly illustrates the contemporary interest in representing the body more fully modeled in space than in earlier sculpture. Lively, thick locks of hair—including three perfect spirals curling across his forehead—frame the king's face, emphasizing the sculpture's three-dimensional quality. This regal visage, enhanced by the hint of a smile and an upward glance, anticipates sculptural innovations produced after the middle of the century in Paris as well as at sites influenced by royal patronage, such as the monastery of Moutiers-Saint-Jean.

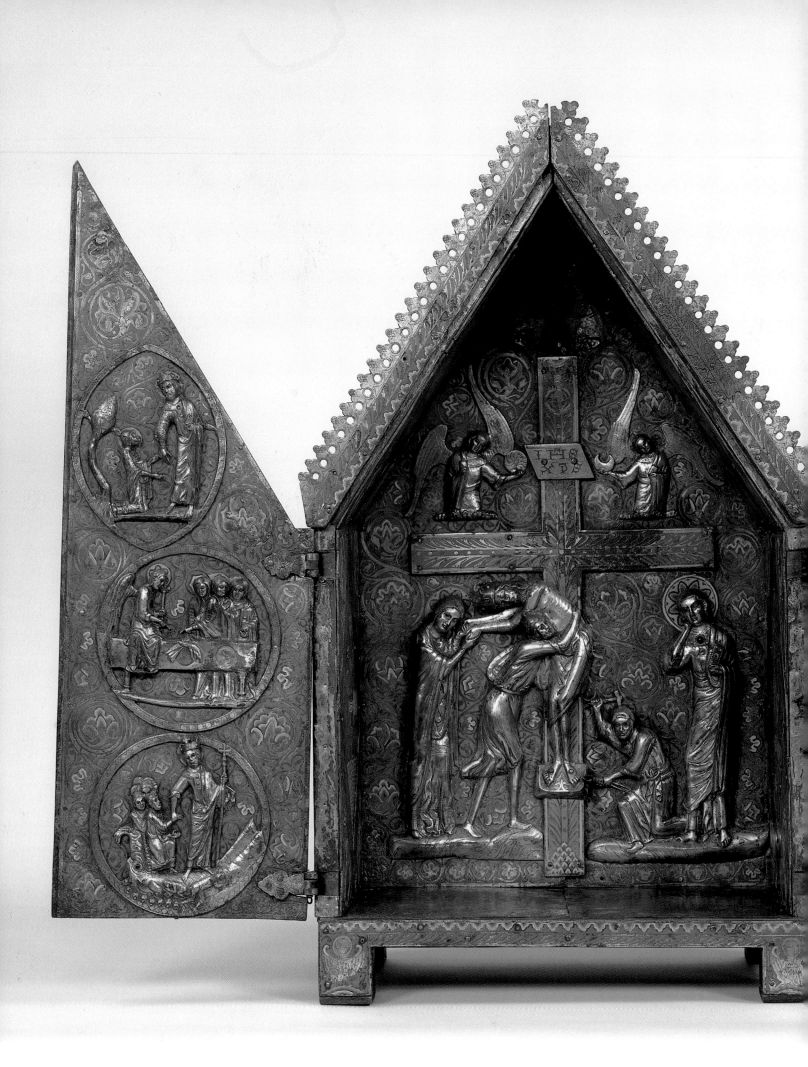

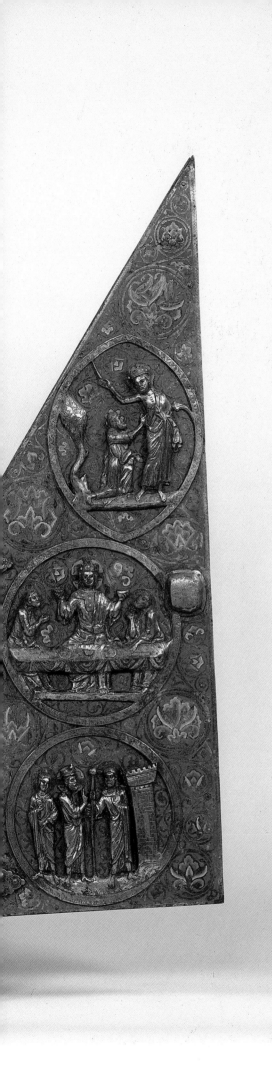

TABERNACLE

Tabernacles such as this were used to store the host between celebrations of the Mass. This vessel, made in Limoges, uses an architectural format as the basis of its design and champlevé enamel and applied copper-gilt figures. The tabernacle's outer doors, adorned with images of Christ and the Virgin Enthroned in Majesty, open to reveal a representation of Christ's Deposition from the Cross. Smaller scenes depicting the events that followed the Resurrection embellish the interior wings. Throughout these scenes, Christ is consistently shown crowned, a visual reference to his victory over death as the King of Salvation. Such imagery is especially appropriate for a container of the Eucharist, emphasizing as it does the belief in the sacrament as the vehicle through which man may share in the Eternal Victory won by Christ over death. This is one of only two Limoges tabernacles of this shape and size to survive. This ensemble with enamel and gilt relief sculpture is among the finest works produced in the renowned workshops of Limoges.

79 Tabernacle
French (Limoges), ca. 1230–35
Champlevé enamel and copper-gilt; closed:
30¾ x 18⅛ x 9⅞ in. (78 x 46 x 25 cm.)
Gift of J. Pierpont Morgan, 1917 (17.190.735)

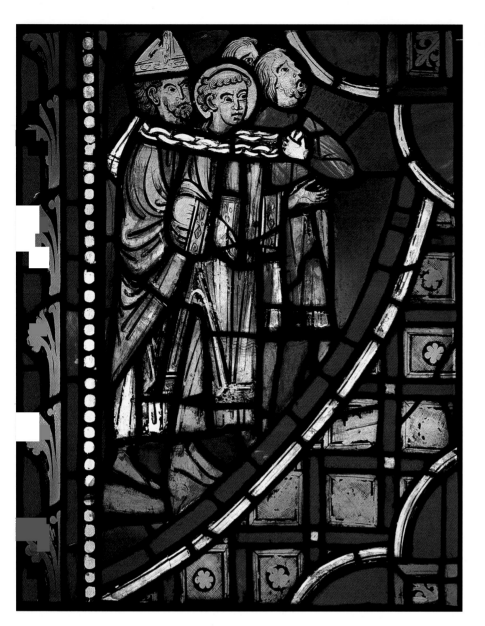

80 Scene from the Life of Saint Vincent (Saint Vincent in Chains)
French (Paris, Abbey of Saint-Germain-des-Prés),
ca. 1245–47
Pot-metal glass; 15 ft. 7 in. x 42½ in. (4.8 m. x 180 cm.)
Gift of George D. Pratt, 1924 (24.167)

81 Doorway
French
(Burgundy, Monastery of Moutiers-Saint-Jean),
ca. 1250
Limestone with traces of polychromy;
185 x 151 x 55 in. (469.9 x 383.5 x 139.7 cm.)
The Cloisters Collection, 1932 and 1940
(32.147; 40.51.1,2)

SAINT VINCENT IN CHAINS

This stained-glass panel is one of a number in the Museum's collection that once formed part of an extensive series dedicated to the life of Saint Vincent of Saragossa, the fourth-century deacon and martyr. Saint Vincent's relics had long been venerated at the Parisian abbey of Saint-Germain-des-Prés, and when a freestanding chapel dedicated to the Virgin was constructed there in the middle of the thirteenth century, his legend was one of several chosen to decorate the windows in its east end. The story of Vincent's arrest, torture, and death at the hands of the Roman consul Dacian is depicted in alternating half-oval frames superimposed on a background of blue squares. The reduction of each scene to only a few figures enabled the viewer to follow the narrative easily to the window's summit. Highlighted against a brilliant blue background, the individual figures are similarly designed for legibility. Their faces are characterized by simple, expressive lines, their clothing is accented by bright colors and straight, boldly drawn folds, and their singular gestures have been chosen to accentuate a specific dramatic point.

DOORWAY FROM MOUTIERS-SAINT-JEAN

This doorway from the Burgundian monastery of Moutiers-Saint-Jean originally served as an entrance from the main cloister to the sanctuary of the abbey church. It was built during a prosperous period in the abbey's history and shows the union of architecture and sculpture popular during the Gothic period. Moldings, ornament, and figural sculpture are worked into a single harmonious unit. The tympanum surmounting the entryway illustrates a celestial court of angels attending Christ and the Virgin as she is crowned Queen of Heaven. The theme of heavenly kingship is transposed to the earthly realm through the large column figures of kings under canopied niches that flank the entrance. Carved almost completely in the round, these sculptures exhibit an extraordinary naturalism and a truly regal presence. It has been suggested that they represent Clovis, the first Christian ruler of France, and his son, Chlothar. Medieval tradition held that the newly converted Clovis granted the monastery a charter exempting it in perpetuity from royal and ecclesiastical jurisdiction, a privilege later confirmed by Chlothar.

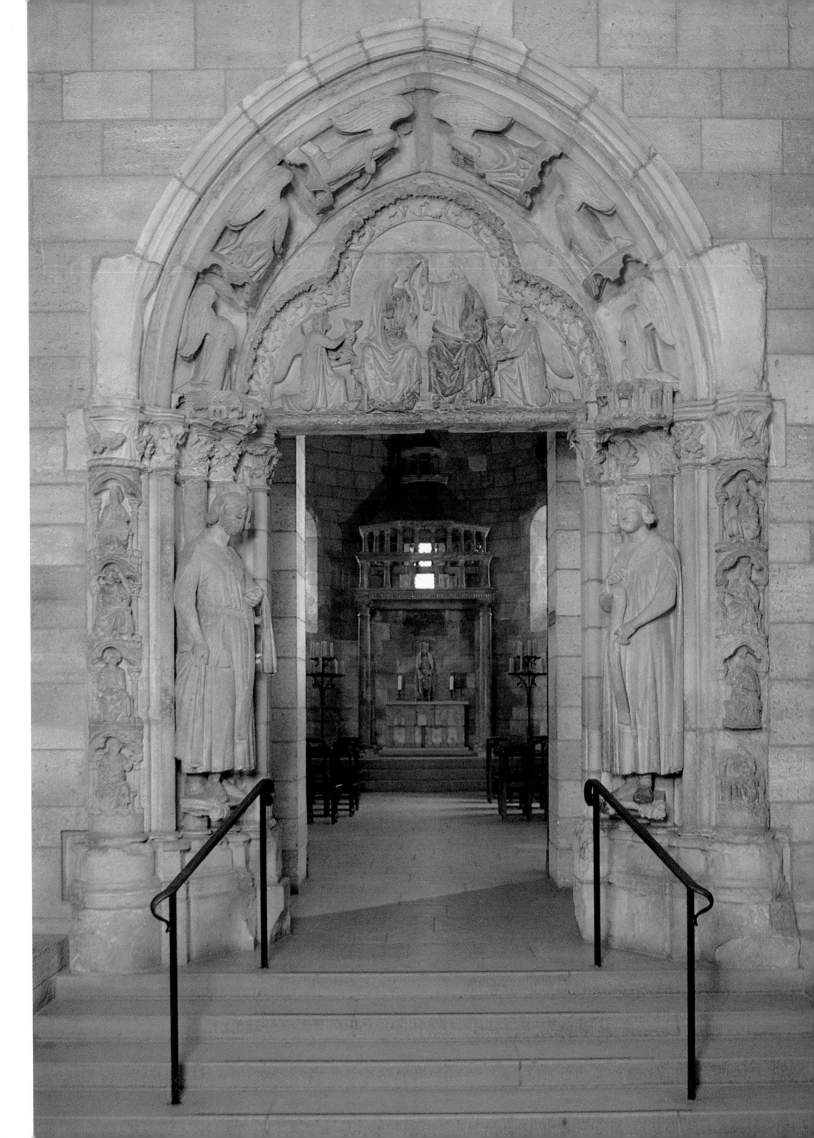

Saltcellar

This accomplished example of Parisian goldsmith work surrounds a delicate rock-crystal container with finely wrought metalwork studded with gems. Mounted on a long, elegant stem and topped by a lid with a serpent-shaped handle, the vessel takes the shape of a boat. Its scale and decoration suggest its use as a container for a precious commodity at the table, such as salt or spice. Such saltcellars are recorded in late medieval princely inventories, where they are described as footed boats or *navettes*. While this example might have had a liturgical function in the sacrament of baptism, it more likely played a role at royal or aristocratic meals. Because of its rarity, salt was traditionally kept in separate containers, which, when placed on the table, determined the relative seating of guests according to their social standing. The tiny serpent handle, often a feature on such salts, was likely to have signified the warding-off of evil.

82 Saltcellar
French (probably Paris), mid-13th c.
Gold, rock crystal, emeralds, pearls,
spinel or balas rubies; H. 5½ in. (14 cm.)
The Cloisters Collection, 1983 (1983.434)

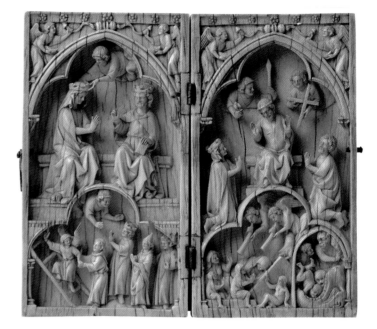

*83 Diptych with the Coronation of
the Virgin and the Last Judgment*
French (Paris), ca. 1260–70
Ivory; H. 4⅞ in. (12.4 cm.)
The Cloisters Collection, 1970
(1970.324.7a,b)

Ivory Diptych

Intended for the private contemplation and devotion of its owner, this palm-size ivory diptych illustrates both the reward of salvation and the consequence of damnation. In the right wing, Christ, accompanied by angels carrying instruments of the Passion, displays the wounds of his Crucifixion. As the dead are called from their graves, the kneeling Virgin Mary and Saint John the Baptist serve as their intercessors in the Last Judgment. The damned appear in the lower right, pushed head first into the mouth of Hell at the order of two grotesque devils. Adapted from representations in contemporary architectural sculpture, these themes are set within a series of trefoil cusped arcades and are elegantly carved in exceptionally high relief. The supple carving enlivens the symmetrical representation of the drama of redemption and condemnation.

*84 Leaf from a Psalter with the Agony in the
Garden and the Betrayal and Arrest of Christ*
English (London ?), ca. 1260
Tempera, gold and silver leaf on parchment;
H. 11⅝ in. (29.55 cm.)
Rogers Fund, 1922 (22.24.4)

Page 95: text

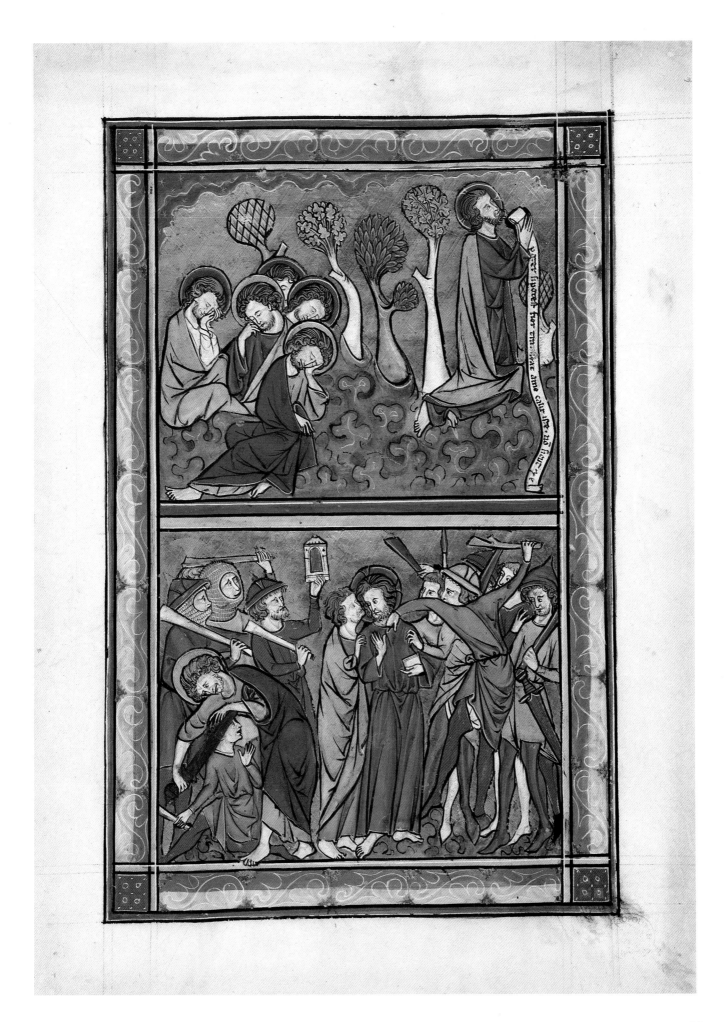

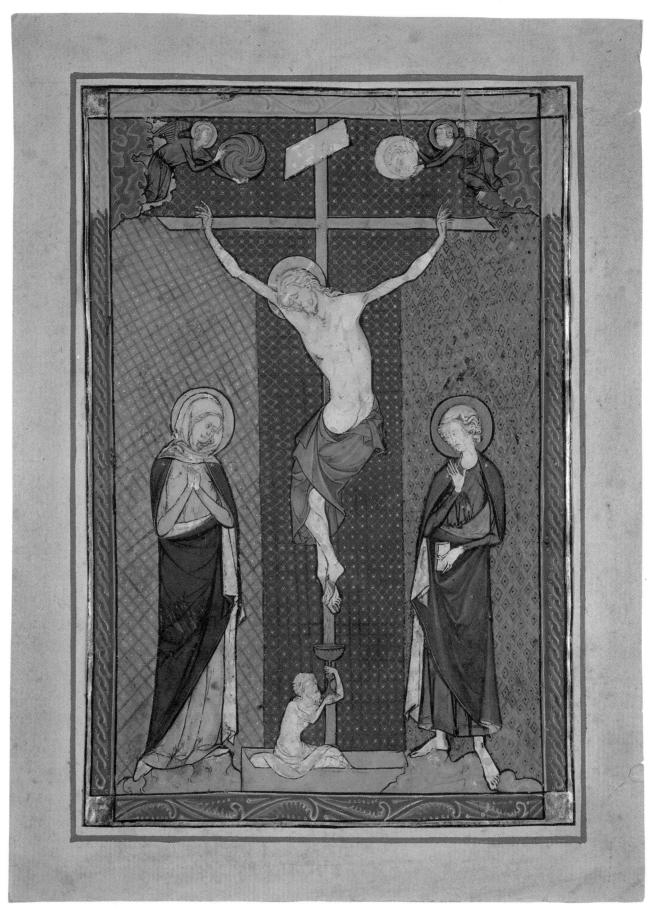

85 *Leaf from a Missal, Representing the Crucifixion*
French (Paris), ca. 1270
Tempera and gold leaf on parchment; 8¾ x 5⅞ in. (22.2 x 15 cm.)
Purchase, Bequest of Thomas W. Lamont, by exchange, 1981
(1981.322)

LEAF FROM AN ENGLISH PSALTER

(Page 93)

This leaf from a psalter (a book often containing a calendar and the Psalms) illustrates two scenes from Christ's Passion —the Agony in the Garden and the Betrayal and Arrest. The mannered yet lively poses of the densely packed figures are matched by the abstracted, animated forms of the landscape. The gold-leaf grounds provide an effective backdrop for the palette of blue and orange. This elegant color and the angular, broad drapery folds are indebted to French manuscript illumination, which influenced English painting patronized by the court around the middle of the thirteenth century. The interest in emotional expression and evocative movement, though, is characteristic of English drawing throughout the medieval era. This expressionism is most adventurously portrayed in the figure of the henchman about to strike Christ in the lower register. With his garment hitched up above his knees, he seems to leap up as he draws a club back with one arm and arches forward to grab Christ's robe with the other. Made for a royal English patron, the manuscript comes from the abbey of Fontevrault in France.

ILLUMINATED CRUCIFIXION and CORPUS OF CHRIST

During the thirteenth century, devotional emphasis on the physical suffering of Christ at the Crucifixion led to a new representation of the event. Embodying a sentiment of profound yet quiet agony, Christ's body is depicted gently swaying against the cross, his eyes closed in death. The illuminated Crucifixion from a missal (a book containing prayers and rites used in the Mass) in Plate 85 and the ivory corpus of Christ from an altar cross in Plate 86 were both created in Paris at a time of unrivaled artistic productivity and reflect this new pathos. The unbending verticality of earlier representations of Christ's Crucifixion, seen in the Spanish and Germanic Romanesque Crucifixes (Plates 57, 58), gives way in these works to a graceful rendering of Christ's body in an elegant S-curve, emphasized by his crossed legs fastened to the cross by a single nail. In both works, the fine, sinuous line created by the elongated body and facial features is echoed in the thin, softly pouching drapery folds.

The emotional impact of the missal illumination is not as highly expressive as that of the corpus. In the illumination, the mourning Virgin and Saint John serve as intermediaries between the viewer and the sacred scene, which is removed from earthly time and place by the brilliant red-and-blue fabriclike background and the angels who rush forward holding symbols of the sun and moon.

Both the corpus—when attached to its cross—and the missal illumination would have been used at the altar during the celebration of the sacrament reenacting Christ's sacrifice. This parallel is further emphasized by the illuminated depiction of Adam rising from a sarcophagus at the foot of the cross to catch Christ's dripping blood in a chalice.

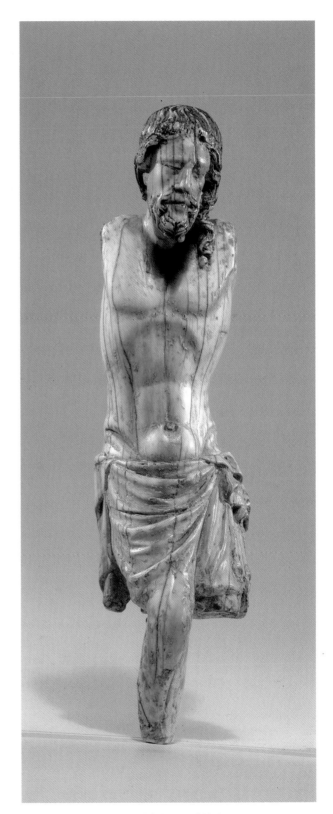

86 Corpus of Christ
French (Paris), 1250–75
Ivory; H. 6½ in. (16.5 cm.) Gift of Mr. and Mrs. Maxime L. Hermanos, 1978 (1978.521.3)

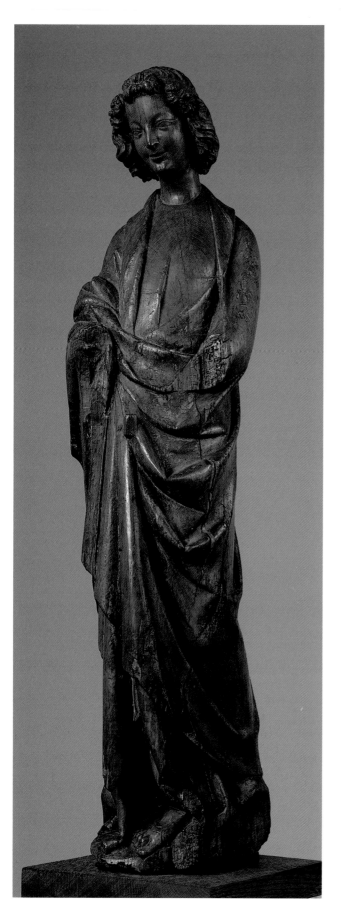

87 Altar Angel
French, late 13th c.
Oak with traces of polychromy;
H. 29 in. (73.7 cm.)
The Cloisters Collection, 1952
(52.33.1)

THREE HIGH GOTHIC STATUES

These three works illustrate the functional variety and stylistic harmony of sculpture produced in northern France during the second half of the thirteenth century. The lifesize painted sandstone Virgin (Plate 89) was once set within the spandrel arcades of the choir screen of Strasbourg Cathedral. Though the screen was destroyed in 1682, earlier drawings and engravings record the statue's original position and indicate that the Christ Child, supported by a rose bush (a reference to Christ's future sacrifice as well as to the Virgin as a rose without thorns), was also present. The Virgin's mantle is wrapped tightly under her elbows and falls into thick, nested folds below her waist—an approach also seen in the drapery of the wooden altar angel and ivory Virgin and Child (Plates 87, 88). The result is an elegant silhouette comprising a gently tilting head and smooth, sloping shoulders that contrast with the strong patterns of light and shadow created by the breaking drapery folds.

While the Strasbourg Virgin's architectural context demanded a columnar stance, the other figures shown here are portrayed in more animated positions: The left foot of the altar angel pivots sideways while the right hip bows outward. This figure is one of a pair of angels, originally painted and gilded and bearing wings, who might have held either candlesticks or instruments of Christ's Passion. The precious ivory Virgin and Child, on the other hand, was most likely made for a private, aristocratic owner. This tender representation is an interpretation of a well-known type of Byzantine Virgin, the Glykophilousa, or Virgin of Sweet Love. The head of the child is a later replacement.

89 Virgin
French (Strasbourg), 1247–52
Sandstone, polychromed and gilded;
H. 58½ in. (148.6 cm.)
The Cloisters Collection, 1947
(47.101.11)

88 Virgin and Child
French (Paris), ca. 1250–60
Ivory; H. 7½ in. (18.5 cm.)
Lent by the Hispanic Society
of America (L. 1986.61)

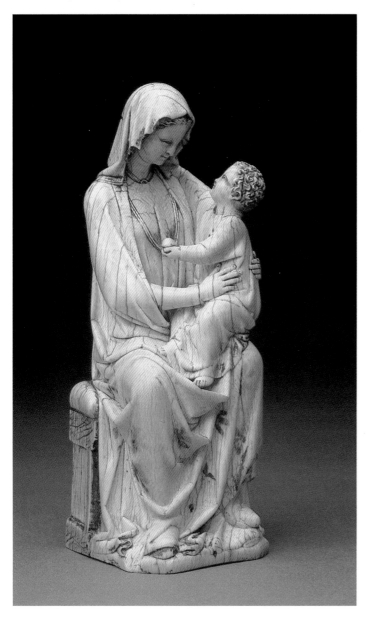

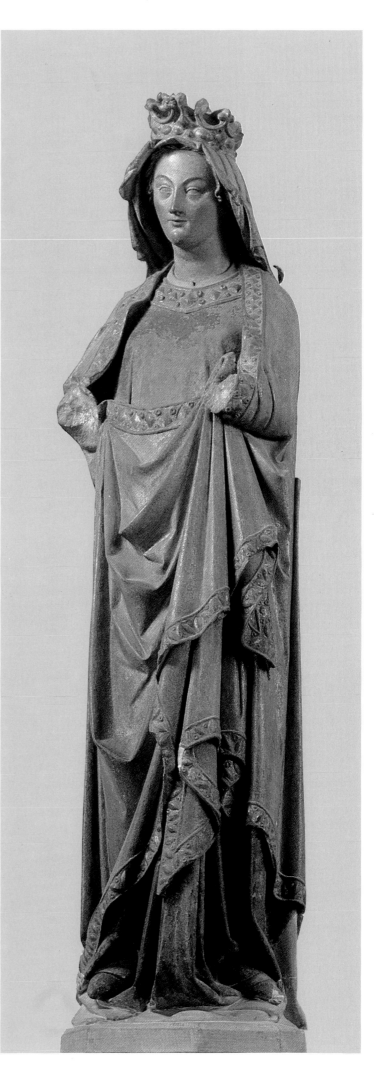

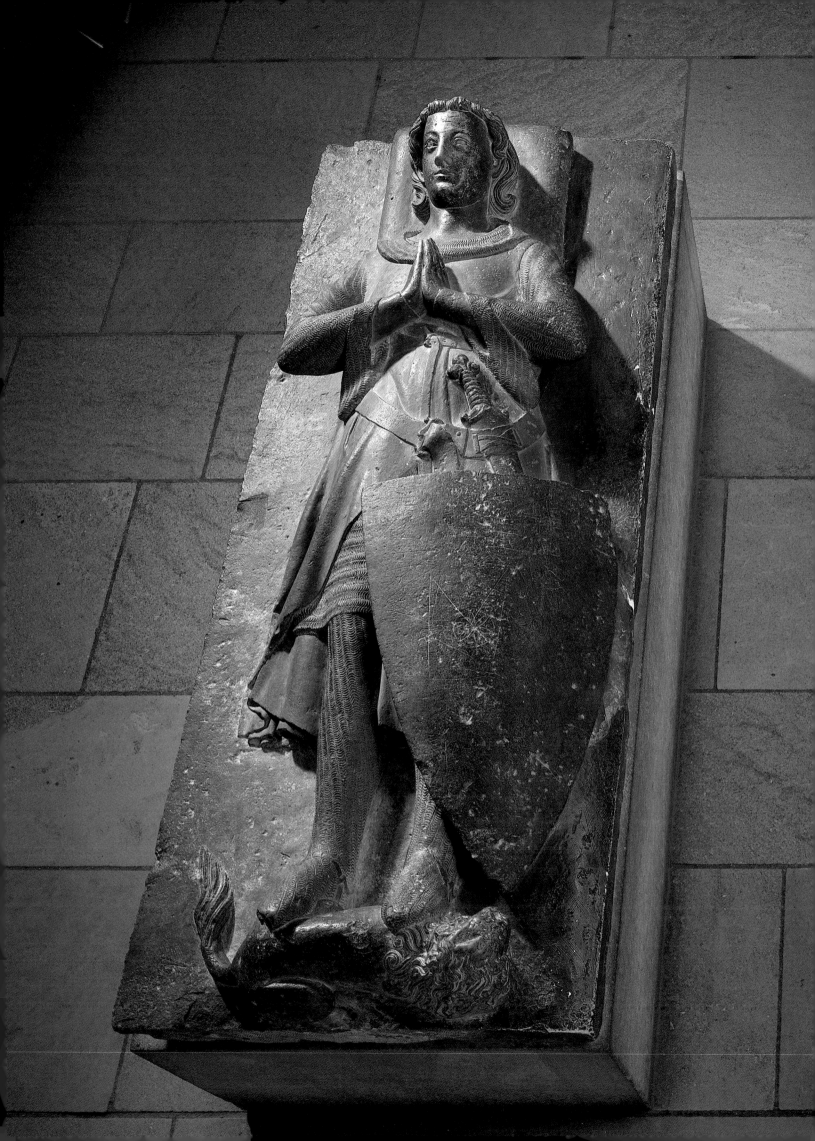

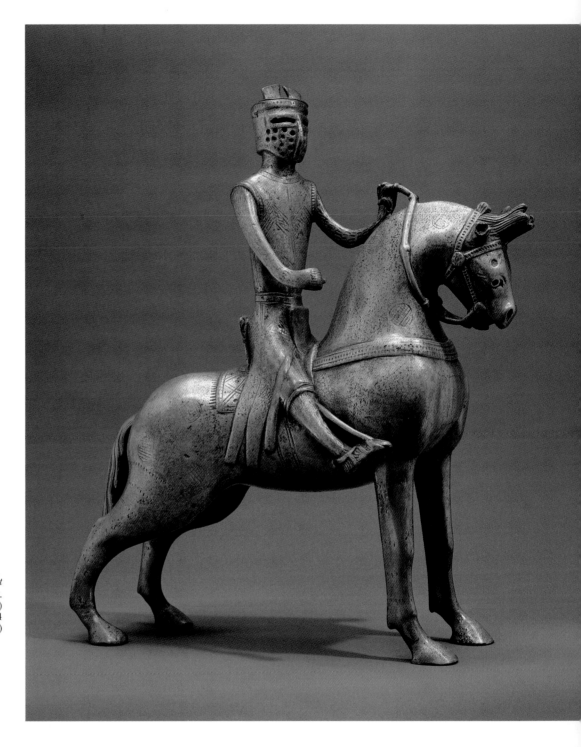

SEPULCHRAL EFFIGY and AQUAMANILE

This French tomb effigy and German aquamanile both exemplify the chivalric ideals that pervaded Western medieval culture. The tomb slab of Jean d'Alluye represents the deceased as a young man fully armed, with his eyes open and his hands joined in prayer. Born to a noble family, and seignior of considerable land, Jean d'Alluye joined a crusade in 1240, returning to France with a relic of the True Cross. After his death a few years later, this effigy was installed in the abbey he had founded, La Clarté-Dieu, near Le Mans. This representation was not intended as a portrait but rather as a commemoration embodying the knightly qualities of strength and courage—symbolized by the lion crouched at Jean d'Alluye's feet.

The horse was the only steed for men possessing such attributes, as a late medieval writer explained:

Knights have not been chosen to ride an ass or a mule; they have not been taken from among feeble or timid or cowardly souls, but from among men who are strong and full of energy, bold and without fear; and for this reason there is no other beast that so befits a knight as a good horse.

The mounted bronze warrior of the aquamanile (his lance and shield no longer survive) fulfills such a description. Clad in mail and plate armor with a type of sleeveless jacket lined with small iron plates, this knight vigorously urges his steed forward. This water vessel (the horse's forelock serves as the spout) would have been displayed at a knight's table.

THE VISITATION

Soon after the Virgin Mary learned of her miraculous conception of Jesus, she visited her kinswoman Elizabeth, who was also expecting a child, John the Baptist. This representation of their joyous meeting comes from the Dominican monastery of Katharinenthal, in the Lake Constance region of present-day Switzerland. Carved of walnut, with the original paint and gilding almost completely preserved, the figures of Mary and Elizabeth are each inset with crystal-covered cavities through which images of their infants would originally have been seen. Peculiarly Germanic, the representation of the Visitation incorporating images of the unborn Christ and John the Baptist emphasizes the moment when, according to *The Golden Legend*, Saint John, being unable "to manifest his joy with his tongue," leapt "with joy in his mother's womb." The Virgin tenderly places her hand on Elizabeth's shoulder, while her cousin raises her arm to her breast in reference to her declaration, "Who am I, that the mother of the Lord should visit me?" (Luke 1:43).

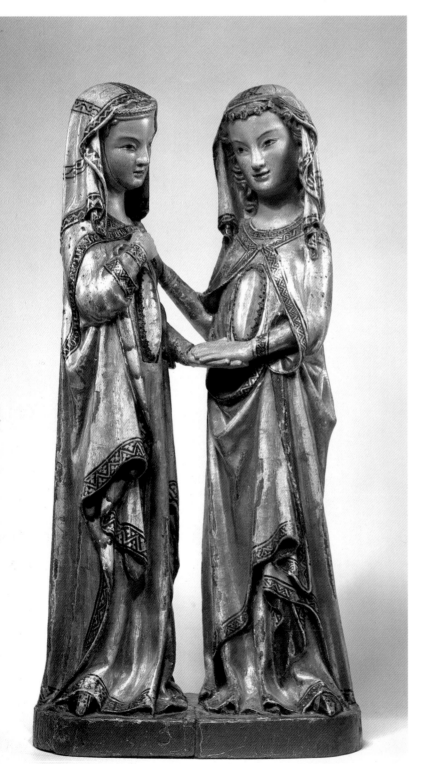

92 *The Visitation*
German (Constance), ca. 1310–20
Walnut, with polychromy and gilt; 23¼ x 12 in.
(59.1 x 30.5 cm.)
Gift of J. Pierpont Morgan, 1917 (17.190.724)

PANEL FROM A TREE OF JESSE WINDOW

Christ's genealogy as listed in the Book of Matthew and foretold in Isaiah (11:10)—"On that day a scion from the root of Jesse shall be set up as a signal to the peoples"—was popularly depicted in the form of a tree growing from the side of King David's father, Jesse. Popular in French stained glass since the twelfth century, this visualization underwent a transformation in Germany a century later. Rather than tracing the kingly lineage of Christ, the German interpretation illustrated scenes of Christ's life juxtaposed with Old Testament prototypes.

This representation of King David holding his emblematic harp is one of six panels from a German Tree of Jesse window that represents a transitional stage in the evolution of this imagery, in that it includes scenes from the infancy of Christ and from his Passion, while retaining the genealogical figure of King David. Interspersed with the lush foliage, Hebrew prophets carrying banderoles inscribed with their exhortations are cradled in the tree's circular branches. The subtlety of design and painting in this work is enhanced by the deeply saturated palette of red, green, and yellow, making a bold contrast with the more translucent hues of French stained glass of the thirteenth century (Plates 74, 80).

93 *Panel Representing King David from a Tree of Jesse Window*
German (Swabia?), 1290–1300
Pot-metal glass with vitreous paint; 25¼ x 14 in. (64.2 x 35.5 cm.)
Frederick C. Hewitt Fund, 1922 (22.25c)

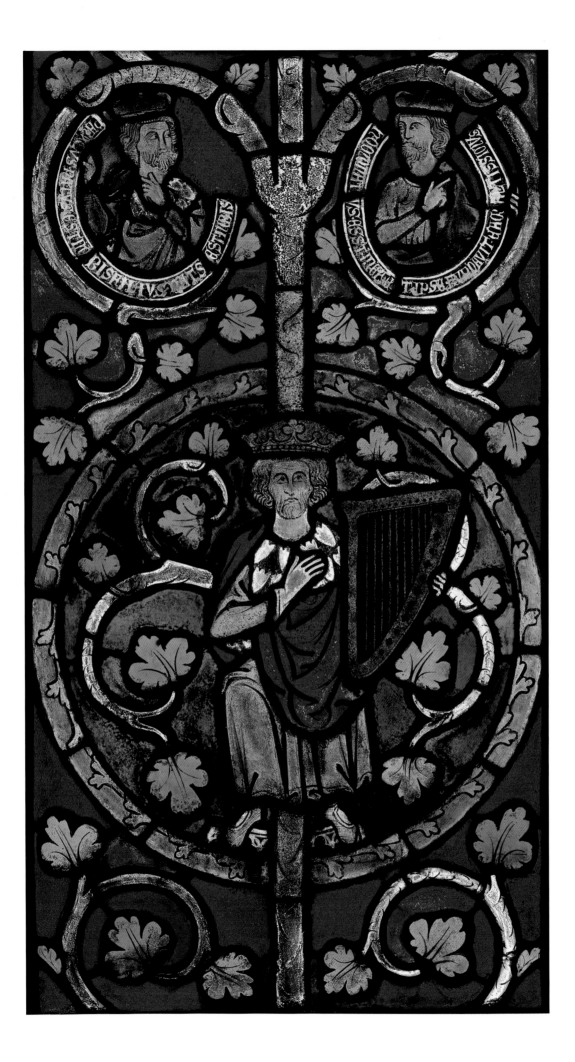

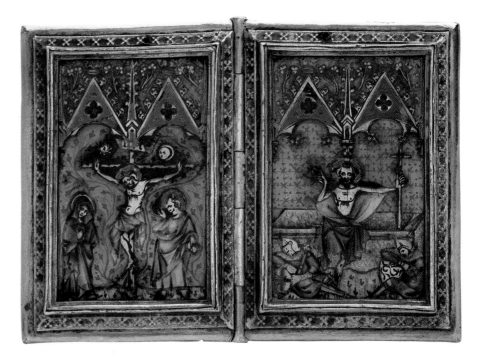

SILVER-GILT AND ENAMEL DIPTYCH

This tiny diptych is at once sumptuous in material and de-votional in theme. The left interior wing illustrates the An-nunciation, while the Nativity is represented on the right. The Crucifixion and Resurrection are shown on the exte-rior. Signifying as they do the beginning and consumma-tion of Christ's sacrifice for mankind, such scenes were ap-propriate subjects for a devotional piece that could be held in the hand.

The interior figures are formed of cast and hammered silver and gilt, while the outside figures and the background design of both sides are incised into the silver base. The coloring is produced by a translucent enamel made by ap-plying an enamel paste to the silver ground onto which the design is engraved in low relief. Light is thus reflected back from the metal ground through a brilliantly colored palette, producing a spiritual aura much like that of stained glass.

DOUBLE CUP

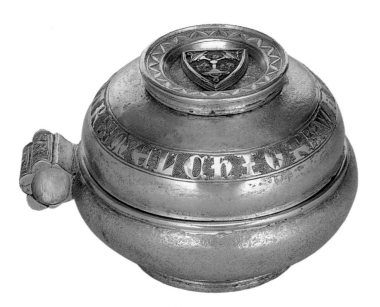

95 Double Cup
German or Bohemian, 1300–1350
Silver and silver gilt with
applied opaque enamel work;
H. 6¼ in. (10.6 cm.)
The Cloisters Collection, 1983
(1983.125ab)

The *Doppelkopf*, or double cup, was popularly associated dur-ing the later Middle Ages with the age-old Germanic cus-tom of making marriage or devotional toasts. The upper section of this rare piece, decorated with an incised inscrip-tion with the names of the Three Kings, *CASPAR + MEL-CHIOR + WALTAZAR*, serves as both a second cup and as a cover for the bottom cup. It is surmounted by a circular fitting that functions as a handle when used as a lid and as a foot when the section is used as a second cup. Such vessels are frequently represented in art of the times.

In the interior of the lower cup and at the base of the foot of the upper cup are two enameled coats of arms showing three conical caps of the type that Jews were forced to wear. The juxtaposition of these arms with the Christian refer-ence to the Three Kings presents something of an anomaly. It may be that the inscription of the kings' names has a purely talismanic or amuletic association with the superstitions about and supernatural events believed to occur on Three Kings' Day. Although the cup's exact context has yet to be determined, this fine piece was most probably owned by a member of the prosperous Jewish burgher class during the time that Jews were under the protection of the Holy Roman Emperor. Thus, this double cup is among a handful of ob-jects documenting an aspect of Jewish life in late-medieval Christian Europe.

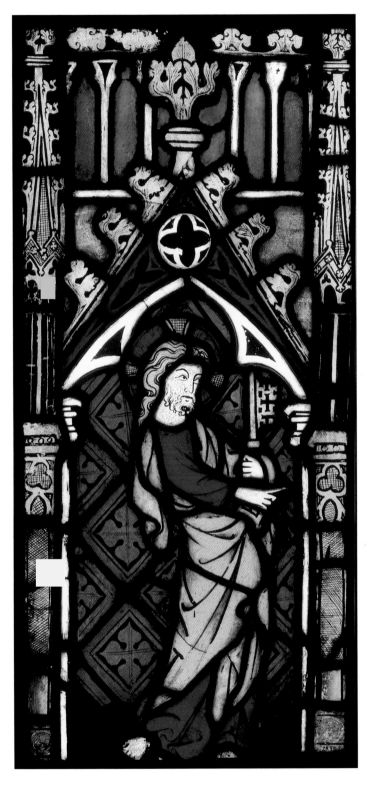
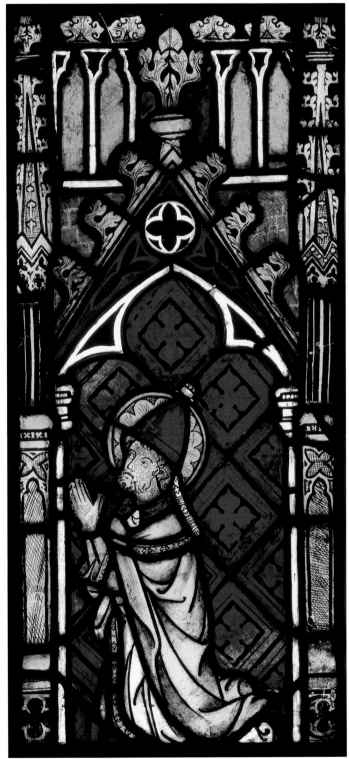

96 Christ Presenting the Keys of Heaven to Saint Peter
German (Cologne), ca. 1315–20
Pot-metal glass with vitreous paint; each panel 28¼ x 13⅝ in.
(71.7 x 34.5 cm.) Rogers Fund, 1929 (29.55.1)

Page 104: text

GERMAN STAINED GLASS

(Page 103)

Chromatic brilliance, masterful technique, and virtuoso design are the hallmarks of Germany's flourishing fourteenth-century stained-glass production. From the very beginning of the century, the city of Cologne, with a long tradition of glass painting, became a center for innovative approaches to window design. These two panels showing Christ presenting Saint Peter with the keys to the Kingdom of Heaven exemplify these changes. The panels form a single scene, portraying Christ's declaration to Peter: "...and I will give unto thee the keys of the Kingdom of Heaven" (Matthew 16:19). Christ holds the two keys representing the keys to the earthly and heavenly Jerusalem and points to Saint Peter, designating him as his successor. Saint Peter, kneeling in acceptance, is shown arrayed in papal vestments, signifying the direct line of succession of the papacy from Christ's authority.

In contrast to the thirteenth-century enclosure of narrative scenes within a medallion, here Christ and Saint Peter are placed within architectural niches. Windows with figural scenes framed in superposed registers of double arches were frequently employed in Cologne in this period. In all probability, these two panels formed one register of such an arrangement. The slender, elegantly posed figures stand out against the patterned background of painted quatrefoils. Their drapery falls in rhythmic curves modeled with thin, delicate brushstrokes. While the gentle play of drapery folds, the sway of the figures' poses, and the delicate facial features are inherited from the style popular in France during the second half of the thirteenth century, the love of color, patterning, and ornament is distinctly Germanic.

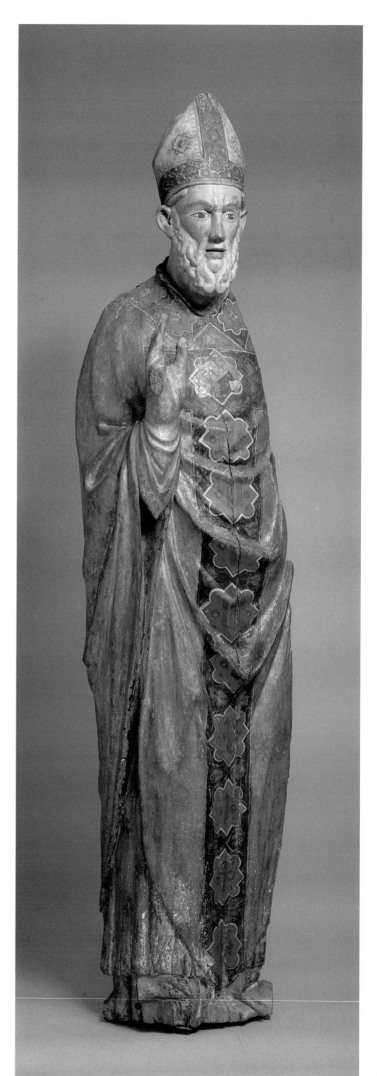

97 Bishop
Italian (Tuscany), 14th c.
Wood, polychromy and gilt;
H. 73½ in. (186.7 cm.)
The Cloisters Collection, 1925
(25.120.218)

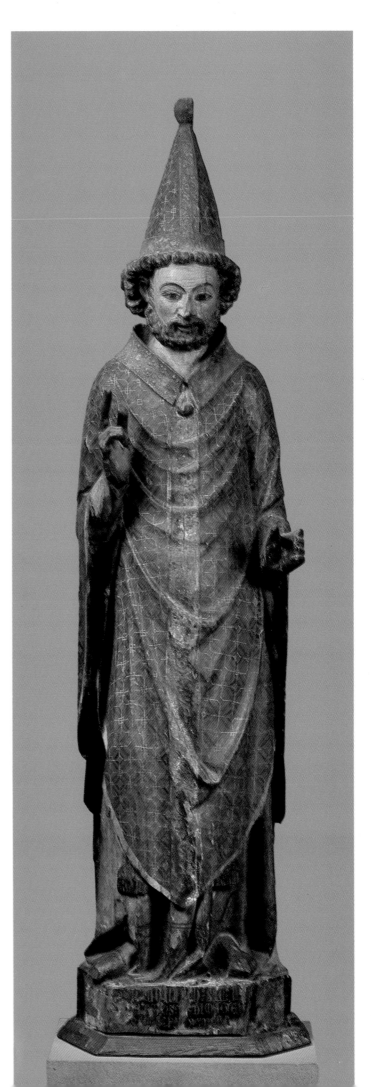

98 Saint Peter
Spanish (Catalonia), early 14th c.
Pine, covered in part with canvas,
entirely with gesso and polychromy;
H. 6 ft. 7 in. (2 m.)
Rogers Fund, 1927 (27.18.2)

STATUES OF A BISHOP AND SAINT PETER

The grandeur of the offices of pope and bishop are strikingly represented in these standing figures, both of whom raise their right hands in blessing. The Catalan wooden sculpture from the parochial church of Bellpuig de Balaquer (Plate 98) portrays Saint Peter as pope dressed in a long oval-shaped chasuble (the principal vestment worn by a priest). As in the stained-glass representation of Saint Peter from Cologne (Plate 96), the tall pointed hat signifies his pontifical rank. Peter's other hand must have once held the Keys of Heaven. The strong frontal orientation of this work is shared by the sculpture of the Italian bishop (Plate 97), identified by the pointed triangular mitre he wears on his head. The bishop's sumptuous chasuble is ornamented with a band of applied embroidery decorated with quatrefoils. The top medallion shows God the Father, while the others contain the letters that together spell Ave Maria. This sculpture, damaged on the right side, comes from the parish church of Monticchio, in the region of Aquila. Like the Catalan Saint Peter, this statue was meant to be seen against a wall or in a niche. Despite this two-dimensional quality, however, both works effectively portray a sense of depth by their extended arms and the heavy draping of their chasubles.

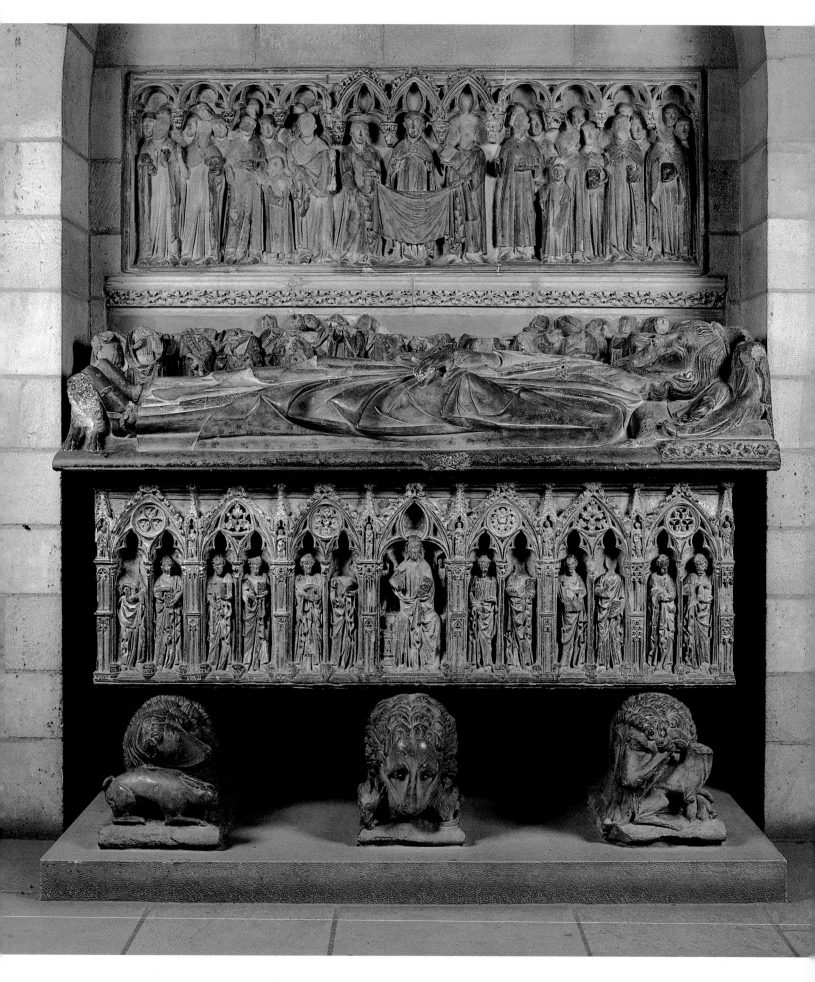

99 *Tomb of Ermengol VII*
Spanish; *effigy:* 1300–50; *sarcophagus and celebrants*
relief: mid-14th c.; assembled in 18th c.
Marble; greatest overall measurements 89 x 79½ x 35½ in.
(226.1 x 201.9 x 90.2 cm.) The Cloisters Collection, 1928 (28.95)

Spanish Tomb and Sarcophagus Lid

By the late eleventh century in western Europe, persons of importance sought to be commemorated with tombstones bearing their effigies. These were sometimes made into splendid monuments like the elaborate ensemble in Plate 99, traditionally associated with Count Ermengol VII (d. 1184), or sometimes into simple commemorations like the sarcophagus lid decorated with the effigy of a young boy in Plate 100. These two monuments and three other tombs in The Cloisters Collection all bear the coats of arms of the counts of Urgel. With the exception of the boy's sarcophagus, the Urgel tombs were probably commissioned by Ermengol X (d. 1314) for himself and his immediate ancestors for the family necropolis at the monastery of Bellpuig de la Avellanas, near Lérida in northeastern Spain.

Ermengol VII's finely carved effigy reclines on a forward-tilted slab, his hands crossed on his robe over a sheathed sword. Beneath the head are two tasseled cushions, the upper one wrought with the family arms. An angel lounging on the top cushion supports the head, and a lion crouches at the feet. Behind the effigy are rows of mourners. In the upper register, clerics perform the funeral rite of absolution. The sarcophagus, somewhat later in date than the effigy, is ornamented with carved reliefs of Christ in Majesty and of the apostles. The tomb is not mentioned in monastic records until the mid-eighteenth century and may have been assembled at that time from parts of other tombs, which would account for the mixture of styles that characterizes its present arrangement.

Like the portrayal of Ermengol VII, the effigy of the boy on the sarcophagus lid is not a portrait, but rather an idealized representation, probably of Ermengol IX (d. ca. 1255), uncle of Ermengol X and the only count of Urgel known to have died in his youth. The family arms are painted on his shoulder strap. This sarcophagus would have been too small even for the body of a youth. It was probably used for a type of burial called *chaux vive*, in which after at least a year of quicklime internment, the remains were rearranged and placed in a small sarcophagus.

100 Sarcophagus Lid: Effigy of a Youth (Ermengol IX ?)
Spanish, 1300–50
Limestone with traces of polychromy; L. 33⅞ in. (86 cm.)
The Cloisters Collection, 1975 (1975.129)

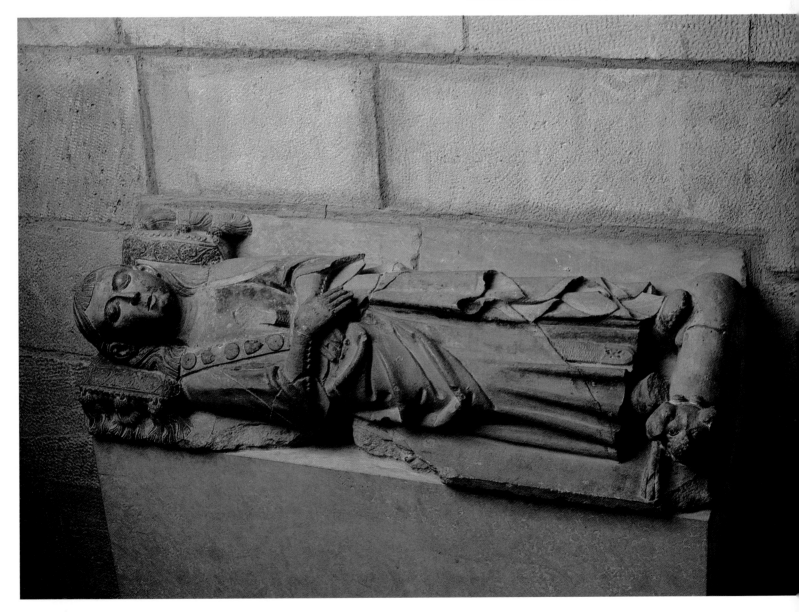

ENGLISH VIRGIN AND CHILD

Ivory statuettes such as this, produced at the height of the medieval popular devotion to the Virgin, were originally intended for private veneration in small chapels or oratories. Only a portion of one leg and foot of the infant Christ remains. Originally, the Child scrambled over his Mother's left knee to meet her gaze, thus evincing the contemporary emphasis on the tender relationship between the Virgin and Child. Mary turns slightly to her left, and the gentle bending of her body is echoed in the flow of her deeply cut, cascading drapery. This tender, human quality is quite different from the rigid frontality resulting from the more spiritual conceptualization that characterized representations of the Virgin and Child during the Romanesque period (see Plates 49, 52).

The statuette's highly polished surface has gained an appealing, dark reddish-brown patina over the centuries. It is a masterpiece—the finest of the very few English examples known to have survived the Protestant Reformation and the English Civil War—eloquently combining a sense of grandeur and refinement with intimacy.

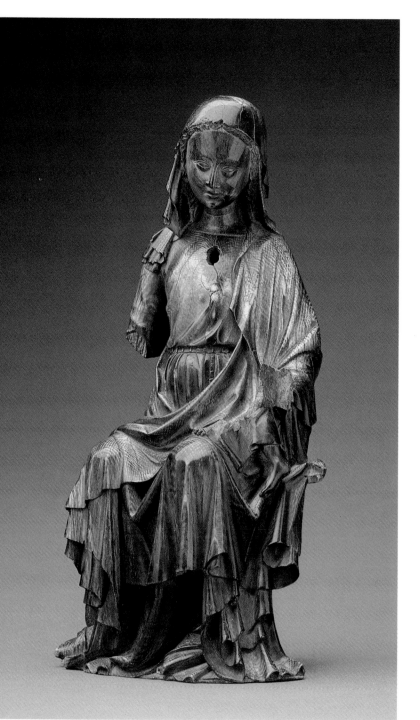

101 *Virgin and Child*
English (London ?), ca. 1300
Ivory; H. 10¾ in. (27.3 cm.)
The Cloisters Collection, 1979
(1979.402)

CHASUBLE

"De opere Anglicano," "de l'ouvrage," or "à la façon d'Angleterre," "de obra Anglaterra," "opus anglicanum"—of English workmanship—appears again and again in descriptions of embroidered ecclesiastical vestments found in Continental inventories of the thirteenth through fifteenth centuries. The thirteenth-century English chronicler Matthew of Paris tells this anecdote concerning Pope Innocent IV's admiration for such work:

> About the same time [1245] my Lord Pope, having noticed that the ecclesiastical ornaments of certain English priests, such as choral copes and mitres, were embroidered in gold thread after a most desirable fashion, asked whence came this work? From England, they told him. Then exclaimed the pope, "England is for us surely a garden of delights, truly an inexhaustible well."

This splendid chasuble is a beautiful example of "opus anglicanum." The principal vestment worn by a priest, bishop, or archbishop in the celebration of the Mass, a chasuble was usually made of the richest materials possible. The back view of this one shows three scenes embroidered directly on the velvet field: The Coronation of the Virgin, the Adoration of the Magi, and the Annunciation. They are placed amid a framework of intertwining oak branches decorated with animal faces as well as with hanging acorns completely fashioned from pearls. Underneath the shoulder seams can be seen the tails of what were originally parakeets. To the left of the Coronation, part of Saint Stephen is visible. The velvet background is still a rich red tone, and the gold embroidery is completely intact, but some of the original smaller figures were cut off or cut apart during a later remodeling.

102 *Chasuble ("Opus Anglicanum")*
English, 1330–50
Silk and metallic threads on velvet;
greatest W. 30 in. (76.2 cm.)
Fletcher Fund, 1927 (27.162.1)

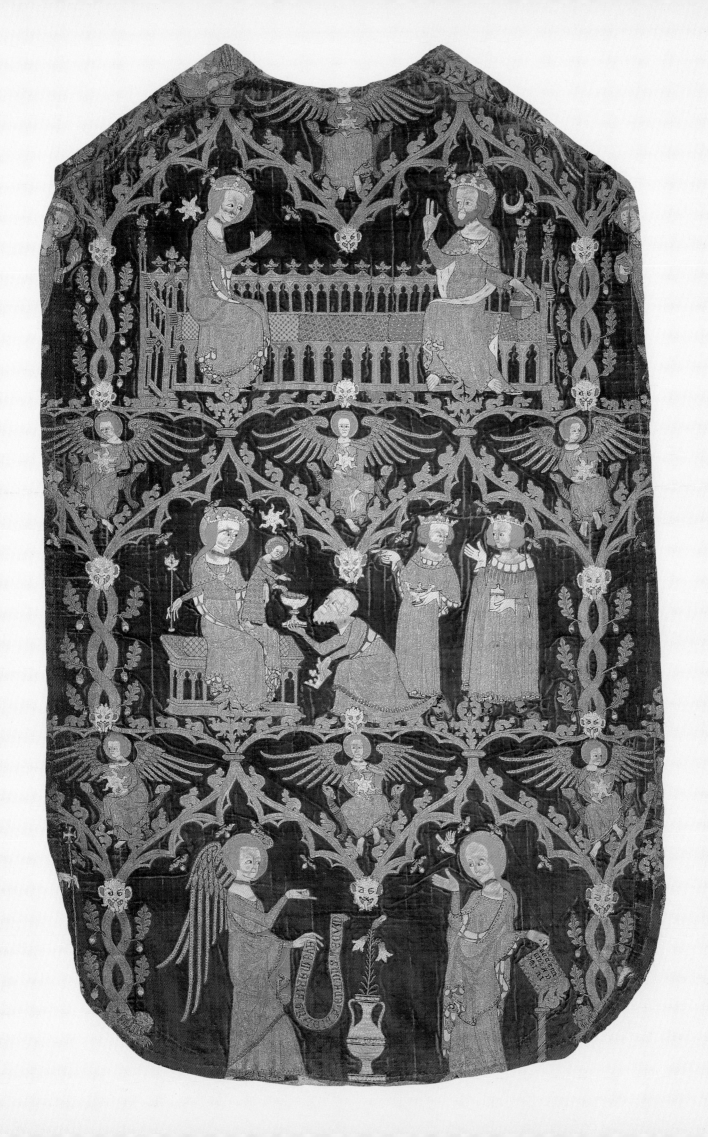

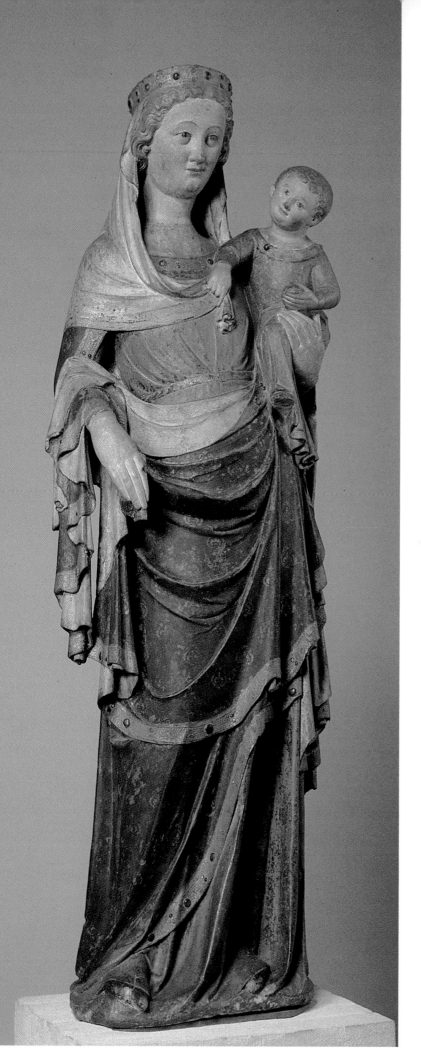

103 *Virgin and Child*
French (Ile-de-France), 1300–50
Limestone, polychromed and gilded;
H. 68 in. (172.7 cm.)
The Cloisters Collection, 1937 (37.159)

104 Seated Virgin and Child
French (Ile-de-France), 1300–50
Wood, polychromed and gilded;
H. 48 in. (121.9 cm.)
The Cloisters Collection, 1925
(25.120.290)

Two Gothic Sculptures of the Virgin and Child

These two sculptures of the Virgin and Child, both made in the region around Paris, portray Mary as an elegant court lady of the fourteenth century. In both works, the regal and serene Virgin tenderly holds the Christ Child—now represented as a chubby-cheeked, playful infant much different from the stern man-child of Romanesque interpretations (see Plates 49, 52). The soft and pliant modeling of the figures' drapery folds reveals the forms of the bodies underneath, thus emphasizing their more human qualities.

The standing limestone sculpture in Plate 103 is extraordinarily well preserved: The paint and gilding are almost intact, as are the round-cut stones in the Virgin's crown and in the borders of her garments. Her posture swings in a graceful S-curve, carefully balancing the child, whom she supports with her right arm. The seated Virgin in Plate 104, reputed to come from a chapel in the Royal Abbey of Saint-Denis, warmly gazes at her son, who touches her breast. As the epitome of the ideal court lady, both Virgins have small, high waists, sweet smiles, high foreheads, and delicate features.

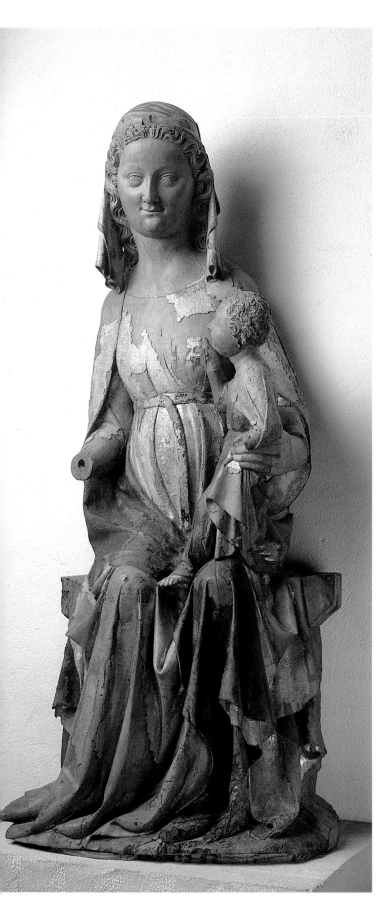

OVERLEAF:

JEAN PUCELLE
(Pages 112–113)
Book of Hours

The drawings in this tiny book of hours (a type of prayer and service book designed for private use) are the foremost testimony to the artistry of Jean Pucelle, the painter whose style influenced not only contemporary manuscript illumination, but stained glass and enameling as well. It was made for Jeanne d'Evreux, queen of France and wife of Charles IV. (In the *Annunciation* page—on the left—she is shown framed by the letter D, reading her book of hours.) Arranged according to the eight canonical hours of the day, the book contains twenty-five full-page miniatures, a calendar illustrating the signs of the zodiac, and numerous drawings in the margins and at the bottoms of pages. To the modern viewer, many of these drawings may seem both irrelevant and irreverent in a book of prayer, yet often what appears profane may have been intended to suggest a moral lesson. All of the images in the book are painted in grisaille —a technique in which figures are drawn and modeled entirely in black, with only background and flesh tones in color.

In the center is an episode from an unusual cycle of scenes from the life of Saint Louis (King Louis IX) opposite a decorated text page. While Saint Louis was a prisoner of the Saracens during his first Crusade, his prayer book, lost during the battle, was miraculously returned to him. This incident is pictured in *The Miracle of the Breviary*. Such illustrations of Louis's heroic deeds are indicative of his enthusiastic cult among the ladies of the court.

The prayers associated with the Virgin are illustrated with scenes from the infancy of Christ juxtaposed with episodes from his Passion. *The Betrayal of Christ* opposite *The Annunciation* are pictured on the left, and *The Crucifixion* opposite *The Adoration of the Magi* are reproduced on the right. Pucelle's ground-breaking portrayal of three-dimensional space in *The Annunciation* was most probably influenced by the work of the Sienese master Duccio, as was his portrayal of the crowd gathered at the foot of the cross in *The Crucifixion*. Yet he treats these subjects with an elegant mastery that is characteristically French. Indeed, the refinement of his drawing, his inventive freedom in the creation and handling of forms, and his innovative spirit in the expression of space and emotion make Pucelle one of the greatest artists of his day.

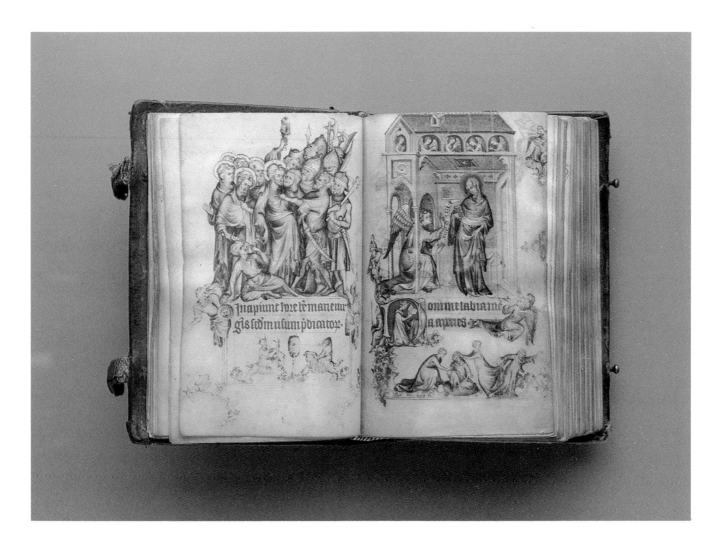

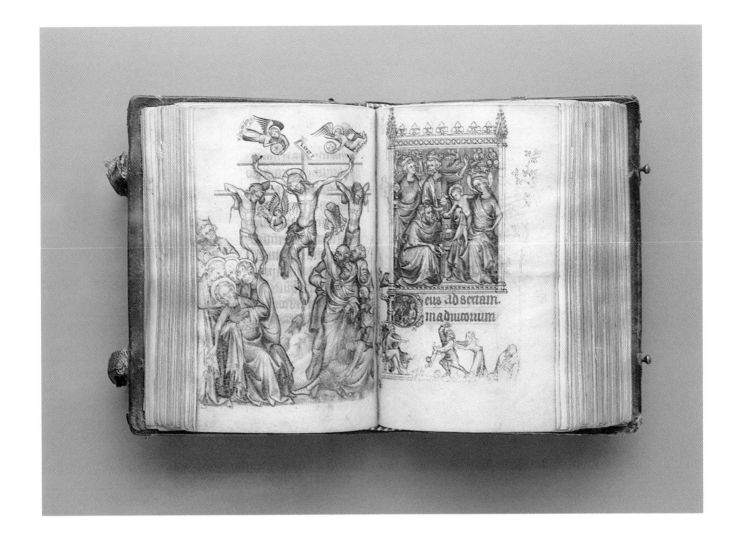

105 The Book of Hours of Jeanne d'Evreux, 1325–28
Jean Pucelle
French, act. ca. 1320–50
Tempera and gold leaf on parchment; 3½ x 2⅞ in. (8.9 x 6.2 cm.)
The Cloisters Collection, 1954 (54.1.2)

Page 111: text

Left: The Betrayal of Christ and *The Annunciation* (folios 15v–16)

Center: The Miracle of the Breviary and text page (folios 154v–155)

Right: The Crucifixion and *The Adoration of the Magi* (folios 68v–69)

GRISAILLE WINDOW

Grisaille windows, or panels of white glass painted in black and highlighted with colored ornamental designs, reached the height of their popularity during the fourteenth century. They lack brilliant color partly for economy, since full-color windows, made up of panels such as those from Soissons and Saint-Germain-des-Prés (Plates 74, 80) were more costly, and partly to allow more light to accentuate the delicate details of church architecture. This grisaille window is composed of panels from three distinct windows from the abbey church of Saint-Ouen in Rouen, whose choir windows were glazed between 1325 and 1335. The foliate designs of the Saint-Ouen grisaille have been said to evoke "the gardens of their time," appearing like "leafy vines growing on a trellis." Each of these plant patterns is botanically accurate. Periwinkle flowers, leaves of strawberry, and buttercup plants, as well as columbine and artemisia are illustrated growing around a central stem. These painted patterns are highlighted with colored decorative elements at the center of each rectangular panel. They are accented with silver stain, a coloring agent made of silver oxide or sulphide, which, when applied to a glass surface, produces a wide range of tonalities from pale yellow to fiery orange, depending on the length of firing time. While this assemblage does not include the colored figural panel that originally would have been set between large expanses of grisaille glass, its beauty and refinement indicate the importance given to ornament in glazing decoration at this time.

106 Grisaille Window
French (Rouen, Abbey of Saint-Ouen), ca. 1325–35
Pot-metal and white glass with vitreous paint and silver stain;
H. 8 ft. 7 in. x 35½ in. (2.65 m. x 90 cm.)
The Cloisters Collection, 1984 (48.183.2, 1984,199.1–11)

MINIATURE FROM THE PSALTER AND PRAYER BOOK OF BONNE OF LUXEMBOURG

Made for Bonne, daughter of Jean of Luxembourg, king of Bohemia, and mother of Charles V of France, this little manuscript is one of the finest productions of the Pucelle workshop tradition favored by French royalty at this time. Its ornamented foliate borders with spiky tendrils serve as perches for nearly forty species of acutely observed and rendered birds. The sequence of miniatures reaches its artistic highpoint in this double-page painting of *The Three Living and the Three Dead*. This story, which enjoyed widespread popularity all over Europe from the middle of the thirteenth century, tells of an encounter between three young hunters and three dead men. The youths speak to the grim visitors, who in the miniature are shown in different stages of decomposition. The first dead man replies, "What you are, we were, and what we are, you will be." The second dead man recalls that death treats rich and poor alike, while the third emphasizes that there is no escape from his dreaded summons. The meticulously articulated and brittle style of drawing accentuates the grim morality of the scene.

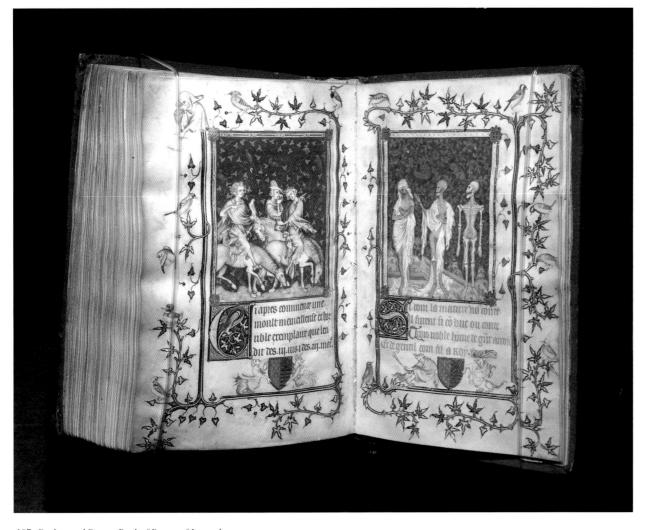

107 *Psalter and Prayer Book of Bonne of Luxembourg:*
The Three Living and the Three Dead (folios 321v, 322)
French (Paris), ca. 1345
Tempera and gold leaf on vellum; 4¹⁵⁄₁₆ x 3⁹⁄₁₆ in.
(12.5 x 9.1 cm.) The Cloisters Collection, 1969 (69.86)

108 *Mirror Back*
French (Paris), 14th c.
Ivory; D. 4½ in. (11.4 cm.)
Gift of George Blumenthal,
1941 (41.100.160)

MIRROR BACK

Although large mirrors with decorated bases and handles
were common throughout the late Middle Ages, few exam-
ples have survived. More familiar are small mirror backs, or
folding mirror cases, such as this Parisian example, made of
ivory and often carried on the person. Bounded by four
lions on the rim, this mirror back illustrates a fashionably
dressed lady and gentleman hunting with falcons. Dogs
scamper about the horses' feet. Wearing leather gloves to
protect their hands from the birds' talons, the hunters are
shown at rest. While one attendant blows a horn to com-
municate with his companions, the other holds the lure
to draw in another falcon. The less strenuous nature of
this popular sport made it a suitable outdoor activity for
ladies. This piece was made by an ivory carver (called a
pignier) who most likely specialized in combs and mirror
backs. The subject matter and fine carving here indicate
that the mirror back was probably owned by an aristocrat.

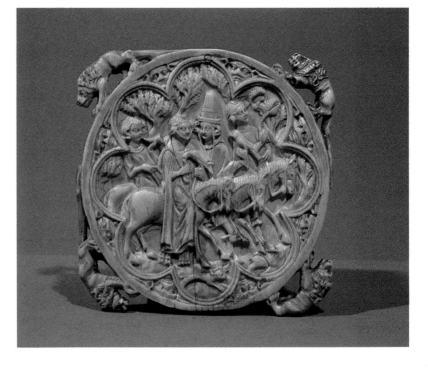

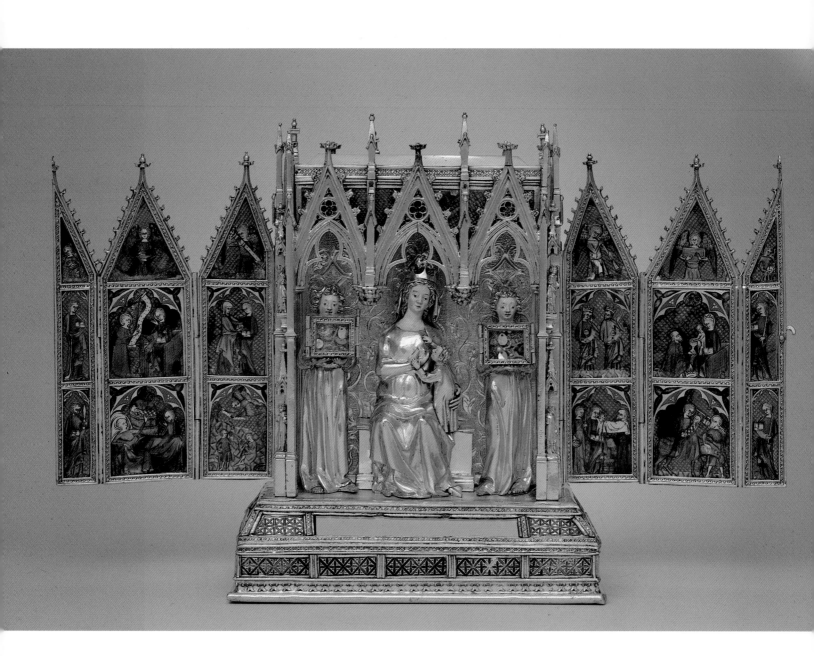

FRENCH RELIQUARY SHRINE

Constructed in the form of a miniature church-shaped altarpiece with hinged wings at either side, this fourteenth-century shrine of silver gilt and translucent enamel once belonged to the Convent of the Poor Clares in Budapest. Queen Elizabeth of Hungary, who founded the convent in 1334, may also have been the donor of the shrine. The little scenes on the wings, front and back, are of a jewellike brilliance, resembling stained glass. The delicate drawing style, intricate patterns of ornament, sinuous drapery folds, and use of architectural elements to frame figures make a striking comparison with the style of Jean Pucelle seen in Plate 105. A number of the architectural details are reminiscent of Gothic churches, notably the trefoil arches and the ribbed vaulting above the angels attending the seated Virgin Mary, shown nursing the Christ Child. Since most of the scenes on the wings illustrate events from the infancy of Christ, these angels probably once displayed relics associated with the Nativity in their small windowed boxes.

109 Reliquary Shrine
French (Paris), ca. 1320–40
Silver gilt and translucent enamel;
H. 10 in. (25.4 cm.), W. open 16 in.
(40.6 cm.)
The Cloisters Collection, 1962
(62.96)

Opposite: detail

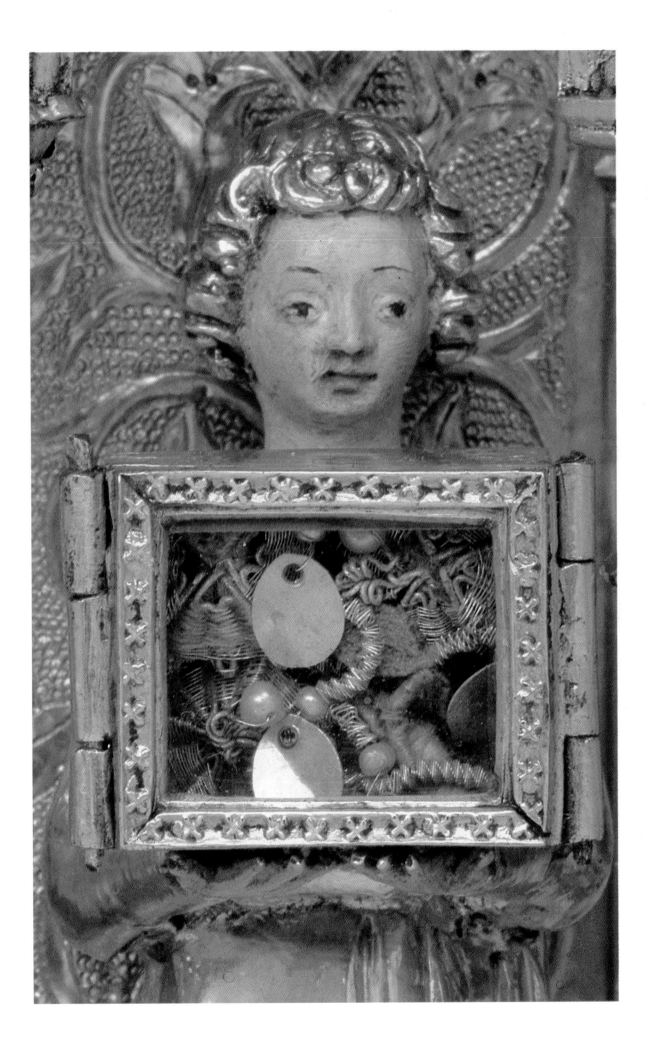

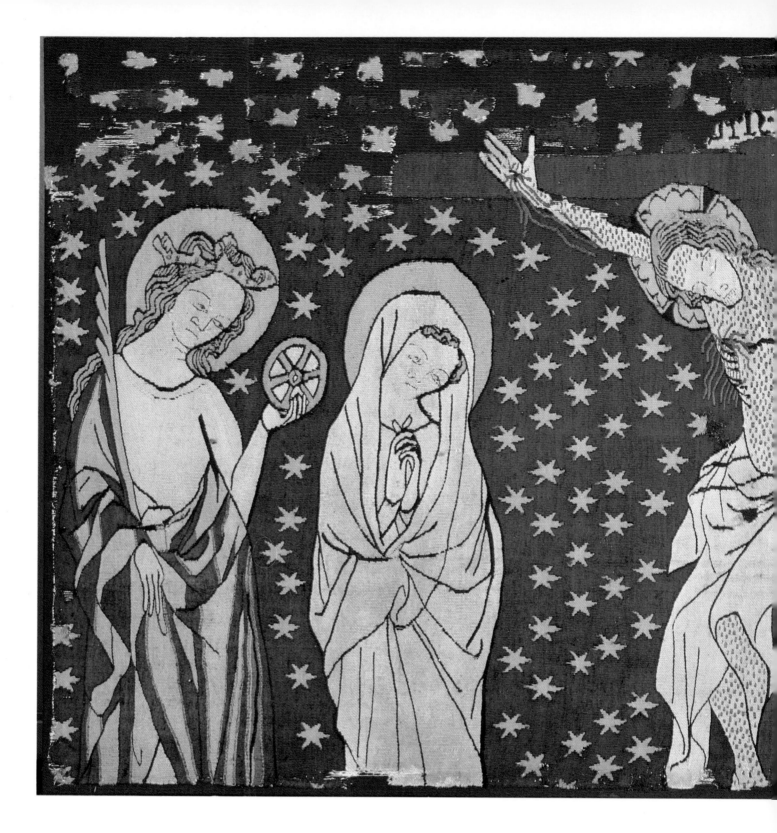

Tapestry with the Crucifixion

This tapestry fragment illustrating the Crucifixion was originally the central part of an altar frontal or a hanging behind the altar. Like the Crucifixion illumination from the Parisian missal (Plate 85), here Christ's body hangs from the cross in an elegantly curving line; his feet (now missing) were attached by a single nail. However, the quiet serenity of death that pervaded the Parisian work is altered here, as Christ's tortured body appears to bleed from every pore. This increasing emphasis during the later Middle Ages on

the physical pain and suffering of the crucified Christ has been linked with contemporary mysticism, which exhorted the faithful to appreciate Christ's sacrifice by empathizing with and concentrating on his physical agony. The Virgin Mary and Saint John the Evangelist flank Christ, their hand gestures silently, conveying their grief. Saint Catherine of Alexandria, holding a palm and a wheel (the symbols of her martyrdom), stands next to Mary, while Saint Dorothy, surrounded by flames, which refer to her martyrdom

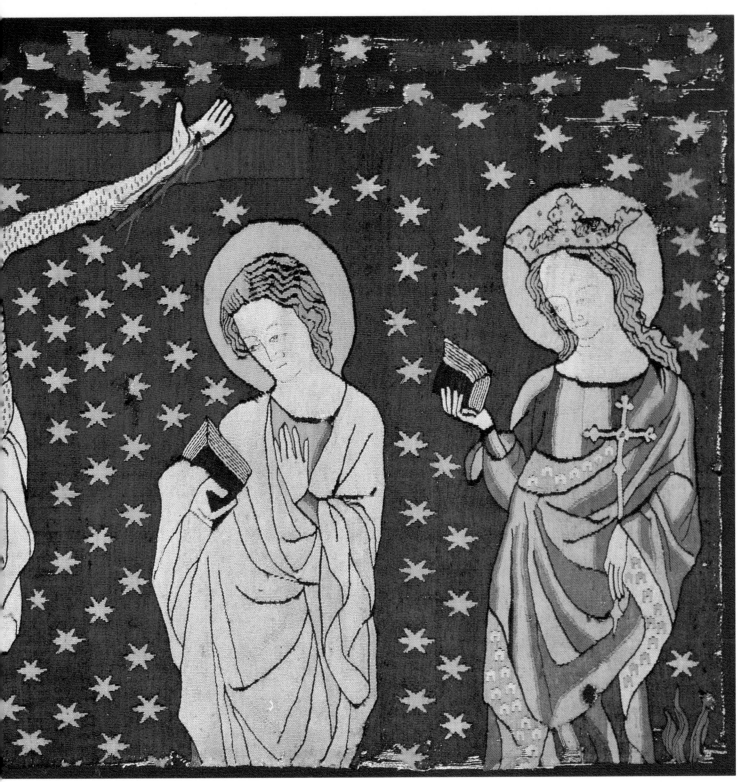

110 Tapestry with the Crucifixion
German, mid-14th c.
Wool and linen; 32½ x 79 in. (82.5 x 200.7 cm.)
Purchase, Francis L. Leland Fund and Mitchell
Samuels Gift, 1916 (16.90)

at the stake, is next to Saint John. The strong linear portrayal, without modeling or shading, makes an effective contrast to the blue background filled with golden stars.

The tapestry's production in both linen and wool is characteristic of German weaving. (Owing to its tendency to stretch, the use of linen was prohibited by the weaving regulations of France and England.) Also distinctive to Germany, and to the Upper Rhine region in particular, was the use of embroidery for fine detailing. With wool and silk

threads, the facial features and jewels on the crowns in this work are fashioned in an embroidery technique called couching, in which the design's outline is formed by a thread laid flat on the fabric and secured by fine stitches. While documentation of weaving practices in Germany are scarce for the fourteenth century, the presence of Saint Clare in another fragment of this work suggests that it may have been produced in a convent of the Poor Clares, whose nuns often supported their houses by producing fine handwork.

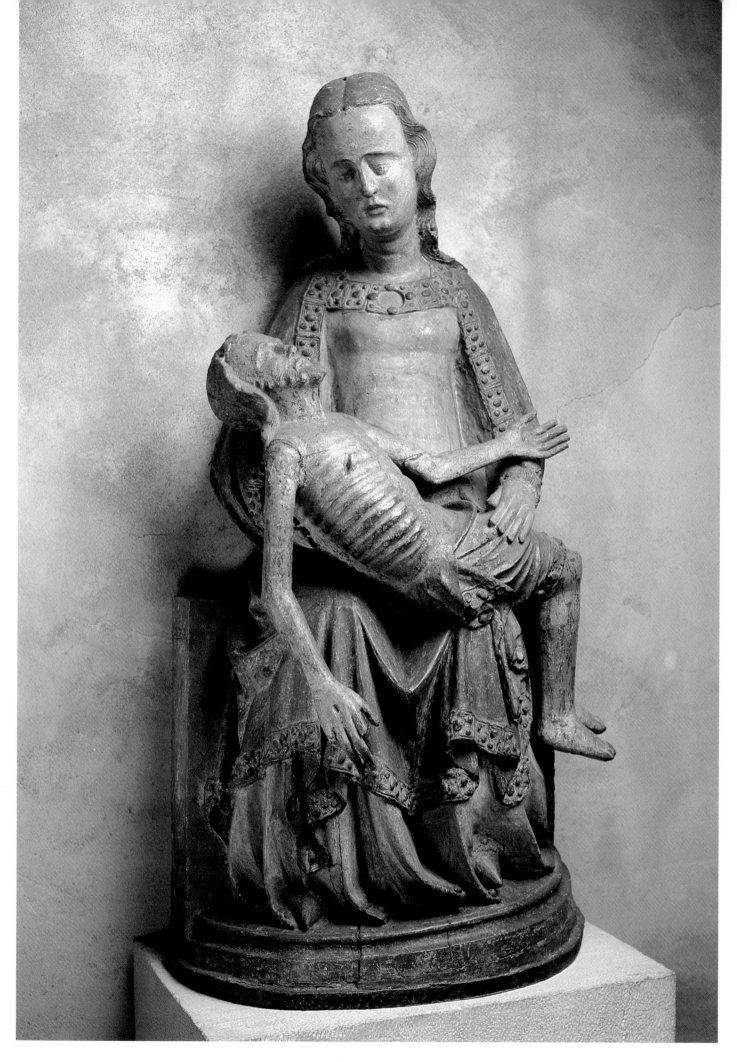

111 Pietà
South German or Rhenish, 1375–1400
Wood, plaster, polychromy, and gilt;
52¼ x 27⅜ in. (132.7 x 69.5 cm.)
The Cloisters Collection, 1948 (48.85)

112 Enthroned Virgin and Child
Austrian, ca. 1360
Lindenwood, polychromy, and gilt;
29⅝ x 13⅜ in. (75.3 x 34 cm.)
The Cloisters Collection, 1965
(65.215.1)

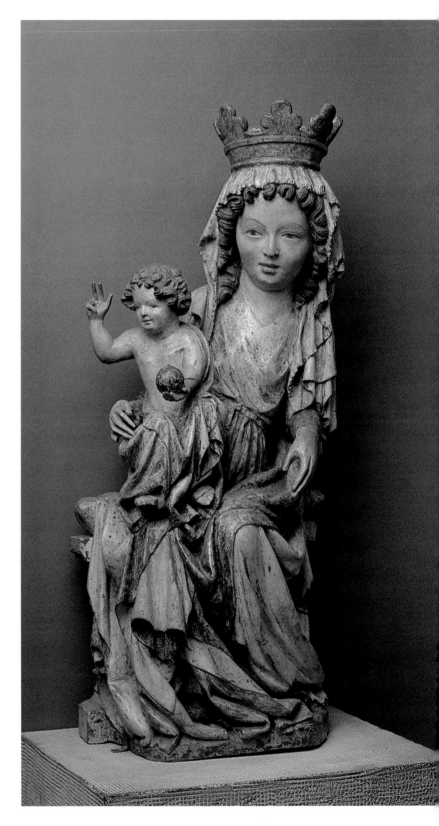

Pieta and Enthroned Virgin and Child

These two very different representations of the Virgin Mary with her son both exhibit a characteristic mid-fourteenth-century Germanic tendency toward powerful gestures, bold, tactile modeling, and a suggestion of orthogonal movement. The Pietà, or portrayal of the sorrowful figure of Mary mourning over her dead son (Plate 111), developed out of the mystical contemplation of the sufferings of Christ, which also influenced the depiction of the Crucifixion in the mid-fourteenth-century German tapestry (Plate 110). Mystics also brooded over the suffering of Mary, which paralleled the Passion of her son, and in considering the deposition of the body of Christ from the cross, separate emphasis was given to the moment when Mary in her grief took the body upon her lap. Thus, this came to be thought of as an isolated devotional theme, set apart from the other historical scenes of the Passion. This Pietà treats the subject with dignity and restraint. The full folds of the Virgin's robe, its gold borders enriched with jewels, are in striking contrast to the flat modeling of the figure of Christ. Rigid in death, his body bears the marks of his Passion. The small size of the Christ figure here may reflect the writings of German mystics, who believed that the Virgin, in the agony of her grief, imagined that she was holding Christ as a baby once again in her arms.

While the Pietà is direct and austere, the Enthroned Virgin and Child is elegant and lithesome. Probably originally intended as part of a group representing the Adoration of the Magi, the Virgin is seated in a *contrapposto* position; her legs swing to the left, while her torso leans to the right. Furthering this sense of movement, the Christ Child reaches forward to bless the approaching Magi, whose drapery falls in soft swinging folds that harmonize the entire work.

AUSTRIAN STAINED-GLASS PANELS

Plate 113 illustrates the installation at The Cloisters of more than twenty panels of stained glass from the south Austrian church of Saint Leonhard. There is no evidence of a comprehensive plan in the selection of subject matter for the church's glazing program, and the panels in the Museum's collection depict a variety of saints as well as episodes from events after Christ's Resurrection and popular images of the Virgin.

The Saint Leonhard glass is representative of the type of stained-glass window popular throughout the Holy Roman Empire in the middle of the fourteenth century. Medallion frames, decorated with geometric shapes evoking precious gems, frequently assumed complicated shapes in which were set figures or narrative scenes. These panels were adapted from a series of frequently employed cartoons, or full-size preliminary drawings. The figures are of short, stocky proportions and have heavy, rather somber facial features. Rather than being comfortably contained in the medallion frames, their bodies seem to thrust forward, expanding beyond their borders by their sheer corporeal weight. This creates an effect of dramatic tension that is intensified by the varied palette of brilliant color. The floral backgrounds combined with rudimentary architectural forms may have been inspired by textiles imported from the East. The patterned effect imbues the glass with a textural richness and vibrancy quite different from the lithe and mannered naturalism popular in French glazing at roughly the same time (see Plate 106).

113 Panels Showing Saints, and Christological and Marian Scenes
Austrian (Carinthia, Bad Saint Leonhard im Lavanthal,
Church of Saint Leonhard), 1340–50
Pot-metal glass with vitreous paint; each panel approx. 35–39
13–17 ft. (8.9–9 x 3.3–4.4 m.)
The Cloisters Collection, 1965 (65.96.1–4; 65.97.1–6;
65.98); 1968 (68.224.1–13); 1970 (1970.320)

Left: Panel showing Saint Nicholas

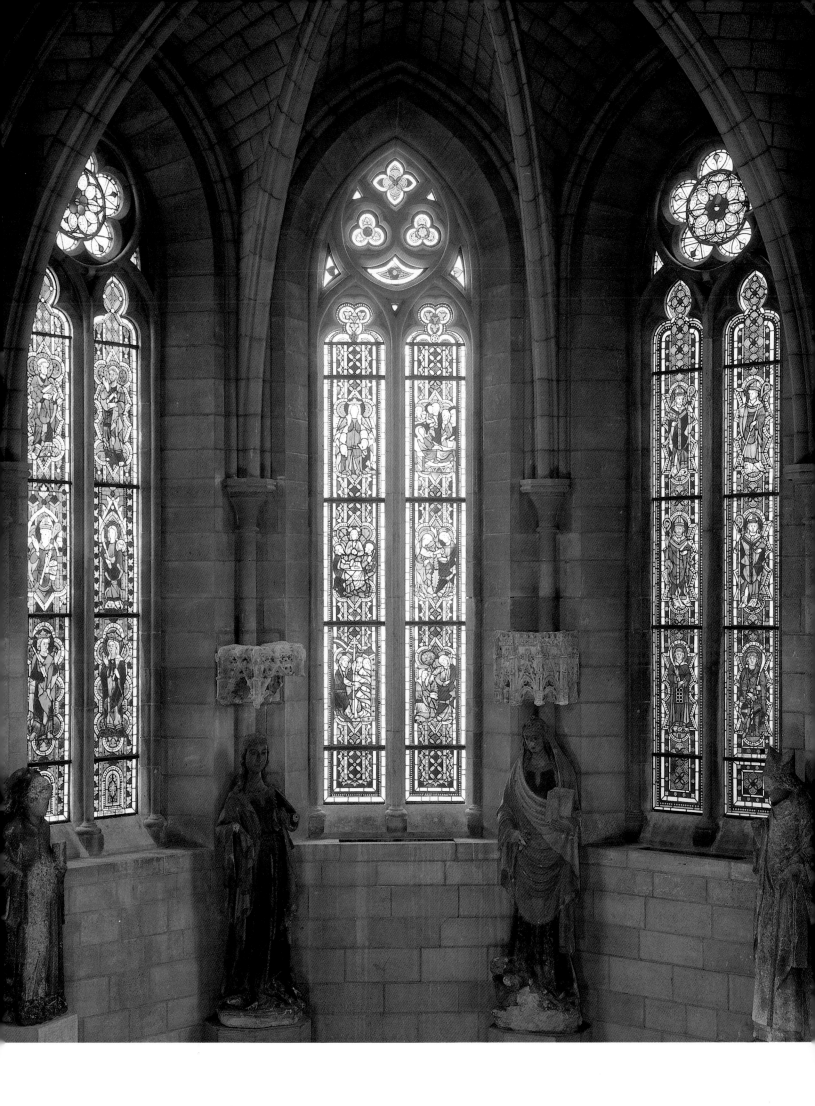

114 Morse with the Stigmatization of Saint Francis
Italian (Tuscany ?), ca. 1350
Copper gilt and translucent and opaque enamel;
D. 4¼ in. (10.8 cm.)
Gift of Georges and Edna Seligmann, in memory of
his father, Simon Seligmann, the collector of Medieval
art, and of his brother Rene, 1979 (1979.498.2)

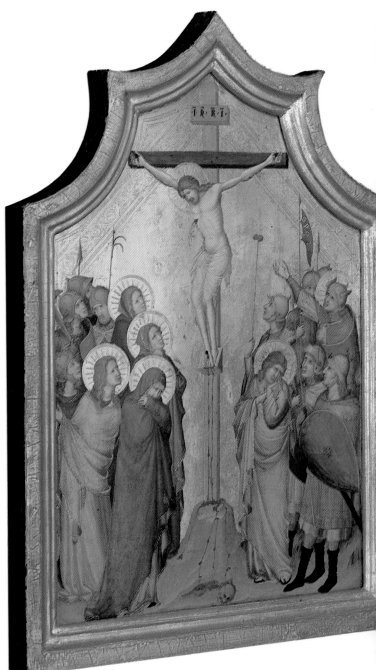

THREE ITALIAN WORKS

Despite their varied size and mediums, these three works all communicate the sense of deep spiritual reflection that runs through Tuscan art of the fourteenth century. Saint Francis of Assisi, whose stigmata were the marks of such piety, was widely seen as the exemplar of someone who experienced the profundity of Christ's life and sacrifice through mystical contemplation. Saint Francis receiving the stigmata is portrayed in this morse, or clasp, for an ecclesiastical mantle (Plate 114).

Emphasis on the grief experienced by the witnesses to Christ's death explains the sorrowful figures represented in the diptych of the Crucifixion and Lamentation (Plate

115). As the Lamentation is not mentioned in the Gospels, depictions of the event are dependent on the description by the thirteenth-century Franciscan Pseudo-Bonaventura: "Our Lady supports the head and shoulders [of Christ] in her lap, the Magdalene the feet at which she had formerly found so much grace. The others stand about making a great bewailing over him . . . as for a first-born son." The illustration of the Nativity (Plate 116) similarly emphasizes meditation in its focus on the adoration of the newly born Christ Child.

In all three works the contemplative ideal is conveyed through a style that evokes the viewer's empathy. The figures

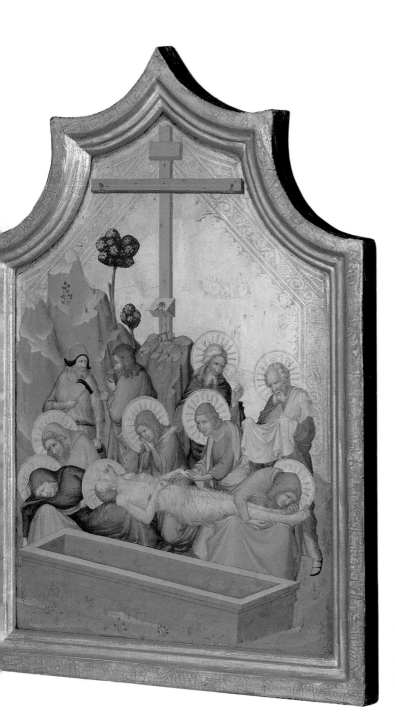

116 Disk with the Nativity
Italian (Tuscany ?), 1375–1400
Verre églomisé; 22 x 9⅜ in. (56 x 23.2 cm.)
Gift of J. Pierpont Morgan, 1917 (17.190.504)

115 Diptych with the Crucifixion and the Lamentation
Master of the Codex of Saint George
Italian (Tuscany), act. after 1310–40s
Tempera on wood, tooled gold ground;
each panel 15⅝ x 10⅝ in. (39.7 x 27 cm.)
The Cloisters Collection, 1961 (61.200.1,2)

are characterized by expressive faces and by weighty drapery folds modeled by light and shadow. Attention is also given to the landscape backgrounds. The stigmatization of Saint Francis is set in the middle of a rocky landscape with rugged mountains and a brook cutting deep into the stone. While the composition was probably adapted from a monumental wall painting in the saint's home church at Assisi, this work departs from other representations of the event by casting it as a night scene, with a crescent moon shining in gold on a dark blue sky. (The seraph, too, radiates a golden light, and the saint's body is surrounded by luminous rays.) The diptych also utilizes this type of mountainous landscape, in

this instance to suggest Calvary. And here the emotional nature of the scene is given further emphasis by a lyric sense of color, shading, and figural mass, as well as beautifully balanced proportions and a forceful and dramatic composition, characteristics that are also exhibited in the *verre églomisé* disk. Made by drawing with a stylus on the gilded glass surface, the disk was set into a metal mount and the darker surface beneath was revealed through the drawing. The use of gold in this piece, as well as the tooled gold leaf in the background of the Crucifixion and Lamentation diptych and the copper ground of the morse, serve to heighten the contemplative quality of each work.

Bust of Marie de France

This marble bust once formed part of a tomb effigy of the French princess Marie de France (1327–41), daughter of King Charles IV and Jeanne d'Evreux, whose tiny book of hours (Plate 105) is also in the Museum's collection. The princess died at the age of fourteen and was buried at the royal abbey of Saint-Denis, which served as the necropolis for the French monarchy. An eighteenth-century engraving shows the original position of the full-length sculpture, reclining beneath a simple architectural canopy, with the head supported by a pillow. The sculpture was reported stolen following the abbey's vandalization in the aftermath of the French Revolution, and it is likely that the head was separated at that time. The princess is portrayed wearing the headdress and coiffure popular among ladies of the French court during the reign of Charles V, more than forty years after her death. Unlike the tomb effigies of Jean d'Alluye (Plate 90) and the two counts of Urgel (Plates 99, 100), there is a greater attempt at portraiture in this tomb sculpture apparent in the general facial characteristics of the royal family.

The bust apparently formed part of a commission for the double tomb of Marie and her sister, Blanche, whose effigy was probably modeled from life. Both works were carved by Jean de Liège, a sculptor who was granted many royal commissions.

118 Bust of Marie de France
Jean de Liège, ca. 1380–81
Franco-Flemish, act. ca. 1371–82
Marble with traces of polychromy; H. 12¼ in.
(31 cm.)
Gift of George Blumenthal, 1941 (41.100.132)

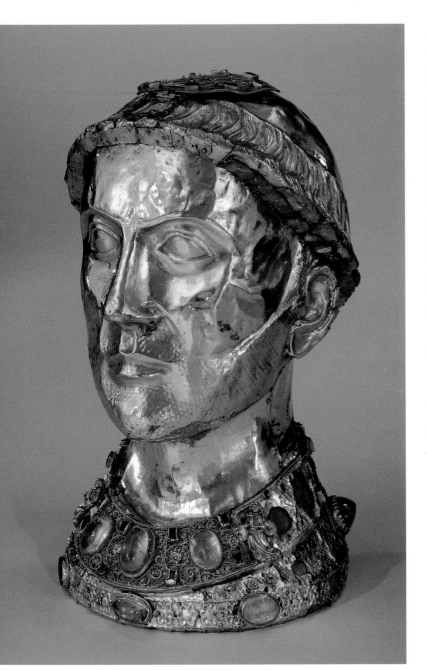

117 Reliquary Bust
French (Limoges), 13th c.
Silver gilt and jewels over wooden core;
H. 14¾ in. (37.5 cm.)
Gift of J. Pierpont Morgan, 1917 (17.190.352)

Reliquary Bust

While the châsse continued to be the most popular reliquary format throughout the Middle Ages, vessels containing particularly sacred remains were sometimes designed in the shape of the relic they housed. This reliquary bust of Saint Yrieix once held pieces of the saint's skull. It comes from the abbey church of Attane in the Limousin, which was founded by the saint, a local bishop and nobleman, during the sixth century.

The sumptuous materials used in the reliquary's construction reflect its importance. Adorned with a jeweled, filigree collar and fashioned over an extant wooden core, its silver casing is carefully worked to reveal a portrait bust that combines idealization with great naturalism. The portrayal of the saint's clear, sharp features, his impressively detailed beard and tonsure (the ring of hair left after cutting the hair on top of the head as an indication of a monk's vows), and his wide, staring eyes enhanced by arching eyebrows, must have presented an awesome vision in its original installation on an altar, with the flickering of candlelight reflected on its polished surfaces.

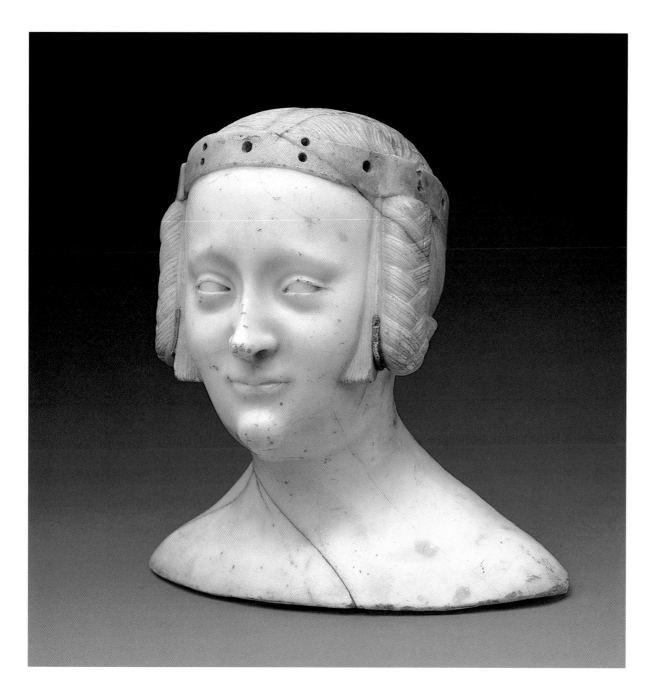

OVERLEAF:

JULIUS CAESAR, FROM THE
NINE HEROES TAPESTRIES *(Page 128)*

The Nine Heroes Tapestries are among the earliest Gothic tapestries to survive. Originally, there were three hangings, each more than 21 feet wide and containing the likenesses of three heroic figures. The theme of the Nine Heroes was popularized in a French poem of about 1312 in which three pagan, three Hebrew, and three Christian heroes were described. Julius Caesar, illustrated here, can be identified by his shield bearing the double-headed eagle in sable on gold, his customary medieval coat of arms.

In their variety, these fascinating works depict the highest level of the rich and powerful social structure of late-fourteenth-century France. Not only are the heroes portrayed in contemporary dress, but the little figures in the surrounding arcades constitute the members of a medieval court: knights, spearmen, archers, ladies, and musicians. Such elaborate works of fine craftsmanship were no doubt made for a noble patron. While the tapestries have sustained damage and loss, even in their fragmented state they offer remarkable glimpses into late medieval court life.

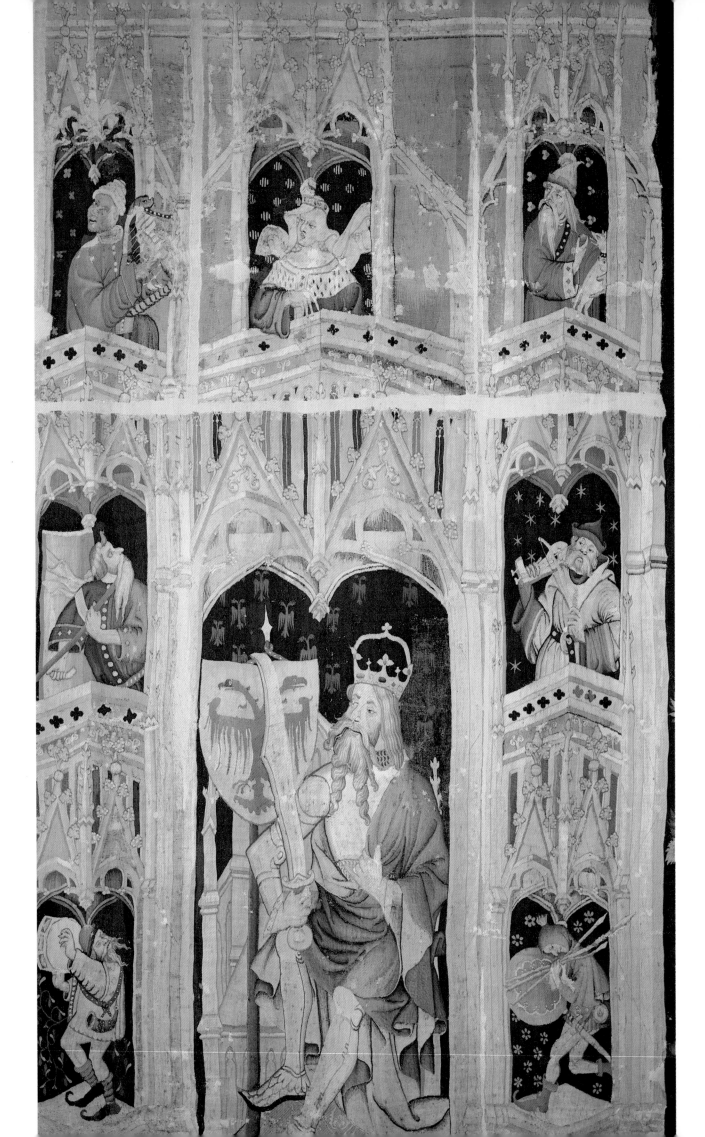

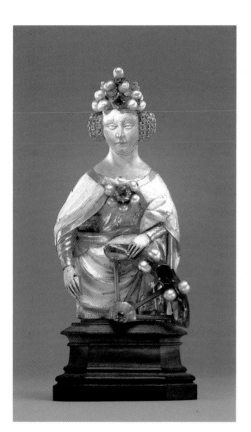

AQUAMANILE and STATUETTE OF SAINT CATHERINE

The triumphs of two gifted women—one pagan, one Christian—are celebrated in these two works. The aquamanile is an exceptional piece of secular sculpture. It represents Phyllis and Aristotle, whose fabled confrontation was popularly told in the Middle Ages. It was said that Alexander the Great was so infatuated with the beautiful Phyllis that he neglected the affairs of state. When his former tutor, Aristotle, intervened to induce Alexander to return to his duties, Phyllis sought revenge. She made Aristotle fall in love with her, and then insisted he prove his love by allowing her to ride on his back. When Alexander demanded that Aristotle explain his conduct—so contrary to his own advice—the philosopher replied, "If a woman can make such a fool of a man of my age and wisdom, how much more dangerous must she be for younger ones?"

Saint Catherine, depicted in the delicately jeweled statuette (Plate 120), was seen to embody the power of Christian erudition. According to legend, Saint Catherine's learned arguments on behalf of Christianity converted not only the court philosophers of the pagan emperor Maxentius, but two hundred guardian soldiers and the ruler's wife as well. In retribution, all were put to death. This virtuous saint is shown holding the spiked wheel upon which she was tortured before being decapitated. Though the statue is reputed to have come from a convent in Clermont-Ferrand, the fine workmanship, sensitive modeling, and precious gem-studded decoration are consistent with the finest works produced in Paris. The image may have come from a reliquary, where it and figures of other saints would have been integrated into an architectural ensemble.

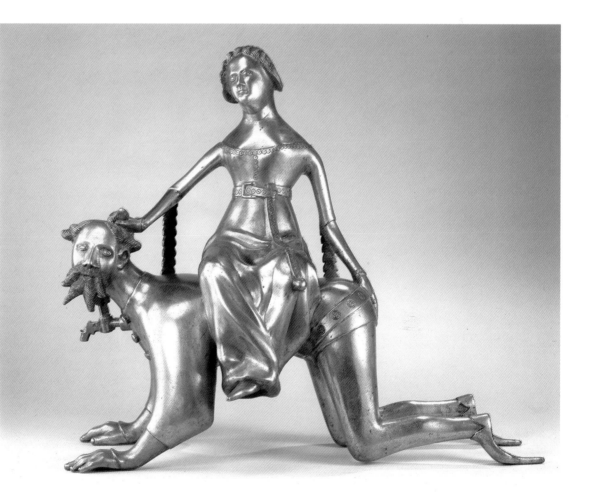

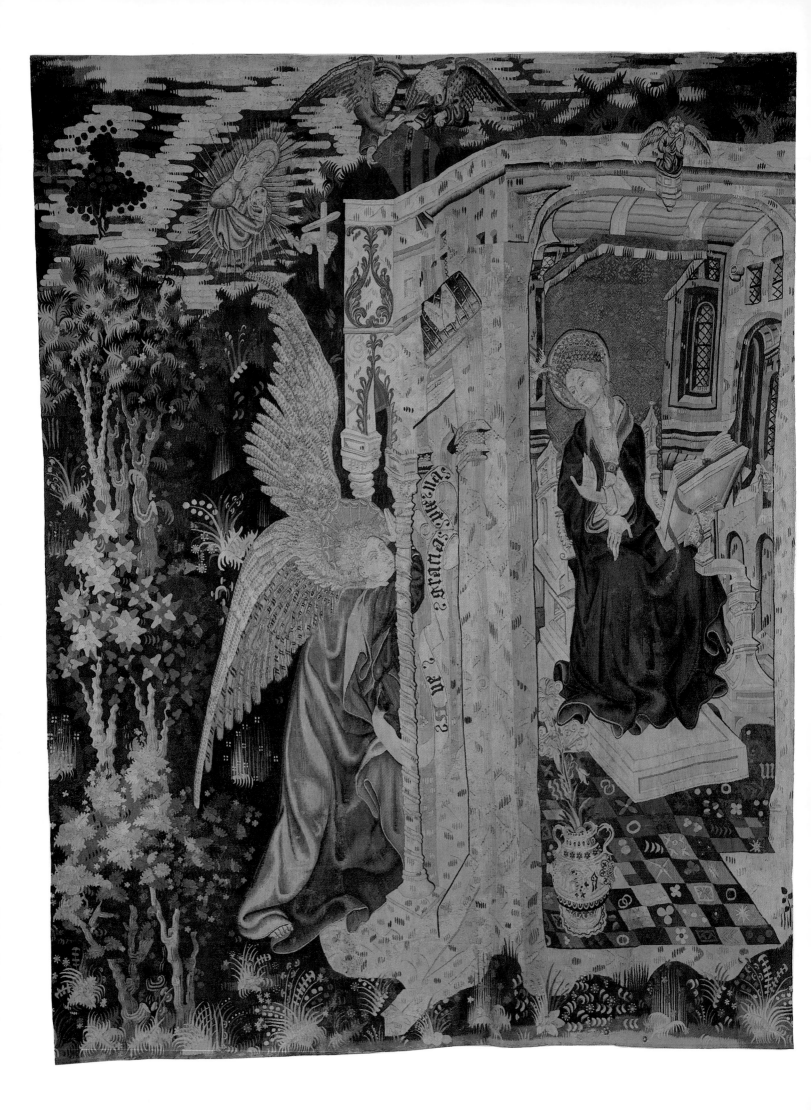

TAPESTRY WITH THE ANNUNCIATION

Seated in a spacious room of the elaborate type first represented in northern Europe by the illuminator Jean Pucelle (see Plate 105), the Virgin Mary looks away from her book on the reading lectern, startled by the sudden entrance of the archangel Gabriel. He holds a scroll with the words *Ave gracia plena* (Hail [Mary] full of grace). In the sky, God the Father sends the infant Jesus bearing a cross toward the Virgin, preceded by the dove of the Holy Spirit. They descend in the direction of the Virgin's ear, as it was believed that her ear was the opening through which she conceived. Other imagery in the tapestry, such as the enclosed garden, similarly emphasizes her virginity, while the single white lily placed in an elaborate pottery jar symbolizes her purity.

While the tapestry was probably woven in Arras in Flanders—the leading center of tapestry production following the decline of Paris during the Hundred Years War—it was found in Spain. The fame of Flemish weavers extended throughout Europe, and Flemish art was especially prized by Spaniards, who had established close diplomatic and commercial ties with Flanders.

122 Tapestry with the Annunciation
Southern Netherlandish, 1410–30
Wool and silk with gilt thread; 136 x 114 in. (345 x 290 cm.)
Gift of Harriet Barnes Pratt, in memory of her husband,
Harold Irving Pratt, 1945 (45.76)

SAINT CHRISTOPHER

Venerated from the early centuries of Christianity, Saint Christopher—meaning Christ-bearer—was honored as protector of travelers. According to *The Golden Legend*, Christopher ferried a small child, whose weight grew increasingly, across a river. When Christopher complained that it seemed as if he had carried the weight of the world, the child replied, "Wonder not, Christopher, for not only hast thou borne the whole world upon thy shoulders, but Him who created the world. For I am Christ thy King." In this imposing statuette-reliquary, Christopher is portrayed striding through the water, twisting as he turns to look at the Christ Child, who holds an orb in reference to his dominion. The small leaves sprouting from the top of the staff are a reminder of the miracle promised by Christ—that if the saint, upon his return home, implanted the staff into the ground, it would bear leaves and fruit in the morning.

The hallmarks stamped on the hem of the saint's cloak and on the statue's base clearly show this piece to be from the silversmith shops of Toulouse. The reliquary, excellently preserved, reveals a masterful treatment of the material. The soft, rich folds of the saint's cloak belie their metal substance. The ungilded surfaces of the faces are framed by the crisp design of the hair. The engraving of the short curls of the Christ Child, the hair and flowing beard of the saint, and the fish in the turbulent water is accented by the juxtaposition of large areas of silver with bright flashes of gilding. The now-lost relic of the saint was placed in the small box covered with crystal on the statue's base, through which the relic could be seen.

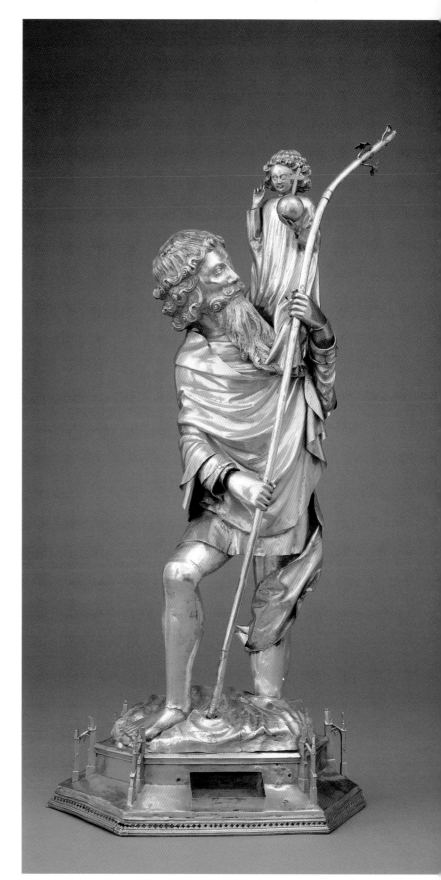

123 Saint Christopher
French (Toulouse), 1400–25
Silver, partly gilt;
23⅝ x 11¾ in. (65.1 x 29.9 cm.)
Gift of J. Pierpont Morgan, 1917
(17.190.361)

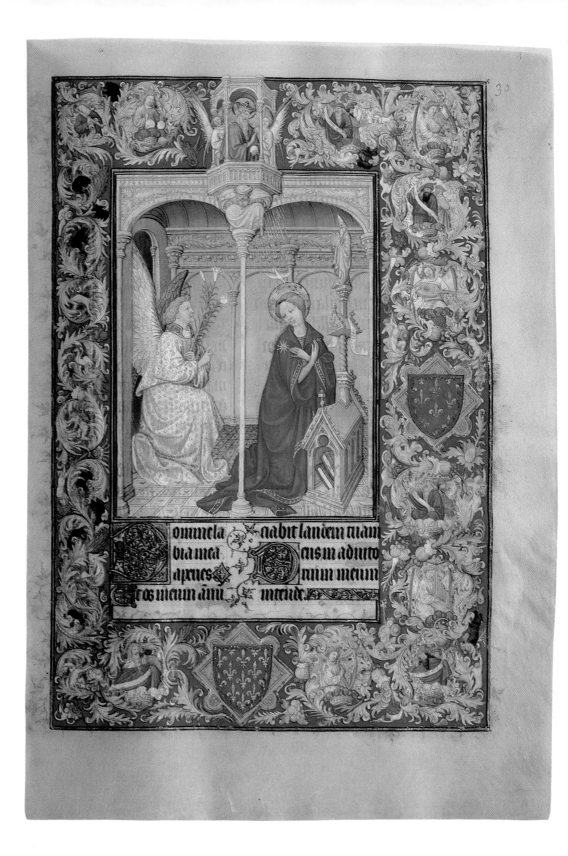

LIMBOURG BROTHERS

The Belles Heures of Jean, Duc de Berry

Jean, duc de Berry, one of the greatest art patrons of the Middle Ages, avidly collected tapestries (see Plate 119), goldsmith work, jewels, and books such as this extraordinary book of hours. The illuminators are Pol de Limbourg and his brothers, Janequin and Herman; after working in Paris, the three joined the duke's entourage and worked exclusively for him. The high quality demanded by the duke is evident in the use of perfect vellum, in the exquisite and

unusual decoration, and above all, in the luminous, vibrant paintings. Of the 172 miniatures, ninety-four are full-page pictures.

The *Annunciation*, opposite, is embellished with a lavish use of gold and a lush acanthus border, inhabited by music-making angels and prophets, as well as the arms and emblems (swans and bears) of the duke. The Limbourgs were also masters of narrative, as revealed in the illustration of *The Martyrdom of Saint Ursula* above. The Huns' slaughter of Ursula, daughter of the Christian King of Brittany, and her

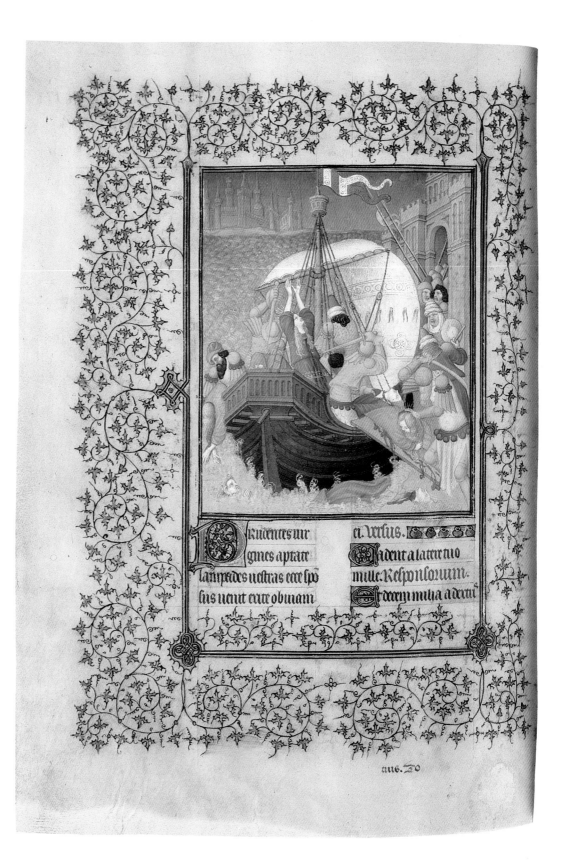

company of eleven thousand virgins is depicted in dramatic fashion: Surrounded by the frothy waters of the Rhine, the tiny ship becomes the focal point for a series of slashing orthogonals and prayerful gestures as the soldiers carry out their duties. The image is bordered by a thick vine of intricately composed, spiky ivy leaves. Lines of beautiful Gothic lettering in black and vermilion or blue and red complete the design. Text, illustration, and border thus combine to create pages that are truly "illuminated," that is, "lighted up" and sparkling.

124 The Belles Heures de Jean, Duc de Berry, ca. 1410
Pol, Janequin, and Herman de Limbourg
French, act. ca. 1400–16
Tempera and gold leaf on parchment; 9⅜ x 6⅝ in.
(23.8 x 16.8 cm.) The Cloisters Collection, 1954 (54.1.1)

Opposite: The Annunciation (f. 30)

Above: The Martyrdom of Saint Ursula and the Eleven Thousand Virgins (f. 178v)

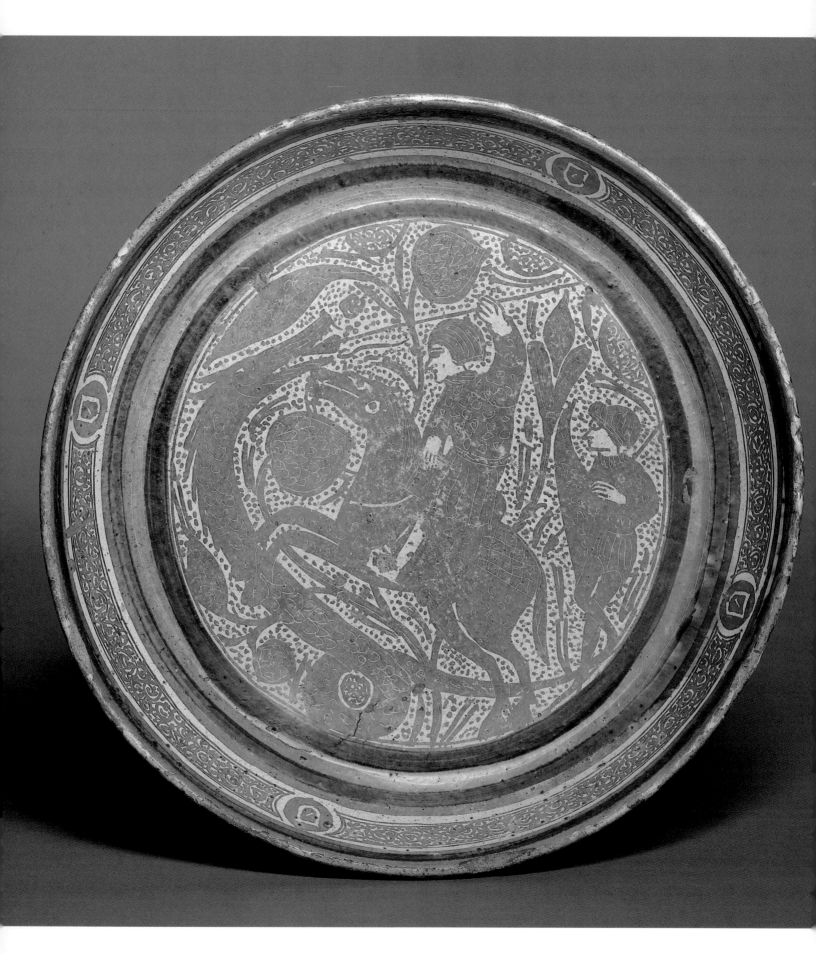

125 Basin with a Horseman Spearing a Serpent
Spanish (Valencia ?), 1390–1400
Lustered earthenware; D. 17¼ in. (43.8 cm.)
Gift of George Blumenthal, 1941 (41.100.173)

SPANISH BASIN

The earliest example of medieval lusterware in the Museum's collection, this basin was probably either used as a serving dish or intended for display. The brilliant coloring and expert craftsmanship of Spanish lusterware made it renowned throughout Europe. As early as the tenth century, the Moors in Spain had mastered the technique of lusterware, and by the turn of the fifteenth, when this basin was made, artists were still following those same glazing methods. The choice of decoration was sometimes indebted to Moorish motifs but could also be drawn from Western imagery, as with this representation of a horseman spearing a serpent, perhaps inspired by the legend of Saint George and the dragon. The shields bearing coats of arms that decorate the basin's rim have not as yet been identified.

The first step in the technique of Spanish lusterware was to glaze a fired piece of clay with an undercoat of white and then paint the design in deep blue. Details could be obtained by sgraffito—a method of scratching the surface to reveal the white undercoat. Luster, a mixture of silver and copper oxides to which red ocher, silt, and vinegar were added, was applied only after a second firing. It was this last step, mixing and applying the luster and then firing the lustered object, that distinguishes Hispano-Moresque wares from other contemporary ceramic production.

ITALIAN STRINGED INSTRUMENT

This appealing little cousin of the guitar was probably meant as a gift for the enjoyment and edification of a young woman. Many alterations over the years have changed its original appearance. At least five strings would have passed over a low flat bridge, and the player would have used a quill, or plectrum, to strum a chord or pick out a melody on one string at a time. In the Late Gothic era, stringed instruments were traditionally associated with the planet Venus, which ruled over music, love, and well-being, and with springtime and vernal pursuits. Music in this case is associated with love. On the back of the instrument is portrayed a young falconer and his lady beneath a Tree of Life in which Cupid draws his bow. They are the object of a moralizing juxtaposition of fidelity, of which the falcon is a symbol, and love of the flesh. The horned dragon carved on the instrument's neck evokes the serpent that first tempted Adam and Eve and that was regularly associated with lust by medieval writers. Counteracting this influence are a falcon and a dog, other symbols of faithfulness, as well as a stag, the antlers of which, when burned, were thought to repel snakes. Very likely, such a piece could have served as a nuptial gift, urging the need for constancy and devotion in marriage.

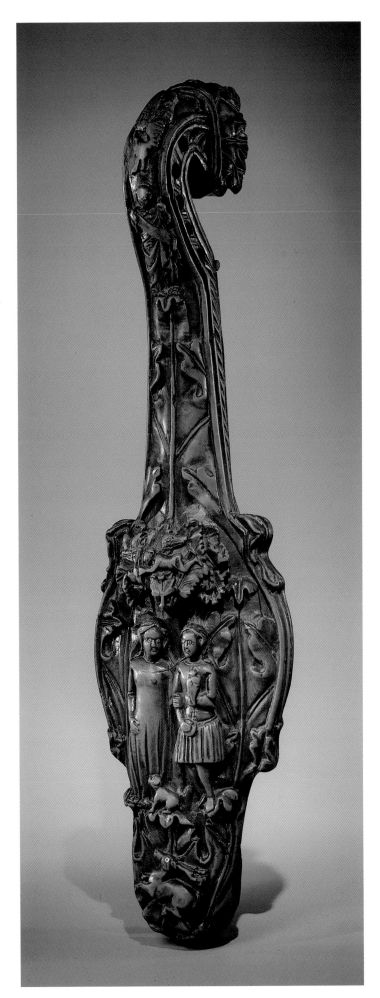

126 Stringed Instrument
Northern Italian, ca. 1420
Boxwood, rosewood; L. 14⅛ in. (36 cm.)
Gift of Irwin Untermyer, 1964 (64.101.1409)

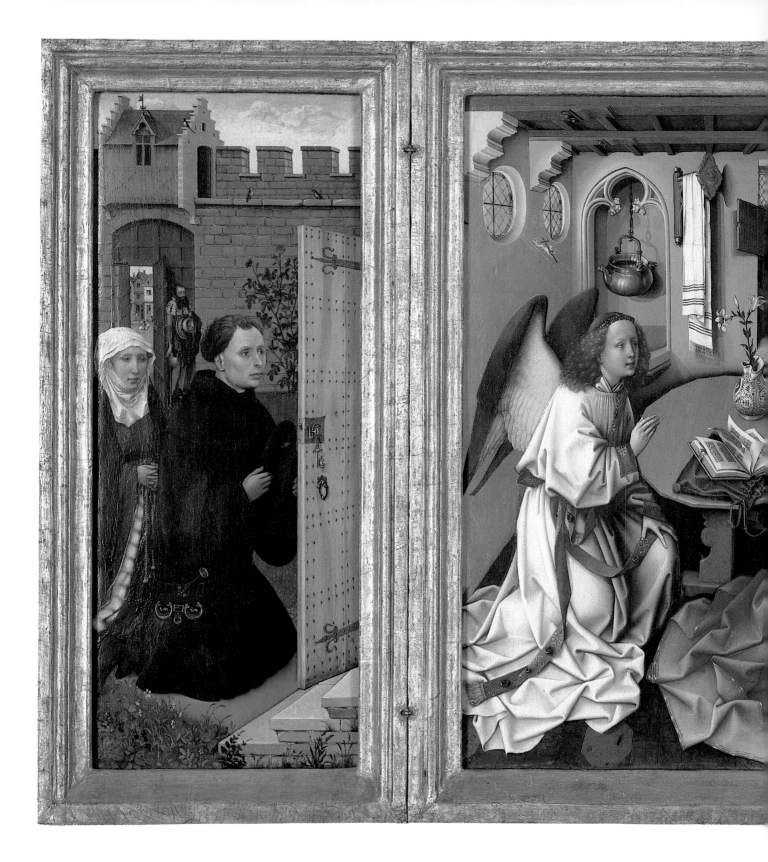

Robert Campin

Triptych with the Annunciation

Often referred to as the *Mérode Altarpiece*, after the family that owned it in the nineteenth century, this small triptych illustrates the Annunciation in the central panel with representations of Joseph in his workshop and the donor, presumably the merchant Ingelbrecht of Mechelen, and his wife occupying the outer wings. For this painting, the Flemish painter Robert Campin used the then-innovative technique of oil colors on a wooden panel. Although Campin clearly delighted in the way the technique enabled him to represent objects of the real world with an emphasis on their form and texture, he was primarily guided by the symbolic needs of his story. The brass basin, for example, signifies Mary's purity, as does the Madonna lily in the vase. The rays of sun entering the window give visual form to the medieval allegory of Mary's perpetual virginity, for it was believed that just as sunshine could pass through glass without damaging

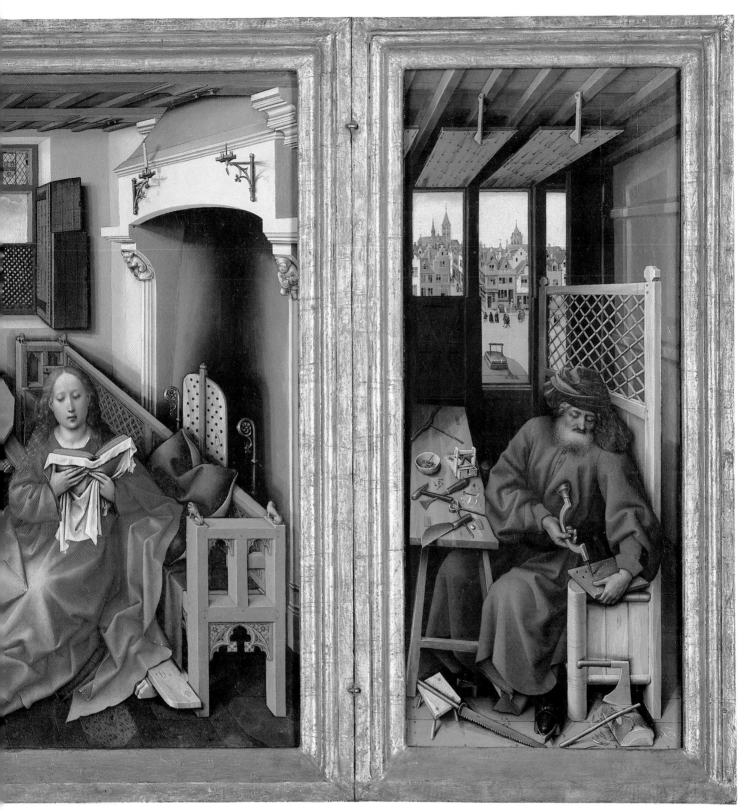

127 *Triptych with the Annunciation*
Robert Campin; Flemish, ca. 1378–1444
Oil on wood; central panel: 25¼ x 24⅞ in. (64.1 x 63.2 cm.); each wing:
25⅜ x 10¾ in. (64.5 x 27.3 cm.) The Cloisters Collection, 1956 (56.70)

it, so was the Virgin's womb filled with the Holy Spirit while leaving her virtue untouched. Campin demonstrates Mary's humility by seating her on the floor instead of on the bench. In his workshop, Joseph is portrayed making mousetraps—a completed example has been set on the window ledge. As Saint Augustine explained, "The cross of the Lord was a mousetrap for the Devil, the bait by which he would be caught was the Lord's Death." As in the tapestry showing the Annunciation (Plate 122), so here the tiny Christ Child, borne on the entering rays of light in the main scene, already carries the cross of the Lord. In the opposite wing, the donor and his wife are shown kneeling outside the Virgin's door. In earlier times a donor was apt to be shown small in size, a subordinate presence in the composition. Here he is portrayed as large as the other figures, and he takes an active part in the drama.

137

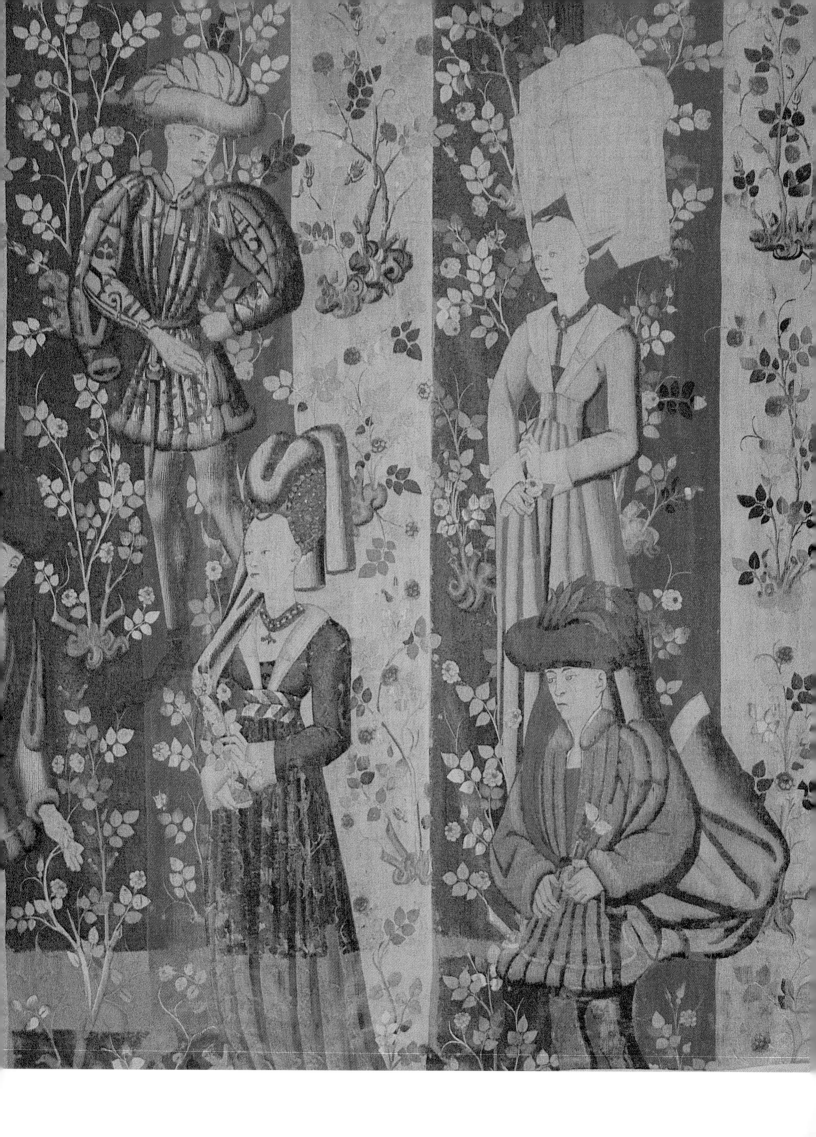

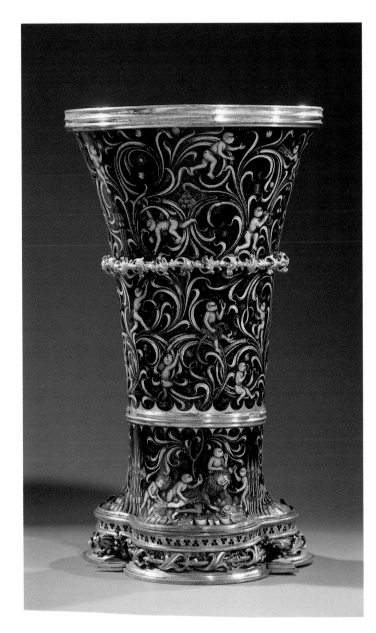

TAPESTRY WITH THREE LORDS AND TWO LADIES

This work is part of a series of tapestries designed to cover the walls of an entire room. Such sets were often referred to in medieval inventories as "rooms" (*chambres*). It is possible that this set was made for the French king Charles VII, whose colors were white, red, and green, and one of whose emblems was the rose tree. A royal connection is certainly likely, for the tapestries are sumptuous, with metal threads not only in the clothing and jewelry worn by the fashionable courtiers and ladies, but also in the background leaves, buds, and open roses. The weavers of tapestries such as this produced the fabric from full-scale painted designs, forcing the cross threads (weft) tightly into place—each different-colored thread separately—until all the undyed lengthwise threads (warp) were concealed. Even with several weavers working side by side—the usual procedure—and with the tapestries of a single set being worked simultaneously on separate looms, their production would have taken several years. Hung on the walls of a castle or manor house, tapestries not only served the practical function of insulation, preventing dampness from entering the room, but also constituted a visible and portable declaration of their owner's wealth and taste.

SILVER-GILT BEAKER

This rare and beautiful beaker, the work of Netherlandish or Franco-Netherlandish artists, was probably made for the Burgundian court. It is decorated with "painted" enamel, so called because the material was applied freely over the silver. Inside the beaker, two apes, with their hounds, pursue two stags. One ape has a hunting horn, the other a bow and arrow. The chase occurs in a forest made up of schematic tree clumps with a band of clouds at the rim. On the exterior, thirty-five apes rob a sleeping peddler of his wares and his clothing, and disport themselves with their prizes in the beaker's elegant foliage scrolls. The theme of the mischievous apes and the unlucky peddler was widely appreciated in the fifteenth and sixteenth centuries. Such a delicate piece would hardly have been used on ordinary occasions, for its enamel is extremely brittle. It may have been used for only one festive occasion, such as an aristocratic wedding.

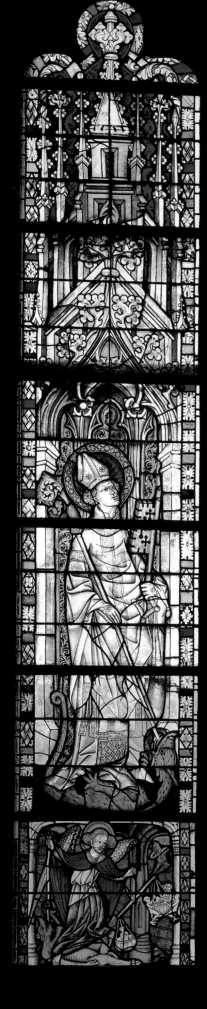
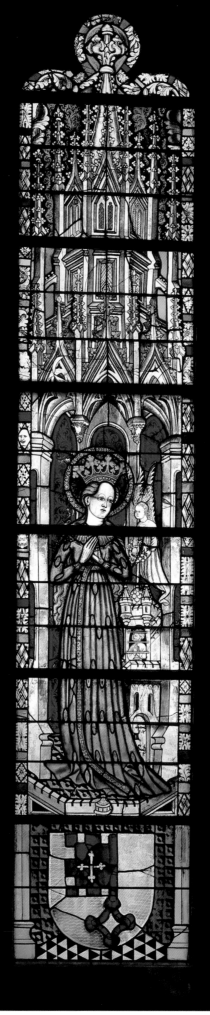
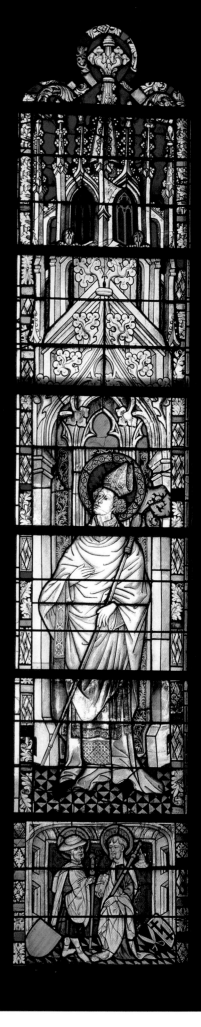

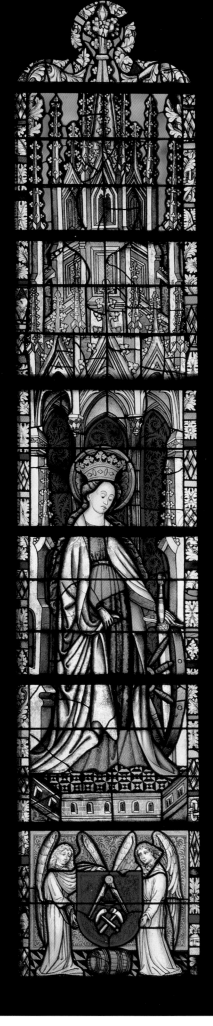
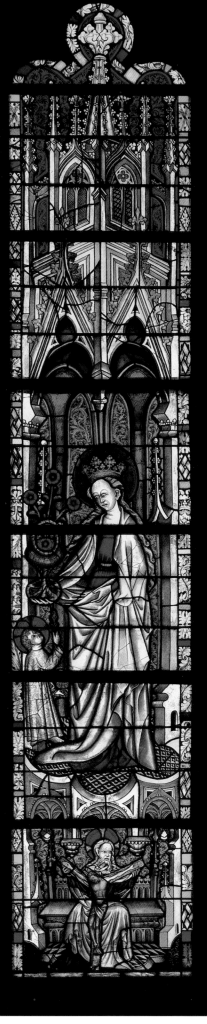

130 Windows with the Virgin and Saints
Rhenish (Boppard-am-Rhine), 1440–47
Pot-metal glass; each window:

148½ x 28¼ in. (337.2 x 71.8 cm.)
The Cloisters Collection, 1937
(37.52.1-6) *Page 142*: text

Windows with the Virgin and Saints

(Pages 140–141)

In the fifteenth century, the Rhine river acted as an artery along which artistic influences were transmitted from centers of production to outlying areas. An example of such a transfer can be seen in these six lancets of stained glass now installed at The Cloisters. They were painted by a master whose slender, elongated figure style and extensive use of silvery-white glass suggest he was trained in Cologne. This glass, however, comes from the Carmelite church of Saint-Severinus at Boppard-am-Rhine—more than sixty miles south of Cologne. The lancets, placed three over three, originally constituted a single tall window in the nave. The church was dedicated to the Virgin, patroness of the Carmelite order, and she figured prominently in its glazing program. Depicted as a young girl in the middle of the three lancets on the left, Mary stands within an elaborate architectural niche, dressed in a robe embroidered with sheaves of wheat. This eucharistic symbolism refers to Mary as the field of grain nourishing mankind with the bread of life. She is flanked by Saint Servatius, bishop of Tongres, and Saint Lambert. On the lower level are three of the most important virgin saints of the Christian church: Catherine, with her attributes of the sword and wheel; Dorothea, accompanied by the Christ Child, who presents her with a basket of roses from the heavenly garden; and Barbara, holding the tower in which she was imprisoned. Some of the smaller panels located under the principal figures contain coats of arms, such as that of the cooper's guild located beneath Saint Catherine, who was patroness of the guild. Following the secularization of the monasteries in the wake of the Napoleonic invasion of the Rhineland, all the stained glass in the church of Saint-Severinus was gradually removed and dispersed. These lancets are not only the most brilliant ensemble of Late Gothic stained glass in the United States, but they are also the only series from the extensive cycle at Boppard to have survived intact.

Attributed to Claux de Werve
Virgin and Child

This monumental work is distinguished by its convincing naturalism, boldly modeled forms, and thick, heavy woolen drapery that falls in deep folds, creating rich surface patterns of light and shadow. This emphasis on monumentality is indebted to the innovative work of the late fourteenth-century Netherlandish sculptor Claus Sluter, whose work in the Burgundian city of Dijon influenced Burgundian sculpture for several generations. Recently attributed to the sculptor Claux de Werve, the Virgin and Child from the convent of the Poor Clares in Poligny is no longer characterized as an elegant lady of the court (see Plates 101, 103, 104) but is instead shown as a loving mother of middle-class means. She commands the full space of the bench on which she sits, and her dress and mantle flow outward to create a powerful pyramidal image. The chubby Christ Child rests between his mother's knees, capturing her gaze by playing with her book—his foot, jammed underneath, is about to flip it closed. The emotional immediacy of this work is heightened by the painted flesh tones and draperies. While one could interpret this sculpture as a secular portrait of a mother and child, its religious nature is reinforced in the inscription on the right side of the bench. Translated, this quotation from the "Little Chapter" of the Office of Our Lady in the book of hours reads: "From the beginning and before the ages, I was created. Even unto the age to come I shall not cease to be. In the holy habitation have I ministered before him."

131 Virgin and Child
French (Poligny), ca. 1415
Attrib. to Claux de Werve, ca. 1380–1439
Limestone, polychromy, and gilt;
53¼ x 41½ in. (135.3 x 105.4 cm.)
Rogers Fund, 1933 (33.23)

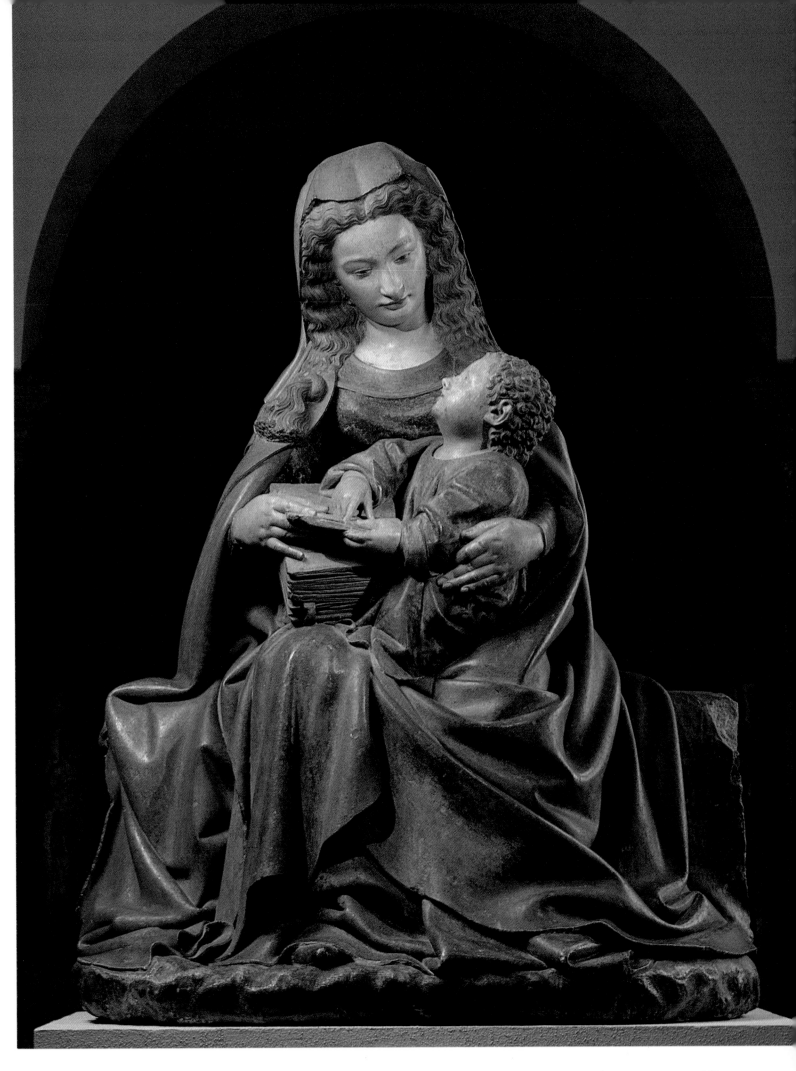

143

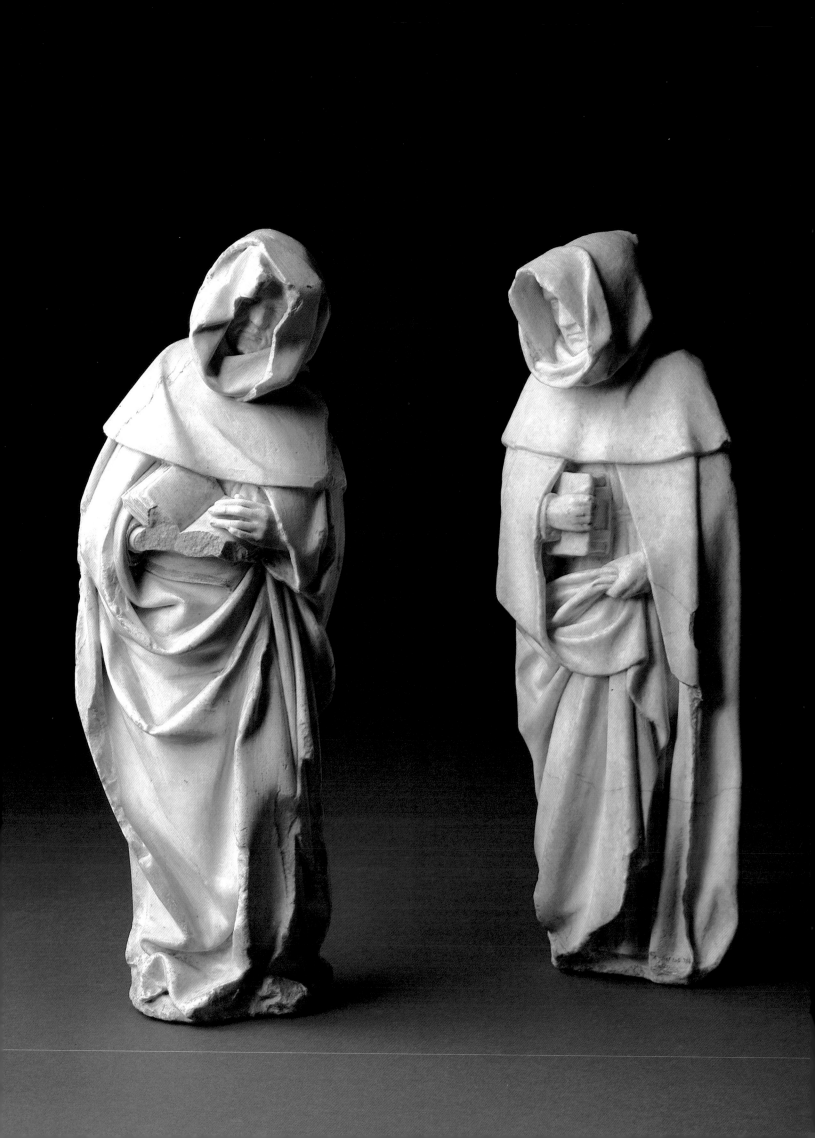

MOURNERS FROM THE TOMB OF THE DUC DE BERRY

The tomb at Bourges of Jean, duc de Berry (1340–1416), was begun by Jean de Cambrai and completed by Etienne Bobillet and Paul de Mosselman. For the duke's tomb, his lifesize portrait-effigy was placed on top of a sarcophagus, with figures of mourners rendered in high relief along its sides. The idea of surrounding the tomb with such figures most likely derived from an early thirteenth-century custom of attaching tokens of sorrowful remembrance of the deceased to his sarcophagus. Perhaps representing specific members of the duke's family, the faces of the mourners are hidden by deep hoods, and their bodies are engulfed by the voluminous cloaks so typical of Burgundian sculpture (Plate 131). The duke's tomb was vandalized during the French Revolution, and the mourner figures were destroyed or dispersed. Of the original forty statuettes, only twenty-five survive, including these two impressive examples.

MASTER OF THE ALTAR OF RIMINI
Kneeling Angel

The carving and naturalism of this piece make it a distinguished example of the International Style. Flourishing around 1400, this style—mingling northern and Italian traditions—was common to the whole of Europe, since with the marked expansion of trade at the time, works of art were exchanged throughout Europe, spurring the spread and standardization of artistic ideas. As it developed, the International Style was characterized by an elegance tempered by an emphasis on human interaction. This kneeling angel was once part of an Annunciation group. Carved from alabaster, the figure's proportions, gracefully falling drapery folds, and beautifully modeled facial features endow this work with a sensitivity and nobility appropriate to the angel's role as God's messenger.

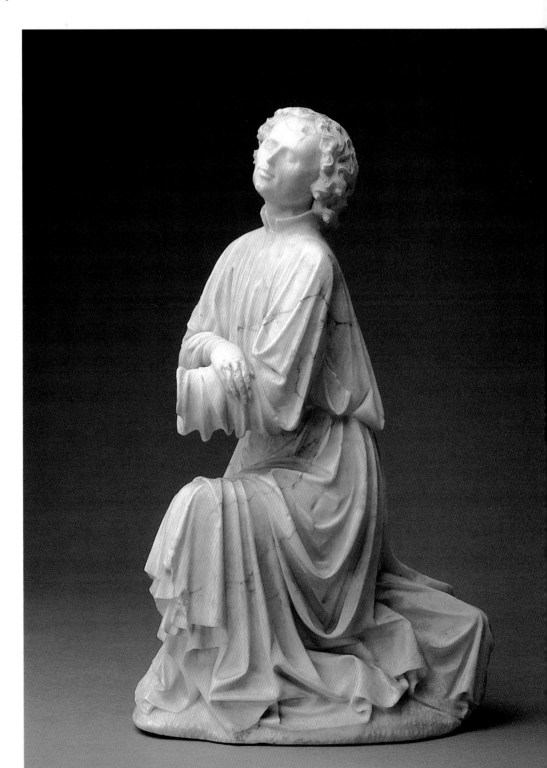

132 Mourners from the Tomb of Jean, duc de Berry
French (Burgundy), 1453–57
Alabaster;
H. 15¼ in. (38.7 cm.) and 15⅛ in. (38.4 cm.)
Gift of J. Pierpont Morgan, 1917 (17.190,386,9)

133 Kneeling Angel, ca. 1420–40
Master of the Altar of Rimini
Northern French-Netherlandish
Alabaster; 14½ x 3¾ in. (36.9 x 9.5 cm.)
The Cloisters Collection, 1965 (65.215.3)

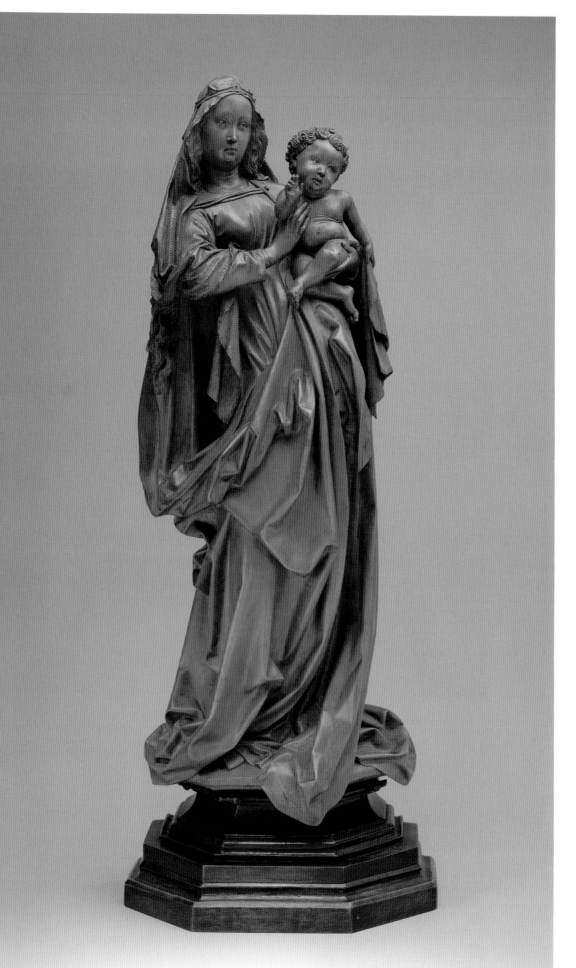

134 *Standing Virgin and Child*
Attrib. to Nikolaus Gerhaert von Leiden
Northern Netherlandish, act.
1460–73, d. 1473
Vienna, ca. 1470
Boxwood; H. 13¼ in. (33.6 cm.)
Purchase, The Cloisters Collection and
Lila Acheson Wallace Gift, 1996 (1996.14)

ATTRIBUTED TO NIKOLAUS GERHAERT VON LEIDEN
Standing Virgin and Child

This arresting statuette expresses a combined sense of drama and elegance that is at once intimate and monumental. Originally intended as an object of private devotion, this work was carved from fine-grained boxwood—a material traditionally used for this purpose. Its exceptional artistry, indicating its possible commission by a member of the imperial court in Vienna, is revealed in the rhythm and balance of the mother's swaying stance while supporting her twisting, cross-legged infant. The supple patterning of the deeply cut drapery folds, details such as the delicate pressing of the Virgin's fingertips into the chubby flesh of the child, and the subtle use of paint to articulate the eyes and lips create an intrinsic naturalism that engages the viewer. The sculpture's attribution to the accomplished sculptor Nikolaus Gerhaert makes it one of only a small number known or believed to be by his hand.

LATE GOTHIC TABERNACLE

The inscription *RUDBERTI ABBATIS PERSTO EGO IUSSO SUO* (I stand by order of Abbot Rupert) and the engraved heraldic arms boldly proclaim that Abbot Rupert Keutzl of the Benedictine Monastery of Saint Peter of Salzburg commissioned this superb tabernacle. According to abbey records, it was created by the master goldsmith Perchtold (*Pertoldus aurofaber*) in 1494. This date also appears on the tabernacle itself, in the scene of the Crucifixion and twice on the base. Rendered in exquisite mother-of-pearl carvings, the drama of Christ's Crucifixion is played out against a polished silver background that emphasizes the figures' lively silhouettes. The fine engraved Passion scenes on the back draw freely upon the work of the leading Germanic printmakers of the day. The tabernacle's soaring elegance echoes the delicate window tracery, finials, and flying buttresses of Late Gothic architecture. Made resplendent with images of Christ's sacrifice, this tabernacle was most likely a shrine for the abbot's personal contemplation in the privacy of his rooms.

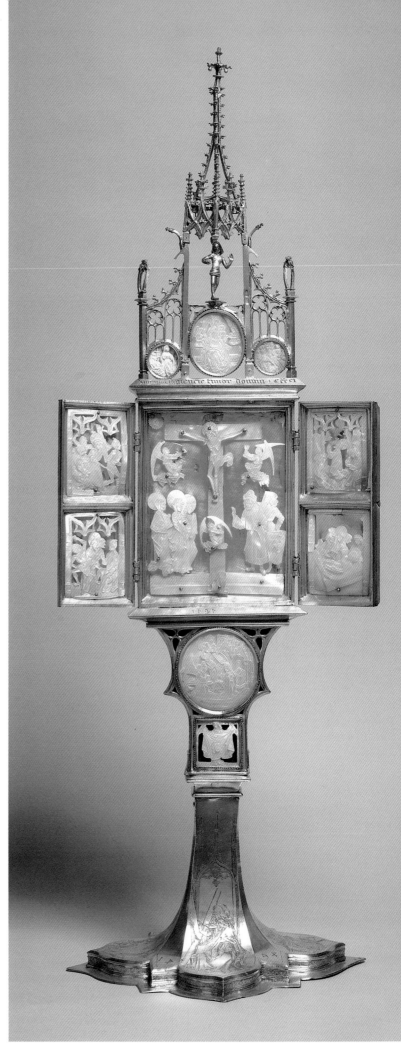

135 Tabernacle with Folding Wings
Austrian (Salzburg), 1494
Silver, parcel-gilt, mother-of-pearl, enamel;
H. 27⅜ in. (69.2 cm.), W. (open) 9⅞ in. (25.1 cm.)
Gift of Ruth and Leopold Blumka, 1969 (69.226)

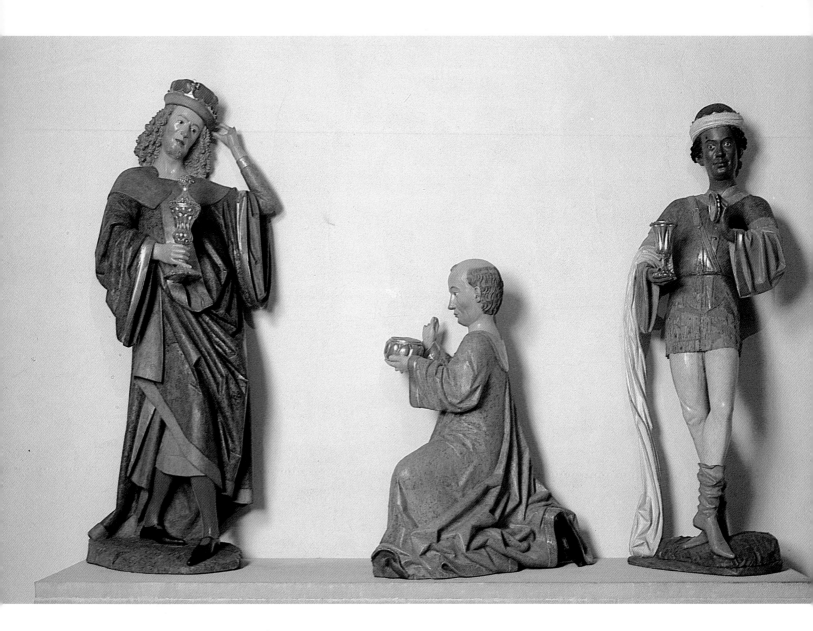

THE THREE MAGI

In the Middle Ages, the kings who brought the Christ Child gifts of gold, frankincense, and myrrh were thought to have descended from the three sons of Noah, and thus to represent the three races of mankind. Sculpted nearly lifesize, here Caspar is portrayed as the Moorish king, Melchior as the Asian king, and Balthasar as the European king. Melchior, whose crown is removed in humility, kneels to present his gift, while the others stand waiting their turn. The gifts are contained in intricately worked vessels resembling fine German metalwork of the late fifteenth century. These kings were carved around 1490 as part of a large altarpiece with painted wings made for the high altar of the convent of Lichtenthal in Baden-Baden, Germany. (The Virgin and Child from the group remain at the convent today.) They are especially appealing in the elegance and vivacity of their poses. The movement of each statue is self-contained when viewed alone but becomes part of a dramatic whole when the group is assembled. The brocaded garments (achieved by yellow and red glazes combined with tin foil, applied in squares, and scratched with a tool), the flesh colors, and the gilding give a striking impression of the resplendence of the original ensemble.

HISPANO-FLEMISH LAMENTATION

In the later part of the fifteenth century, Spain, like the rest of Europe, was under the spell of Flemish art. The realism of northern art had an especially strong appeal to Spanish taste, and it stimulated Spanish artists to meld Netherlandish models with their own distinctly Spanish motifs. This carved work, originally the center of a large altarpiece with painted wings, shows the fusion of these styles. It represents the Lamentation, or mourning over the body of Christ. The Virgin and Christ flanked by Saint John and the Magdalene in the lower register are nearly freestanding, while the two half-figures of mourning women above are carved in high relief. The group is surmounted by the cross in low relief against a background painting of Jerusalem. The individual figures, with the possible exception of the Pietà, are based on Flemish models, while the framework, the painted background, and the brocaded side walls, which form the setting, are purely Spanish. This composition is especially effective in the arrangement of angles formed by the figures' arms, brows, and drapery, which draw the eye upward toward the cross and then return it to the Pietà. The interplay of rhythms is wonderfully enriched by the alternation of dark blues and greens with gold and white.

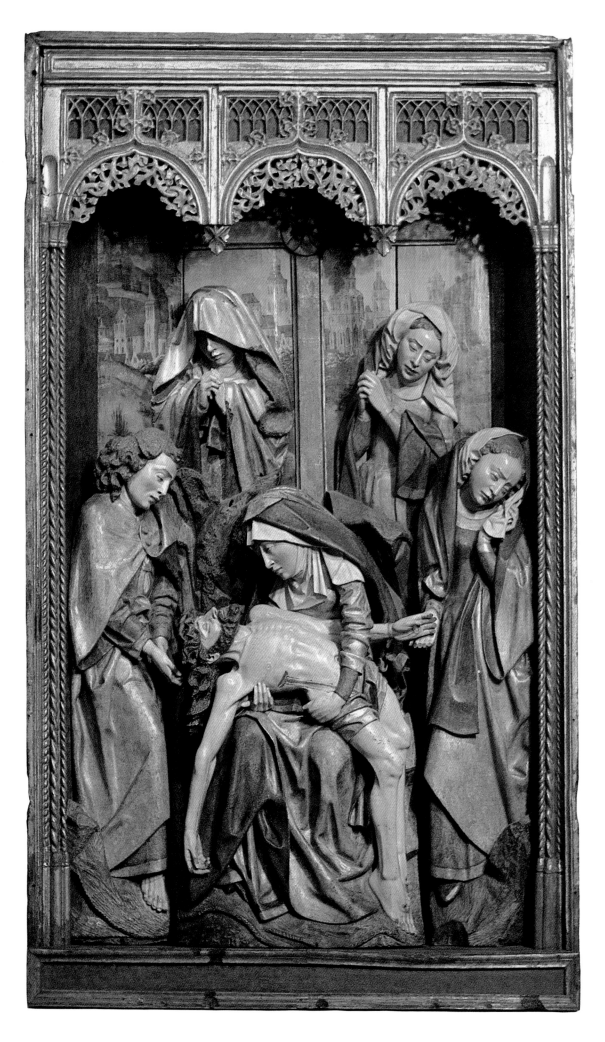

136 *The Three Magi*
German (Swabia), ca. 1490
Limewood, polychromy, and gilt;
Melchior: H. 40 in. (101.6 cm.),
Caspar: H. 61½ in. (156.2 cm.),
Balthasar: H. 64½ in. (163.8 cm.)
The Cloisters Collection, 1952
(52.83.1,2,3)

137 *The Lamentation*
Hispano-Flemish, ca. 1480–1500
Walnut with polychromy
and gilding; 83 x 48½ x 13½ in.
(210.8 x 123.2 x 34.3 cm.)
The Cloisters Collection, 1955
(55.85)

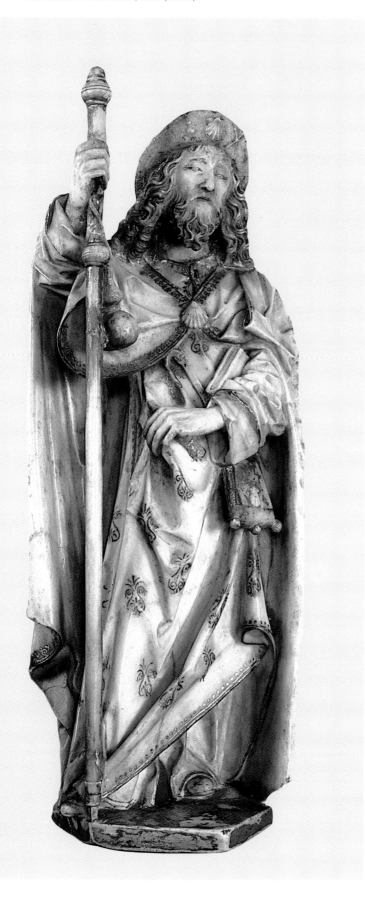

GIL DE SILOE
Saint James the Greater

In 1486, Isabel of Castile, the patroness of the explorer Christopher Columbus, commissioned an elaborate alabaster tomb for her parents, Juan II of Castile and Isabel of Portugal. This star-shaped tomb, still standing in the center of the church of the Carthusian monastery of Miraflores in Burgos, was made between 1489 and 1493. The sculptor, Gil de Siloe, employed assistants who were responsible for many of the monument's figures, but this statuette of the patron saint of Spain (known from old photographs to have been originally placed near the head of the queen) must surely have been carved by him alone. The soft, translucent quality of alabaster provides an ideal medium for the artist's penchant for beautifully articulated drapery folds and facial details, which still bear traces of gilding and paint. Saint James is portrayed here as a pilgrim—a person who makes a journey to a sacred place as a holy act. As a traveler, he is shown well equipped with a staff, purse, water gourd, and traveler's hat, whose upturned brim is adorned with a cockleshell, the emblem of his shrine at Santiago de Compostela. Medieval pilgrims would similarly place such badges on their clothing to indicate the number of holy shrines they had visited.

TILMAN RIEMENSCHNEIDER
Three Helpers in Need

Saints Christopher, Eustace, and Erasmus, represented here with a combination of skilled realism and intense emotional expression, are three of the so-called Fourteen Helpers in Need. Particularly venerated in Germany, each of these saints was believed to fulfill a particular need, and, according to legend, if the faithful turned to them, aid would surely be given. In this work, the sharp linear quality of design and execution, the complex interrelation of forms, and such peculiar facial characteristics as the figures' asymmetrical eyes and beards with dividing curls terminated by a drilled hole, all point to the mastery of Tilman Riemenschneider, one of the greatest Late Gothic German sculptors. Riemenschneider particularly favored unpainted sculptures utilizing the natural texture of the wood—in this case, lindenwood. He most likely created this work as part of a commission for a hospital dedicated to the Fourteen Helpers in a suburb of Würzburg.

139 Three Helpers in Need, ca. 1494
Tilman Riemenschneider
German, 1460(?)–1531
Lindenwood; 21 x 13 in. (53.3 x 33 cm.)
The Cloisters Collection, 1961 (61.86)

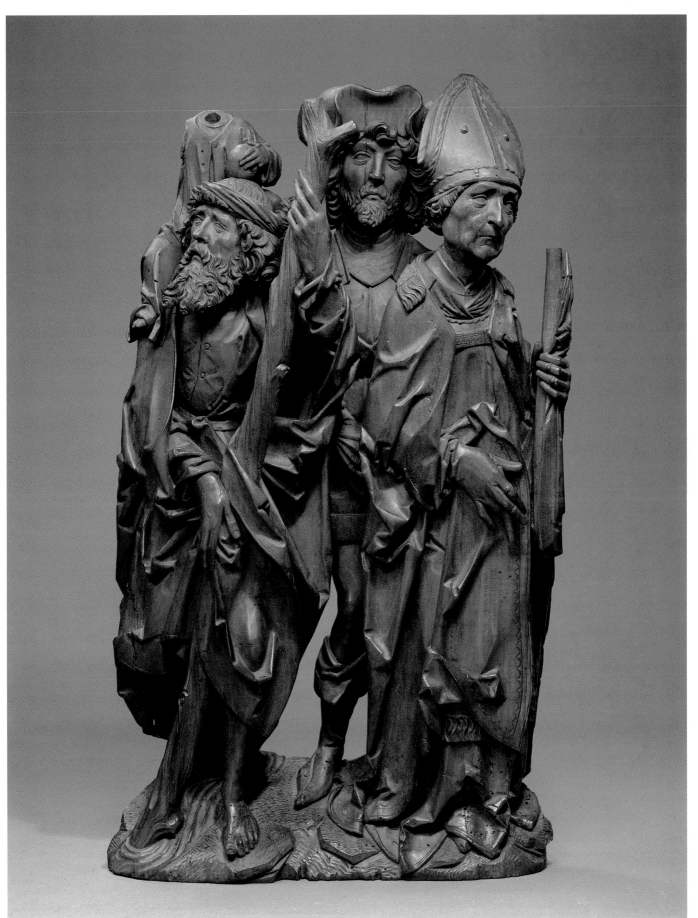

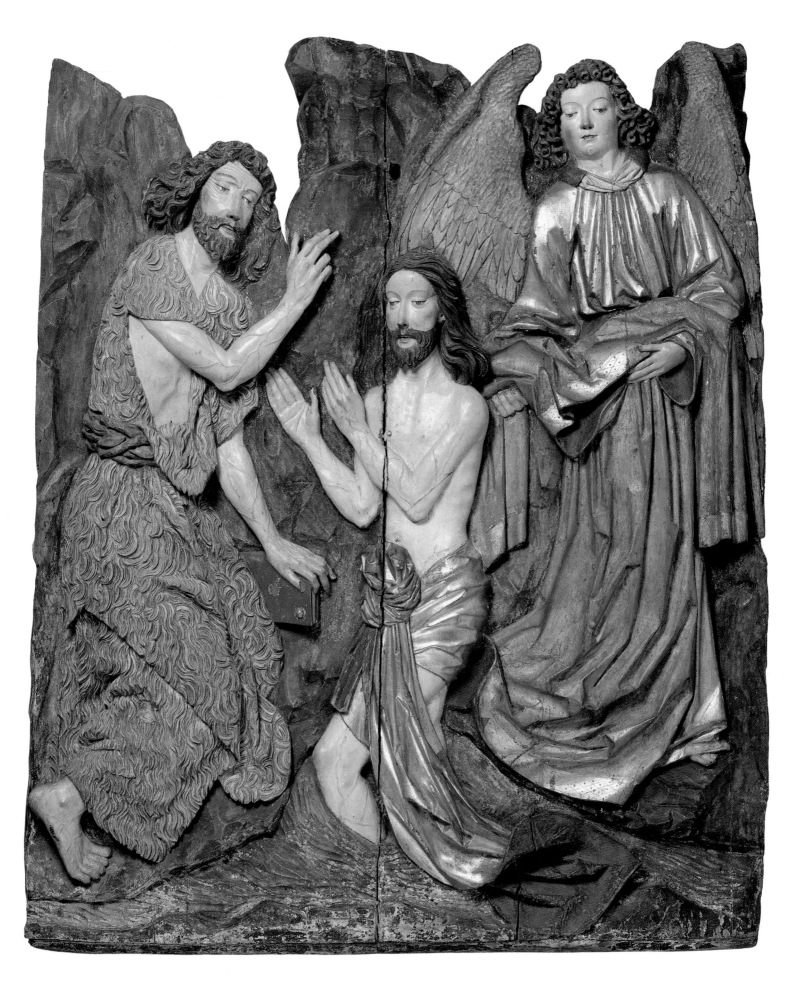

PUPIL OF VEIT STOSS
The Baptism of Christ

Veit Stoss of Nuremberg was one of the most influential German artists of the Late Gothic era. This work by one of his pupils most likely dates from Stoss's residency in Cracow, where he maintained a thriving workshop for nearly twenty years before returning to Nuremberg in 1496. This composition was adapted from an engraving of the Baptism of Christ. It probably once included the figures of God the Father and the dove of the Holy Spirit shown blessing the event in accordance with scripture: "He saw the Spirit of God descending like a dove to alight upon him; and a voice from heaven was heard saying, 'This is my Son, my Beloved, on whom my favor rests'" (Matthew 3:16-17). John, dressed in his "rough coat of camel hair," anoints Christ with the waters of the River Jordan while an attending angel waits with Christ's robe. The mannered flow of Christ's loincloth echoes the river's swirling current, as do the circular patterns suggested by the arrangement of the figures and their gestures. Originally, this work would have been part of an altarpiece; it is perhaps from a lateral wing composed of a much larger ensemble of scenes. The play of both candlelight and daylight over the relief would have enhanced the richness of the painted and gilded wood surfaces.

140 The Baptism of Christ
Pupil of Veit Stoss
Cracow, ca. 1480–90
Linden(?)-wood;
47⅞ x 39³⁄₁₆ in. (120.6 x 99.6 cm.)
Rogers Fund, 1912 (12.130.1)

GERMAN EWER

This splendid ewer, topped with a finial in the form of a wild man, is one of a pair in The Cloisters Collection. Intended to symbolize the fortitude and might of its owner, possibly Hartmann von Stockheim, German master of the Order of Teutonic Knights from 1499 to 1510 or 1513, the wild man was a mythical woodland creature. Originally regarded as brutish and irrational, by the time of his portrayal on this ewer, he was perceived as the embodiment of legendary Germanic strength and endurance. Such a standard would seem an appropriate choice for an order of knights that took vows of poverty, chastity, and obedience and was a powerful military force in Germany at the turn of the sixteenth century. Holding the traditional attributes of club and armorial shield (once bearing a coat of arms), the wild man at once announced and protected the ewer's ownership. In most cases, the kneeling wild man's defense is only symbolic, but here a toothed and clawed dragon—forming the ewer's handle—represents a tangible threat.

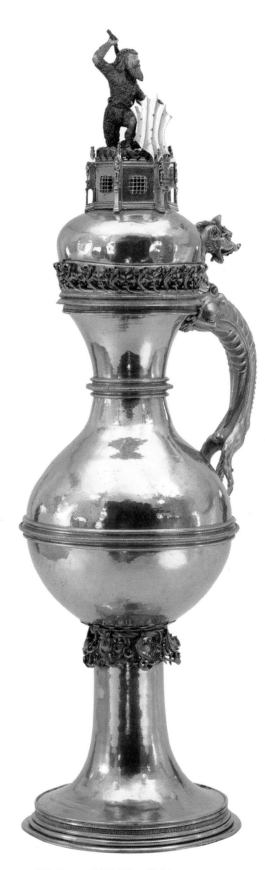

141 Ewer with Wild Man Finial
German (Nuremberg), ca. 1500
Silver, silver gilt, with painted and
enameled decoration; H. 25 in. (63.5 cm.)
The Cloisters Collection, 1953 (53.20.2)

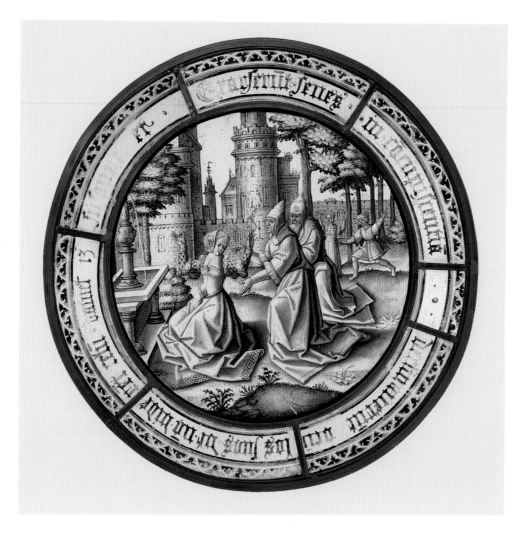

142 Silver-Stained Roundel with Susanna and the Elders
Lowlands (Antwerp?), ca. 1520–25
White glass with vitreous paint and silver stain;
D. 13 in. (33 cm.)
The Cloisters Collection, 1990 (1990.119.1)

SILVER-STAINED ROUNDEL

The assault on the virtuous Susanna by two lascivious elders, recounted in the Book of Daniel, is given a dramatic portrayal in this silver-stained roundel. Its composition is exceptional in that it retains its original border, a rare survivor. Translated from the original Latin, the inscription reads: "Susanna went in, and walked in her husband's orchard . . . and they [the elders] were inflamed with lust towards her . . . and turned away their eyes that they might not look unto heaven . . ." (Daniel 13:7–9). Moralizing subjects, such as the story of Susanna, were popular choices for late-medieval painted-glass roundels. They were most often destined for secular contexts, ending up installed in the windows of affluent private homes or civic buildings. Roundels were usually rendered with black paint and highlighted with a silver sulfide or silver oxide, which, when fired, stained the glass a range of hues from pale yellow (as here, on the grass) to a fiery orange (as on Susanna's sleeves). The painting style of this example is distinguished by an exacting mastery of line, shade, and texture. Even the waters of the fountain, which were created with a sharp stylus by thinly scraping away the paint, seem to shimmer.

LECTERN IN THE FORM OF AN EAGLE

Assembled from many separately cast parts, this monumental lectern was made in about 1500 in Maastricht, possibly by the Belgian metal caster Aert van Tricht the Elder. It was from lecterns such as this that priests and monks read from scripture or sang the liturgy. The eagle's wings support a large bookrack, with a smaller rack, possibly for the use of choirboys, below. Because of its association with the evangelist Saint John, whose gospel begins as a praise of the Word of God, the eagle was an appropriate selection for such an object. Supported by three crouching lions, this lectern is executed as a tree with tendrillike branches inhabited by various figures, including the Magi, Hebrew prophets, Christ, Saint Peter, and Saint Barbara. Three knotty branches spring from the core, two ending in candle holders and the central one supporting the Virgin and Child with a kneeling Wise Man. Three small lions ring the top of the core from which rises the magnificent eagle with spread wings, holding in his claw a dragon—symbol of the power of the Word to vanquish evil. Similar in type to lecterns still used in modern-day Belgian parish churches, this example is believed to have come from the north side of the high altar of the collegiate church of Saint Peter in Louvain.

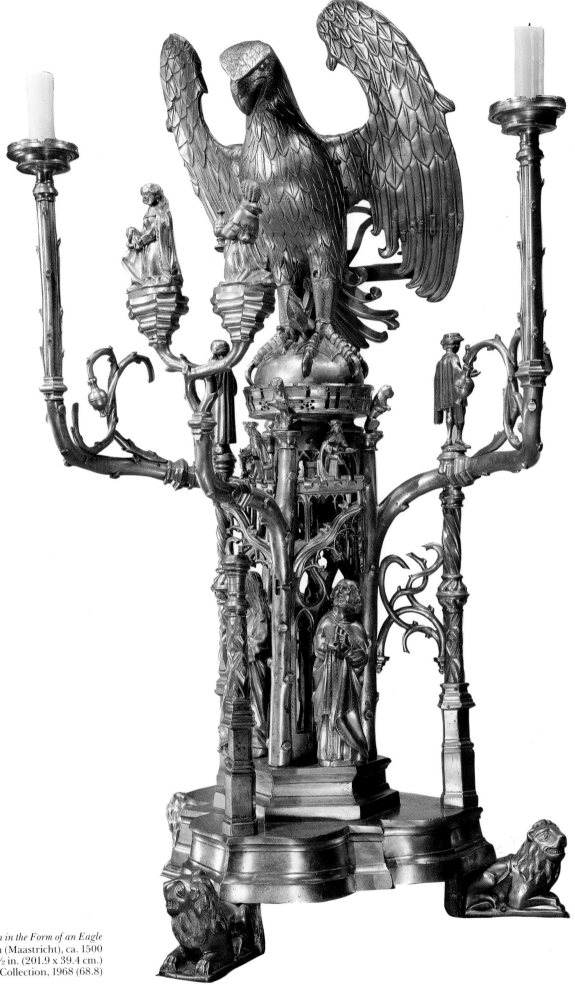

143 Lectern in the Form of an Eagle
Southern Netherlandish (Maastricht), ca. 1500
Brass; 79½ x 15½ in. (201.9 x 39.4 cm.)
The Cloisters Collection, 1968 (68.8)

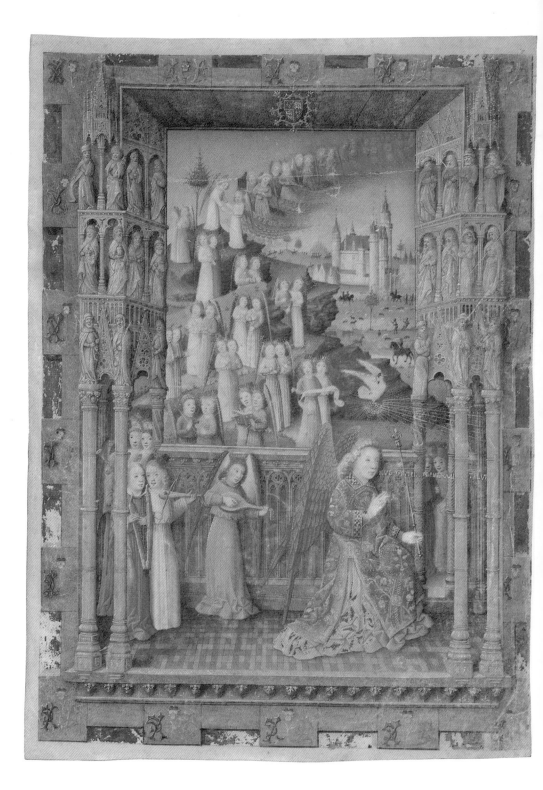

MASTER OF CHARLES OF FRANCE
Annunciation from a Book of Hours

Despite its small size, this manuscript painting presents the Annunciation as a bustling tableau in elegant and refined surroundings. The double-page illumination was originally part of an unfinished book of hours, made for Charles of France and now in Paris at the Bibliothèque Mazarine. This picture shows Charles's coat of arms while he was duke of Normandy; it bears an identifying inscription on its reverse that translated reads: "Charles of France, son of Charles VII, ninth Duke of Normandy, in the year 1465. Long may he live."

The ceremonial aspects of the scene are emphasized by

its extended treatment on two manuscript leaves. The kneeling angel Gabriel, bearing his scepter as herald of God, is placed inside a gilded portico on one page facing the golden-haired Virgin seated on a brocaded cushion beneath an elaborate octagonal structure representing the Temple. Unlike the other representations of the Annunciation in the Museum's collection (see Plates 105, 122, 124, 127), Gabriel does not appear to the Virgin alone, but is accompanied by a procession of angels, some playing musical instruments in celebration of the good news he brings. His words of greeting, "Hail, full of grace, the Lord is with thee," are written

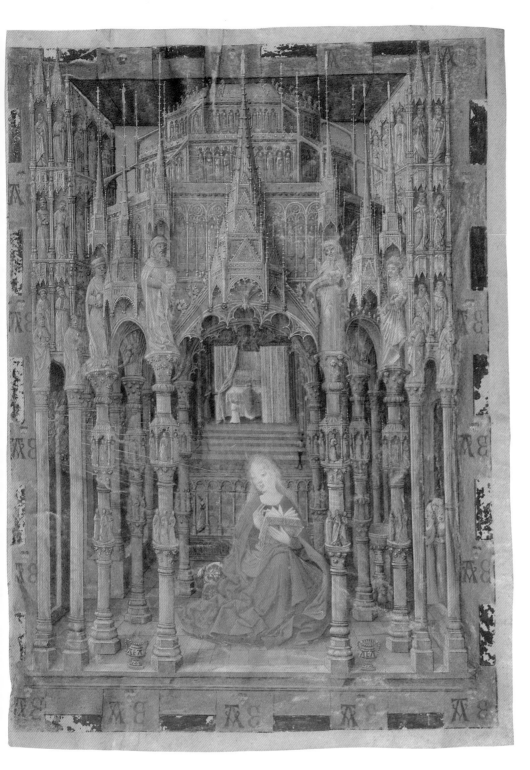

144 *Two Leaves from a Book of Hours,*
Representing the Annunciation, 1465
Master of Charles of France
French (Bourges)
Tempera and gold leaf on vellum;
each 6¾ x 4⅞ in. (17.1 x 12.4 cm.)
The Cloisters Collection, 1958 (58.71a,b)

in gold, while above, the dove of the Holy Spirit flies toward the Virgin, emanating rays of light. In the church interior extending behind the Virgin, Mass is being celebrated, attended by a fashionably dressed lady and two gentlemen. Also depicted are sculpted figures of prophets and the sibyl who foretold the coming of the Savior. Adam, too, whose sin made necessary the advent of a Redeemer, appears. This juxtaposition places the Annunciation within its theological, rather than narrative, context.

The compositional innovations are enhanced by the virtuoso illusionism. Not only are the sculpted architectural elements and decoration captured in superb naturalism, but the lush representation of the French countryside contains a princely château that can be identified as Mehun-sur-Yèvre. Now in ruins, the château was one of the favorite residences of Jean, duc de Berry, and a place where Charles spent a great part of his youth. The artist's sophisticated illusionism further develops the elegant, courtly tradition of French manuscript illumination as seen in the illustrations of the Annunciation in the *Book of Hours of Jean d'Evreux* (Plate 105), the *Psalter and Prayer Book of Bonne of Luxembourg* (Plate 107), and the *Belles Heures of Jean, duc de Berry* (Plate 124).

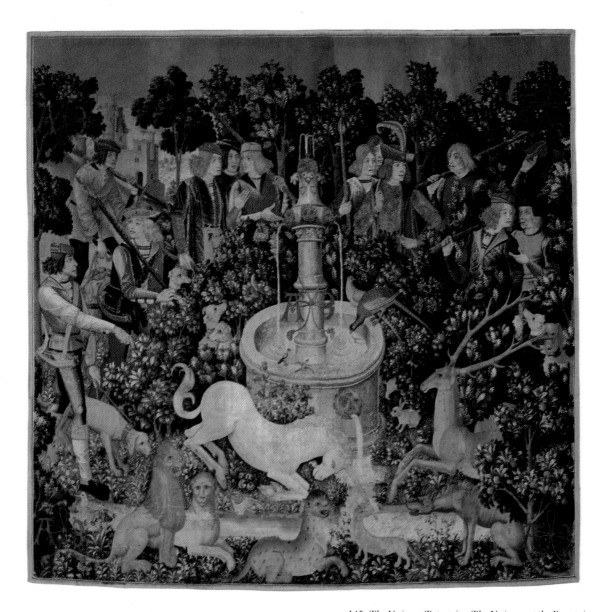

145 The Unicorn Tapestries: The Unicorn at the Fountain
Southern Netherlandish, 1475–1500
Wool, with silk and metal threads; 145 x 149 in.
(368.3 x 378.5 cm.)
Gift of John D. Rockefeller, Jr., 1937 (37.80.2)

Opposite: detail

TAPESTRY OF THE UNICORN AT THE FOUNTAIN

This tapestry, showing a unicorn surrounded by hunters at a fountain, is the second in a series of seven representing The Hunt of the Unicorn. The first tapestry pictures the beginning of the hunt. In the third, the unicorn attempts to escape, and in the fourth, he defends himself. Only a small fragment of the fifth remains, illustrating the best-known part of the legend, in which the beast is captured as he rests his head in the lap of a virgin. The sixth tapestry shows the slain unicorn brought back to the castle, and in the seventh, he is resurrected, enclosed in a garden under a pomegranate tree.

While the style points to the southern Netherlands as the place of manufacture, the patron and the occasion for which the set was commissioned are a mystery. In this tapestry, the hunters gather at a fountain in a forest to watch the milk-white unicorn dip his purifying horn into a stream that has been poisoned by the serpent—the Devil. Waiting to drink the water are animals, beautifully rendered in naturalistic detail, whose characters were praised by writers of medieval lore. For example the panther, good tempered and gentle, was loved by all creatures, except the dragon, and was considered to be a symbol of Jesus. Such christological parallels figure throughout the tapestries, as the legend of the unicorn was seen to mirror the Passion of Christ: Just as the unicorn gave up his fierceness and was tamed by a maid, so Christ surrendered his divine nature and became human, born of a woman. The mingling of Christian symbolism, popular legend, and flora and fauna associated with love and fertility suggests that the tapestries may have been designed to celebrate a marriage.

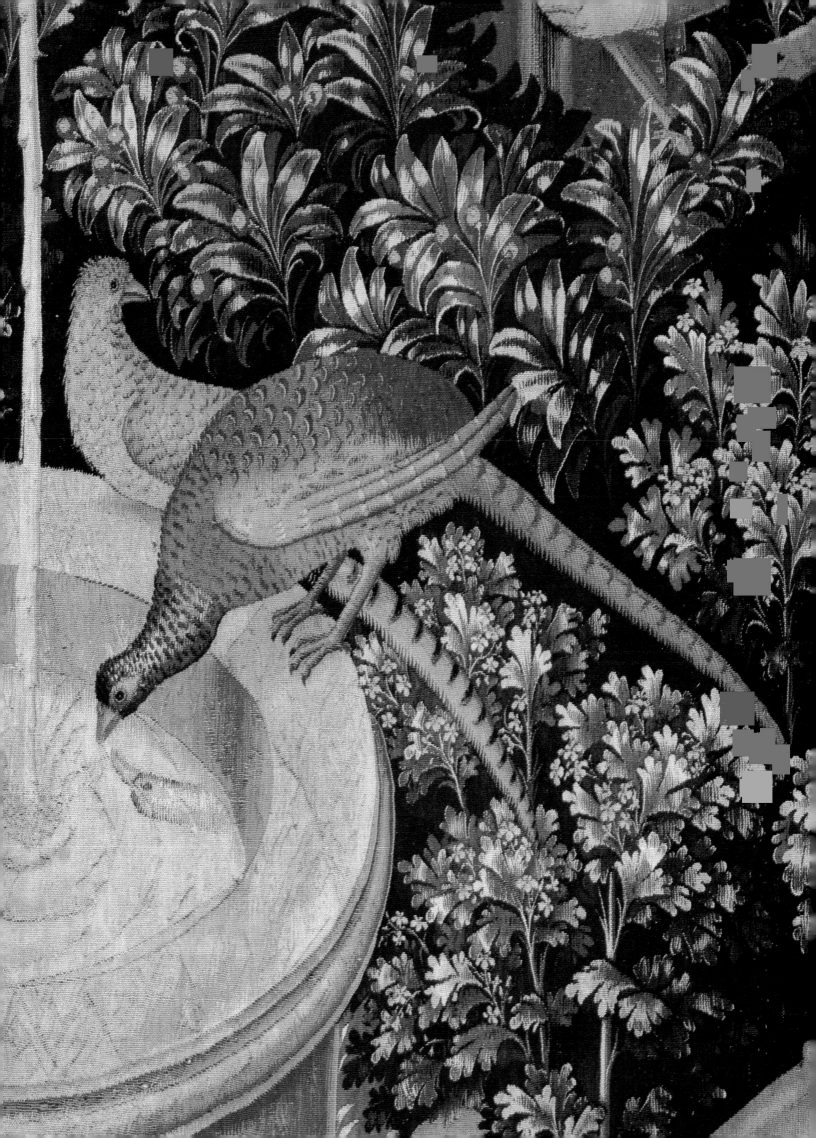

SUGGESTED FURTHER READING

On medieval works in the collections of The Metropolitan Museum of Art:

The Art of Medieval Spain, A.D. 500–1200. Exhibition catalogue. The Metropolitan Museum of Art. New York: 1993.

Boehm, B. D., and E. Taburet-Delahaye. *Enamels of Limoges, 1100–1350.* Exhibition catalogue. The Metropolitan Museum of Art. New York: 1996.

Brown, K. *Migration Art, A.D. 300–800.* New York: 1995.

Cavallo, A. S. *Medieval Tapestries in The Metropolitan Museum of Art.* New York: 1993.

Caviness, M., et al. "Stained Glass before 1700 in American Collections: New England and New York (Corpus Vitrearum Checklist I)." *Studies in the History of Art* 15, 1985.

Deuchler, F., et al. *The Cloisters Apocalypse: An Early Fourteenth-Century Manuscript in Facsimile.* New York: 1971.

Dodds, J. D., ed. *Al-Andalus: The Art of Islamic Spain.* Exhibition catalogue. The Metropolitan Museum of Art. New York: 1992.

Evans, H. C., and W. D. Wixom. *The Glory of Byzantium: Art and Culture of the Middle Byzantine Era, A.D. 843–1261.* Exhibition catalogue. The Metropolitan Museum of Art. New York: 1997.

Frazer, M. "Medieval Church Treasuries." *The Metropolitan Museum of Art Bulletin,* Winter 1985/86.

Freeman, M. B. *The St. Martin Embroideries: A Fifteenth-Century Series Illustrating the Life and Legend of St. Martin of Tours.* New York: 1968.

——————————— . *The Unicorn Tapestries.* New York: 1976.

Gothic and Renaissance Art in Nuremberg, 1300–1550. Exhibition catalogue. The Metropolitan Museum of Art. New York: 1986.

Husband, T. B. *The Luminous Image: Painted Glass Roundels in the Lowlands, 1480–1560.* Exhibition catalogue. The Metropolitan Museum of Art. New York: 1995.

Little, C. T. , and E. C. Parker. *The Cloisters Cross: Its Art and Meaning.* New York: 1994.

Parker, E. C., with the assistance of M. B. Shepard, eds. *The Cloisters: Studies in Honor of the Fiftieth Anniversary.* New York: 1992.

Rorimer, J. *Medieval Monuments at The Cloisters as They Were and Are.* New York: 1972.

The Secular Spirit—Life and Art at the End of the Middle Ages. Exhibition catalogue. The Metropolitan Museum of Art. New York: 1975.

Schrader, J. L. "A Medieval Bestiary." *The Metropolitan Museum of Art Bulletin,* Summer 1986.

Weitzmann, K., ed. *The Age of Spirituality—Late Antique and Early Christian Art, Third to Seventh Century.* Exhibition catalogue. The Metropolitan Museum of Art. New York: 1979.

Wixom, W. D. "Medieval Sculpture at The Cloisters." *The Metropolitan Museum of Art Bulletin,* Winter 1988/89.

——————————— . *Medieval Art Acquisitions.* New York: 1998.

The Year 1200. Exhibition catalogue and symposium. The Metropolitan Museum of Art. New York: 1970.

Young, B. *A Walk Through The Cloisters.* Rev. ed. New York: 1988.

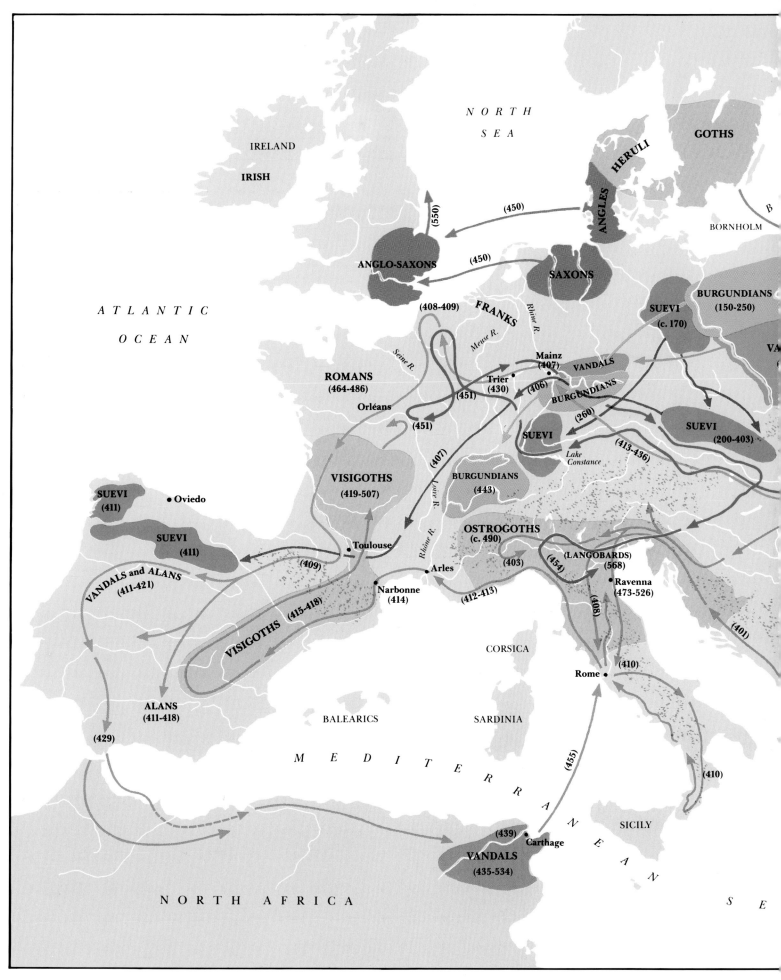

NORTH
SEA

IRELAND

IRISH

GOTHS

HERULI

ANGLES

BORNHOLM

ATLANTIC

OCEAN

(550)

(450)

(450)

ANGLO-SAXONS

SAXONS

BURGUNDIANS
(150-250)

SUEVI
(c. 170)

(408-409)

FRANKS

Rhine R.

Meuse R.

Seine R.

ROMANS
(464-486)

Orléans

Mainz
(407)

VANDALS

VA

Trier
(430)

(451)

(406)

BURGUNDIANS

(451)

(407)

SUEVI

(260)

SUEVI
(200-403)

(413-436)

Loire R.

VISIGOTHS
(419-507)

BURGUNDIANS
(443)

Lake
Constance

SUEVI
(411)

● Oviedo

SUEVI
(411)

VANDALS and ALANS
(411-421)

(409)

Toulouse ●

VISIGOTHS (415-418)

Narbonne
(414)

Rhône R.

Arles ●

OSTROGOTHS
(c. 490)

(403)

(LANGOBARDS)
(568)

(454)

● Ravenna
(473-526)

(401)

(412-413)

(408)

ALANS
(411-418)

BALEARICS

CORSICA

SARDINIA

Rome ●

(410)

(429)

M E D I T E R

R

A

(455)

(410)

SICILY

N E A N

(439)

Carthage ●

VANDALS
(435-534)

NORTH AFRICA

S E

First church at Cluny 900–11
Cluniac Order founded 910
Constantine VII, Byzantine emperor r. 913–?
Second abbey church at Cluny ca. 955–81
Romanus II, Byzantine emperor r. 959–63
Otto I, first Holy Roman Emperor (HRE)
 r. 962–73

Plate 19

ATION

SH

Plate 34

Plate 3?

CAROLINGIAN

Plate 21

Book of Kells ca. 800
Charlemagne emperor r. 800–14
Louis I ("the Pious"), emperor r. 814–40
Plan of ideal monastery, St. Gall ca. 817
Einhard writes *Life of Charlemagne* 821
Vikings begin raids on England 835

Plate 31

MIDDLE

Beowulf ca. 700–30
Muslim conquest of Spain 711
Iconoclastic controversy 726–843
Muslim invasion of France halted by Charles
 Martel 732
Pepin, first Carolingian king of Franks
 r. 751–68
Lombards conquer Ravenna 752
Carolingian rebuilding of St.-Denis abbey
 754–75
Charlemagne, Carolingian king of Franks
 r. 768–814
Council of Nicaea rejects iconoclasm 787
Vikings destroy Lindisfarne 793
Alcuin begins revision of Vulgate 796
Palace Chapel, Aachen late 8th c.

Lothar I, emperor r. 840–55
Charles II ("the Bald"), emperor r. 840–77
Council of Constantinople ends iconoclasm 843
Treaty of Verdun: Carolingian empire divided
 among sons of Louis I 843
Vikings lay siege to Paris 885–86

Danish king Harald Bluetooth adopts
 Christianity ca. 965
Cross of Archbishop Gero 969–76
Otto II, HRE r. 973–83
Otto III, HRE r. 983–1002
Hugh Capet, French king r. 987–96

29

26

38

Plate 22

Plate 36

EARLY CHRISTIAN—EARLY BYZANTINE

MIGRATION

MIGR

FRANKI

Romans invade Britain 43
Goths cross the Danube, 238, invade Gaul 280s
Christian house, synagogue, Dura-Europos
 before 256
Constantine, emperor r. 306–37
Battle of Milvian Bridge 312
Arch of Constantine, Rome 312–15
Edict of Milan 313
.Founding of Constantinople 324
Council of Nicaea condemns Arianism 325
Basilica of Old St. Peter's founded, Rome
 ca. 330
Church of the Holy Sepulcher, Jerusalem
 ca. 335
Constantine baptized on his deathbed 337
First division of Roman Empire 337
Constantine II r. 337-61
Theodosius I, emperor of the East (from 379)
 and West (from 392) ca. 346–95

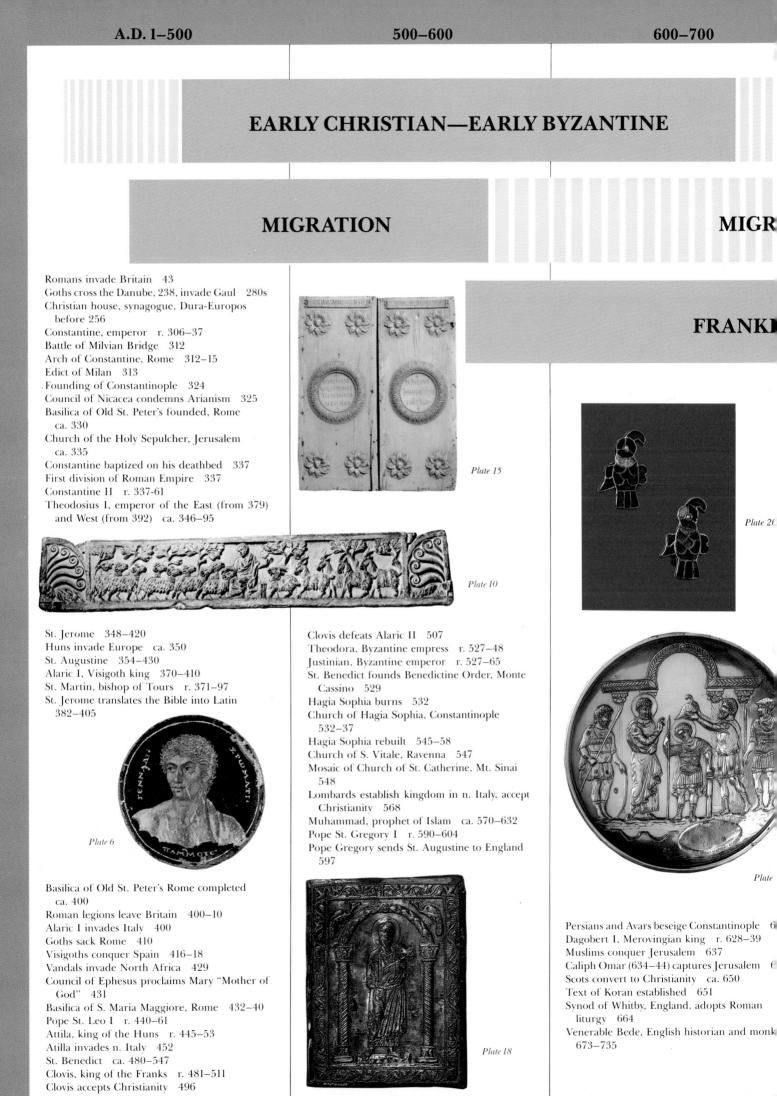

Plate 15

Plate 20

Plate 10

St. Jerome 348–420
Huns invade Europe ca. 350
St. Augustine 354–430
Alaric I, Visigoth king 370–410
St. Martin, bishop of Tours r. 371–97
St. Jerome translates the Bible into Latin
 382–405

Clovis defeats Alaric II 507
Theodora, Byzantine empress r. 527–48
Justinian, Byzantine emperor r. 527–65
St. Benedict founds Benedictine Order, Monte
 Cassino 529
Hagia Sophia burns 532
Church of Hagia Sophia, Constantinople
 532–37
Hagia Sophia rebuilt 545–58
Church of S. Vitale, Ravenna 547
Mosaic of Church of St. Catherine, Mt. Sinai
 548
Lombards establish kingdom in n. Italy, accept
 Christianity 568
Muhammad, prophet of Islam ca. 570–632
Pope St. Gregory I r. 590–604
Pope Gregory sends St. Augustine to England
 597

Plate 6

Plate

Basilica of Old St. Peter's Rome completed
 ca. 400
Roman legions leave Britain 400–10
Alaric I invades Italy 400
Goths sack Rome 410
Visigoths conquer Spain 416–18
Vandals invade North Africa 429
Council of Ephesus proclaims Mary "Mother of
 God" 431
Basilica of S. Maria Maggiore, Rome 432–40
Pope St. Leo I r. 440–61
Attila, king of the Huns r. 445–53
Atilla invades n. Italy 452
St. Benedict ca. 480–547
Clovis, king of the Franks r. 481–511
Clovis accepts Christianity 496

Persians and Avars beseige Constantinople 6
Dagobert I, Merovingian king r. 628–39
Muslims conquer Jerusalem 637
Caliph Omar (634–44) captures Jerusalem 6
Scots convert to Christianity ca. 650
Text of Koran established 651
Synod of Whitby, England, adopts Roman
 liturgy 664
Venerable Bede, English historian and monk
 673–735

Plate 18

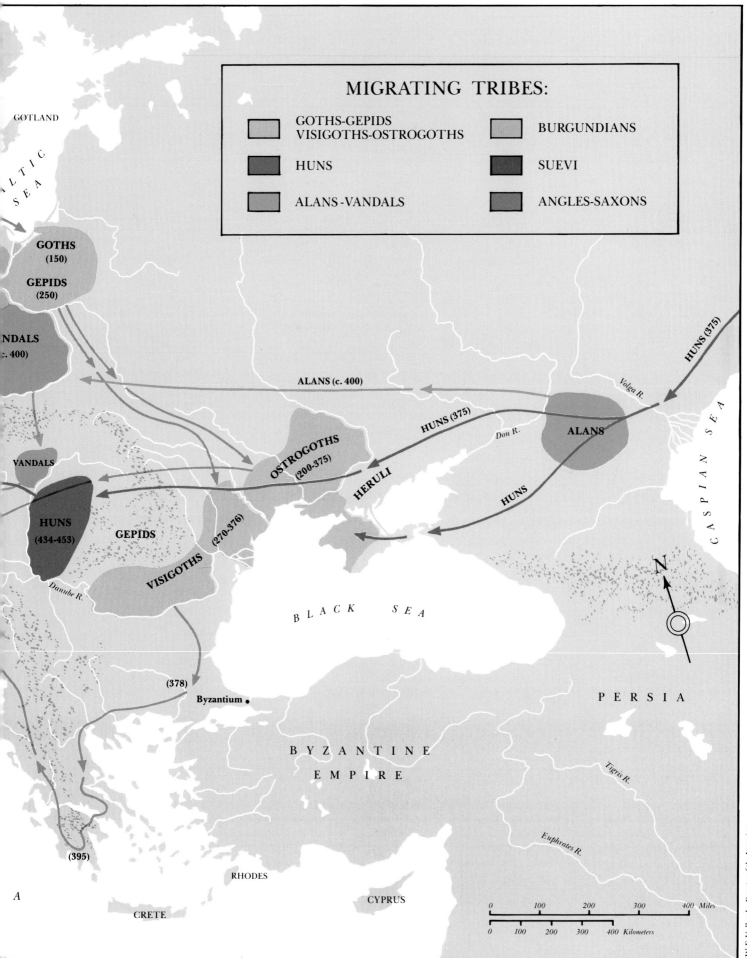

GOTLAND

ALTIC
SEA

MIGRATING TRIBES:

GOTHS-GEPIDS
VISIGOTHS-OSTROGOTHS

BURGUNDIANS

HUNS

SUEVI

ALANS-VANDALS

ANGLES-SAXONS

**GOTHS
(150)**

**GEPIDS
(250)**

NDALS
c. 400)

ALANS (c. 400)

HUNS (375)

Volga R.

HUNS (375)

VANDALS

HUNS (375)

Don R.

ALANS

**OSTROGOTHS
(200-375)**

HERULI

HUNS

C
A
S
P
I
A
N

S
E
A

**HUNS
(434-453)**

GEPIDS

(270-376)

HUNS

VISIGOTHS

Danube R.

B L A C K S E A

N

(378)

Byzantium •

P E R S I A

B Y Z A N T I N E

E M P I R E

Tigris R.

(395)

Euphrates R.

RHODES

A

CYPRUS

CRETE

| 0 | 100 | 200 | 300 | 400 Miles |

| 0 | 100 | 200 | 300 | 400 Kilometers |

THE MEDIEVAL WORLD

Paris 1200–20
ople 1201–04
202
–61
r 1206
Assisi 1209
uilding begins 1211

1220–50

VIII) and regent of

53

Plate 94

Plate 120 *Plate 134*

author of *Historia*

1260
om Latins 1261

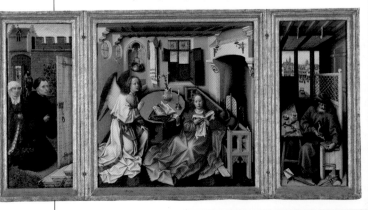

Plate 107

Plate 127

H GOTHIC

LATE GOTHIC

264
e 1270–85
opher d. 1280
de 1284
blai Khan 1285
nd 1291

Plate 103

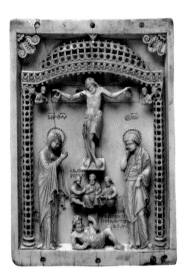

Plate 41

Theophilus writes *On Diverse Arts* ca. 1100
Wiligelmo, sculpture, cathedral of Modena ca. 1100
Rainier de Huy, baptismal font, Liège 1107–10
Cloister, Moissac, ca. 1100, portal 1115–31
St. Bernard, abbot of Clairvaux 1115–53
Church of St.-Lazare, Autun 1120s
Church of the Madeleine, Vezelay, rebuilt after 1120
Abbot Suger of St.-Denis r. 1122–51
Gilabertus, sculpture, Autun cathedral 1125–35
Master Hugo makes Bury Bible 1130–40
Eleanor of Aquitaine: French queen, 1137–52, English
 queen, 1154–89 d. 1204
Louis VII, king of France 1137–80
West facade of Chartes Cathedral 1140s
Ambulatory, St.-Denis 1141–44
Second Crusade 1146–49

West facade, Notre-Dame Cathedral
Fourth Crusade, Sack of Constantin
Fourth Crusade sails from Venice
Latin Kingdom in Byzantium 1204
St. Dominic founds Dominican Orde
St. Francis founds Franciscan Order
Cathedral of Reims burns, 1210, reb
Fourth Lateran Council 1215
Magna Carta 1215
Cathedral of Amiens 1218–88
Frederick II (Hohenstaufen), HRE
Cathedral of Burgos begun 1221
Blanche of Castile, queen (of Louis
 France r. 1223–52
St. Thomas Aquinas 1225–75
Louis IX, king of France 1226–70
Sixth Crusade 1228
Church of St. Francis, Assisi 1228–
Ste.-Chapelle, Paris 1243–48
Westminster Abbey after 1245
Seventh Crusade 1248–54
Sorbonne founded, Paris 1253
Cathedral of Cologne begun 1254
Matthew Paris, English illuminator,
 Anglorum 1259
Nicola Pisano: Pisa baptistery, pulpi
Byzantines retake Constantinople fr

Leif Ericson reaches N. America 1000–02
Abbey Church of St.-Martin, Tours, rebuilt 1003–14
William the Conquerer 1035–87
Ferdinand I, king of Castile (1035) and Leon r. 1037–65
Edward ("the Confessor"), king of England r. 1042–66
Normans begin conquest of Sicily 1043
Schism of Eastern and Western churches 1054
Basilica of St. Mark's, Venice 1064–77
Normans conquer England in Battle of Hastings 1066

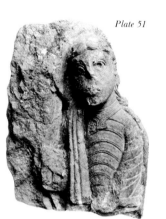

Plate 51

Plate 74

OTTONIAN

ROMANESQUE

Plate 64

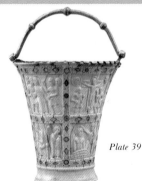

Plate 39

BYZANTINE

Plate 44

EARLY GOTHIC

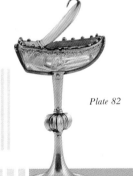

Plate 82

Bayeux Tapestry after 1066
Investiture contest between papacy and German emperors
 1075–1122
Cathedral of Santiago de Compostela 1078–1120
Third abbey church of Cluny 1088–1130
First Crusade 1095–99
Cistercian Order founded 1098
Song of Roland ca. 1098
Latin Kingdom of Jerusalem founded 1099
Cathedral of Modena 1099–1106

Frederick I (Barbarossa), German king r. 1152–90
Henry II (Plantagenet), English king r. 1154–89
Ferdinand II, king of Aragon r. 1157–88
St. Thomas Becket, archbishop of Canterbury 1162–70
Canterbury Cathedral burns 1174
Philip II, Augustus, king of France 1180–1223
Nicolas of Verdun: enamels, Klosterneuberg 1181
Saladin captures Jerusalem 1187
Master Mateo, *Portico de la Gloria*, Santiago Cathedral
 1188
Third Crusade captures Jerusalem 1189–92
Richard ("the Lion-Hearted"), king of England
 r. 1189–99
Chartres Cathedral, rebuilt after fire 1194
Pope Innocent III r. 1198–1216

HIG

Merton College founded, Oxford
Philip III ("the Bold"), king of Fran
Albertus Magnus, scientist and phil
Giovanni Pisano, Siena Cathedral fa
Marco Polo returns from court of K
Turks drive Christians from Holy L
Cathedral of Barcelona begun 129

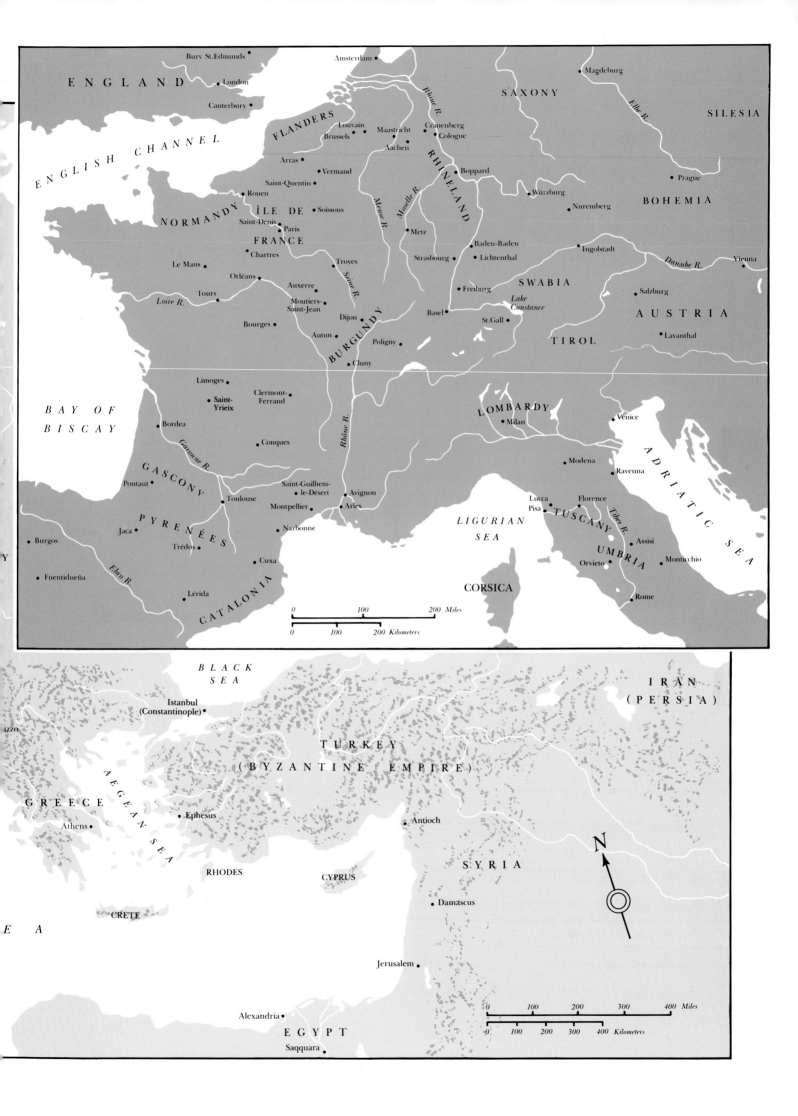